FASHION IN COLORS

FASHION IN COLORS
Curated by Akiko Fukai

Contributors:
Paul Warwick Thompson
Yoshikata Tsukamoto
Barbara Bloemink
Claude Lévi-Strauss
Lourdes Font
Claude Imbert
Yasuo Kobayashi
Dominique Cardon

Published by Assouline Publishing
601 West 26th Street, 18th floor
New York, NY 10001, USA
www.assouline.com
in association with
Cooper-Hewitt, National Design Museum
Smithsonian Institution
2 East 91st Street
New York, NY 10128
www.cooperhewitt.org

Published on the occasion of the exhibition *Fashion in Colors*
at Cooper-Hewitt, National Design Museum, Smithsonian Institution,
December 9, 2005–March 26, 2006.

Original exhibition organized by The Kyoto Costume Institute.
First exhibited at the National Museum of Modern Art, Kyoto, Japan,
April 29–June 20, 2004; and at the Mori Art Museum, Tokyo,
August 24–December 5, 2004.

Fashion in Colors is made possible in part by LANCÔME
PARIS

Media support is provided by E L L E

Additional support is provided by Wacoal, Mr. and Mrs. Lee S. Ainslie III, and
ESP Trendlab.

Generous in-kind support is provided by Rootstein Mannequins, Japan Airlines, and
Yamato Logistics Co., Ltd.

Design: Tsutomu Nishioka

Editors:
International edition:
Chul R. Kim, Head of Publications, Cooper-Hewitt, National Design Museum,
Smithsonian Institution
Esther Kremer, Editor, Assouline Publishing

Japanese edition: Tamami Suoh, Rie Nii, Makoto Ishizeki, Naoko Tsutsui, and Naoko
Yamamoto, Kyoto Costume Institute; Office Fukumoto Co., Ltd.

FASHION IN COLORS

Curated by Akiko Fukai

with:
Paul Warwick Thompson
Yoshikata Tsukamoto
Barbara Bloemink
Claude Lévi-Strauss
Lourdes Font
Claude Imbert
Yasuo Kobayashi
Dominique Cardon

Smithsonian
Cooper-Hewitt, National Design Museum

ASSOULINE

BLACK
MULTICOL
RED

Contents

Foreword...........................7

Paul Warwick Thompson, Director, Cooper-Hewitt, National Design Museum, Smithsonian Institution

Foreword...........................8

Yoshikata Tsukamoto, Director, The Kyoto Costume Institute

The New Century of Color...........................9

Barbara Bloemink, Curatorial Director, Cooper-Hewitt, National Design Museum, Smithsonian Institution

The Colors of a Period as the Embodiment of Dreams...........................12

Akiko Fukai, Chief Curator, The Kyoto Costume Institute

The Two Faces of Red...........................21

Claude Lévi-Strauss, Académie Française

Dreaming in Color: Form and Structure in *Fashion in Colors*...........................23

Lourdes Font, Assistant Professor, Fashion Institute of Technology

Designer Profiles...........................28

Black...........................40
Multicolor...........................74
Blue...........................106
Red/Yellow...........................136
White...........................168

List of Works...........................194

Manet, Impressions of Black...........................217

Claude Imbert, École Normale Supérieure

Blue: Poetry of Space and the Body...........................225

Yasuo Kobayashi, Professor, University of Tokyo

Fashion in Colors and Natural Dyes: History under Tension...........................229

Dominique Cardon, Research Director, Centre National de la Recherche Scientifique

Glossary of Dyeing...........................236
Glossary of Fashion...........................240
Selected References...........................242
Acknowledgments: The Kyoto Costume Institute...........................247

By Paul Warwick Thompson, Director, Cooper-Hewitt, National Design Museum, Smithsonian Institution

Foreword

Fashion in Colors, organized by the Kyoto Costume Institute (KCI), is a provocative and visually stunning examination of color through four centuries of Western fashion. The exhibition's original concept was developed by the innovative Dutch fashion designers Viktor & Rolf, and curated by Akiko Fukai of KCI. Viktor & Rolf are, I believe, two of the most interesting new fashion designers to have surfaced in the past decade; their examination of color in the history and aesthetics of costume is both audacious and illuminating. Prior to its New York showing, the exhibition opened at the National Museum of Modern Art in Kyoto, Japan, before traveling to the Mori Art Museum in Tokyo. Cooper-Hewitt is proud to be the first museum outside Japan to partner with KCI and host this extraordinary exhibition. As such, it stands as the first major survey of fashion in the Museum's history.

As the Smithsonian Institution's National Design Museum, the Cooper-Hewitt endeavors to study and celebrate myriad facets of design, and color is an absolutely essential, yet often denigrated, element of design. It is particularly gratifying for us to consider color through the vibrant medium of fashion, and fashion through the lens filter of color. *Fashion in Colors* is a dynamic survey of innovative cut, cloth, and color in costume, whose energy and diversity, position and ideology are decidedly different from the monographic, often staid eulogies of fashion and fashion designers that so often surface in museum exhibitions of fashion.

I would like to express my gratitude to those who have conceived this exhibition and accompanying catalogue: at the Kyoto Costume Institute: Yoshikata Tsukamoto, Chairman, Akiko Fukai, Chief Curator and senior curator of this exhibition, Tamami Suoh, Assistant Curator, and Naoko Yamamoto, Assistant Curator; and at Assouline Publishing: Martine Assouline, Publisher, Ausbert de Arce, U.S. Director, and Esther Kremer, Editor. Our thanks also to Molly Sorkin and Rebecca Jumper Matheson at the Fashion Institute of Technology. Lastly, we extend our thanks to the Groninger Museum and the Centraal Museum in the Netherlands for their participation in this exhibition.

Great thanks go to our sponsor Lancôme for helping to make this exhibition a reality, as well as ELLE magazine, Wacoal, Mr. and Mrs. Lee S. Ainslie III, and ESP Trendlab.

At Cooper-Hewitt, I would like to thank Barbara Bloemink, Curatorial Director, for identifying this captivating exhibition and working closely with Akiko Fukai to curate the New York version at Cooper-Hewitt; Elizabeth Chase, Curatorial Assistant; Jocelyn Groom, Head of Exhibitions; Mick O'Shea, Head of Installations; Steven Langehough, Registrar; Susan Brown, Lucy Commoner, and Sandra Sardjono in Textile Conservation; and Chul R. Kim, Head of Publications.

"Color is life," as Bauhaus theorist Johannes Itten wrote in *The Art of Color,* and this is certainly true in the world of fashion. All of us have a relationship with color; in our clothing, it reflects our feelings, character, and taste, but also transfers significant messages of culture and of social systems. In this exhibition, organized by The Kyoto Costume Institute (KCI) and Cooper-Hewitt, National Design Museum, Smithsonian Institution, fashion is reexamined in the historical and social context of color, from the eighteenth century to the present.

The focus of KCI, which was founded in 1978, is its collection, which comprises 11,000 costumes and related materials of Western clothing and modern Japanese fashion. The collection ranges from the early seventeenth century up to the present, and includes clothing created by world-famous Western designers as well as Japanese designers active since the 1970s, such as Rei Kawakubo's Comme des Garçons, which has donated over 2,000 items; Issey Miyake; and Yohji Yamamoto.

Around this collection, and in conjunction with The National Museum of Modern Art, KCI has created an acclaimed series of exhibitions spotlighting fashion. Five full-scale exhibitions have been organized over the last twenty-five years—The National Museum of Modern Art's longest-running exhibition series.

A quarter century of accumulated time and experience has shown us that a long-lived exhibition series spontaneously evolves, grows, and matures. The first and second KCI exhibitions, *Evolution of Fashion 1835–1895* (1980) and *Revolution in Fashion 1715–1815* (1989), highlighted the magnificence of Western costumes as well as significant historical transitions, and demonstrated that fashion can fascinate and inform in the context of an art museum. With the third exhibition, *Japonism in Fashion (1994),* KCI revealed systematically the influence of Japanese culture on Western fashion and culture in general. The fourth exhibition, *Visions of the Body* (1999), revealed the synchronous relationship and shared awareness between contemporary fashion practices and trends in contemporary art. As a result of this exhibition, fashion found a place in the fields of perception and image, and the exhibition series began to deconstruct the conventional framework of fashion. With sensitivity to this itinerary, KCI launched the fifth exhibition, *Colors: Viktor & Rolf & KCI* (2004).

Colors: Viktor & Rolf & KCI was conceived and planned by KCI with the renowned design duo Viktor & Rolf as guest curators. It was first mounted at The National Museum of Modern Art, Kyoto, and at the Mori Art Museum, Tokyo.

It is a great pleasure to be able to show a new version of *Fashion in Colors* at Cooper-Hewitt, and we would like to express our deepest gratitude to Dr. Paul Warwick Thompson, Dr. Barbara Bloemink, and the entire staff at Cooper-Hewitt, and also to Viktor & Rolf and their staff. Moreover, this opportunity would not have come about without the cooperation of a large number of individuals and institutions, and the generous support given by government ministries, agencies, and many other organizations. We would like to express our sincerest thanks to them all.

From ancient times, color has fascinated us. We hope that many people will be able to take advantage of the opportunity provided by *Fashion in Colors* to reaffirm the fundamental attraction, pleasure, and dynamism of color.

December 2005

The New Century of Color[1]

Barbara Bloemink, Curatorial Director, Cooper-Hewitt, National Design Museum

The widespread use of color is one of the most visible trends in contemporary design, as evidenced by the new shades and hues appearing on everything from automobiles and appliances to food and fashion. Yet color is rarely given the consideration with which we reflect on other elements of design, such as form, structure, materials, function, and process. This is, in part, because color is impossible to describe definitively. Depending on to whom one poses the question, color is defined as a reflection of light, a visual sensation, an objective trait with millions of variations, or a cultural phenomenon.[2]

The relegation of color as a secondary element of design has existed in Western philosophy from at least the third century BC, in the writings of Plato and Aristotle, who argued that color is dangerous in its imitation of reality. In the eighteenth century, the philosopher Immanuel Kant declared color to be merely a sensation, and therefore only "secondary" in our experience of the beautiful. Today, however, color is considered a primary attribute of what we judge to be appealing and beautiful, and acts as an aesthetic marker that is helping to characterize and differentiate the marketplace for contemporary design.

Different ages and cultures define colors differently, ascribing to them varying symbols and emotive associations. Until fairly recently, color was always a luxury, due to the preciousness of certain dyes, and the available technology for extracting and adhering the colors to different forms and materials. For centuries, the only colors available were those derived from dyes acquired from natural minerals and organic substances, such as plants, tree saps, and certain insects. The difficulty in extracting dyes from their sources added to their value. In the late Middle Ages, for example, red dye extracted from the crushed bodies of cochineal insects began to be imported into Europe where, combined with a salt, it created a bright, deep red on silk and woolen fabrics. European courts from the Middle Ages through the seventeenth century favored rich, jewel tones such as blue, red, and green for court fashions, with purple generally reserved for the reigning monarch. With the beginning of the Rococo style under the reign of Louis XV, the decorative arts, fashion, and textiles took on a more feminine pastel palette of pinks, blues, and greens.

Nineteenth-century technological innovations led to new synthetic dyes and pigments and advances in color printing and manufacturing techniques. As color shades became less expensive and more readily available, cyclical changes in color usage, particularly in fashion and art, occurred increasingly rapidly.[3] Global trade and intercontinental travel also brought unseen ranges of colors to Europe and America. In 1876, Christopher Dresser, the first Western designer to be invited to Japan, radically influenced manufacturing in England, bringing back not only innovative shapes and techniques, but also an entirely new variety of colors to be used on European ceramics, glazes, wallpapers, and metalwork. Meanwhile, his contemporary, the Arts and Crafts proponent William Morris, reacted against the increasing use of manufacturing and synthetic colors by designing fabrics, wallpapers, tiles, and furniture using only natural dyes. He often reverted to ancient formulas for extracting the dyes from only organic sources.

In the twentieth century, context influenced color preferences. New York's Art Deco style, for example, reflected the metallic colors of industry and commerce, including black, gold, and silver; while Florida's characteristic Art Deco architecture featured a palette of sun-washed tropical colors. As times changed, so did many of the traditional associations of colors in areas of design. By the early twentieth century, the use of black in women's clothing, no longer merely associated

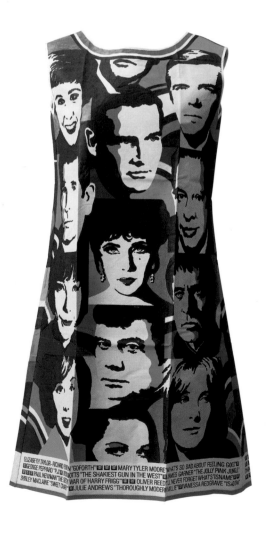

with mourning, quickly became linked with perceptions of elegance and glamour. The simplicity of Gabrielle "Coco" Chanel's signature "little black dress" helped establish black as an appealing color for women's fashions, as it conferred on urban women a "uniform" that could easily transition from day to night through the changing of accessories (Nos. 7, 8). Following World War II, the general public gained access to a broad array of colors, synthetic dyes, and mass-produced fabrics. As burgeoning postwar families moved to the suburbs, manufacturers reinforced women's domestic roles by offering the illusion of glamour to daily chores, creating appliances in a wide assortment of colors. During the 1950s, washing machines were available in pink, turquoise, and yellow, changing in the next decade to earth tones of gold, brown, and avocado.[4] Advertising suggested that women decorate their kitchens and washrooms around the colors of their appliances, implying a planned obsolescence based on aesthetics rather than function. By the 1970s, most domestic appliances were again available in only neutral shades of white or beige.

The closest parallel to the current zeal for color in fashion and consumer products took place during the Pop era of the 1960s. The spread of color in photography, printing, films, magazines, and television significantly increased the public's awareness of—and appetite for—color in everyday life. For the first time, styles and fashions focused on adolescents, and reflected their enthusiasm for space-age metallics, bright acrylic paints, and the application of color to new materials such as polyesters and plastics. The palette of the Pop era reflected the growth of interest in advertising and popular culture (No. 26).

While fashion reflected these tendencies in the United States, in Europe during the same period, the use of color extended more generally to include interior and product design. In addition to devising his own idiosyncratic color theories, Danish designer Verner Panton was highly influential in promoting the use of saturated colors in interior design and furniture during the 1960s and 1970s. Panton once observed, "I am not fond of white, the world would be more beautiful without it. There should be a tax on white paint." Richly toned rooms with color-drenched walls, rugs, furniture, and lighting were conceived by Panton to "glow" in a visual bath of singular color.[6]

During the 1970s and 1980s in the United States, although specific colors reflected the fashion "trends" of the year, most designed objects were largely available only in neutral colors. This was particularly true of new technological gadgets, from the calculator to the computer. The designers, wanting to emphasize the "serious" functionality of their inventions, only offered these devices to the public in metallic grey, black, or white. Apple computers, in a brilliant effort to reinforce its signature branding as different from the norm, revolutionized consumer technology in the late 1990s with the original iMac computer, which came in three bright, translucent colors: aqua, tangerine, and cranberry. Over a decade later, Apple's all-white iPod set itself apart from its gray metal competitors, then empowered consumers to choose from a selection of fun colors for its iPod minis.

Through television and magazines, design doyenne Martha Stewart made color, and the coordination of matching items for the home, accessible to the general public at low prices. In doing so, she not only promoted awareness of design, but also enabled consumers to feel their choices all reflected "good taste."

In recent years, however, consumer interest has moved from matching colors to variety and individuality. Although still in concept form, Ford Company's 2004 "Mood Car" suggests that in the future,

consumers will be able to change the color of their car according to their mood or occasion. Suddenly, colors are no longer tied to acceptable behavior or specific objects. Instead, everything from mixers and washer/dryers to toasters and tea kettles comes with color choices. In fashion, it is now accepted that there are no longer any inappropriate combinations of color or pattern. Compared with the 1960s, where the Pop fashions featured bold, but consistent, colors, many designers today juxtapose and mix unexpected patterns and colors in a single outfit (No. 29). Meanwhile, accessory companies have changed the paradigm so that handbags and shoe colors are not limited to seasonal black, white, navy, or brown, but are changed on a whim and replaced to match whatever outfit is being worn.

With the use of the Internet and computers giving users access to millions of color combinations, companies such as BMW and Nike increasingly promote the individualization of purchases. On the Mini-Cooper's "design-your-own" Web site, buyers can select the colors of their new car's body, roof, and interior. And if you are lucky enough to get an appointment, the Nike Lab provides customization of your shoes.

At least among young consumers, colors have become divorced from their historic psychological, cultural, and emotional associations. Traditional rules of what colors are considered most inherently "appetizing" no longer apply. The color blue rarely occurs in nature, and almost never from edible organic sources. In the past, if your meat or cheese turned blue, it indicated that it was rotting and no longer healthy to eat. Currently, however, tomato catsup comes in bright blue, purple, and green as well as red; M&M's has introduced blue into its traditional candy palette; and electric-blue coloring is regularly found in carbonated and high-energy drinks, ice cream, and snacks.

Today, most of us take for granted our immediate access to a myriad of colors, and feel free to use color to design and define our environments. However, we rarely stop and consider how it influences our choices of what we buy and wear. By presenting three hundreds years of Western costumes by color, rather than chronology, *Fashion in Colors* offers us a thoughtful respite from the usual museum installation. Rather than being drawn to a particular gown because of its color, the viewer's eye is now drenched in color, making the individual "materiality" of each gown disappear. Gradually, as the eye adjusts, one notices subtle surface details, and similarities of structure, form, and materials across time. The resulting immersive environment encourages viewers to ponder color's historical and symbolic associations, and, finally, the role our daily color choices play in how we define ourselves.

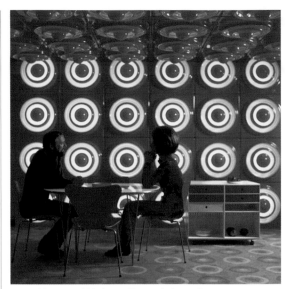

ABOVE: Verner and Marianne Panton in front of a wall of ring-lamps.
OPPOSITE: Minidress, U.S.A., 1968, KCI.
BELOW: Apple's iPod mini.

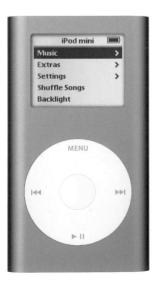

Notes:
1. Taken from William Segal, "Color Association of America," foreword to *The Color Compendium* by Margaret Walch and Augustine Hope (New York: Van Nostrand Reinhold Press, 1990).
2. Red has the lowest frequency on the visible spectrum that humans can perceive; all colors that are invisible to our eye and below red's "frequency" are known as "infra-red." Similarly, purple sits at the top of humans' observable spectrum, and anything above is called "ultra-violet." To see "infra-red" or "UV" light, we need instruments that reinterpret the "color" and allow us to see its signature as colors within our visible range.
3. In the 1820s, the French chemist Michel-Eugène Chevreul began lecturing on the influence on perception of colors placed adjacent to each other. Chevreul's highly influential *On the Law of Simultaneous Contrast of Colors*, published in 1828, presaged Bauhaus teacher Joseph Albers's 1963 book, *On the Interaction of Color*, both of which radically influenced artists and designers throughout the nineteenth and twentieth centuries.
4. Ellen Lupton, "Sex objects," in *Mechanical Brides,* exhibition catalogue (New York: Cooper-Hewitt, National Design Museum and Princeton Architectural Press, 1993), p. 23.
5. Quoted in *Verner Panton, The Collected Works,* exhibition at AXA Gallery, New York, June–October 2005, originally organized by the Vitra Museum, Weil am Rhein, Germany.
6. This concept is recalled in Viktor & Rolf's original design concept for the exhibition of works from the Kyoto Costume Institute, *Fashion in Colors,* which opened at The Museum of Modern Art, Kyoto, before traveling to the Mori Art Museum in Tokyo. Although redesigned for its installation in Cooper-Hewitt, National Design Museum in New York, Viktor & Rolf's notion of organizing the fashions by color rather than chronology remains constant in each installation of the exhibition.

Akiko Fukai, Chief Curator, The Kyoto Costume Institute

The Colors of a Period as the Embodiment of Dreams

Towards the Surface

Viktor & Rolf's *Long Live the Immaterial!* show, presented in Paris in the fall of 2002, offered a clear thematic direction for The Kyoto Costume Institute's *Fashion in Colors* exhibition. In that collection, entire outfits, or details of clothing, appeared on the runway in a special color known as "chroma-key" blue. As they walked down the runway, the models' images were simultaneously projected onto an enormous screen in the background. Through video technology, the blue sections of the clothing projected onto the screen disappeared, replaced by moving images. The audience found itself looking at a model no longer wearing a shirt collar or a necktie, but rather scenes of city traffic, cars racing past each other down the freeway, a series of sand dunes, or pigeons exploding into the air.

The clothes themselves, inherently "unique material objects," were obliterated; instead, patterns and images were projected onto, and colored, the body. This layered interweaving of the unique material object and the image is an inherent feature of the clothes we wear. Viktor & Rolf's chroma-key show reaffirmed this concept that clothes can be "an embodiment of dreams." However, the show was arguably the first to succeed in conveying so vividly and dramatically the message that clothing has layers of invisible meaning.

In an interview with KCI, Viktor & Rolf said that "fashion is more than just clothing, it provides an aura and an escape from reality, a fantasy, a dream."[1] Clothes provide a way to drift away from and transcend reality, and to discover different images. They represent at once a "unique material object" and a complex presence onto which dreams and fantasies are projected.

In 2001, Viktor & Rolf held a show saturated in black, designed to prioritize the formal qualities of the clothing on display. Black, while filling in the form, had the effect of completely removing both the rich texture of the materials and the details of the intricate cut used in their designs; only an integrated flat, black surface and a stunning silhouette remained. Texture and ornament were completely effaced, and all that remained visible was the silhouette of the clothing that enclosed the form. The clothing was then used to convey to the observer various images contained within the silhouette.

Viktor & Rolf's work highlights the idea of clothes as "surface," a concept that corresponds with KCI's current thematic emphasis on colors, which represent or enact on some level the values and anxieties of the era in which they appear.

Color and the Spirit of the Age

Even a narrow discussion of color—about dyed fabric, for example—would inevitably need to consider the cultures of different people at different times. The dialogue would also likely encompass issues of color recognition, the symbolism of color, and a history of the extensive, worldwide commerce in color—an industry which dates back to antiquity, as evidenced by early trade in murex shells and red dyes such as cochineal. One could also include the history of science and technology, the physiology of the brain, psychology, and even botany and zoology. There is always the angle of fashion, or trends, and the social context of colors, including an examination of social tastes and

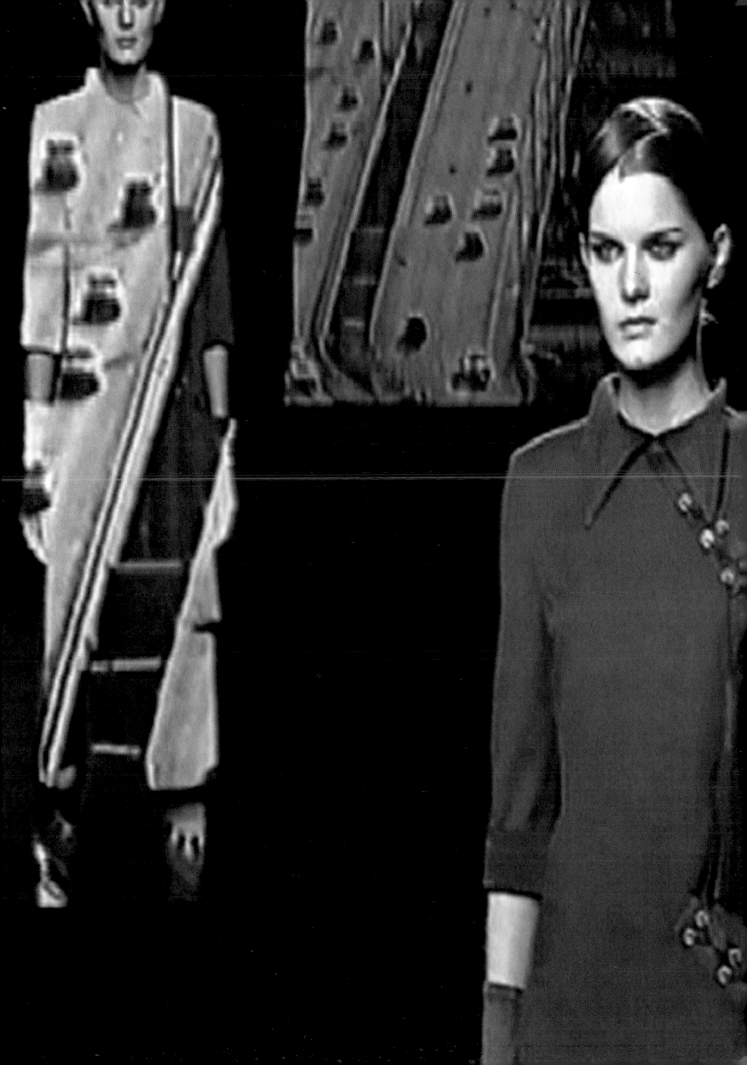

preferences. Furthermore, there is the matter of color as found in diverse literature from all ages and cultures, where it has been freed from its materiality to appear as its essence in words. The range of perspectives on color is truly staggering.

It is necessary to emphasize, however, that the focus of this exhibition and book is, specifically, color in fashion. We are focusing on the period spanning the eighteenth century to the present, with a spotlight on France, which, arguably, has been the center of fashion during most of that time. What we are attempting to do is to completely remove the articles of clothing, most of which belong to the KCI collection, from a purely historical axis or interpretation, and to present the relationship between the element of color and clothes in a new way.

We at KCI have noticed, through our work, that certain groups of clothes in the collection, classified by period, clearly differentiate themselves by tone or color, suggesting that certain colors dominate certain periods. For instance, many eighteenth-century costumes, which belonged to the upper class, are extremely colorful, featuring reds, yellows, and blues on rich silk textiles. However, the dominant colors of this period are pale and light tones, colors generally classified as pale pastels. The values of the Rococo period—during which even shadows were depicted in rose pink—were then radically transformed in the early nineteenth century by what can be described as *tabula rasa* values. White, often in the form of white cotton, was recognized as the new, fashionable color, the result of advancements in bleaching methods.[3] It was during this time that white became, for the general public, a color that was attainable, yet luxurious and totally new.

Colors in fashion underwent another dramatic change in the mid-nineteenth century. The dazzling, even somewhat gaudy colors of costumes from the late nineteenth century reflect the discovery of aniline dye in 1856. Impressionist painters, who were simultaneously exploring new ways to express color on the canvas, frequently featured such fashionable clothes in their work. It is possible to suggest that painters responded to the new colors—mauve, magenta, fuchsia, aniline black, and methyl blue, among others—because they were making widespread appearances in artificially dyed *mode* clothing.

The Impressionists were also attentive to the close relationship between color and texture. The deep and dazzling colors made available by artificial dyes were strongly linked with the heavy, luxurious textiles typical of the period, including velvet, armure-weave velvet, damask, grosgrain, and satin. Black and colors with little sheen—and with color saturation so dark as to appear black—were also features of fashion in the late nineteenth century. Adding to the visual and physical weight, much clothing of this period was dominated by excessive decoration such as *passementerie* trimmings.

White reappeared as a dominant color in women's clothing at the beginning of the twentieth century. Eventually, the taste for strong colors returned, influenced perhaps by those featured in the Ballets Russes, which at the time took Paris by storm, or by the work of the designer Paul Poiret, who wrote, "I released several aggressive wolves amongst the sheep on the pasture (all in soft colors like pale pink, lilac, and corn): the red, green, violet, and royal blue of the wolves made the other colors sing loudly."[5] Regardless of the cause, popular preferences shifted toward a wide range of colors described as "Oriental"—combinations of orange, purple, and emerald green, for example. Trends in fashion reflected trends in art—early twentieth-century artists such as

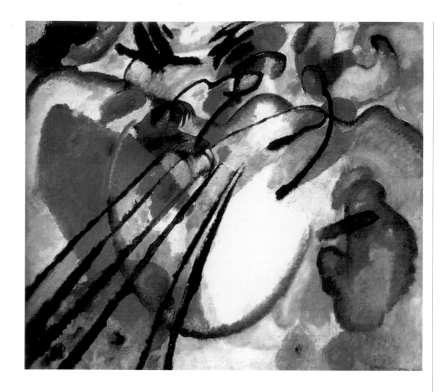

the Futurists, the Fauves, and members of the Russian avant-garde, spurred on by emerging scientific theories on color, experimented extensively with color, and during this process, such colors came to fill their canvases.

Black regained its dominance in the 1920s. Gabrielle "Coco" Chanel's legendary *petite robe noire,* or little black dress, is the archetypal example of this phenomenon. The modern quality of black had dominated men's clothing during the nineteenth century,[6] but it took slightly longer for womenswear to join the trend. Black surged forth as the color of the moment in various phases during the twentieth century. Embraced by the Existentialists in the 1950s and the punks in the late 1970s, black enjoyed a resurgence in Japanese fashion—represented by designers such as Rei Kawakubo and Yohji Yamamoto—in the early 1980s.[7] By the end of the twentieth century, black had become established as an everyday color for clothing.

Though the cycles of fashion have become shorter in recent times, and there is greater freedom to choose different colors in comparison to the past, the phenomenon of a preferred color dominating, and even characterizing, a certain period still remains. The structure of the fashion industry and the demands made by the newly emerging consumer society make such color dominance inevitable. When we choose the clothes that we wear, we are fully convinced that we are selecting the colors that we like. However, in examining the eternal theme of color, it is evident that our color choices are made within the restrictions of a certain period. That is to say, we are limited to the choices offered by the market at any given time; after all, the market itself is strictly controlled by the economics of fashion trends and the structure of the industry. However, no matter how restricted our choices may be, the colors of the clothes that we wear on a day-to-day basis represent the easiest and most effective way for us to express a range of different feelings—our hopes, desires, and emotions. Color is directed at our deepest sensibilities.

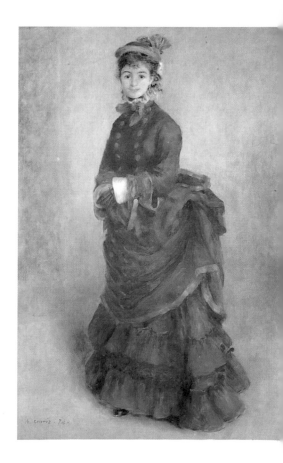

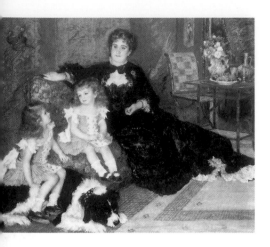

ABOVE: Pierre-Auguste Renoir, *Madame Georges Charpentier and Her Children* (portrait de Madame Charpentier et ses enfants), 1878. The Metropolitan Museum of Art, N.Y., Catherine Lorillard Wolfe Collection, Wolfe Fund, 1907 (07.122).

OPPOSITE: Pierre-Auguste Renoir, *The Umbrellas* (Les parapluies), 1881-86. The National Gallery, London.

Mad about Mauve: A Newly Discovered Sense of Color

Aniline dye was accidentally created from coal by the young English chemist William Henry Perkin in 1856, during his research into a remedy for malaria. The first artificial aniline dye was mauve (or mauvein), and the resulting color was an unprecedented, vivid purple with fuchsia tones. Dating back to antiquity, purple or Tyrian purple had always been regarded as a particularly noble color, and Perkin gave the name Tyrian purple to the first dye he synthesized. In retrospect, the combination of the purple color, with its connotations of wealth, and the sensibilities of the new, moneyed class that suddenly emerged during this period was a happy coincidence. Perkin went on to build a dye factory in Greenford, England, where he began commercial production of his discovery. Large quantities of the synthesized mauve dye were made available at a low price, becoming the catalyst for the development of other new artificial dyes. Innumerable inventions and developments in dye colors followed during the latter part of the nineteenth century,[8] enabled by significant technological and scientific advances made during the Industrial Revolution. The discovery of aniline dyes helped ignite the sudden growth and expansion of the chemical industry. Initially, chemical dyes had the drawback of not being colorfast, but as improvements were made to the process, and once large quantities of fabric could be dyed economically, artificial dyes quickly replaced natural dyes. The dyeing industry was then able to expand the application of dyes as a medium of expression, and a larger segment of the population was able to enjoy the new range of colors. Amongst the records of the Lyon presence at the *International Exposition* held in Paris in 1889 is a thesis by Léo Vignon, titled "La Chimie à l'Exposition de 1889 (Chemistry at the 1889 Exposition)."[9] Vignon wrote of how he had benefited greatly from the remarkable progress achieved in the chemical industry, and attributed that progress to artificial dyes. The mid-nineteenth century saw a dramatic democratization of clothing, with the new dyestuffs joining improvements to the sewing machine as major factors contributing to the increase in accessibility. Spurred by their initial successes, manufacturers came up with more colors that could not be created with natural dyes—colors that had "never been seen before *(effets inconnus jusqu'alors)*" or were "extraordinarily bright *(vivacité extraordinaire)*." The new sensibility is evident from the "scientific" names given to these dyes—alizarin black, methyl violet, etc. In later years, once the novelty had worn off, such colors were viewed as gaudy and artificial. Mauve had staying power long enough to support a trend that benefited the synthetic dye industry. The color's popularity may have come from, in part, its membership in the purple family—purple was the color favored by Empress Eugénie of France's Second Empire, a woman at the forefront of contemporary fashion. When Queen Victoria of England, on the advice of Empress Eugénie, wore a lilac velvet dress at her daughter's wedding in 1858, mauve was officially "in." According to the author of *Mauve,* a biography of Perkin,[10] three months after the *Illustrated London News* carried a detailed description of the dress worn by Queen Victoria, fashion magazines touted mauve as Queen Victoria's favorite color, thus spreading the trend. The credibility of this statement may not stand up to detailed analysis, but it throws some light on the kind of events which may have served as catalysts for shifts in color popularity and dominance. At the

end of the nineteenth century, mauve denoted a bright purple color, with a slight hint of ultramarine blue. I believe it is a purple distinct to this period, as seen in several fashions in the book. The synergistic effect of the eccentric clothing fashionable at the time and the color mauve, as seen in this bustle dress, perfectly convey the outlandish quality of the new synthetic color.

Renoir's Sense of Color

A similar mauve can be seen in Pierre-Auguste Renoir's *Reading the Role* (1874). Renoir embarked on his career as a portrait artist with *Lise with a Parasol* (1868), and produced numerous portraits in the 1880s. Mauve with blue tones is also featured in *Madame Claude Monet Reading* (1872). The dress worn by the model in *La parisienne* (1874), which Renoir exhibited in the *First Impressionist Exhibition* in 1874, is somewhat bluer in tone than mauve. After this exhibition, Renoir went on to become a highly acclaimed portraitist. In *La parisienne,* the purple-blue of the model's dress is so vivid that the observer's attention is directed away from the model's face. Rather than a conventional portrait, this painting seems more like a fashion plate or a pin-up photo, and in it the new color assumes heightened significance. The model for the painting was actress Henriette Henriot, who was appearing on the stage at the Odéon in Paris. As Madame Henriot was still a budding actress, her clothing was not likely to have been designed by a great couturier, but the bright blue-purple of her outfit shows that she was nonetheless dressed in the height of fashion. In other words, this painting reveals how the invention of new chemical dyes created dramatic changes in the preference for certain colors in fashion.

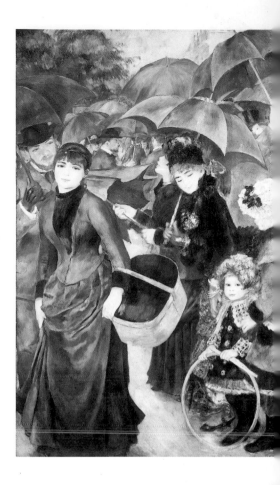

At the time, Impressionist painters were using chemically synthesized inorganic pigments that allowed them to experiment with new colors. Renoir, it could be said, found that fashionable women's dresses worked perfectly as a medium for the new colors of mauve and bright blue that he favored. Eventually, these pigments would be "released" from the dresses, and form dots in the sky, in water, or on the surface of rocks in Renoir's paintings.

Marcel Proust made frequent references to mauve in his novel cycle *In Search of Lost Time,* and mauve, the color of the period, was strongly associated with a central character, Odette, the high-class prostitute who represented the height of fashion. Proust's depiction of life at the turn of the century was enhanced by his lush sense of color and his rich language, and the color relationships between fashion and his characters are of great interest. The great aristocrat, the Duchess de Guermantes, appears wearing a black velvet dress, a white muslin evening dress, and an almost lurid red velvet evening dress. While she is depicted in luxurious Mariano Fortuny dresses—richly colored garments that act as metaphors for Venice or Carpaccio—Albertine, the main character's lover, is represented in white and gray.

Black, alongside mauve, represents a defining color of this period in fashion history. Impressive women dressed in black were depicted by artists such as Edouard Manet,[11] Renoir, James-Jacques-Joseph Tissot, Gustave Caillebotte, Edgar Degas, John Singer Sargent, Carolus-Duran, and Jean Béraud.

Renoir's paintings of the 1870s frequently featured women dressed in

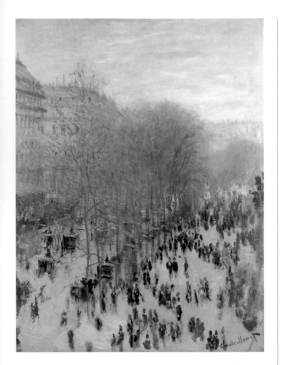

black. In his *Madame Georges Charpentier and Her Children* (1878), we see Marguerite Charpentier, one of the "queens" of Paris society, posed in the newest fashion. Madame Charpentier's dress was designed by the House of Worth, and she is depicted with her two children. The Charpentiers first purchased a painting by Renoir in 1875, and later commissioned him to paint several portraits of their family. Georges Charpentier was a prominent publisher who produced books by such popular contemporary authors as Emile Zola, Guy de Maupassant, and the Goncourt brothers, and the significance of Renoir's encounter with this family was greater than simple financial sponsorship. Marguerite presided over the leading salon in Paris, and those who attended included not only the previously mentioned writers, but also diverse cultural figures and celebrities of the Third Republic, including musicians, politicians, and feminists. Many of those who ordered portraits were of the moneyed class, and the woman being portrayed would choose, together with her couturier, a fashionable outfit for her to wear in the painting. Black was the color of the moment, associated with dignity, mystery, and elegance.

Black, or very dark, clothing was also embraced by ordinary people, as can be seen in Renoir's *The Umbrellas* (1883). In scenes painted by Parisian artists of the time, black clothing was particularly evident in clothing worn by working women, although it was the color of typical work clothes in urban society for both men and women. By the late nineteenth century, however, black was seen as both practical and inflected with fashion and glamour, rendering its associations somewhat ambiguous. It was Chanel who, in the 1920s, brilliantly extracted and applied this element of black to the "little black dress," a quintessentially modern representation of this ambiguity.

The late nineteenth century was a socially rigid and restrictive period, when it was almost compulsory for people in "civil society" to wear certain clothes for specific occasions. For the sake of practicality, it was essential for women to own at least one mourning dress, a black dress to be worn during the long, socially decreed term of grieving.[12] The development of inexpensive black chemical dyes democratized black fabric, making it an economical and practical color to wear. Black fabrics, or fabrics that were chemically dyed in vivid mauves and reds, can be interpreted as representing the dark, cloying, and hidden aspect of moralistic society during the nineteenth century. A color that gradually gains acceptance and reveals itself in fashion, or the surface of an era, is ultimately related to some extremely complex social factors.

New colors, because of their novelty and artifice, captured the hearts and imaginations of the public, particularly artists and fashionable women, during the latter part of the nineteenth century. The colors that are favored by a certain period are not unrelated to the dreams of the people who lived in this period, or the psychology or mindset that they unconsciously reveal. The "surface" of clothes can be colored in accordance with the wishes of each individual—despite the continued presence of certain restrictions. Each time the restrictions loosen a bit—as with the invention of aniline dyes, or the development of chroma-key techniques—a new dimension of desire can be fulfilled.

Toward "Color"

As Viktor & Rolf have observed, clothes, which should by rights be "unique material objects," can also be immaterial substances that drift away from and transcend reality, offering up alternate images or dreams. Throughout the history of fashion, an endless variety of images have been created through the skillful combination of body, clothing, and clothing elements, such as color, fabric texture, and form. Clothing plays the role of canvas, but we also add color directly to our skin, hair, and faces. Young people deconstruct the elements of clothing—taking a part of a sleeve here and a bit of bodice there—and reassemble them creatively to suit their own taste. In the future, it is possible that the making of clothes as we know it now, involving cloth, dyeing, cutting, and sewing, will be replaced by a completely new production method. For now, we cannot resist adorning ourselves with colors, for they stimulate our emotions, sentiments, and our sense of beauty, and harbor complex significances.

In this exhibition and book, clothes have been liberated from their historical contexts so that they might reveal the basic element of color. It is at this point that we should be able to embrace new questions generated about the essential meaning of color with a fresh sensibility.

Notes:

1. Viktor & Rolf, interview by the Kyoto Costume Institute, 2004.
2. Refer to Kyoto Costume Institute, *Revolution in Fashion 1715–1815*, Kyoto Costume Institute, 1989.
3. Bleaching methods were developed in France by Claude-Louis Bertholet in 1786, and substantially improved by Charles Tennant in Scotland in 1796.
4. Paul Poiret, *En habillant l'époque*, Grasset, 1930, p. 64.
5. John Harvey, *Men in Black*, trans. Ota Ryoko, Kenkyusha, 1997.
6. For more details, refer to Akiko Fukai, *Japonism in Fashion*, Heibonsha, 1994.
7. The following are only the major nineteenth-century discoveries in chemical dyes:
1857: Monnet establishes an industrial production system in Lyon to manufacture Perkin's purple.
1858–59: A Lyon dye manufacturer produces fabric dyed with magenta, the red dye originally produced by French chemist Verguin.
1861: Lauth synthesizes Methyl violet.
1862: Hoffman synthesizes Hoffman violet.
1862: Martius and Lightfoot synthesize Bismarck brown.
1863: Lightfoot synthesizes Aniline black.
1868: The German chemists Graebe and Liebermann produce Alizarin. Alizarin is the chemically synthesized version of the natural dye "madder," and was the first chemical dye to replace a natural dye.
1867: Caro develops Methyl blue.
1877: Dobner and Fisher create Malachite green.
1878: The German chemist Bayer synthesizes Indigo (commercially available beginning 1897).
9. Léo Vignon, "La chimie à l'Exposition de 1889," in *Lyon à l'Exposition Universelle de 1889,* ed. Adrien Storck and Henri Martin, vol. 2, A. Storck, 1891, p 131.
10. Simon Garfield, *Mauve*, W. W. Norton & Company, 2001, p. 61.
11. See also Claude Imbert, "Manet, Effets de Noir," trans. Shigemi Inaga, pp. 217–224.
12. Mourning clothes at the end of the nineteenth century—according to the exhibition catalogue *Femme fin de siècle* 1885–1895 (Musée Gariella, 1990, p. 56), widows wore mourning clothes for 18 months.
First stage—6 months. Full mourning (grand deuil). Black clothing, no outings permitted.
Second stage—6 months. Minor mourning (petit deuil). Jet accessories black lace, some white can be worn. Outings permitted.
Third stage—6 months. Semi-mourning (demi deuil). Black, gray or mauve dress, almost normal social life can be resumed.

Claude Lévi-Strauss, Académie Française

The Two Faces of Red

If a language had only three words to name colors, they would be Red, White (Light), and Black (Dark). This elementary triangle, an almost universal foundation of the category of color, unites its two essential contrasts: the presence and absence of luminosity, and the presence and absence of tone. Of this last dimension, Red, because it is the most chromatic and most saturated, is the preeminent color.

Red's recognized superiority is such that, in numerous languages, the words describing its richest shades—for example, *cramoisi* (crimson), or *écarlate* (scarlet), in French—lends sumptuousness to any object. Red endows a sense of the brilliant, dazzling, magnificent, or, simply, beautiful. It is in this sense that the name of Moscow's Red Square should be understood. Until the seventeenth century, to say that someone was this or that *en cramoisi* ("in crimson") in old French meant that he or she possessed a character flaw, exaggerated to the n^{th} degree, which nothing could efface.

A flaw, and not a quality—because Red's eminent position in the system of colors does not always and everywhere give it a positive meaning. Many indigenous societies in Australia, Africa, and America associate Red at times with fertility and life, at others sterility and death—extreme states in both cases, but diametrically opposed.

Specialists of the European Middle Ages point out that knights in *vermeil* ("vermilion") —that is to say, Red—equipment and armor, who often figured in medieval epics, were diabolical figures who came from another world to fight and kill the hero. At the same time, Red's negative connotations, as the color of executioners and prostitutes ("scarlet women" in England, "red lights" at the door of brothels in France), did nothing to deter the Catholic Church from assigning shades of red, purple, and violet to mark the highest degrees of its hierarchy.

In his *Treatise on Color,* Goethe correctly insisted on the ambivalence of Red—the most elevated of all, in his estimation, but which, as a pigment, could lead toward More or Less: "Thus the dignity of age and the gentleness of youth can wear the same color."

The history of the red flag illustrates this ambivalence in another manner. It appears at the beginning of the French Revolution, announcing the intervention of public forces to disperse seditious crowds. A few years later, it took on the opposite meaning.

More recently, towards the middle of the nineteenth century, the romantic Parisian poets, upon visiting the southwest of France near the Spanish border, were shocked by traditional Basque houses, whose red shutters, timbers, and beams gave them a "bloody" and "barbaric" look. On the contrary, as I can personally testify, contemporary visitors to Japan have been surprised and charmed by the red humpback bridges in its parks and gardens. As with the *obi,* whose colors contrast with those of the kimono it encircles, this audacious contrast with the surrounding greenery, gay, seductive, and uncommon for us, has widened our aesthetic sensibilities. I have no doubt that among our architects and designers, this experience inspired the use, inconceivable only fifty years ago, of a range of vivid colors for the decoration of the interiors of our public spaces and transports. As proof, France's newest trains were significantly named *corail* (coral), a shade of red. Among many other such debts, this may be the latest we owe to Japanese taste.

Translated by Chul R. Kim

By Lourdes M. Font, Ph.D.
Dreaming in Color: Form and Structure in *Fashion in Colors*

Fashion in Colors superbly demonstrates the benefits of isolating a single element of fashion, deliberately setting aside the typical curatorial concern with establishing a chronicle of fashion change. A conventional narrative presentation of Western fashions spanning more than three centuries would naturally tend to emphasize the evolution of form or silhouette. But as The Kyoto Costume Institute's Chief Curator Akiko Fukai states in her essay, in this exhibition and book, "Clothes have been liberated from their historical contexts so that they might reveal the basic element of color."[1] These costumes, stripped of historical context, open our eyes to a new understanding of the relation of color to form. The pure pleasure of feasting our eyes on color results in the realization that color is often the most important element in fashion design. In *Fashion in Colors*, we discover many examples of clothes, from the eighteenth century to the present, in which form and structure are designed to display color, pattern, and texture to best advantage.

The Eighteenth Century

The relation of form to color is evident in the book's four eighteenth-century *robes à la française* (Nos. 32, 58, 67, and 68), all meant to be worn over corset and pannier. The form of this quintessential eighteenth-century dress, once it had evolved by the 1730s, remained remarkably stable for decades. One *robe à la française* was made very much like another: The dress was usually open in the front over a petticoat; at the back, a full width of fabric was box-pleated on either side of a central seam. Even the tiered sleeve ruffles seen in Nos. 32 and 67 were part of the formula that most *robes à la française* adhered to. In both France and England, government regulation of the clothing industries and the traditional practices of dressmaking encouraged this fundamental conservatism.[2] The situation in the respective textile industries, however, was completely different. In France, the state-supported silk-weaving industry had long been subject to laws mandating novelty in design. Due to conventions imposed upon them in the seventeenth century by Louis XIV's Finance Minister Jean-Baptiste Colbert, at the start of the eighteenth century, the silk weavers of Lyon introduced new colors and patterns in dress silks every year; by the middle of the century, the pace had quickened to every season.[3] The form of the *robe à la française*—indeed, its raison d'être—was to display the colorful pattern of the silk, the main bearer of fashion news. The ribbon of fur meandering around the bouquets of No. 32, for example, was the novelty that made this *robe à la française* stand out in a crowd of floral brocades in 1760.[4] Like the cut and construction of the dress, the understructure ensured that the textile's fashion message was clearly articulated, even at a distance. Two unbroken widths were displayed down the wearer's back, and, supported by the pannier, two more widths were spread out on either side. The contributions of corset-maker, pannier-maker, and *couturière*, however, were minor; the *robe à la française* was designed to showcase the art of the textile designer.

Another eighteenth-century dress, the *robe à la polonaise,* was an informal walking dress with a fitted back and a skirt gathered up to form three puffy swags. A comparison of the striped silk polonaise (No. 71) to the striped cotton *robe redingote*, or coatdress (No. 70), reveals the dramatic change in the fashionable silhouette between 1780 and 1810.

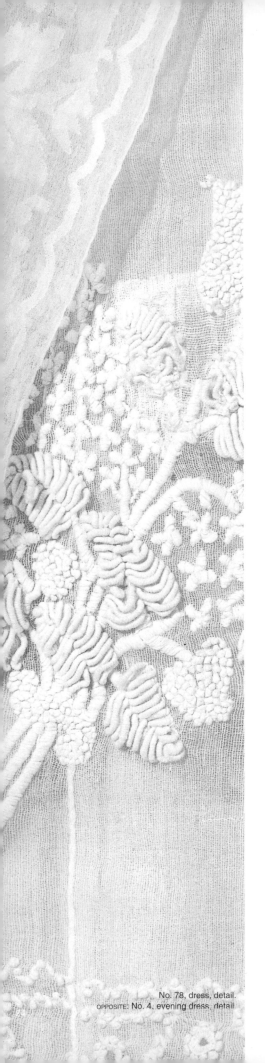

The similarity of the textiles' color and pattern heightens the contrast in form.

The Nineteenth Century

As the nineteenth century began, the corset and pannier—like sumptuous brocaded silks, symbols of the *ancien régime,* the political system which died in France after the Revolution—had disappeared from fashion. The Revolution's desire for a *tabula rasa,* pointed out by Akiko Fukai,[5] affected both the form and the color of women's dresses. The one-piece "round gowns" in white cotton seen in the White section (Nos. 74, 76, 77, and 78) had new proportions, with high waistlines and various ingenious necklines incorporating fall-fronts, surplice wraps, and gathered drawstrings. Less apparent was their structural continuity with the past, but it can be seen in their narrow backs, curving sleeves, and the tendency to concentrate skirt fullness at the center back. Moreover, brightly colored silks did not cease to exist during this period despite the dominance of white cotton, and in these dresses (Nos. 57, 73) the chromatic legacy of the eighteenth century was preserved. As we move from the Red & Yellow to the White sections of *Fashion in Colors,* we observe the power of color to transform style in fashion. While structurally very similar, a white cotton "round gown" was a neoclassical tribute to antiquity; one in red silk brocade heralded the Renaissance revival of the Romantics.

Fashion in Colors allows us to follow this evolution. Approximately twenty years separate the two yellow silk day dresses (Nos. 72, 73) in the Red & Yellow section; the later of the two once again required supportive infrastructure to achieve the fashionable ideal. A corset of corded cotton shaped the waistline, now back at the natural level, and at least one petticoat supported the increasing width of skirts. The desire for narrow waistlines and full skirts culminated in the 1850s, with multiple tiers of flounces on the exterior of skirts (Nos. 43 and 44) supported by layers of petticoats beneath. The cage crinoline, a petticoat of flexible steel hoops, replaced the layered petticoats around 1855. To achieve a closer fit, most dresses were made as separate bodices and skirts, like the mauve silk taffeta day dress (No. 51) in the Blue section. One of the first modifications to the fashionable silhouette attributed to Charles Frederick Worth (1825–1895), the founder of modern haute couture, was the introduction of gored skirts, which achieved fullness at the hem without adding bulk at the waist[6] (No. 15).

Worth would also claim credit for the gradual collapse of the cage crinoline at the end of the 1860s, and its eventual transformation into a bustle[7] (No. 61). With a corset stiffened with steel to mold the torso into the ideal hourglass, the bustle supported dresses that were richly sculptural arrangements of puffs and swags (Nos. 11, 50, 52) reminiscent of the polonaise. These dresses with separate bodices and skirts are structurally less complex than they appear. The skirts are often made in two layers—a long, pleated or gathered under-skirt and an over-skirt that drapes front to back like an apron (as in No. 50). Typically, both layers were cut in fairly straight panels; rows of gathering stitches and/or ties hidden in the interior created the puffs on the exterior. The dresses from this period in *Fashion in Colors* display a striking harmony between color and form. The mauve silk taffeta (No. 50) is as exuberant in form as it is in color, whereas the black silk taffeta (No.

11) is a less extreme version of this silhouette. The most extreme, representing the effect of the bustle at its widest circa 1885, is the bright red printed cotton, No. 60.

The last fashionable silhouette of the nineteenth century was based upon the new S-shaped corset, introduced in about 1900, nearly a decade after the final waning of the bustle.[8] The structure of this corset created a curvilinear silhouette emphasized by the swirling skirts of the diaphanous dresses worn over it. In *Fashion in Colors,* these dresses appear at either end of the spectrum—in Black (No. 13) and White (Nos. 79, 80). Once again, one is struck by the difference that the element of color makes to our perception of form. In Black, the graceful curves of the general silhouette are emphasized; in White, the eye gets lost in the surface richness of delicate materials.

The Twentieth Century

The abolition of the corset was the common goal of several early twentieth-century designers represented in *Fashion in Colors*. Mariano Fortuny's famous *Delphos* dress (No. 64, shown under a caftan), first created in 1909, was meant to be worn without a corset. The *Delphos* dress was made of full widths of silk joined together in straight, vertical seams. The silk was so tightly pleated that the seams were difficult to detect, and so lightweight that the glass beads threaded through silk cord at the side seams were not just decorative, but necessary to weigh the garment down, as in the draped costume of the ancient Greeks.[9] Worn as Fortuny intended, the rippling pleats of the dress expand and contract, revealing every contour of the uncorseted body; without the body, the *Delphos* dress shrinks to a narrow coil of luminous color.

Austerity of color and apparently simple forms are joined in the dresses from the 1920s in *Fashion in Colors*. As we have come to expect, Gabrielle Chanel's "little black dresses" (Nos. 7-8) look deceptively simple at a distance; at close range, we perceive the complexity of cut which ensures their perfect proportions. Her silk chiffon dress in white (No. 82) shares with Madeleine Vionnet's dress (No. 83) a gossamer lightness as well as color and material. An evening gown in black from 1932 (No. 3) reveals Vionnet's full mastery of the bias-cut. The modernity of these dresses, whether black or white, lay in a fundamentally new way of relating to the body. They rested upon the shoulders and flowed easily over the hard, spare body of the twentieth-century woman.

The structural principles of modern architecture, first seen in fashion in the steel skeleton of the nineteenth century's cage crinoline, were fully articulated in Vionnet's 1939 evening gown (No. 4). The form of this dress is created by the tension between its materials—gold lamé tape arranged in concentric circles, with an overlayer of gathered tulle creating a literal "curtain wall." The transparency of the tulle allows us to see the underlayer of gold lamé, and the black velvet halter strap reminds us that, despite the stiffness of tape and tulle, the dress hangs upon the body.

The fashions of the mid-twentieth century, when Christian Dior and others revived the structures and silhouettes of the nineteenth century, represented an interesting contrast. Dior's silk taffeta cocktail dress (No. 45) has a strapless bodice supported by an inner corset, and the full tiered skirt echoes the longer version of a century earlier (No. 44), also

seen in Blue. Balenciaga, however, remained true to modernist principles, and relied upon the properties of materials to create his sculptural effects (No. 46). Within a single section of the exhibition and book, *Fashion in Colors* has made these complex formal relationships immediately visible.

In the Multicolor section, it is equally clear that the sleeveless A-line shifts of the 1960s (Nos. 24 and 26) provided an ideal field for the display of color and pattern. Like the eighteenth-century *robe à la française* it resembles in reduced form, once established, the basic silhouette remained stable, only growing shorter as the decade advanced.[10] Color and form were also complementary in the work of the most exciting designers of the 1980s. The silhouettes proposed by Rei Kawakubo (No. 18), Azzedine Alaïa (No. 19), and Jean-Paul Gaultier (No. 20) were even stronger statements because they were expressed in black.

One of the greatest pleasures offered by *Fashion in Colors* is the opportunity to observe the constant dialogue maintained by contemporary designers with the past even as they explore new paths to the future. In White, we can appreciate how Chanel would have loved the "little white dresses" of Rei Kawakubo (Nos. 85 and 86). In Black, we can imagine that Balenciaga would have recognized the homage to his repetition of forms (No. 2 and No. 5) paid by Viktor & Rolf (No. 1). Freedom from historical context allows us to see the relationship between the floral-patterned silk *robe à la française* (No. 32) in Multicolor and Junya Watanabe's polyester organdy dress (No. 36), in which the texture of the contemporary material creates a form that vaguely recalls the past. Like our attraction to color, the relationship between present and past in fashion design is instinctive. The forms of the fashions of the past are remembered not consciously, but as if in a dream.

At the heart of *Fashion in Colors,* in the Blue section, which represents universality, a "celestial blue" mantua from 1740 shares a serene beauty with Viktor & Rolf's "chroma-key blue" ensemble from 2002. As the "Bluescreen" fashion show dramatized, and now *Fashion in Colors* demonstrates, all fashions offer an invitation to dream.

Notes

1. Akiko Fukai, "The Colors of a Period as the Embodiment of Dreams," *Fashion in Colors* (this catalogue), p. 19.
2. See Jacques Anquetil and Pascale Ballesteros, *Silk,* trans. Louise Guiney. Flammarion, 1995, p. 99-102.
3. Aileen Ribeiro, *Dress in Eighteenth Century Europe,* Batsford, 1984, p. 48.
4. Musée des Tissus de Lyon, *Guide des Collections,* Editions Lyonnaises, 2001, p. 187.
5. Akiko Fukai, "The Colors of a Period as the Embodiment of Dreams," *Fashion in Colors* (this catalogue), p. 14.
6. See the Maison Worth sketches dated 1865 compared to earlier fashion plates in Elizabeth Ann Coleman, *The Opulent Era: Fashions of Worth, Doucet and Pingat.* Thames & Hudson and The Brooklyn Museum, 1989, pp. 64.
7. Coleman, p. 47.
8. Valerie Steele, *The Corset: A Cultural History.* Yale University Press, 2001, p. 84.
9. Anne-Marie Deschodt and Doretta Davanzo Poli, Fortuny, trans. Anthony Roberts, Abrams, 2001, pp. 171-175.
10. See Joel Lobenthal, *Radical Rags: Fashions of the Sixties,* Abbeville Press, 1990.

Azzedine Alaïa (b. 1940)

Azzedine Alaïa gained recognition in the 1980s for his body-conscious designs that fit the female form like a second skin. Alaïa uses leather as if it were a stretch fabric, with curved seams placed according to the contours of the body.

Born in Tunisia, Alaïa studied art at the École des Beaux Arts in Tunis. In 1957, he moved to Paris, where he worked at the houses of Christian Dior, Guy Laroche, and Thierry Mugler before starting his own label in 1981. His trendsetting work drew much attention for its radical use of leather and jersey, and for its many zippers. He also experimented with the many stretch materials being developed at the time, creating streamlined dresses, miniskirts, and bodysuits.

Alaïa uses fabric in black, navy, or other dark colors to emphasize the silhouette in his designs. He also utilizes colors that seem to merge with the skin, such as beige and brown. White is used in a unique way to make suntanned skin stand out. Alaïa pursues minimalism in color and form in order to express the beauty of the female body, and as a result every garment is monochromatic. His approach can be compared to that of Madeleine Vionnet, who pioneered body-conscious bias-cut dressing.

In the early 1990s, Alaïa stopped participating in the Paris ready-to-wear collections, but has continued to create in his residence-atelier in the Marais quarter of the city. In 1998, he startled the fashion world by designing for Tati, a French discount chain. He is now in partnership with the Prada group, which has decided to support all his activities and established the Alaïa Foundation. His work under the Prada umbrella continues to make headlines.

Cristobal Balenciaga (1895–1972)

Cristobal Balenciaga was a master of cut, construction, and color, whose design aesthetic was ruled by proportion and the architecture of tailoring. Christian Dior, his contemporary, said he was "the master of us all."

The son of a dressmaker in provincial Spain, Balenciaga was interested in fashion from an early age. His career began as a teenager, when he met the Marquesa Casa-Torrès, who commissioned him to copy one of her couture suits. In 1916, he opened his first shop in San Sebastian, followed by two others in Barcelona and Madrid. Fleeing the Spanish Civil War, he moved to Paris, where he set up his couture house in 1937. He closed his house in 1968 and retired to Spain. He died there in 1972.

Balenciaga was a leading figure in the golden age of haute couture in the 1950s. He introduced the loose chemise dress, also known as the sack, in 1956, a style which anticipated the A-line shifts of the 1960s. Balenciaga used textiles with a deep understanding of their properties so that he could create abstract three-dimensional forms without much understructure. Like Vionnet he used the bias-cut, but more often in combination with the straight grain.

Balenciaga's creations are recognizable for his inspired cut and use of color. He preferred black, brown, and other subdued colors, like those found in garments featured in paintings by the Spanish painters Francisco de Goya and Diego Velázquez. He also skillfully used pink, yellow, and green, combined with black and other colors reminiscent of traditional matador costumes. His use of black was particularly striking;

he created lustrous and infinitely deep blacks, and knew how to use its richness to reveal different expressions according to the light and the texture of his chosen materials.

Gabrielle Chanel (1883–1971)
Gabrielle "Coco" Chanel is remembered as one of the most influential fashion designers of the twentieth century, who shared with other women the practical, comfortable, and elegant clothes she devised for herself as a modern woman. Although she was not the only designer to create such classics of modern fashion as wool jersey sportswear or the "little black dress," Chanel forged the most memorable image of herself—an image indelibly stamped upon the history of fashion and inseparable from her work.

Chanel was born the daughter of an itinerant peddler in rural France, who placed her in an orphanage when she was twelve years old. The austere life of the orphanage, where she wore a plain black dress with a white collar, is at the heart of Chanel style. Her career in fashion began as a milliner around 1909. In 1913, she opened a shop in the resort town of Deauville. By 1915, she had established her reputation with easy-fitting suits made of wool jersey, a cheap material formerly used only for men's underwear. In 1919, Chanel opened her Paris house at 31, rue Cambon, and solidified and built upon her success through the 1920s and 1930s. She closed her couture house during World War II, and did not reopen until 1954, at the age of seventy-one. Thus began the start of her second, even more successful, career, when women responded to new versions of the Chanel suit made of soft tweeds in combinations of vivid pastels.

In her early work, Chanel mainly used achromatic colors such as black and white, or subdued colors such as navy and brown—color choices influenced by menswear. At the same time, however, she decorated these clothes with colorful costume jewelry reminiscent of Byzantine jewels, and in so doing, greatly enhanced the charms of both the clothes and the jewelry.

Christian Dior (1905–1957)
French couturier Christian Dior was best known for his debut collection, presented in February 1947, which featured sloping shoulders, corseted waists, and long, full skirts. Inspired by nostalgia for the nineteenth century, Dior's designs were nonetheless nicknamed the "New Look," and credited with helping to reestablish French haute couture as the leader of fashion in the postwar world.

Dior began his career as an art dealer before turning to fashion design for the houses of Robert Piguet and Lucien Lelong. In 1946, he was able to open his own couture house, with the backing of "Cotton King" Marcel Boussac. After producing the "New Look," Dior continued to experiment with silhouette, promoting the *Tulip, H, A,* and *Y* lines, before his death in 1957, at the age of fifty-two.

Dior's choice of fabric color was always calculated to harmonize with the season, as well as the skin tone and hair color of the model who would wear the dress. Although Dior worked from a basic palette of black, white, and navy blue, he also introduced new colors for particular collections, and selected typically 1950s colors such as light blue and his own "Dior pink."

Domenico Dolce (b. 1958)
Stefano Gabbana (b. 1962)

Domenico Dolce and Stefano Gabbana are best known for their sexy, provocative sportswear and body-conscious dresses, mixtures of colorful silkscreen prints, and stylishly tailored suits. Many of their designs incorporate elements of underwear, such as garter belts and bra straps, as outerwear.

Dolce and Gabbana established their brand in 1985, showing their first collection during Milan's fashion week. Together, they have presented men's collections since 1990, and a second line, D&G, since 1994.

Dolce and Gabbana use lustrous, rich colors such as yellow, orange, green, and blue, boldly mixing them with leopard and floral prints. These colors reflect their Italian heritage and Mediterranean sense of optimism. In contrast, they sometimes use quiet and sophisticated colors such as navy, camel, white, or dark brown for their beautifully tailored pantsuits. Black is also a favorite for cocktail and evening dresses. Even with these subdued colors, Dolce and Gabbana's designs always provoke a reaction.

Mariano Fortuny (1871–1949)

Mariano Fortuny y Madrazo is known for his mastery of varied textile techniques, including stenciling, bath-dyeing, shrinking, printing, and pleating, which were inseparable from his clothing designs. In 1906, he began creating textiles and clothes on which he stenciled motifs in gold and silver from the Middle Ages, the Renaissance, and the Orient. His 1907 *Delphos* dress, inspired by the costume of the ancient Greeks, was made of Japanese or Chinese silk pleated using a secret process. These dresses were extremely modern in the way their pleated folds revealed the body.

Fortuny was born in Spain and was named after his father, a painter; he moved to Venice in 1889. By the beginning of the twentieth century, he was using his talents in a range of activities, including painting, photography, and stage and costume design. Fortuny's sense of color was based on his abundant knowledge of ancient dyeing methods. He used mainly natural dyes, and created a rich variety of colors. In his novel series *In Search of Lost Time,* French writer Marcel Proust often mentioned the rich colors, including red, blue, green, and brown, created by Fortuny; a rose color was described as Tiepolo pink after the color used by the painter, and an intense blue was compared with the azure of the Grand Canal.

In his *Delphos* dresses, Fortuny deepened the appearance of the colors by using tiny pleats to create a shimmering effect as the wearer moved. He also doubled and layered colors. His stencil-printed designs were created in shades from green, pink, or pale yellow to muted gold and silver.

John Galliano (b. 1960)

John Galliano is known for taking elements from many sources of inspiration, then cutting, deconstructing, and reconstructing them. His sources have included the cage crinoline and bustle silhouettes of the nineteenth century, Shanghai of the 1930s, the long-necked hill tribes of Thailand, and high-school girls in contemporary Japan. Exotic, glamorous, gorgeous, spectacular, and eccentric are some of the

words used to describe Galliano's designs. The theme of each of his collections is thoroughly researched and developed in his imagination. While his methods of design and presentation employ the usual techniques of the fashion industry, his extreme, sophisticated implementation is unrivaled.

An Englishman born in Gibraltar in 1960, Galliano was already attracting a great deal of attention with his 1984 graduation collection, *Les Incroyables,* at St. Martin's School of Art, London. He moved to Paris in 1991. The LVMH Moët Hennessy-Louis Vuitton group gave him the prestigious role of designer for Givenchy from July 1995 through January 1997, and for Christian Dior from the spring/summer of 1997. He is currently designing both haute couture and *prêt-à-porter* for Christian Dior, while also maintaining his own label. Galliano benefits from the resources of the couture ateliers of Dior, which can execute his eclectic fantasies at the highest level of workmanship.

One of the first things to strike the viewer of a Galliano collection is that his designs are full of color. All elements, including shoes, accessories, make-up, and even the design and lighting of the stage are strong expressions of color, fused together in a subtle balance to create a multi-layered visual effect.

Jean-Paul Gaultier (b. 1952)

Jean-Paul Gaultier's creative method can best be summarized with the word "remix." Undaunted by the conventional boundaries between regions, times, and genders, he appropriates disparate elements in fashion and unites them in unexpected ways.

Born in France, Gaultier presented his first *prêt-à-porter* collection in Paris in 1976 after working at Pierre Cardin and Jean Patou. He launched his men's collection in 1984 and presented his first haute-couture collection in 1997. He has been a member of the Chambre Syndicale de la Couture Parisienne since 1999. In recent seasons, Gaultier has also been designing ready-to-wear for Hermès.

Classic examples of the Gaultier style are the corset-like bustier (spring/summer 1982) worn by Madonna under a meticulously tailored pin-stripe suit. This radical approach to fashion also applies to Gaultier's use of color. He rarely uses primary colors, preferring instead highly saturated deep hues. Influenced by history and the traditional costumes of many cultures, he creates a new kind of multicultural fashion, and uses symbols of traditional French sportswear like the striped *marinière* and black beret in witty and irreverent ways.

Viktor Horsting (b. 1969)
Rolf Snoeren (b. 1969)

Viktor Horsting was born in Israel, Rolf Snoeren in the Netherlands. They both majored in fashion design at the Arnhem Academy of Art in the Netherlands, beginning in 1988. After obtaining their diplomas in 1993, they participated in the Festival of Young Fashion Designers at Hyères in the south of France under the name Viktor & Rolf, winning the Mayor of Hyères' prize for best designer, as well as prizes for each of the three main categories. They presented their first collection in Paris the following year. They launched their haute-couture collection in spring/summer 1998, and have been presenting *prêt-à-porter* collections since autumn/winter 2000.

Viktor & Rolf's conceptual style is also found in their use of colors. This was especially noticeable in the three consecutive collections starting from autumn/winter 2001, which were each based upon a single color: black, white, and blue. The color most representative of that season's concept was chosen and presented using unique, exaggerated forms and unexpected stage effects. For Viktor & Rolf, color is as valuable as form and presentation.

Rei Kawakubo (b. 1942)

Rei Kawakubo is best known for her achromatic and deconstructed clothes, which burst upon the international fashion scene in the early 1980s as a challenge to the conventional Western fashion system. Her method of creating clothes exerted a great influence on the generation of designers who emerged in the 1990s.

Born in Tokyo, Kawakubo graduated from Keio University. She worked as a stylist in the advertising industry before launching her own label in 1969. In 1975, she presented her first collection under the label Comme des Garçons, and made her Paris debut in 1981. At the spring/summer Paris collections in 1983, she presented her "rag-picker" look, which caused a global sensation. Throughout the 1980s, Kawakubo's color palette was dominated by white, gray, and black, plus beige and navy. The theme of "darkness" was omnipresent in her creations. Along with Yohji Yamamoto, she made black fashionable; her black-clad followers stood out so much in Japan they were popularly known as "the crows."

Kawakubo's use of black in the 1980s was so influential that she is still associated with the color. However, since she launched her red autumn/winter 1988 collection, black has nearly disappeared from her work. Moreover, Kawakubo's color choices and combinations are at once radical and harmonious; she seems to have established her own chromatic sensibility. Kawakubo returns to black periodically. For her, black may not be just achromatic, but a "color" in its own right.

Issey Miyake (b. 1938)

The key to Issey Miyake's work is his concern for materials and the processes of production. From the beginning of his career, Miyake has always updated traditional Japanese fabrics such as linen and cotton while also exploring new materials. His *Pleats Please* series, garments made of high-quality, permanently pleated polyester, has been his most accessible and successful work. One of the first Japanese designers to emerge on the international fashion scene, Miyake is characterized by a spirit of innovation and an eagerness to collaborate with other designers and artists. His work is admired all over the world.

Issey Miyake was born in Hiroshima, Japan, and majored in graphic design at Tama University. He graduated in 1964, and in 1965, he went to Paris, where he spent one year studying dressmaking and tailoring at l'Ecole de la Chambre Syndicale de la Couture. By 1966, he was an apprentice with Guy Laroche, and two years later, he was an assistant to Givenchy. After witnessing the student demonstrations in Paris in May 1968, Miyake began to reconsider his plans for a career in haute couture. In 1969, he traveled to New York and spent a year working with Geoffrey Beene, before returning to Tokyo in 1970 and founding the Miyake Design Studio. He presented his first collections in New York in

1971 and in Paris in 1972, followed by the collection *A Piece of Cloth* in Tokyo in 1976.

Miyake has often used natural colors, employing traditional Japanese dyeing methods such as indigo and mud dyeing. He dyes cotton and other natural fibers navy or brown, and these "unsophisticated" colors act to emphasize the qualities of the materials. He has also made many pieces in ethnic colors inspired by African and Asian cultures. At the other end of the spectrum, the *Pleats Please* series uses vivid, clear colors obtained by new materials and dyes, and has included impressive prints in a wide range of fluorescent colors. In Miyake's designs, colors shake, overlap, and mix as the wearer moves.

Robert Piguet (1901–1953)

Robert Piguet had a successful career as a couturier that spanned nearly twenty years. He was celebrated for his chic, romantic clothes and feminine perfumes, but he is best known for giving Christian Dior his first job in fashion.

Born in Switzerland, Piguet originally trained to become a banker. In 1918, he went to Paris, where he worked for John Redfern and Paul Poiret before establishing his own couture house in 1933. He was active throughout the 1930s and 1940s, creating slim suits and romantic dresses. He was close to many contemporary writers and artists, and his friendships nurtured a refined and unusual sense of color that he put to good use in his elegant and sophisticated creations. In 1938, soon after he hired Christian Dior to work as an assistant designer, Piguet opened a new couture salon on the rue de Cirque, with thick black carpets, dark brown satin chairs, and mirrored walls. This interior contrasted with the spartan design studio where Piguet and his assistants, who would also include Hubert de Givenchy and James Galanos, worked at a plain wooden cutting table. Piguet was also known for his designs for the theatre and his theatrical fashion shows and advertising. Illness forced Piguet to close his house in 1951; he died in Switzerland in 1953.

Emilio Pucci (1914–1992)

Emilio Pucci de Barsento was known as "the Prince of Prints" for his brightly colored printed textiles, used for stylish sportswear in the 1950s and a wider array of garments and accessories in the 1960s.

Pucci was born in Naples, Italy, and studied at the University of Milan and in the United States, where he received a master's degree in social sciences before returning to Italy and earning a doctorate in political science from the University of Florence. An avid skier, he became involved with the fashion industry when his skiwear designs were published in *Harper's Bazaar* in 1947, resulting in a contract to design skiwear for the American department store Lord & Taylor. Pucci presented his first collection in spring/summer 1948, and opened his house in Florence. His sporty and casual clothes were highly valued, especially in the American market.

Pucci incorporated his original bright colors into patterns influenced by Pop and psychedelic art, or mosaic patterns influenced by traditional Italian design. By 1960, the "Pucci print" was celebrated throughout the world. Each pattern was always signed "Emilio" to avoid confusion with imitations. His motifs were printed on light materials that did not

wrinkle easily and were convenient to travel with, such as silk georgette, tricot, and crêpe de Chine. A wide range of sporty, chic resort wear, including hostess dresses called Palazzo pajamas and Capri pants, were made in the prints. The luxurious casual wear spread as a typical Italian style, and was especially popular with fashion leader Jacqueline Kennedy Onassis, movie star Elizabeth Taylor, and other jetsetters who traveled freely around the world.

After achromatic colors and minimalism came to dominate fashion, vivid colors and patterns underwent a revival in the 1990s, focusing attention again on Pucci's bright prints and unique creative style.

Yves Saint Laurent (b. 1936)

Yves Saint Laurent will be remembered for his prolific forty-year career, during which he mastered many different styles and created a body of work which places him among the greatest designers of the century. His *Rich Peasant* collection of 1976 will also be remembered as an event that brought haute couture out of a period of crisis, making it relevant again and sustaining it for a generation.

A Frenchman born in Algeria, Yves Saint Laurent studied in Paris and, in 1955, won first prize for a cocktail dress in a contest sponsored by the Wool Secretariat. Soon after, he was hired by the house of Christian Dior. When Dior died suddenly in 1957, Saint Laurent was thrust into the spotlight when he took over the house at the age of twenty-one. He founded his own house in 1961, and presented graphic works in vivid colors for the *Mondrian Look* of autumn/winter 1965 and *Pop Art* of autumn/winter 1966. He adopted ethnic styles from Africa and other parts of the world, and gave women new alternatives to the traditional suit such as the "safari suit," the "smoking" tuxedo for evening, and other variations on the pantsuit. Saint Laurent was one of the first couturiers of his generation to launch a full-fledged ready-to-wear line, *Rive Gauche,* in 1966. From the end of the 1970s, Saint Laurent paid tribute to artists including Pablo Picasso, Jean Cocteau, Henri Matisse, and Vincent van Gogh. He retired after presenting his last haute-couture collection in spring/summer 2002.

Saint Laurent's sense of color was unrivaled, and he manipulated colors with boldness and delicacy. He created complex color combinations that looked as if they occurred naturally, such as bright red with light blue, teal, chartreuse, and plum. His palette was enriched by his memories of his native Oran on the Mediterranean Sea, and especially by his encounter with the ethnic culture of Marrakech. Oran was a cosmopolitan city where merchants gathered from different regions, while Marrakech was full of the colors of the Orient. Saint Laurent would leave Paris after each collection to find inspiration in foreign culture and art. His experiences abroad gave him fresh impressions and nurtured his sense of color.

Elsa Schiaparelli (1890–1973)

The influence of the visual arts is clear in much of Elsa Schiaparelli's work. Her personal friends included Salvador Dalí, Jean Cocteau, Francis Picabia, Jean Béraud, and other artists. She often produced designs in collaboration with them, and enthusiastically incorporated artistic elements into her fashions, especially her unique accessories. She also adopted synthetic materials which had just gone into production,

creating experimental pieces with molded plastics and cellophane—an approach that can be compared to the methods of the avant-garde artists of her time.

Born in Rome, Schiaparelli began her career in sportswear in the 1920s. In 1927, she opened a shop, Pour le Sport (For Sports), in Paris. She first drew public attention with her design for a black sweater hand-knitted with a trompe-l'oeil white bow. Her couture house and boutique opened on the Place Vendôme in 1935, but during World War II she took refuge in New York, returning to Paris in 1945. In 1954, she presented her last collection and spent the rest of her life in retirement.

Schiaparelli was drawn to bold colors. She was influenced by the painter Sonia Delaunay, who made rhythmic, colorful abstract paintings, as well as by the Fauvists and Surrealists. In her collections she promoted strong, vivid colors one after another, with a fuchsia named "shocking pink" recognized as her signature. She launched the perfume *Shocking,* named after the color, in 1937. Schiaparelli dared to dye even fur and zippers. She used colorful, delicate, and witty prints designed by illustrator Marcel Vertès and Dalí. Although Schiaparelli's creations did not deviate from traditional haute couture, she was interested in the transformation of established values. Her originality was particularly evident in her introduction of new colors.

Madeleine Vionnet (1876–1975)

Madeleine Vionnet is particularly known for her use of the bias-cut, which revolutionized dressmaking techniques in the 1920s and 1930s. With skillful cutting and sewing, she made beautiful dresses that show complete harmony between silhouette and construction. Vionnet designed by draping on a one-fifth-scale model mounted on a revolving platform, and her dresses relied on the shape of the human figure for their structure. Vionnet's work has continued to influence subsequent generations, who admire her as one of the greatest fashion designers of the twentieth century.

Born in France, Vionnet apprenticed as a seamstress at an early age. She worked at the houses of Callot Soeurs and Jacques Doucet, the leading couturiers of Paris at the end of the nineteenth century, then opened her own house on rue de Rivoli in Paris in 1912. She closed the house temporarily at the start of World War I, and moved to Rome, reopening again in 1918. The original clothes made with her innovative techniques were highly valued in the 1920s and 1930s. She closed her house in 1939.

Although Vionnet was not a colorist, her ultimate aim was to create harmony, and colors were an essential element in this. Vionnet was so particular about materials that she even changed her designs according to the fabric. Colors and materials were united inseparably in her creations, and she regarded the texture of a fabric as the garment's most beautiful decoration. Vionnet created color effects using the inherent texture of a fabric. For example, she juxtaposed two sides of satin-back crêpe (the lustrous and dull sides), and used velvet with the grain running in various directions, creating the illusion of a difference in color. She liked black, white, beige, soft pastels, and gradations of single colors. "To be simple is to include everything complicated," she said in a statement that may also summarize her preferences in color.

Junya Watanabe (b. 1961)

Junya Watanabe is known for his inspired use of synthetic fabrics to create original and unprecedented clothes that nonetheless have connections to history and to nature.

Watanabe was born in Tokyo and graduated from the Bunka School of Fashion in 1984, and joined Comme des Garçons soon after. He was in charge of Comme des Garçons Tricot from 1987 to 2002. He made his debut under the label Junya Watanabe Comme des Garçons at the Tokyo Collections in autumn/winter 1992, and at the Paris Collections in spring/summer 1993. Since then, he has continued to refine his cut and other techniques, continually exploring new ways to use materials. Watanabe has pursued new silhouettes that are impossible to create with natural fabrics, using ultra-thin polyester organdy and waterproof materials, and using heat instead of sewing to fasten multiple layers of fabric. On the other hand, he takes tweed, denim, and other traditional materials equally seriously, using the latest processing technologies in innovative ways.

Watanabe's use of color is also original. For example, contrasting colors appear when a zipper is opened and closed; polyester and acrylic are dyed in strong colors such as red, yellow, and blue. While he likes using bold colors, he also skillfully brings out the beauty of subdued colors on natural textiles. He is constantly in pursuit of the new, not only in cut and material but also in color. He launched his menswear label Junya Watanabe Comme des Garçons Man in 2001 and has been designing for Comme des Garçons Tricot Hommes with Rei Kawakubo since autumn/winter 2002. He also launched a womenswear label, Junya Watanabe Comme des Garçons Man Pink, in 2003.

Vivienne Westwood (b. 1941)

Vivienne Westwood is known for her punk influences. Inspired by historical garments, paintings, and literature, she interprets them in the punk style, destroying conventional uses and meanings. The sexy, avant-garde clothes she produces do not conform to contemporary trends towards easy-to-wear, functional fashion. She pursues her original concept of elegance, even occasionally forcing the body into bondage. She articulates the curves of the female body.

Born in England, Westwood opened a shop called Let It Rock in London with Malcolm McLaren in 1971. Their punk style, and the music of the Sex Pistols, produced by McLaren, led the way for contemporary street fashion, and articulated the rebellious nature of urban youth culture. Black, used as a color of protest, strengthened their style of torn T-shirts, leather jackets, and black make-up. In 1983, Westwood launched her own Vivienne Westwood label.

Westwood's sense of color is also unique. She uses subdued colors, clear checks, and the stripes of English menswear, or elegant pinks and blues reminiscent of Rococo paintings, and intelligently adopts various colors from different contexts, combining them according to her individual sense. The result is a contemporary feminine fashion which is wholly her own.

Yohji Yamamoto (b. 1943)

Yohji Yamamoto's designs, which arbitrarily leave clothes unfinished, express a very Japanese aesthetic. However, a review of his career

makes it clear that Yamamoto is positive about Western European fashion. He respects traditional tailoring, and brings his original sensitivity to familiar everyday clothes. He pays tribute to couturiers of the past, including Vionnet, Chanel, and Dior, and creates contemporary clothing inspired by their work; he has made oversize clothes with unfinished edges as a way of achieving this end. What he has denied is not tradition, but rather its inflexible aesthetics and constraints.

Yamamoto was born in Tokyo in 1943, and graduated from Keio University. He then studied at the Bunka School of Fashion. In 1973, he established his own company, and presented his first collections in Tokyo in 1977 and in Paris in 1981. Along with fellow Japanese designer Rei Kawakubo, he has startled Europe and the United States with his designs.

Since his design principle is to incorporate the essence of menswear in daily wear, Yamamoto is inevitably a frequent user of achromatic colors such as black. He uses red, yellow, and other vivid colors as accents to create a strong overall impression. His Yohji Yamamoto label showcases the elegance of black, while black's everyday qualities are left to his Y's label. Collaborating with Adidas in 1992, he also launched the Y-3 label, in which he expresses his clear and modern sense of color.

FASHION IN COLORS

BLA

C K

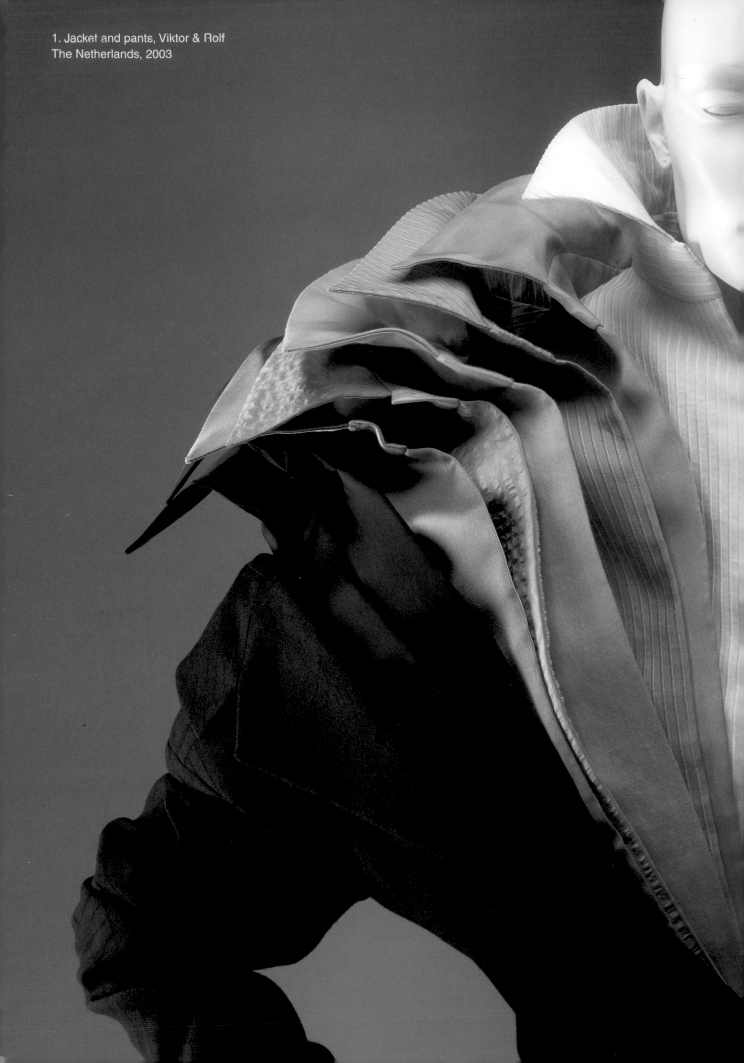

1. Jacket and pants, Viktor & Rolf
The Netherlands, 2003

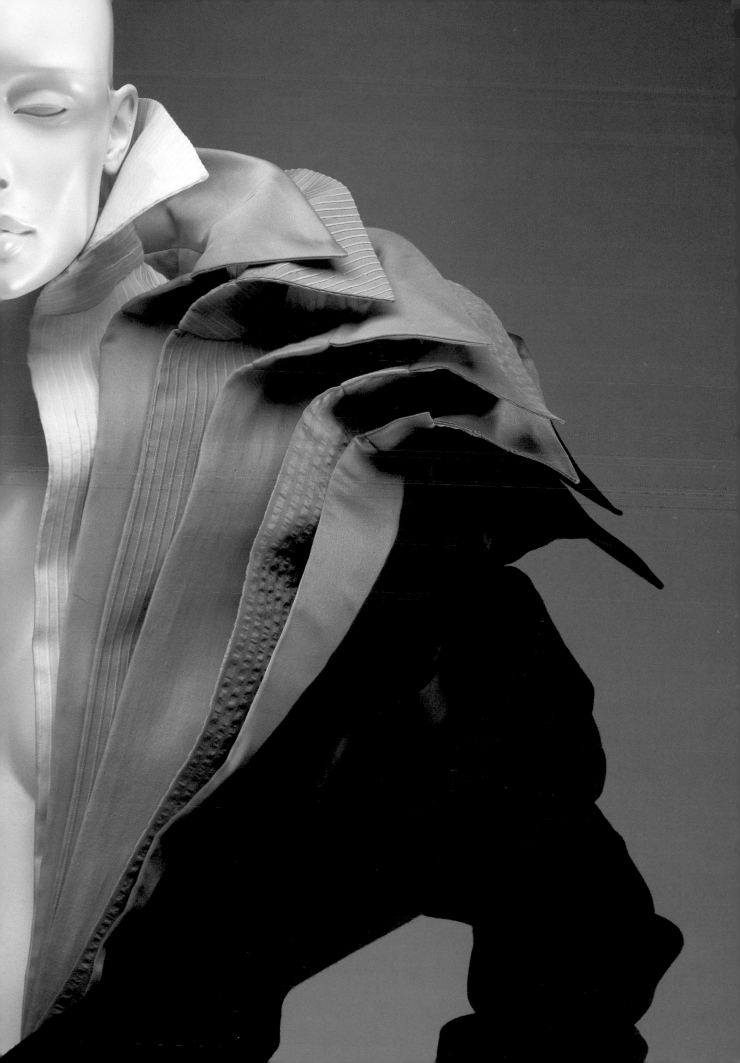

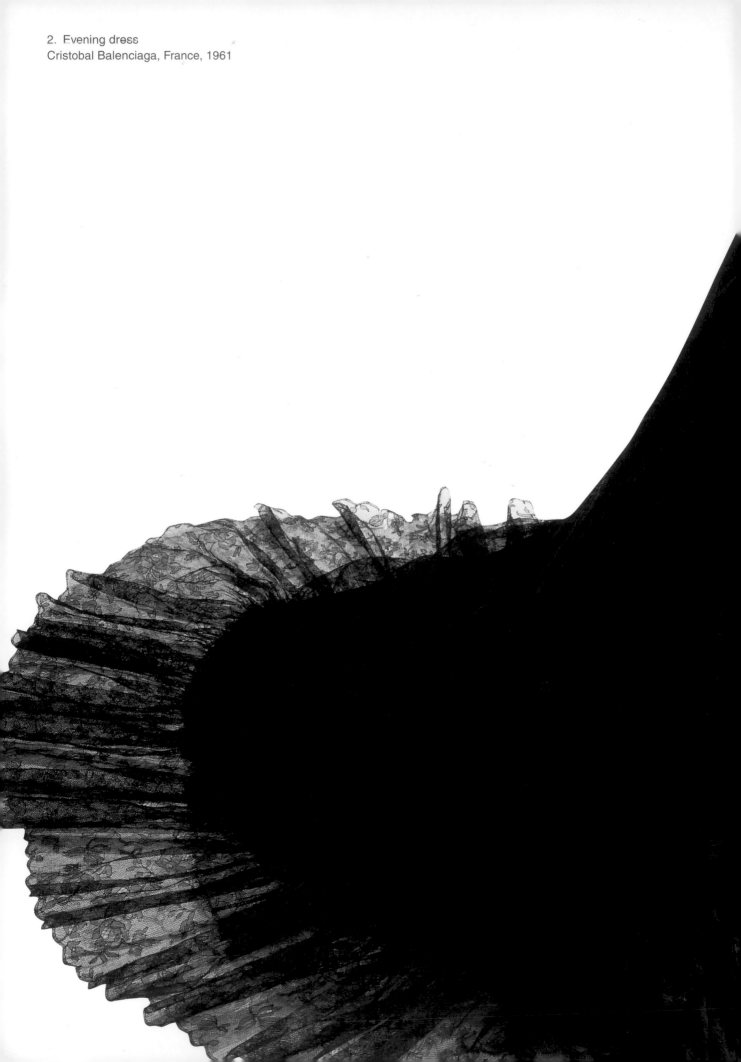

2. Evening dress
Cristobal Balenciaga, France, 1961

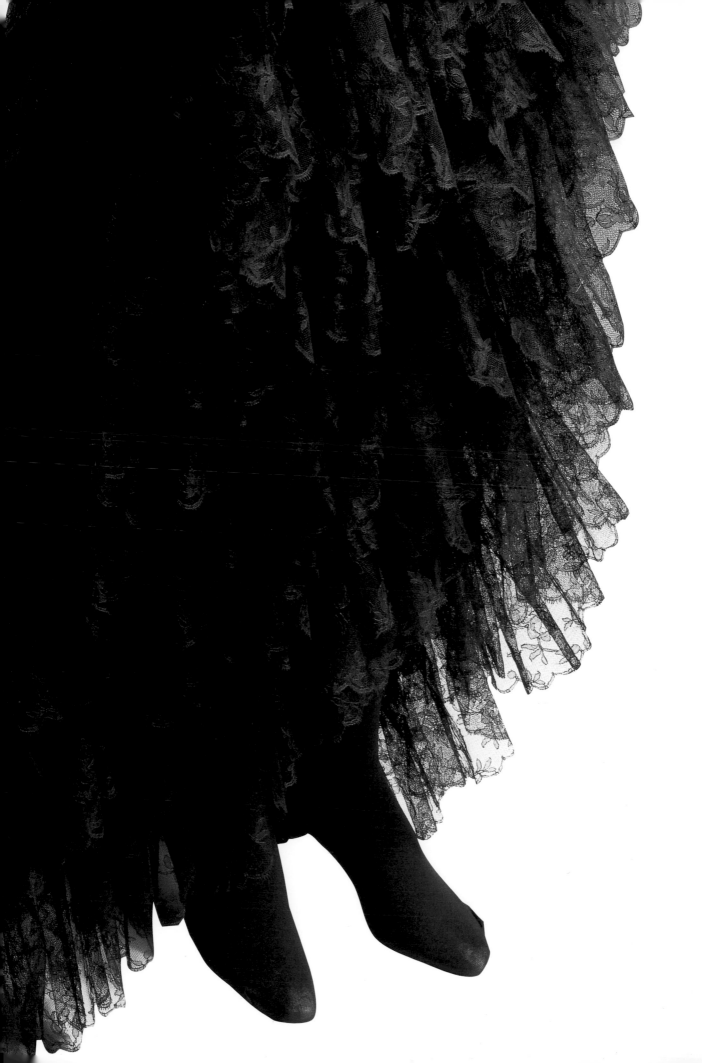

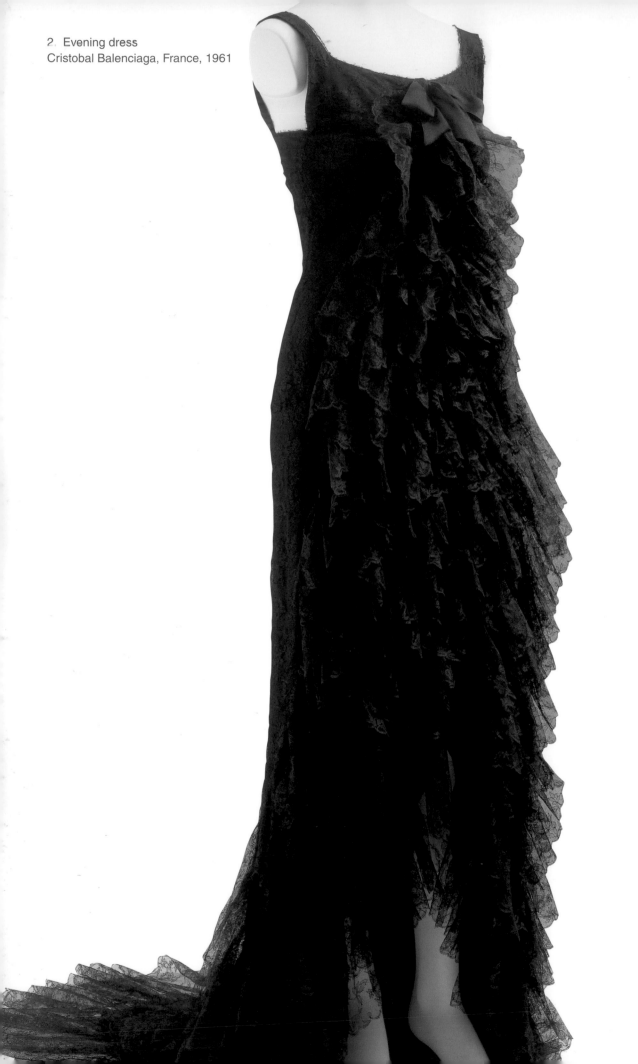

2. Evening dress
Cristobal Balenciaga, France, 1961

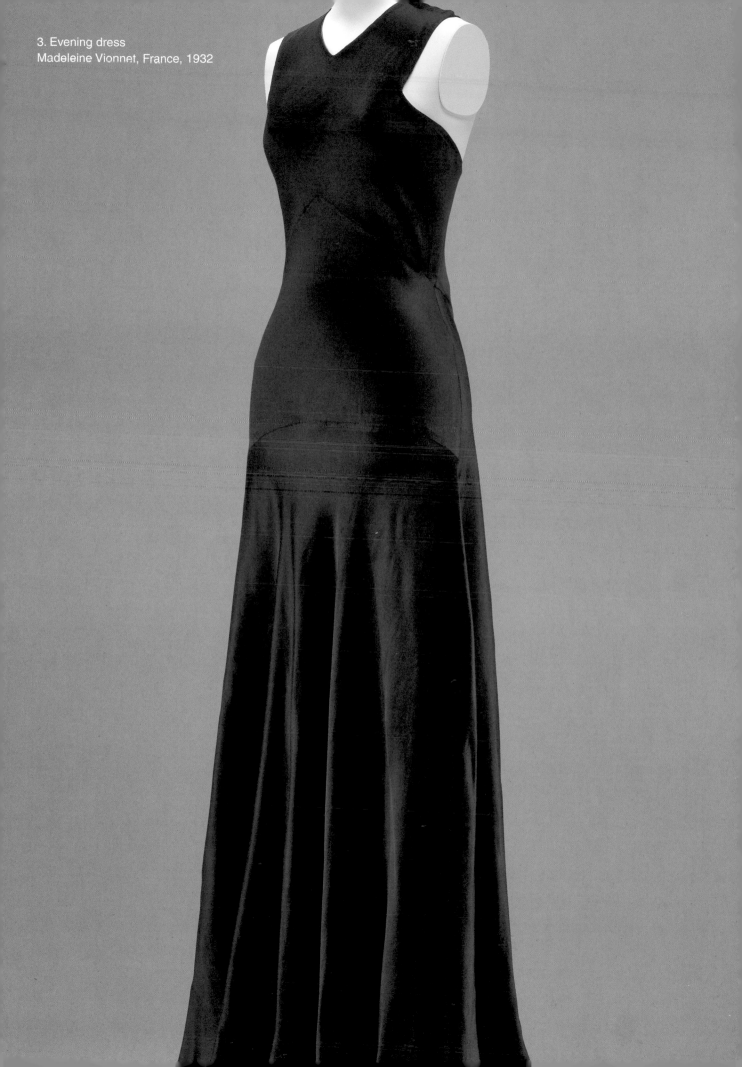

3. Evening dress
Madeleine Vionnet, France, 1932

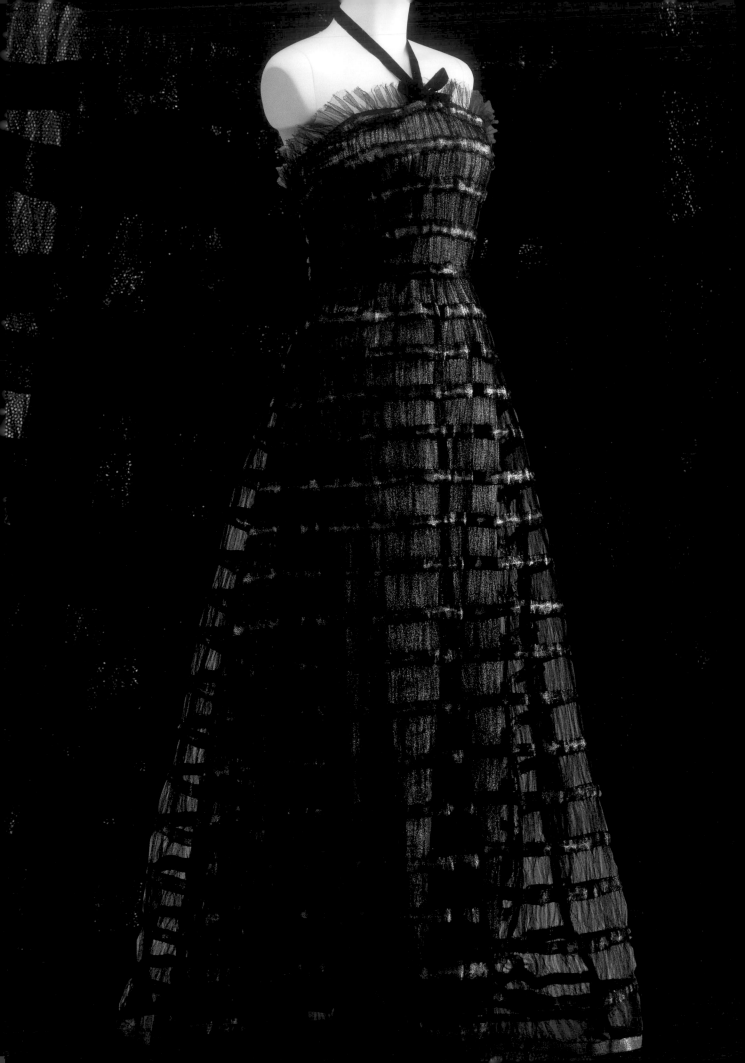

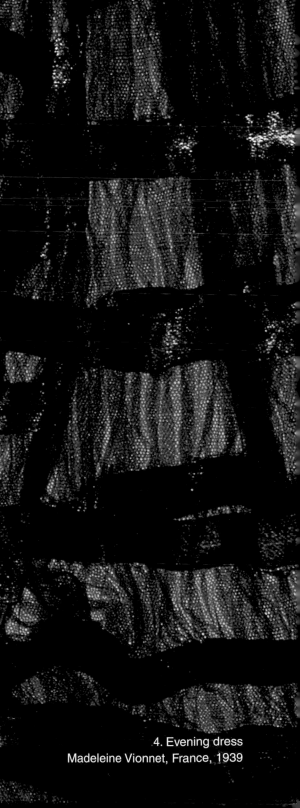

4. Evening dress
Madeleine Vionnet, France, 1939

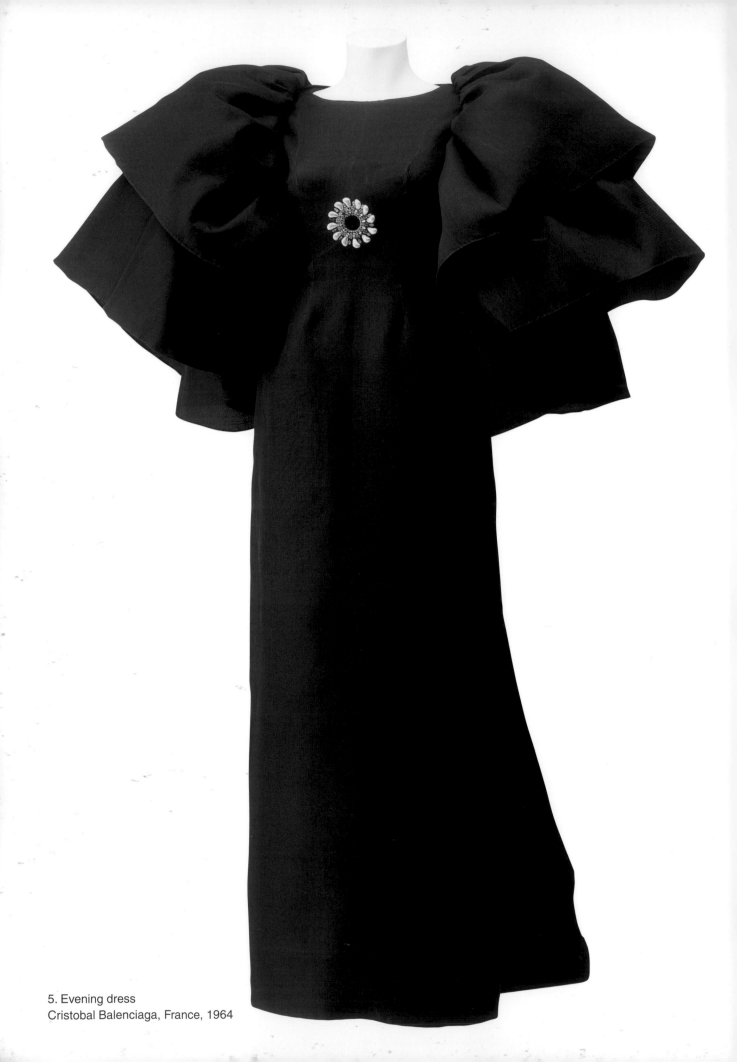

5. Evening dress
Cristobal Balenciaga, France, 1964

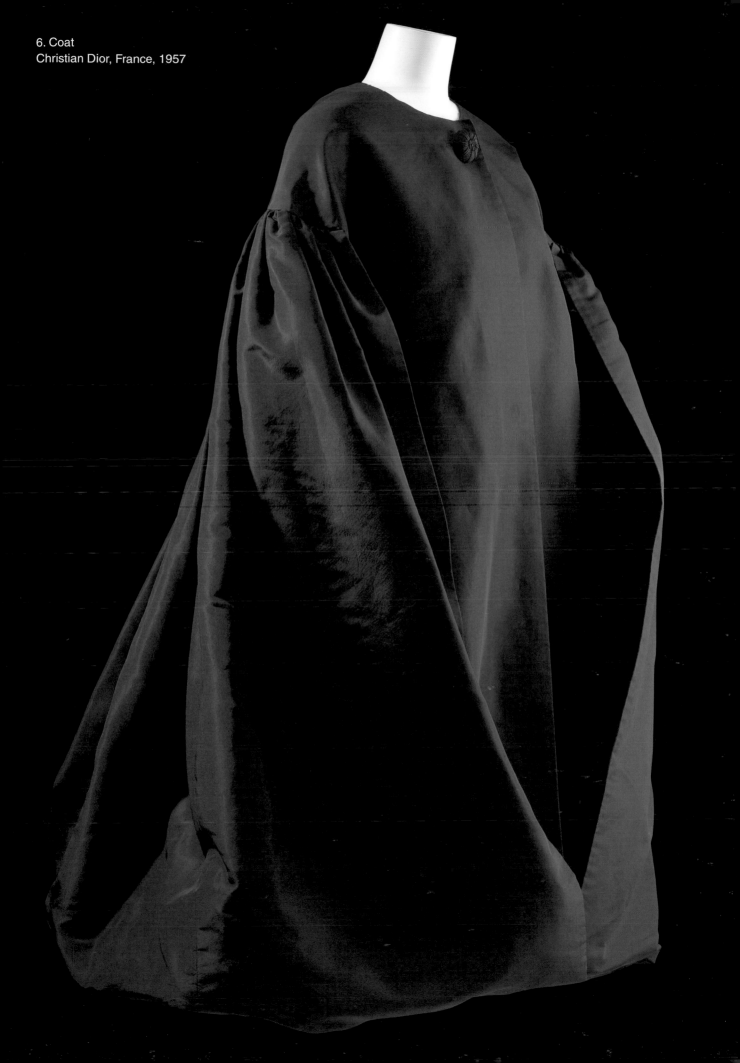

6. Coat
Christian Dior, France, 1957

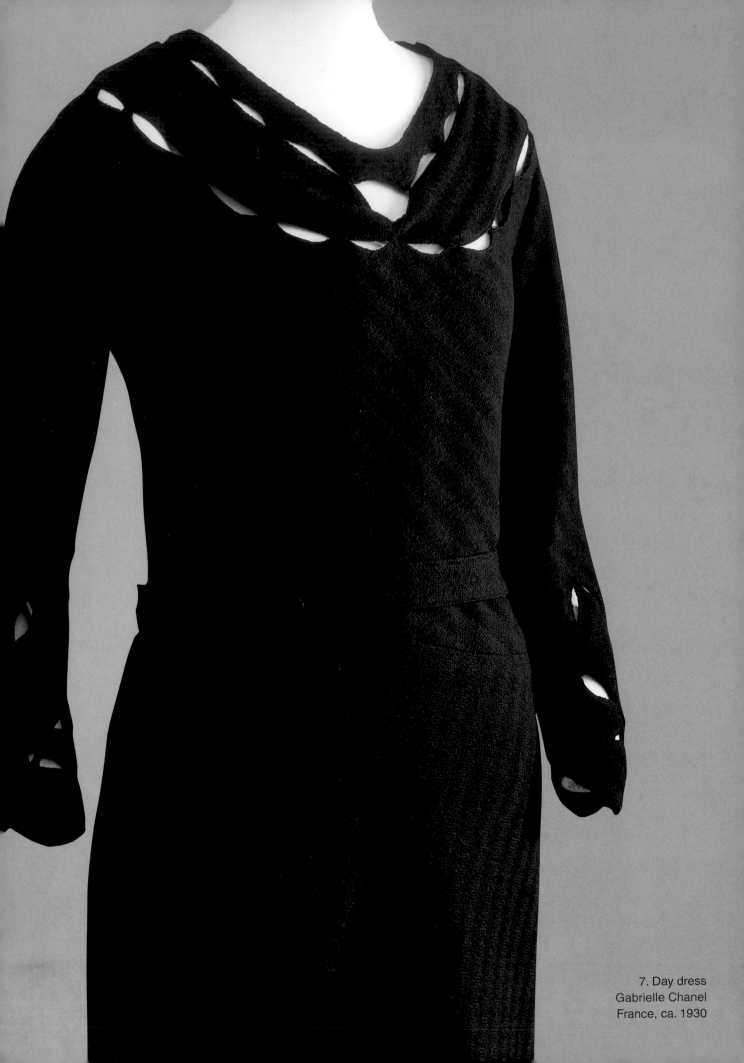

7. Day dress
Gabrielle Chanel
France, ca. 1930

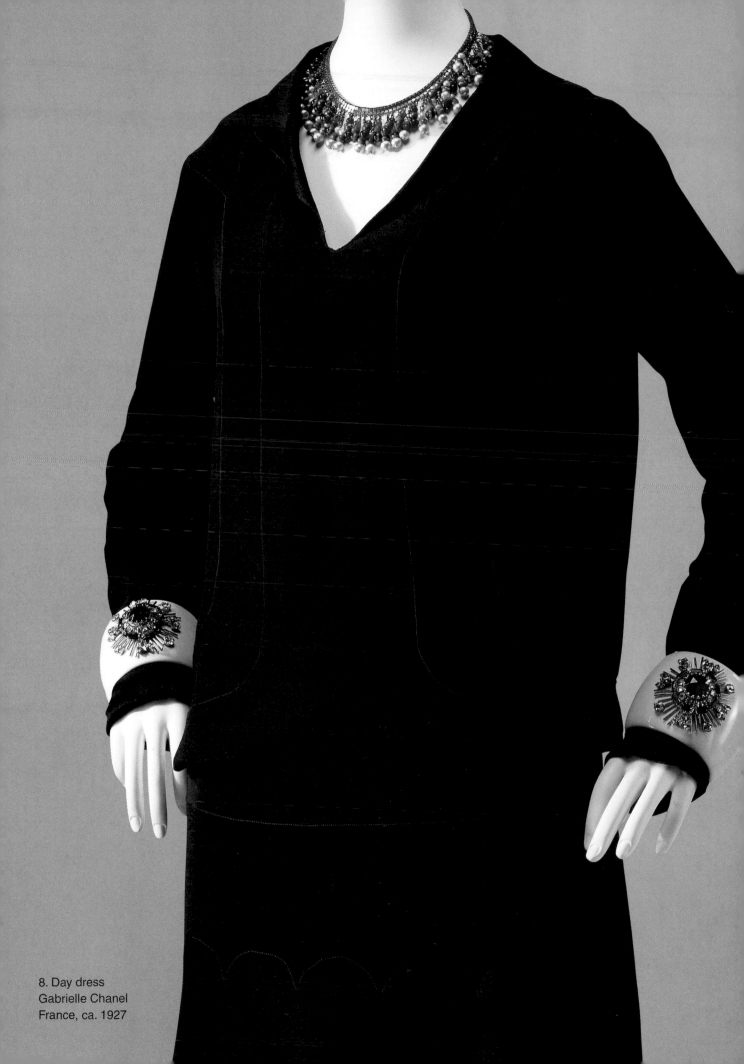

8. Day dress
Gabrielle Chanel
France, ca. 1927

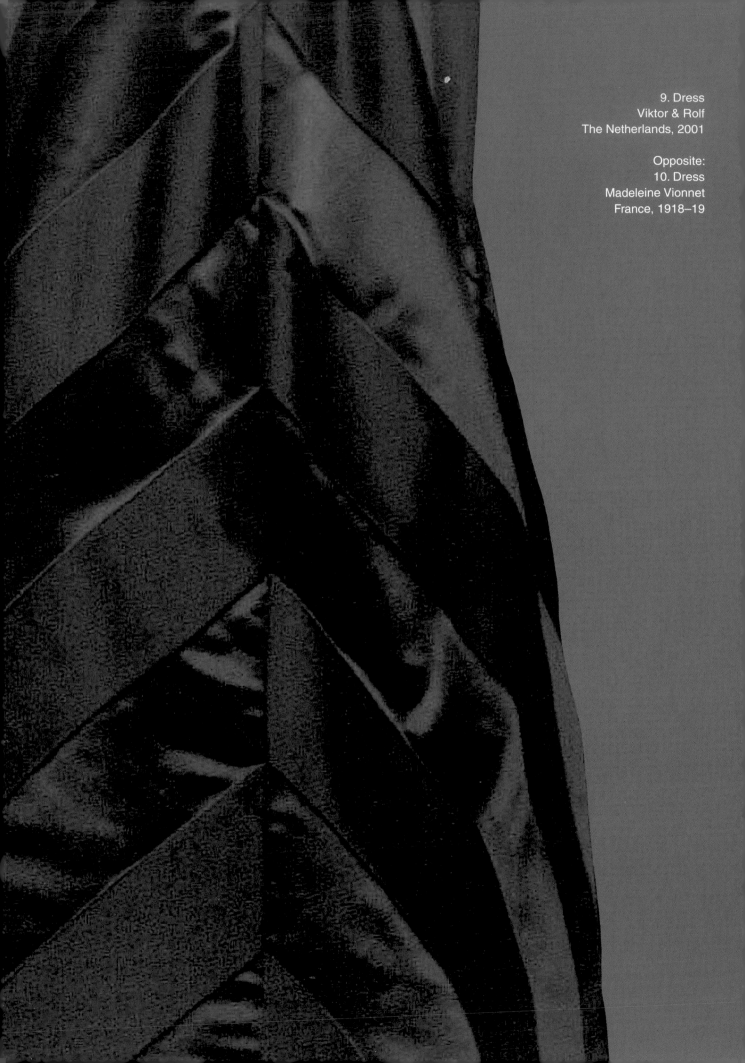

9. Dress
Viktor & Rolf
The Netherlands, 2001

Opposite:
10. Dress
Madeleine Vionnet
France, 1918–19

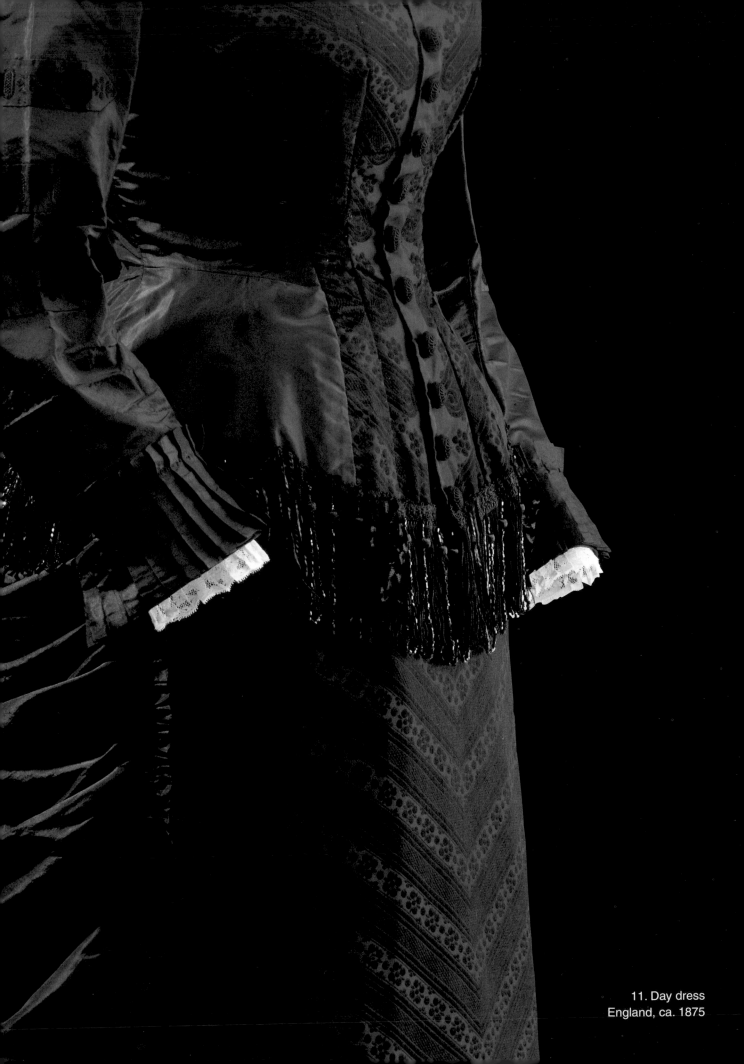

11. Day dress
England, ca. 1875

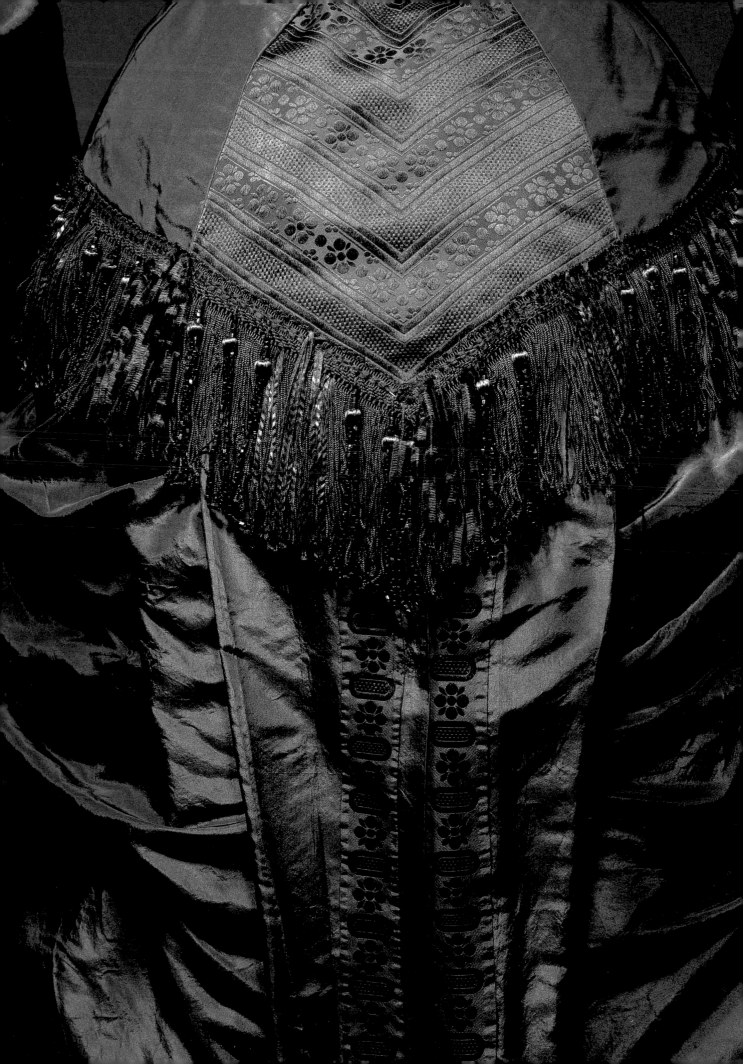

12. Visite (coat)
U.S.A., ca. 1885

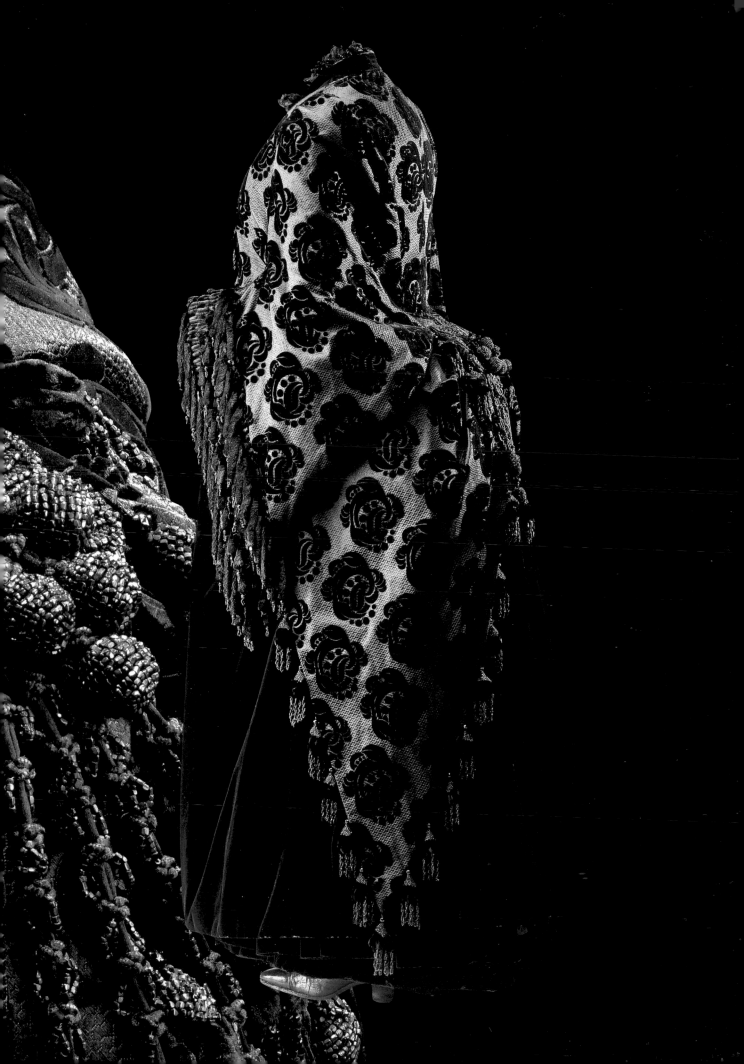

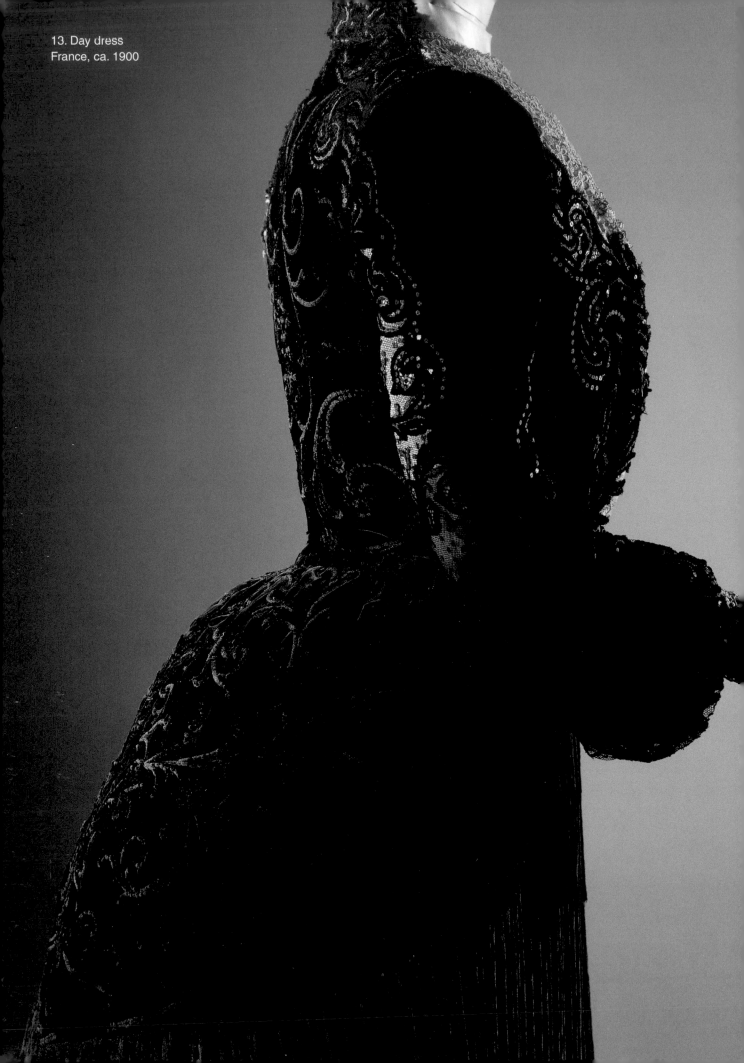

13. Day dress
France, ca. 1900

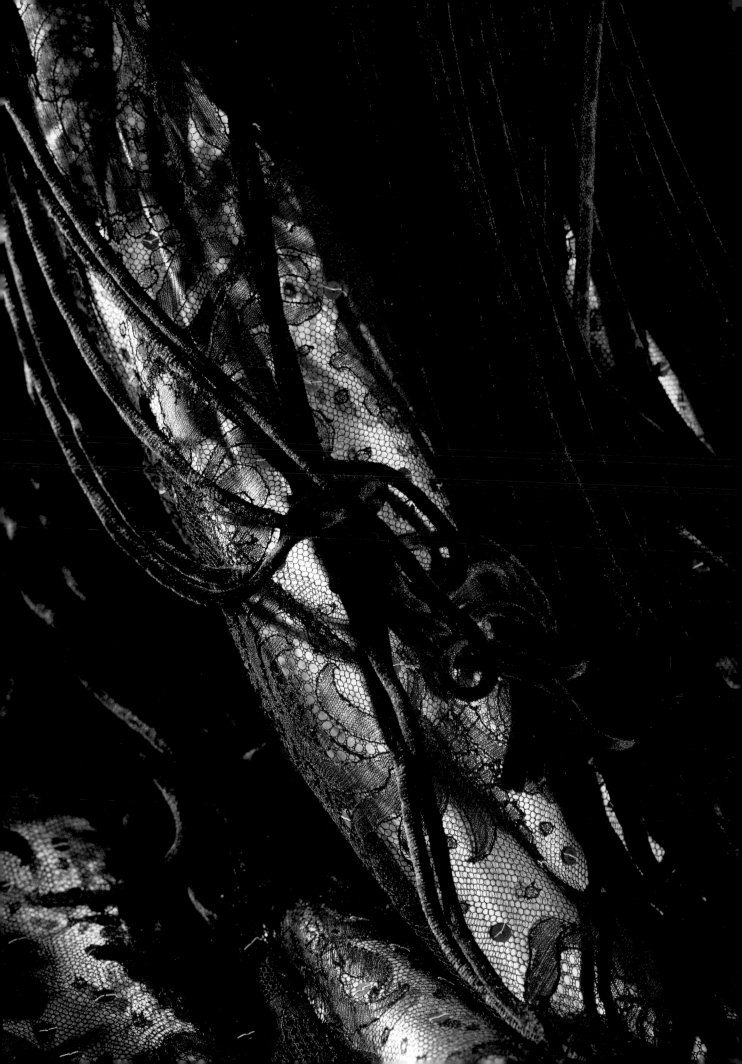

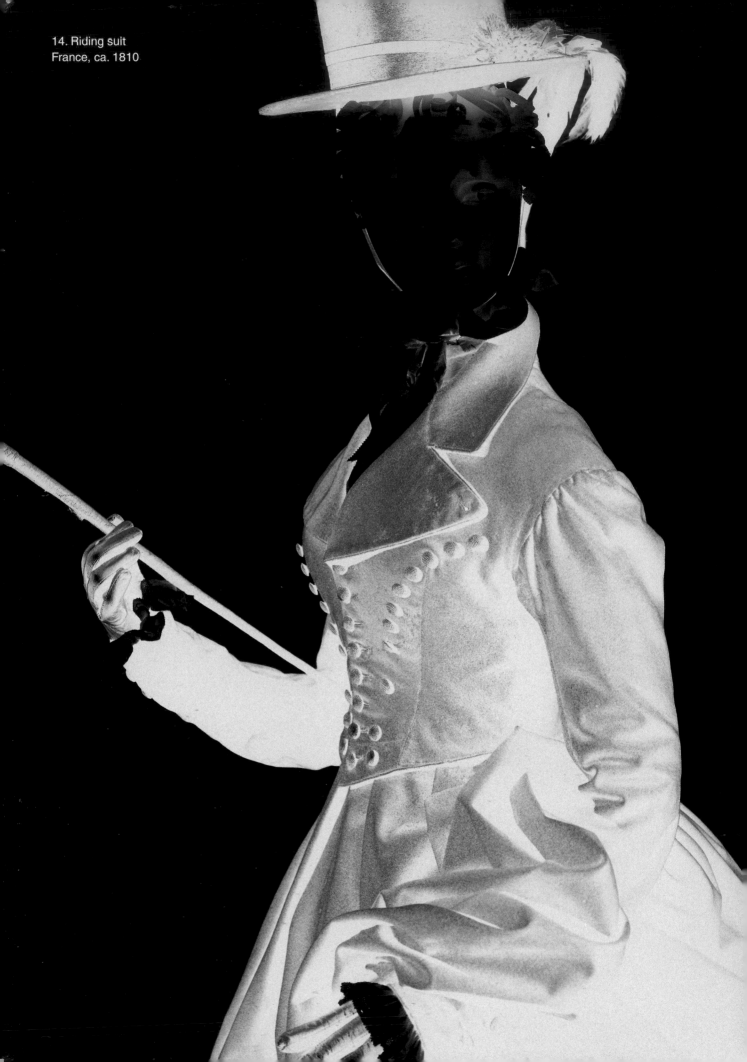

14. Riding suit
France, ca. 1810

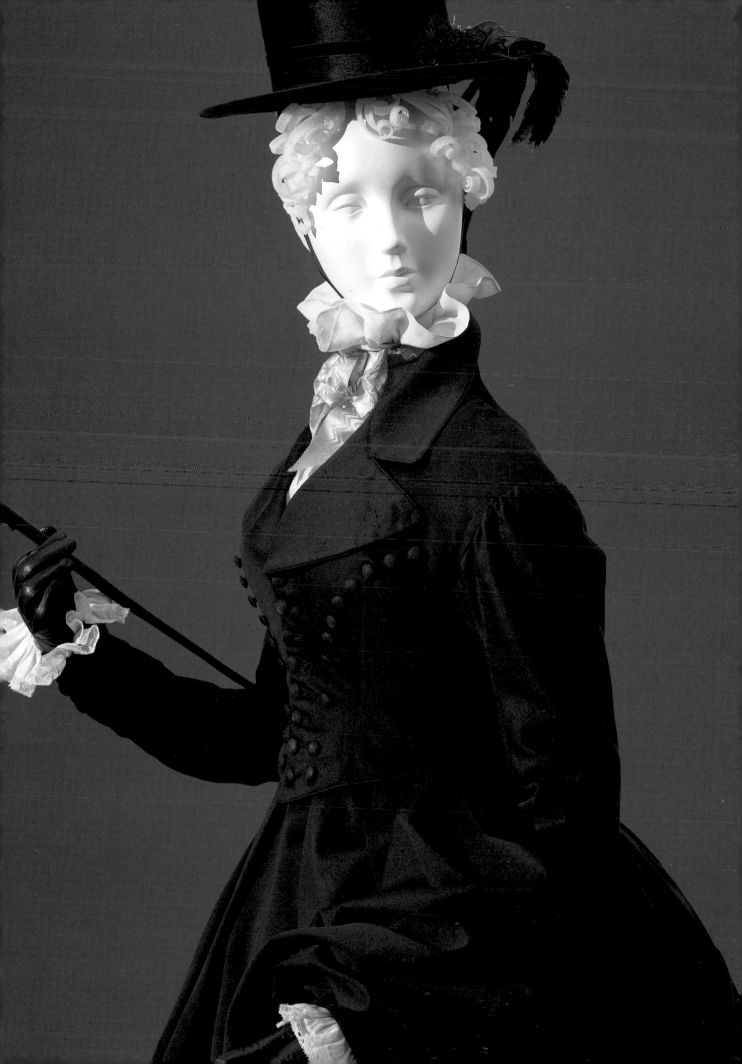

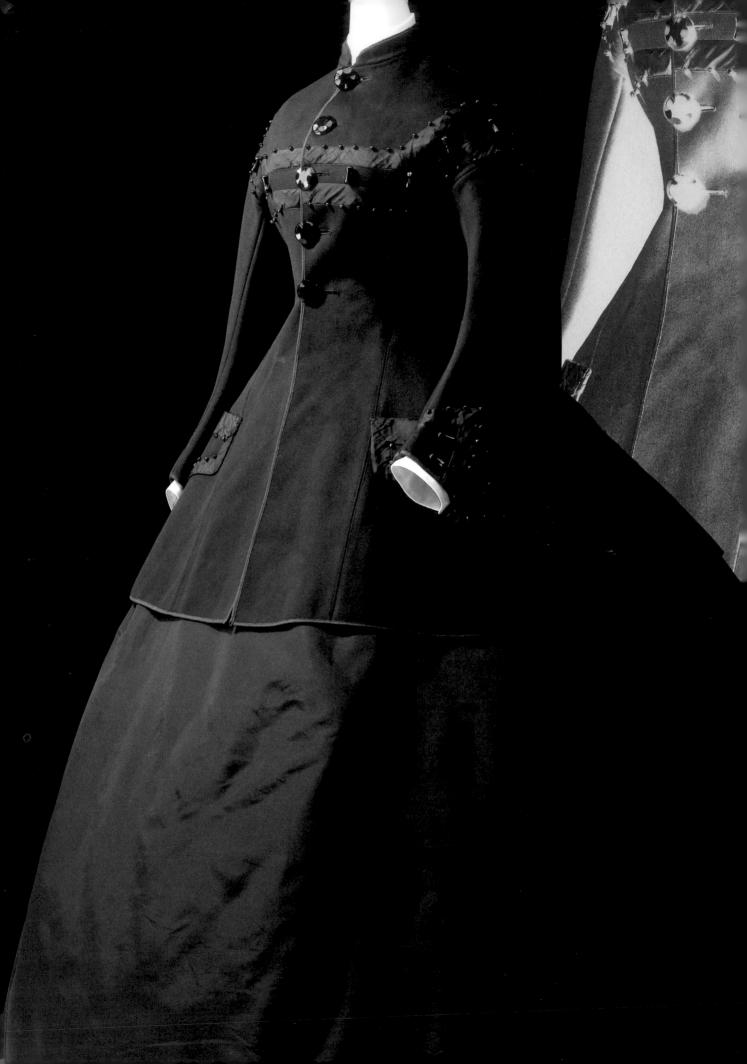

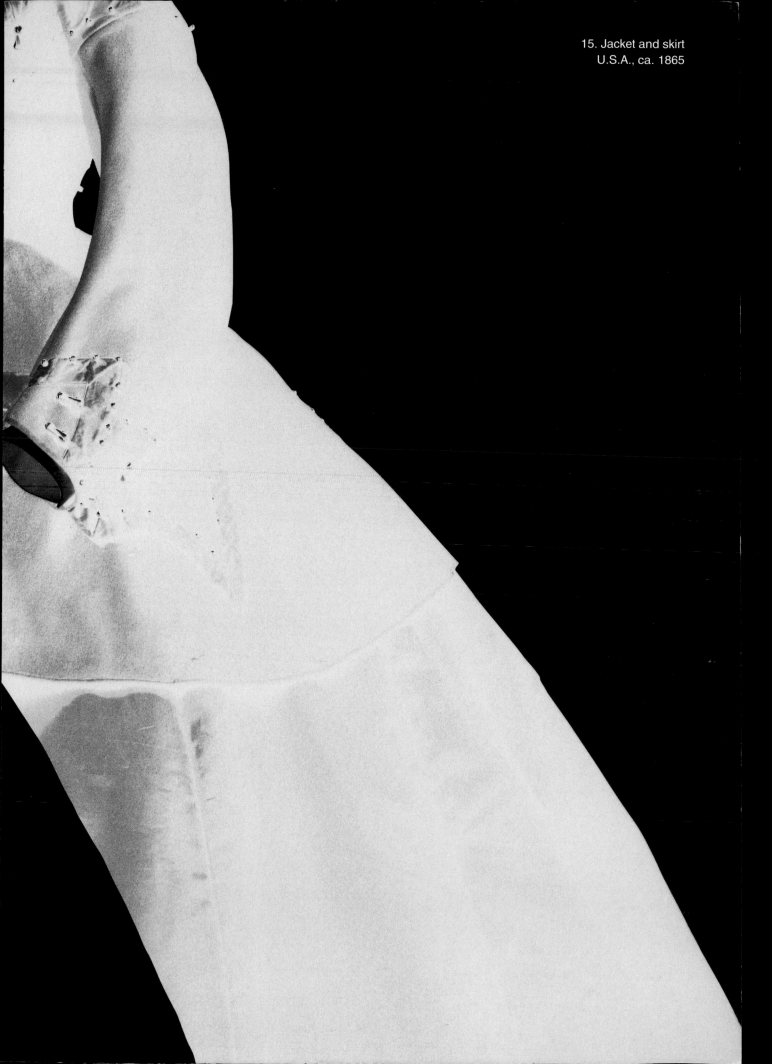

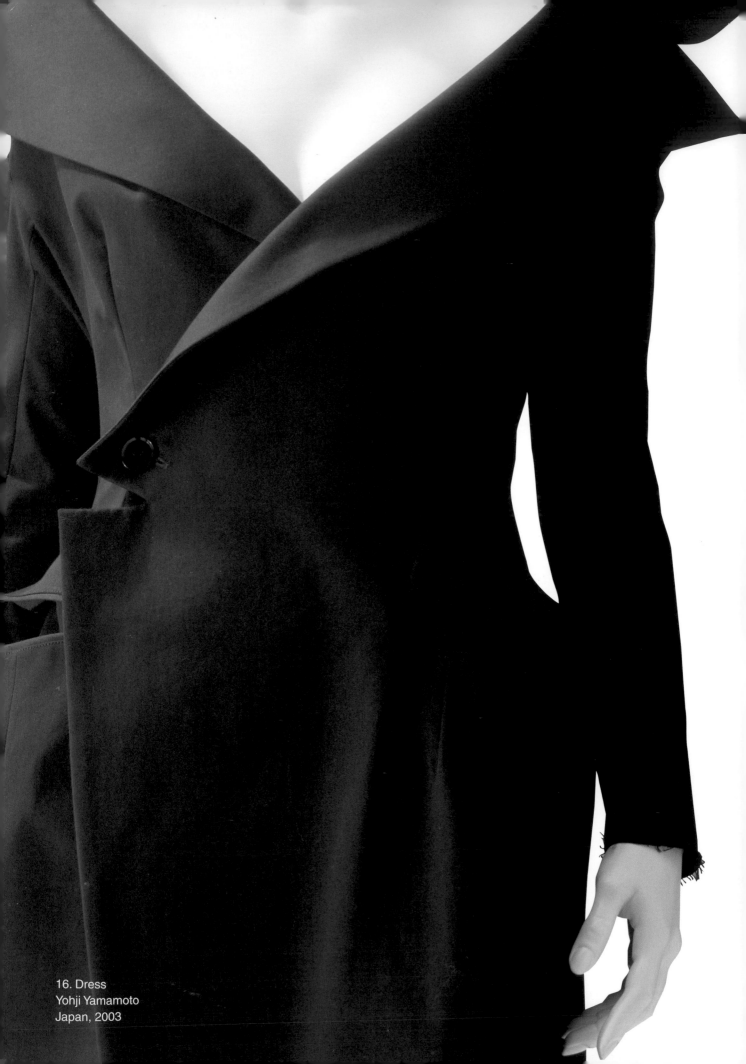

16. Dress
Yohji Yamamoto
Japan, 2003

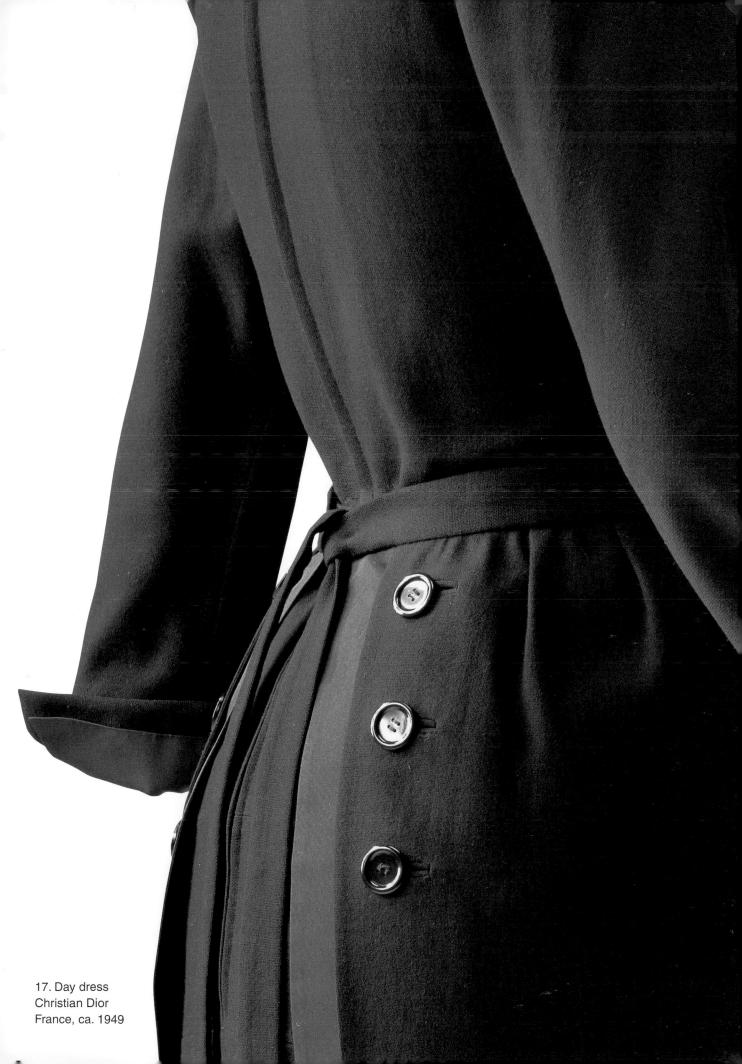

17. Day dress
Christian Dior
France, ca. 1949

18. Sweater and skirt
Rei Kawakubo/Comme des Garçons
Japan, 1983

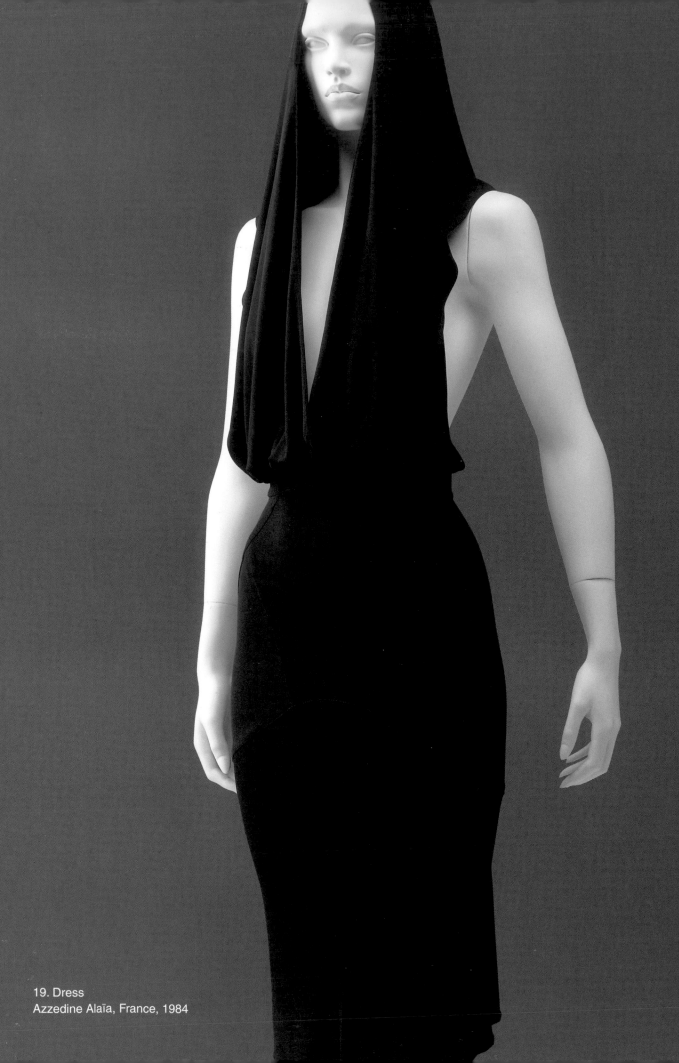

19. Dress
Azzedine Alaïa, France, 1984

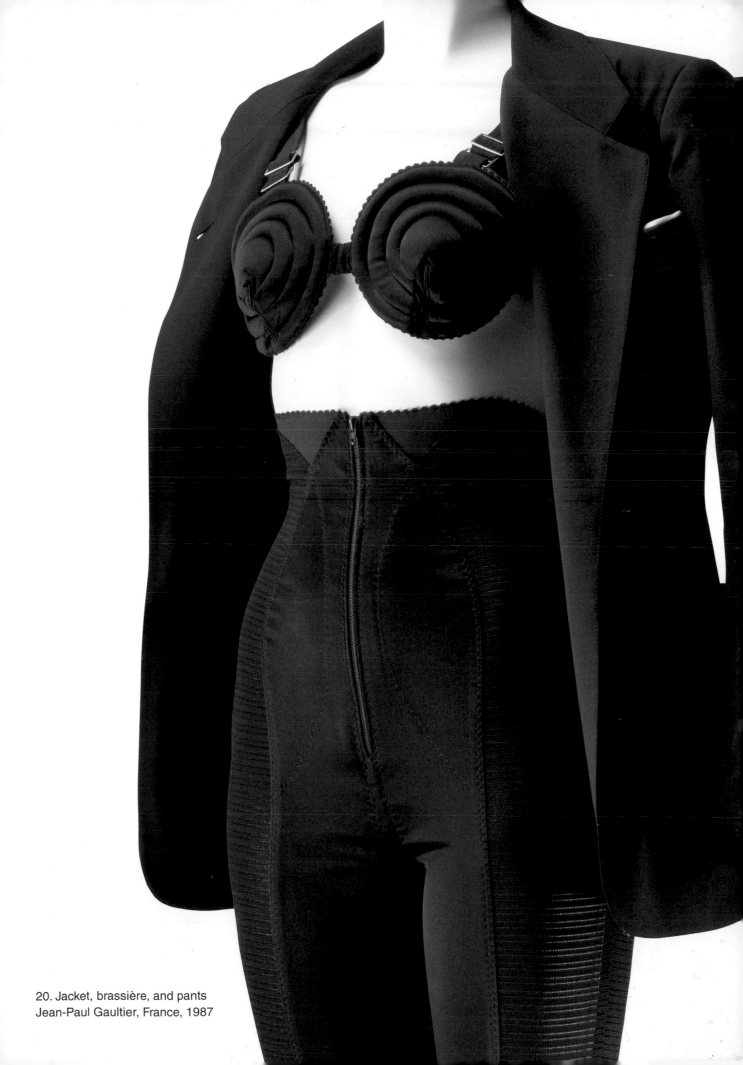

20. Jacket, brassière, and pants
Jean-Paul Gaultier, France, 1987

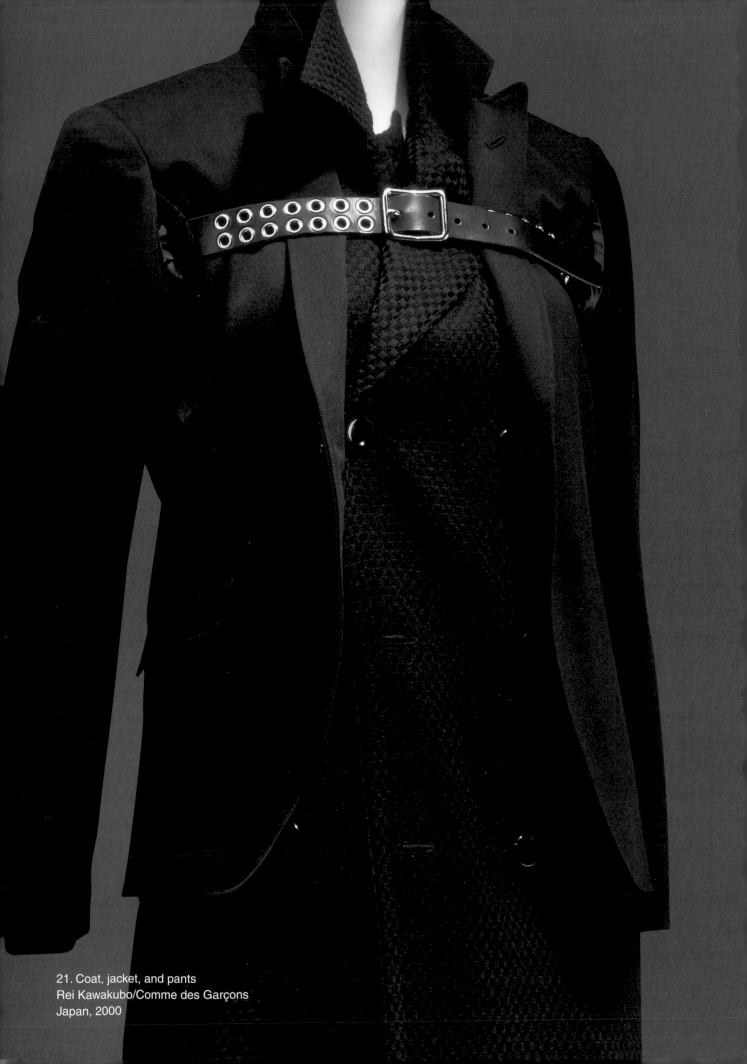

21. Coat, jacket, and pants
Rei Kawakubo/Comme des Garçons
Japan, 2000

MULTI

COLOR

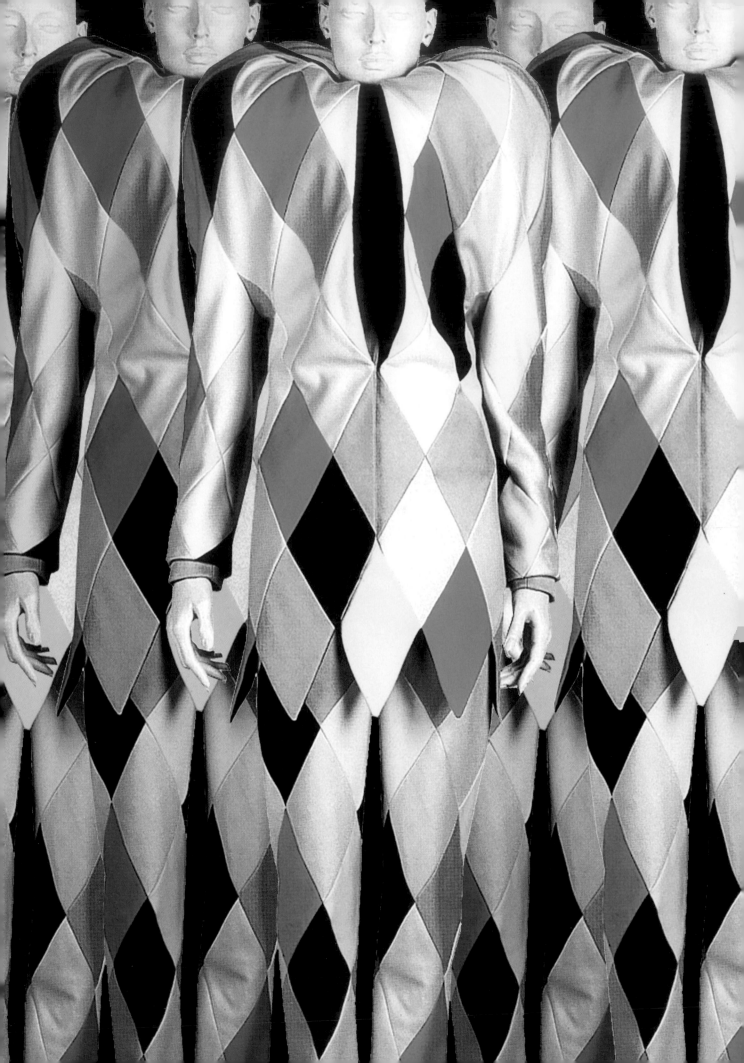

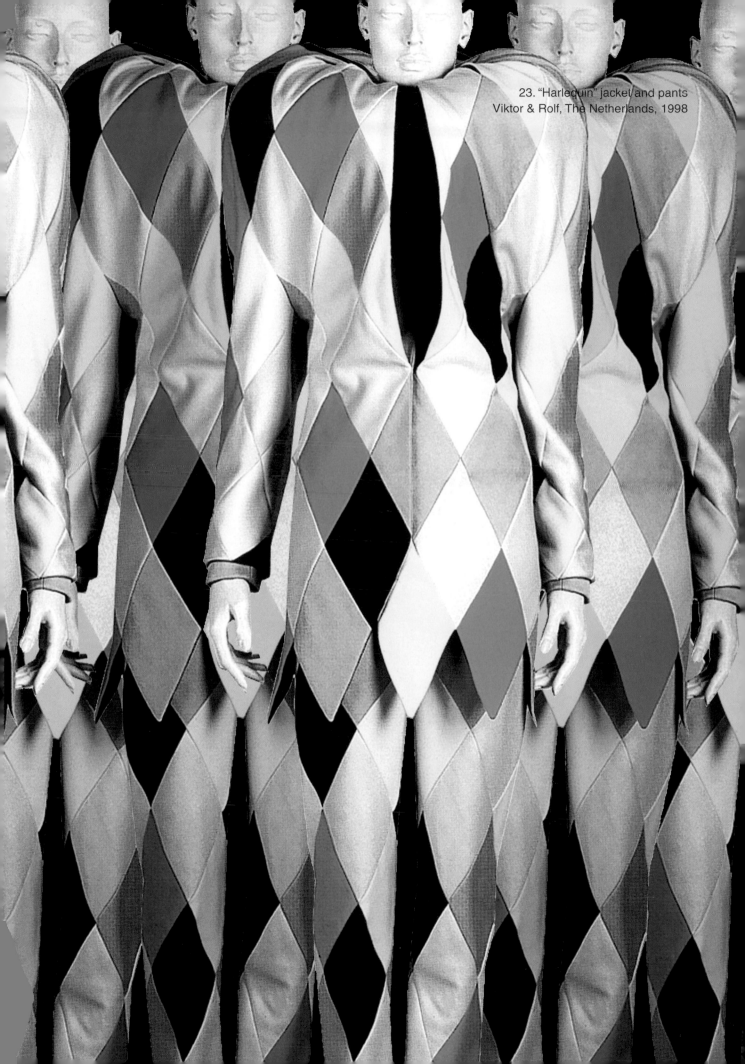

23. "Harlequin" jacket and pants
Viktor & Rolf, The Netherlands, 1998

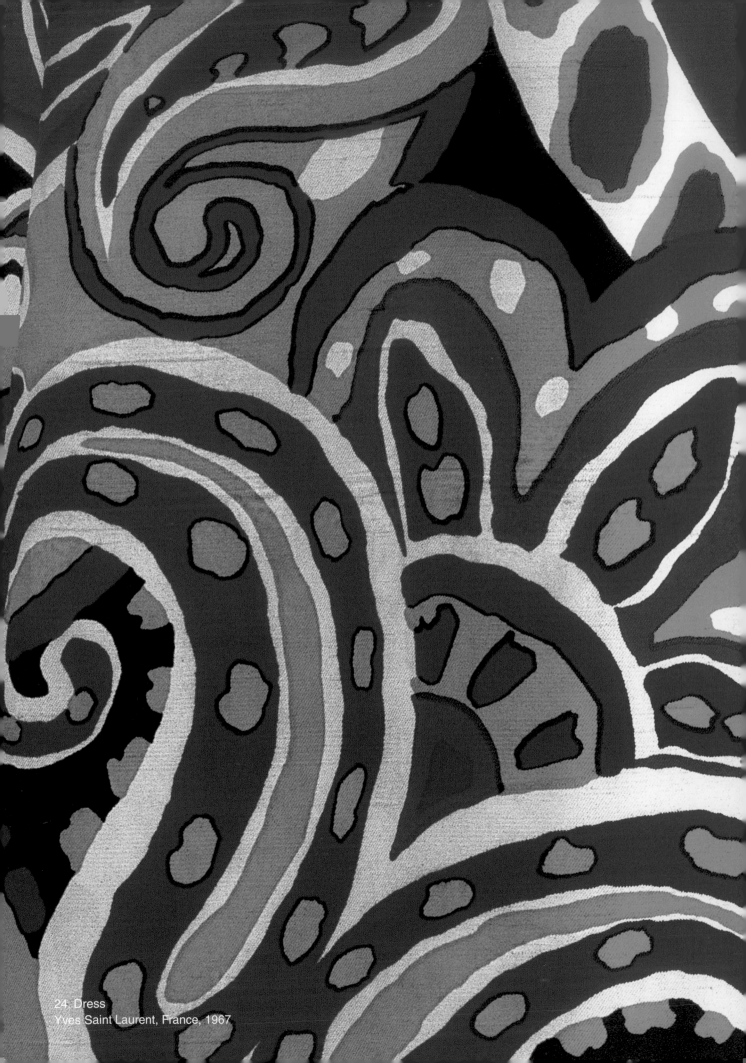

24. Dress
Yves Saint Laurent, France, 1967

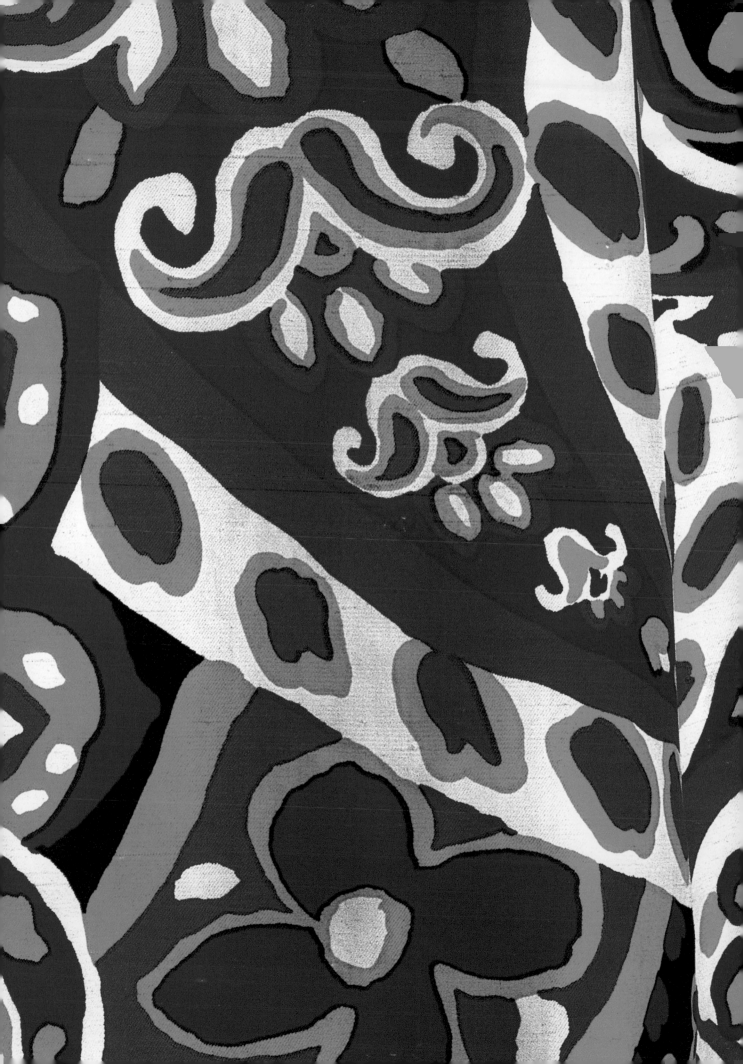

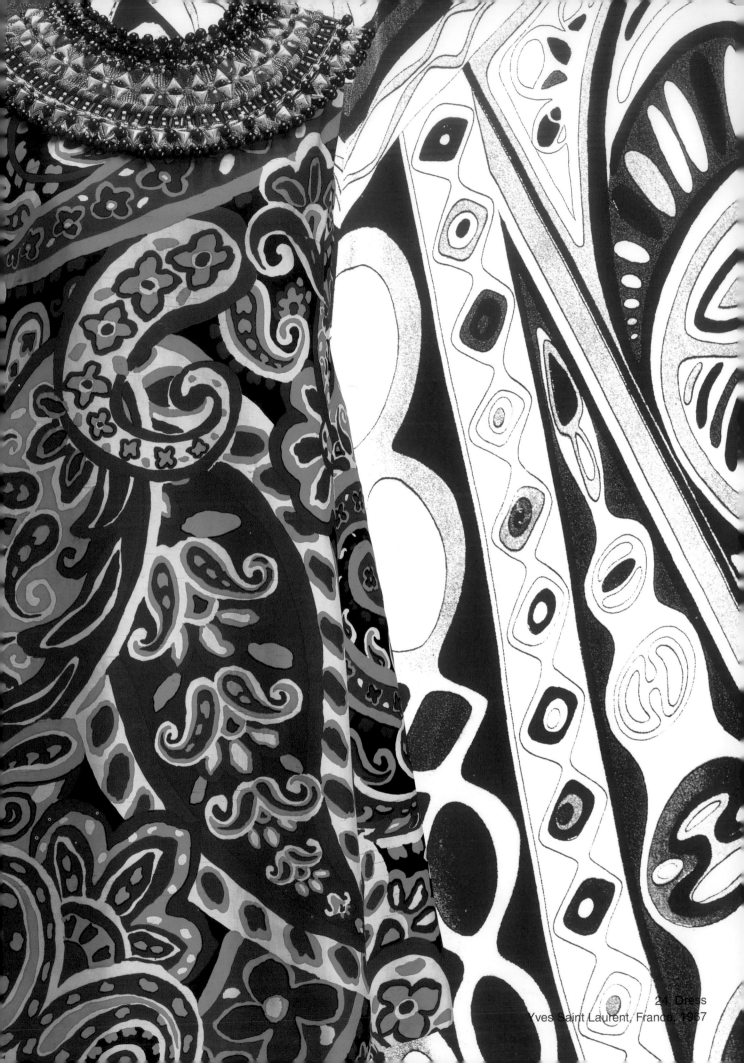

24. Dress
Yves Saint Laurent, France, 1967

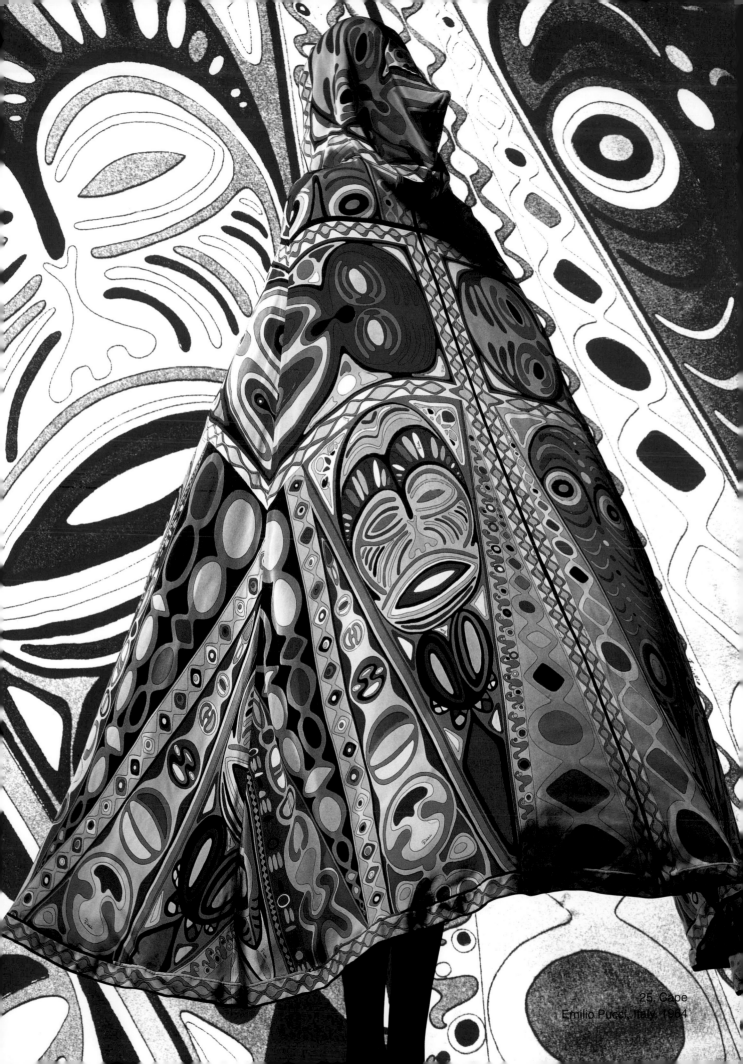

25 Cape
Emilio Pucci, Italy, 1964

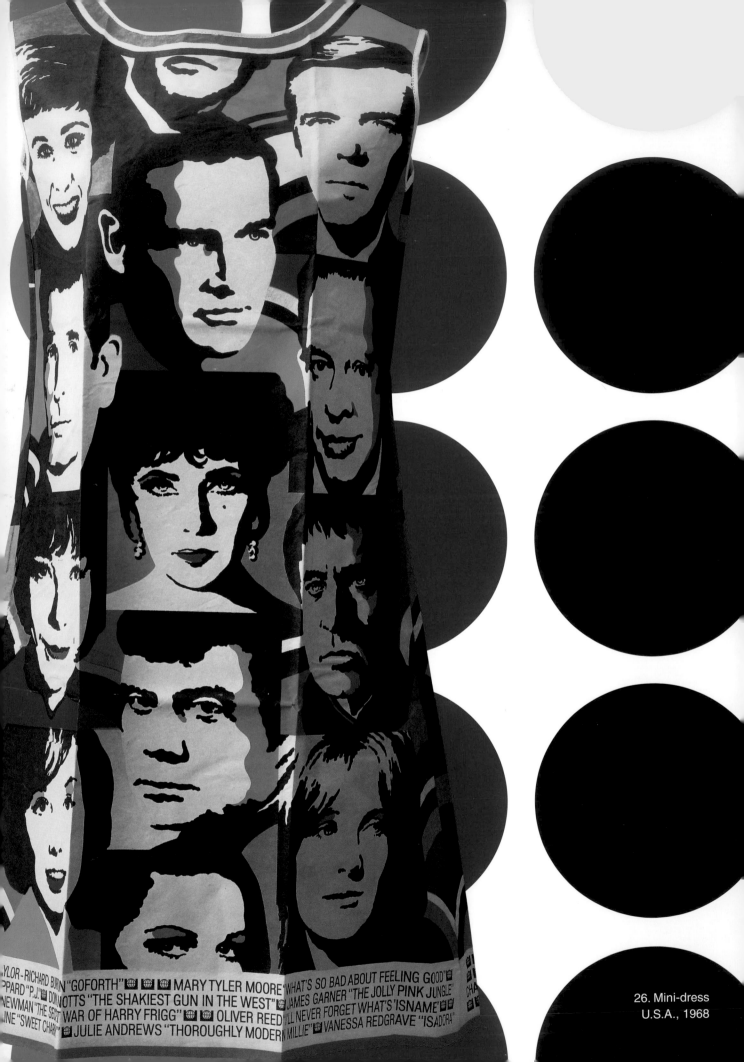

26. Mini-dress
U.S.A., 1968

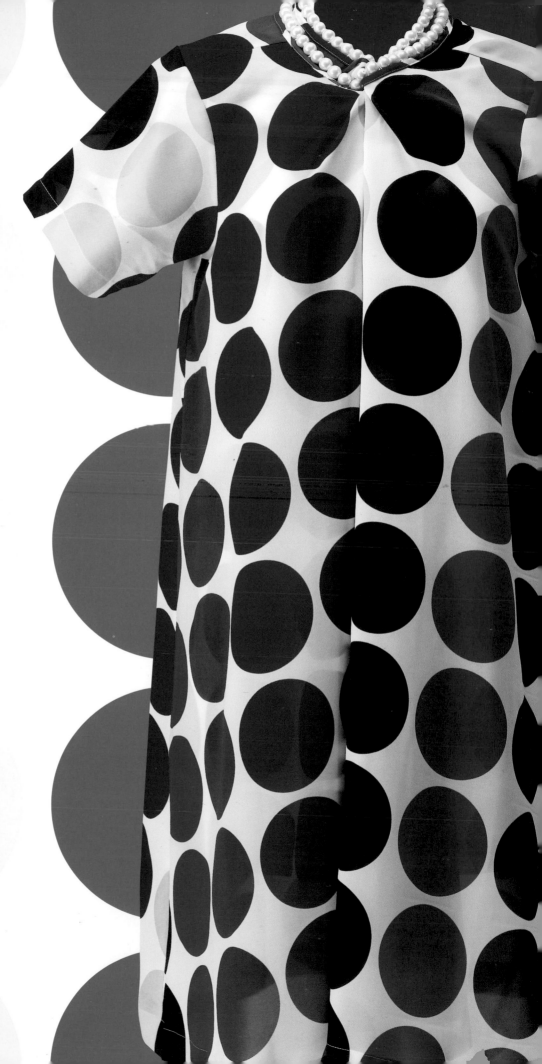

27. Dress
Junya Watanabe, Japan, 2001

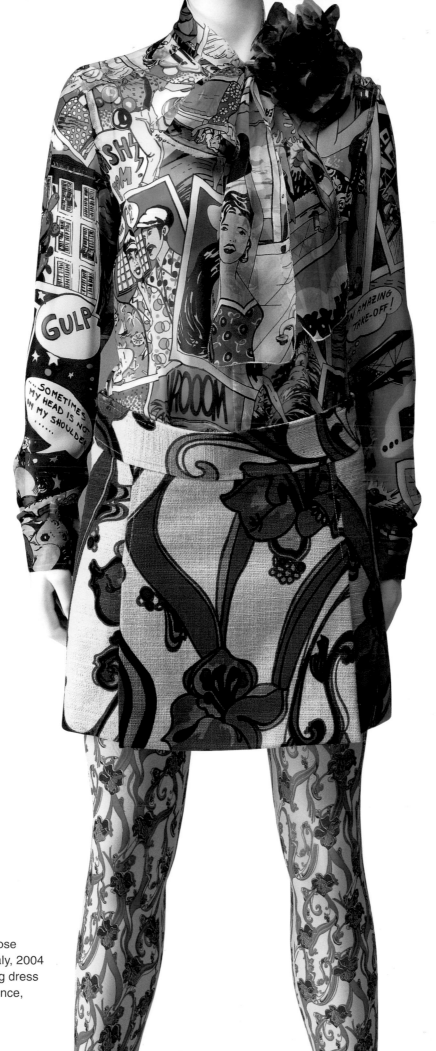

29. Shirt, skirt, and hose
Dolce & Gabbana, Italy, 2004
Opposite: 28. Evening dress
Elsa Schiaparelli, France,
ca. 1937

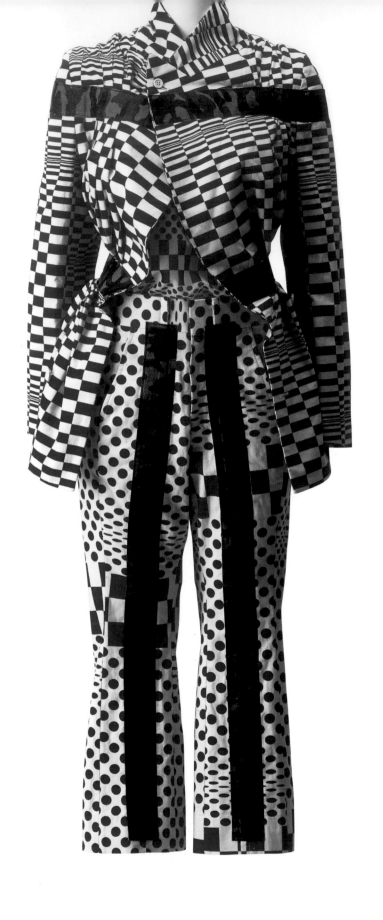

30. Jacket and pants
Rei Kawakubo/Comme des Garçons
Japan, 2001

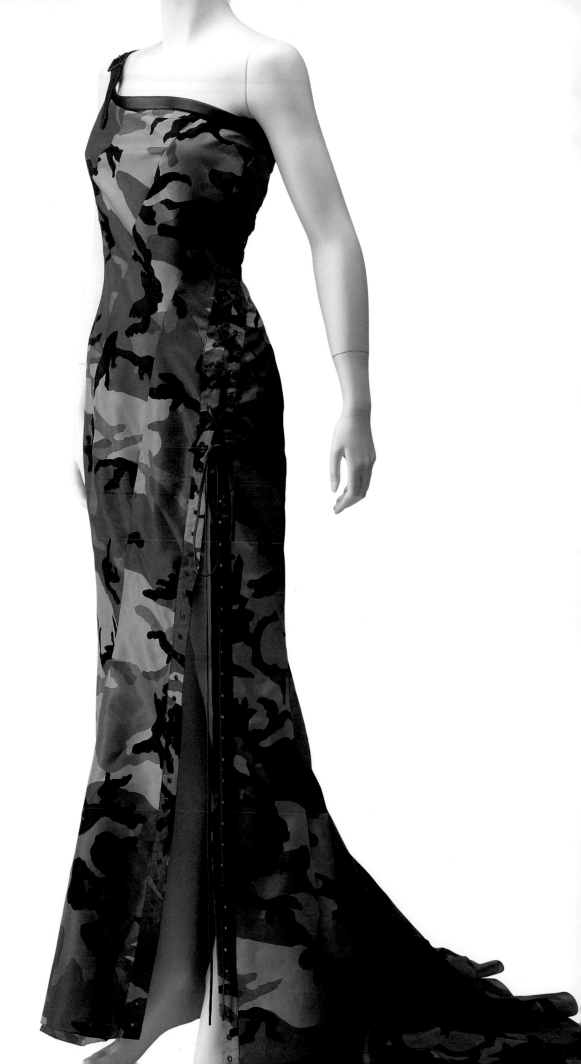

31. Dress
Christian Dior by John
Galliano, France, 2001

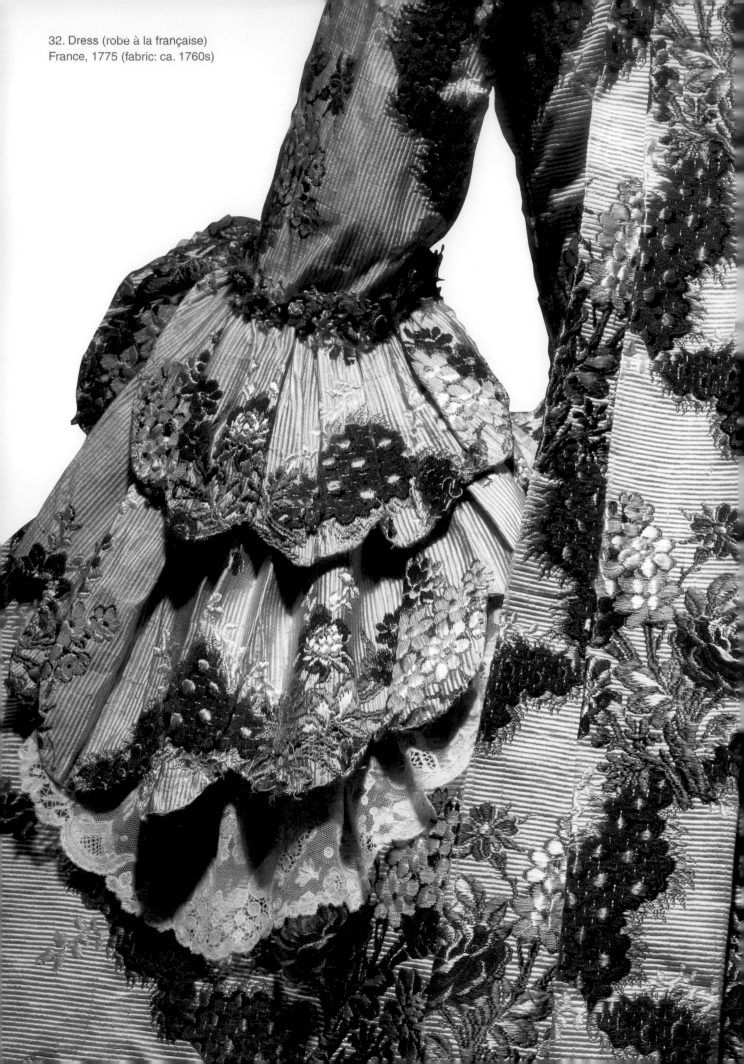

32. Dress (robe à la française)
France, 1775 (fabric: ca. 1760s)

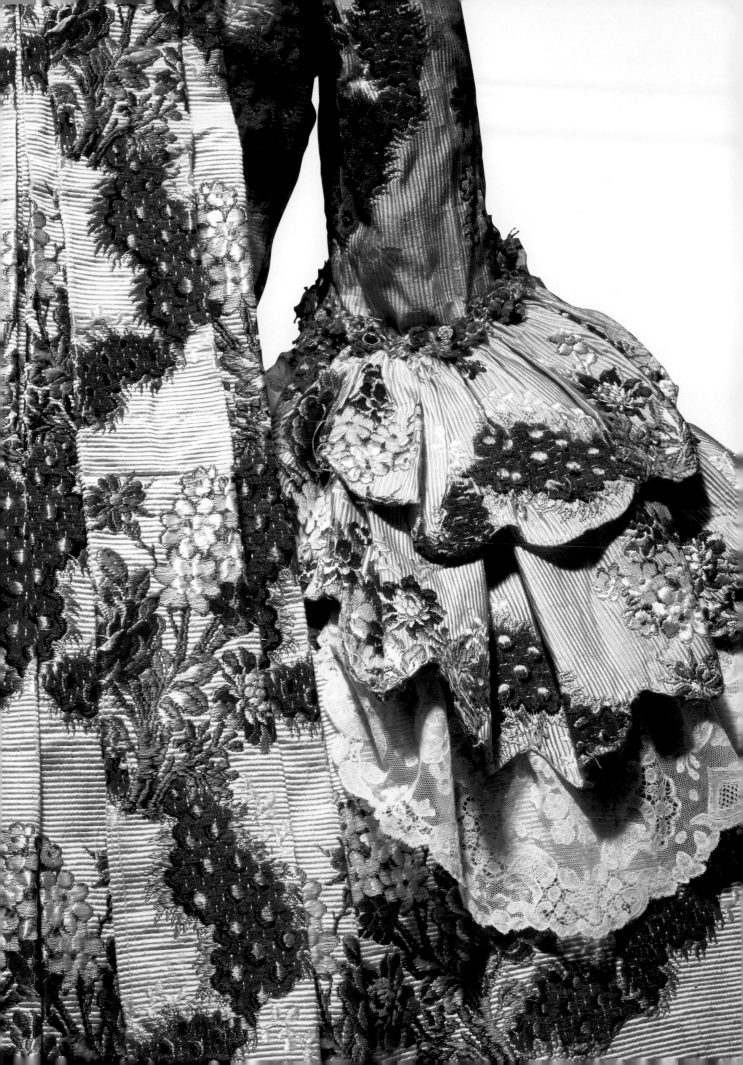

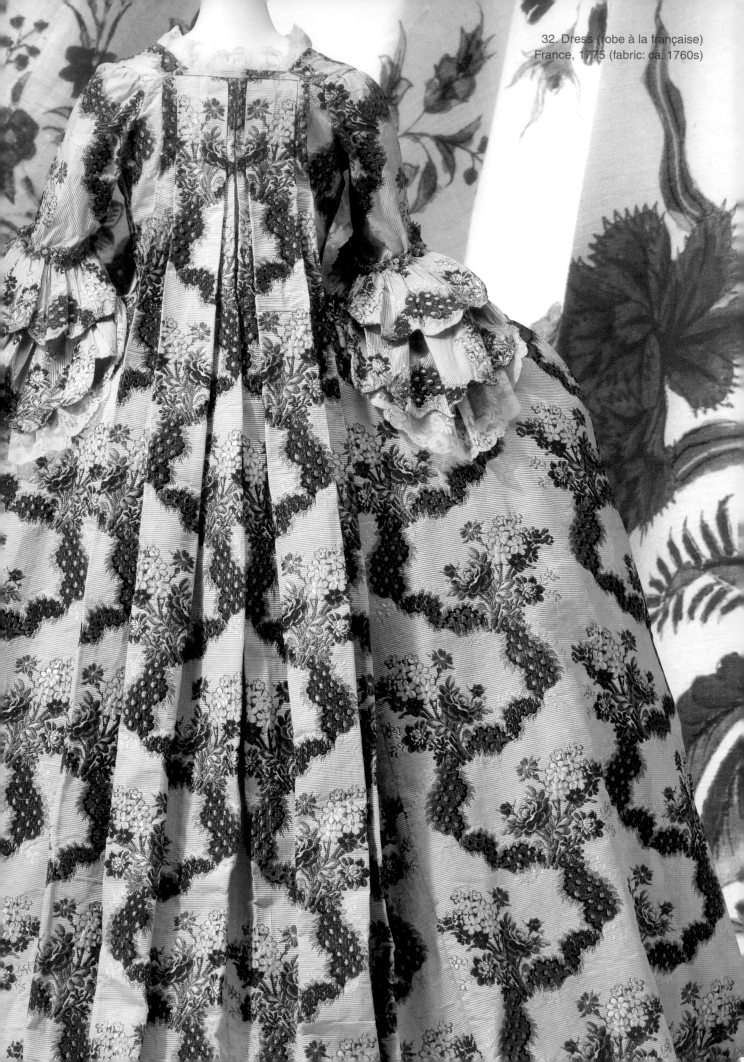

32. Dress (robe à la française)
France, 1775 (fabric: ca. 1760s)

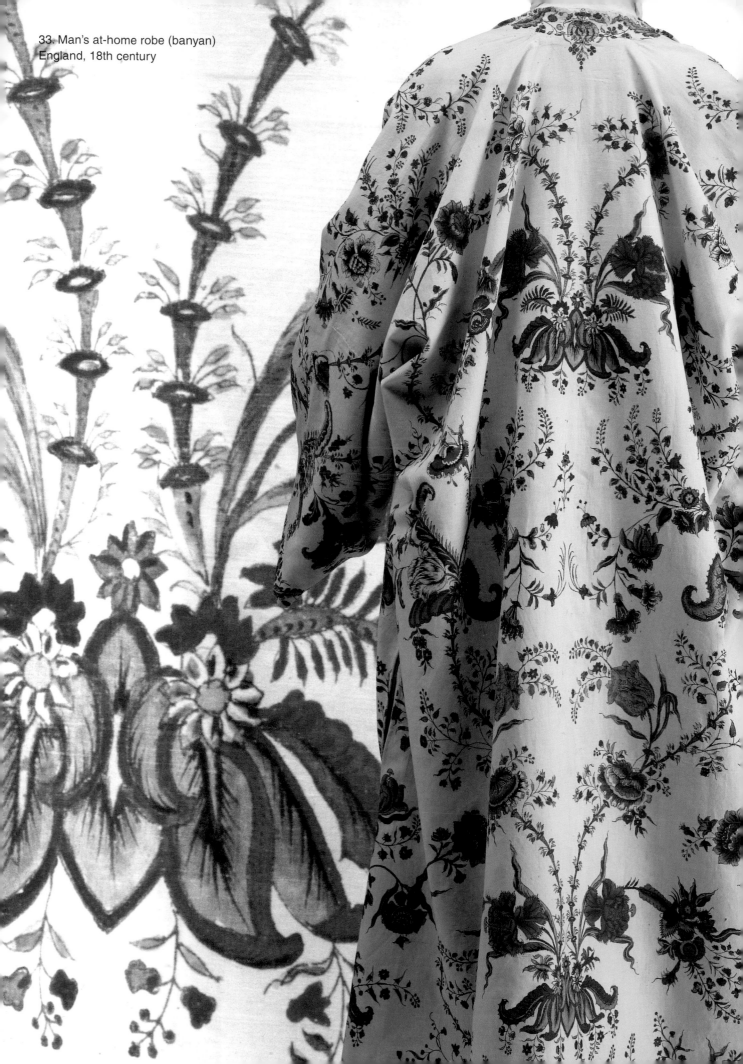

33. Man's at-home robe (banyan)
England, 18th century

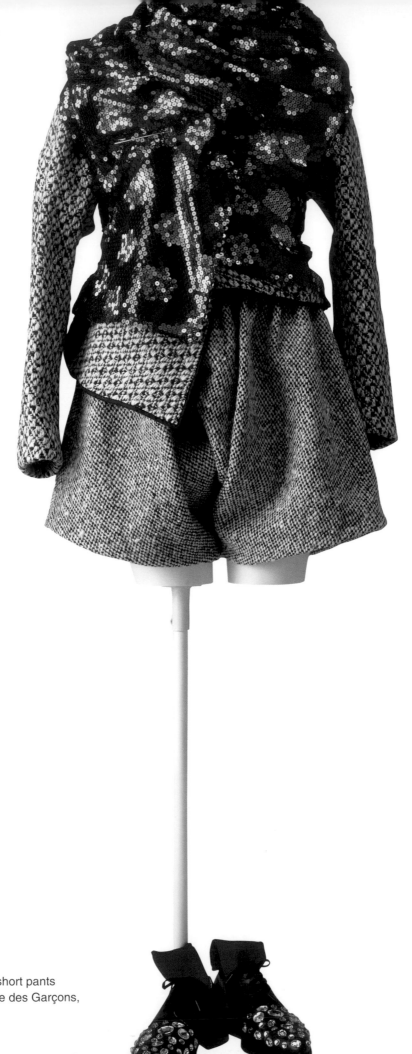

34. Jacket, vest, and short pants
Rei Kawakubo/Comme des Garçons,
Japan, 1999

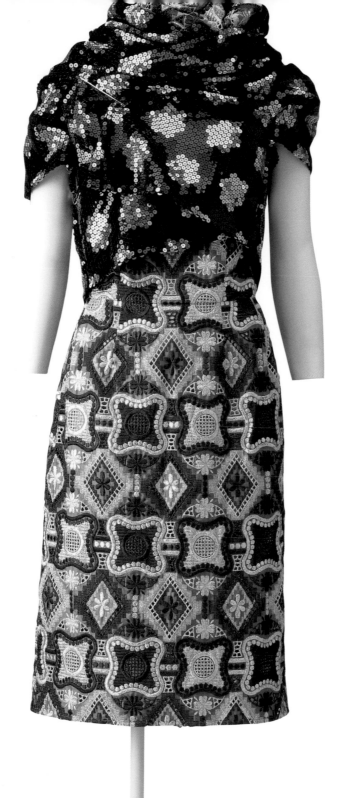

35. Jacket and dress
Rei Kawakubo/Comme des Garçons,
Japan, 1999

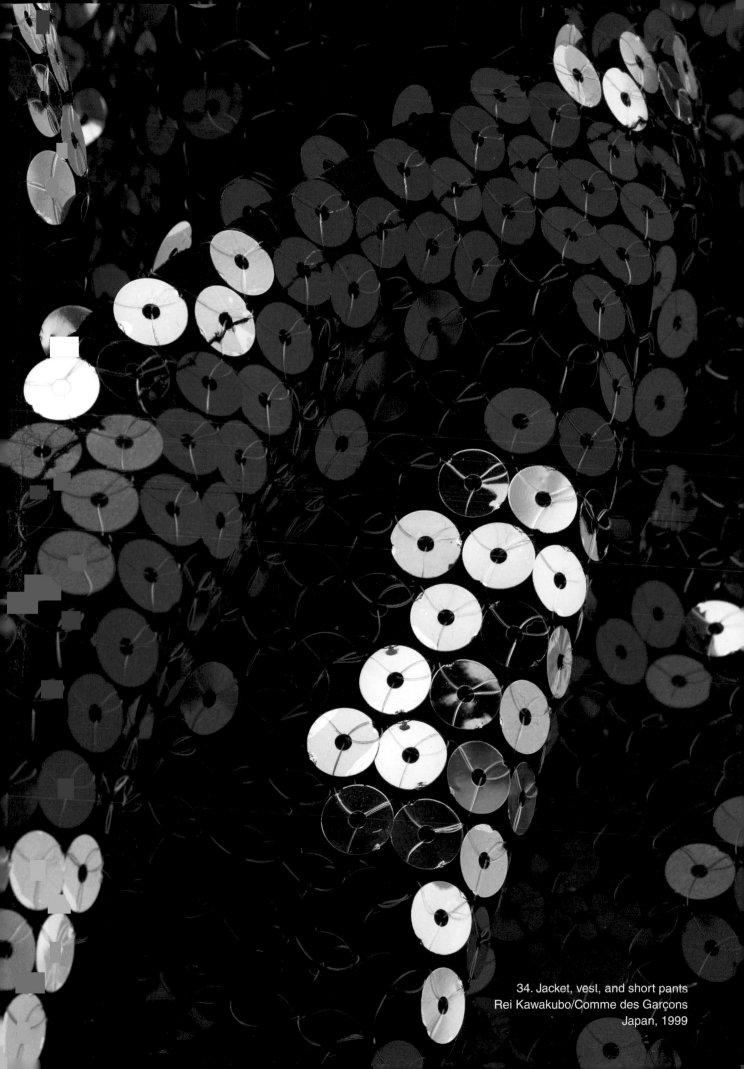

34. Jacket, vest, and short pants
Rei Kawakubo/Comme des Garçons
Japan, 1999

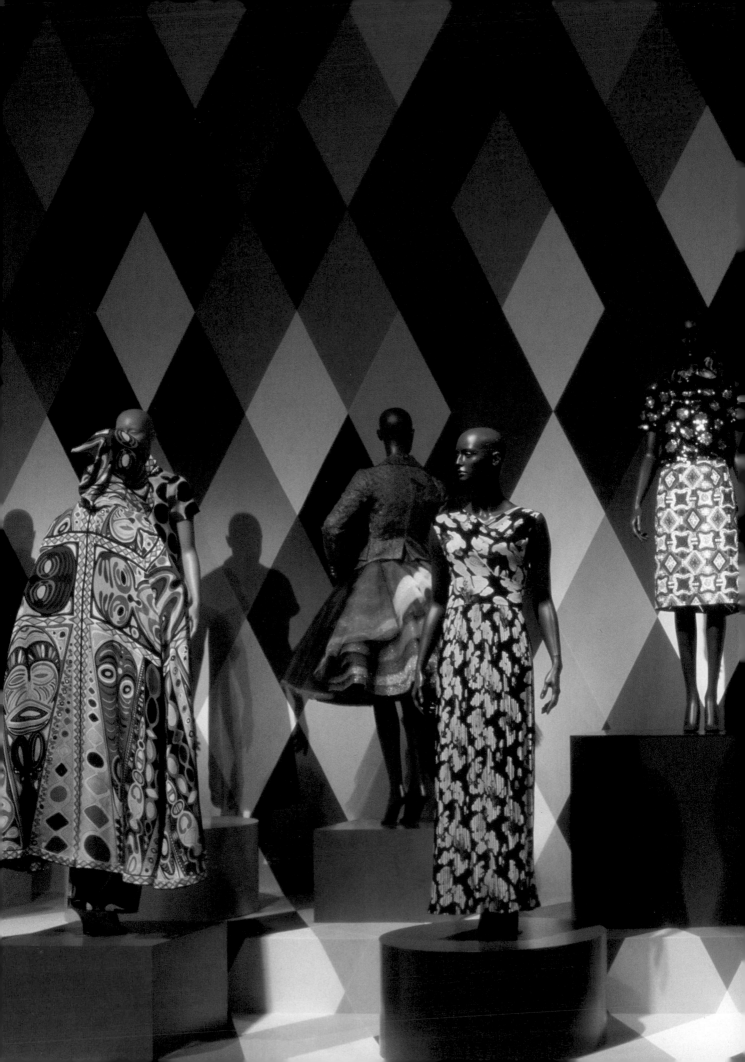

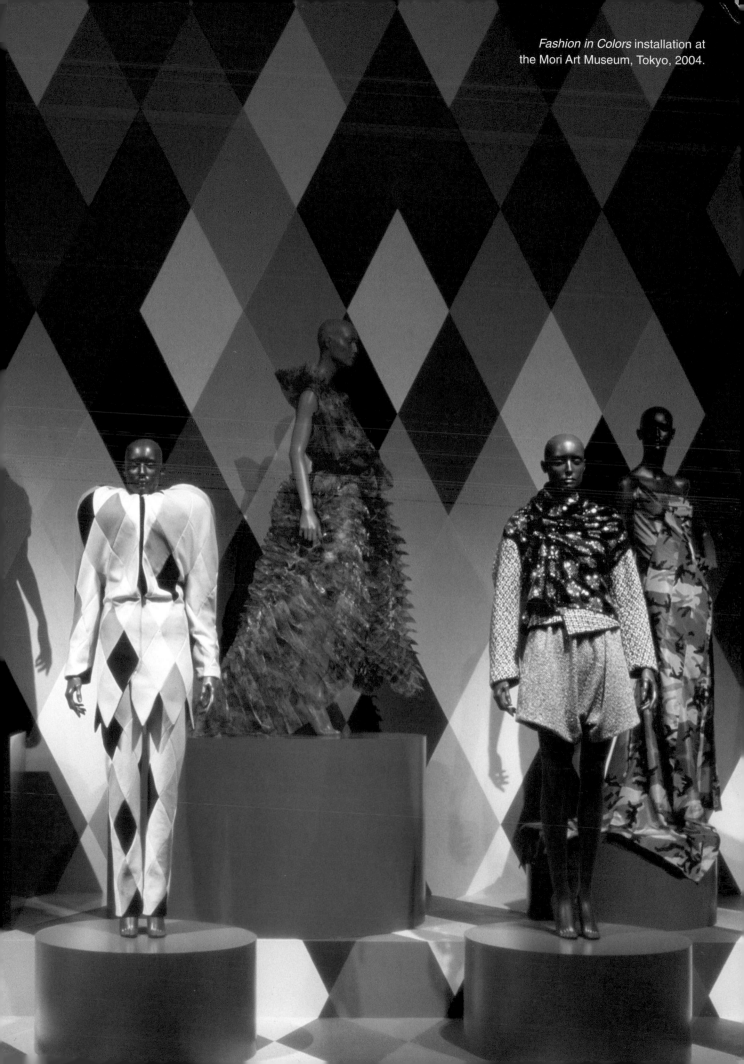

Fashion in Colors installation at the Mori Art Museum, Tokyo, 2004.

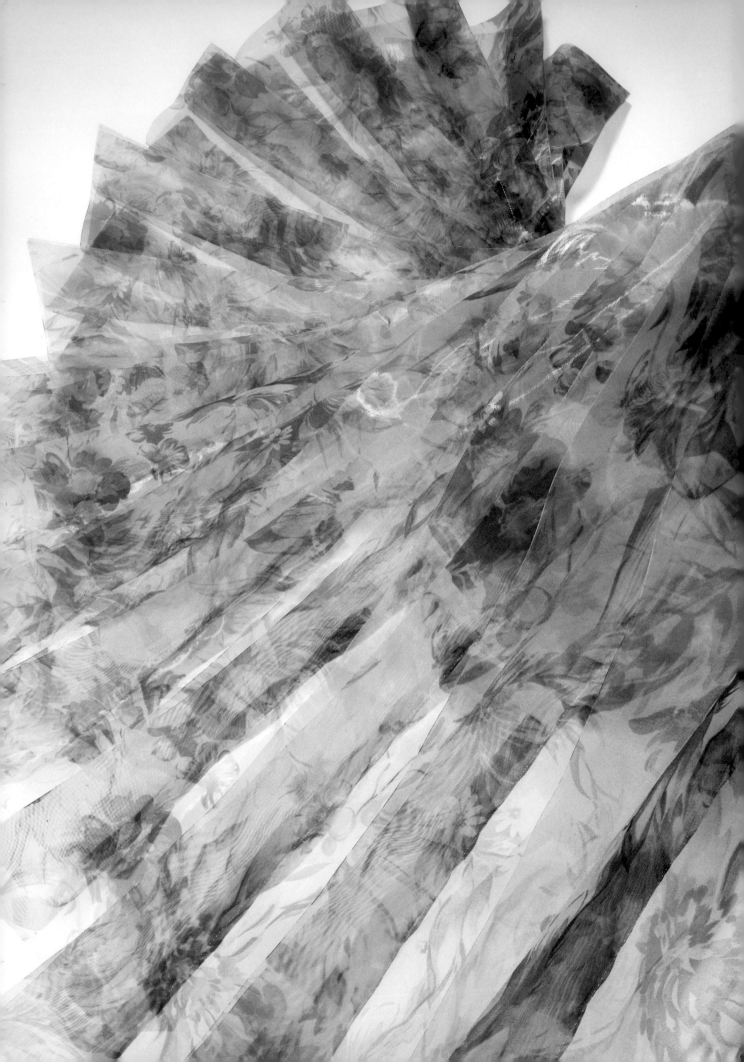

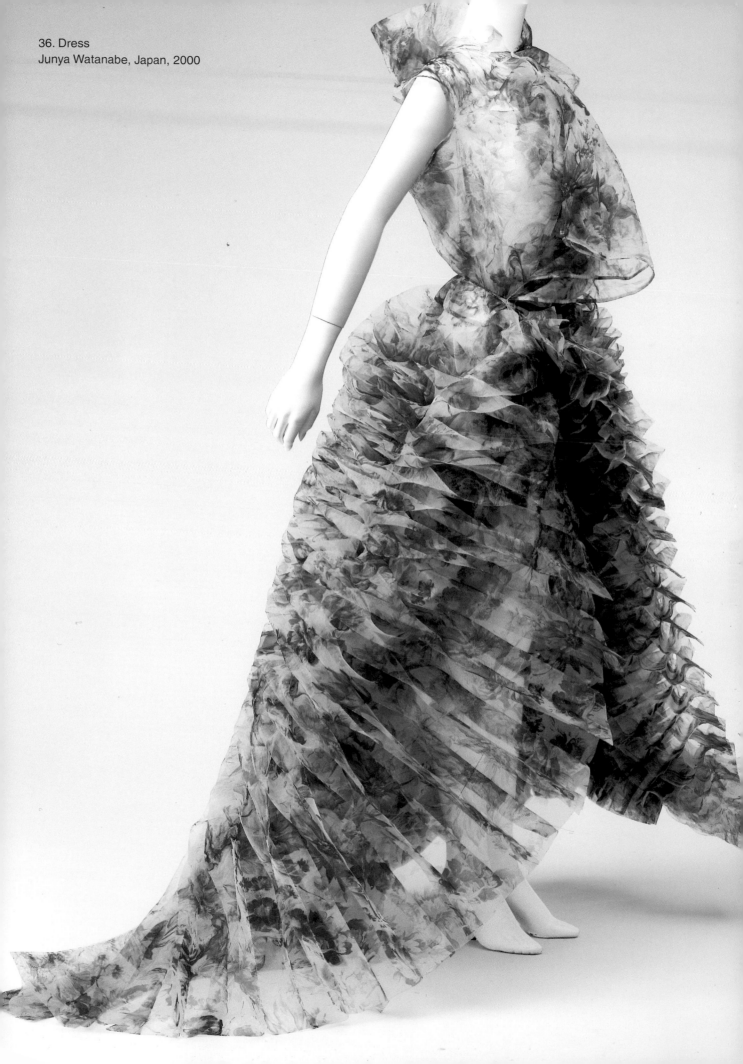

36. Dress
Junya Watanabe, Japan, 2000

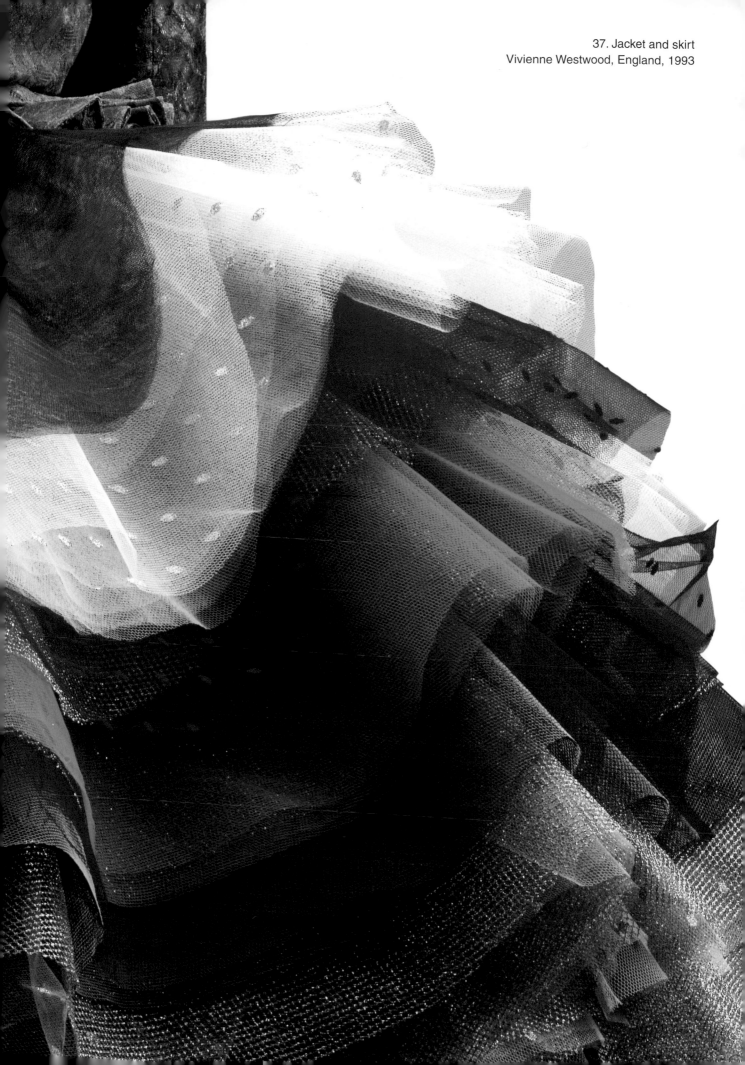

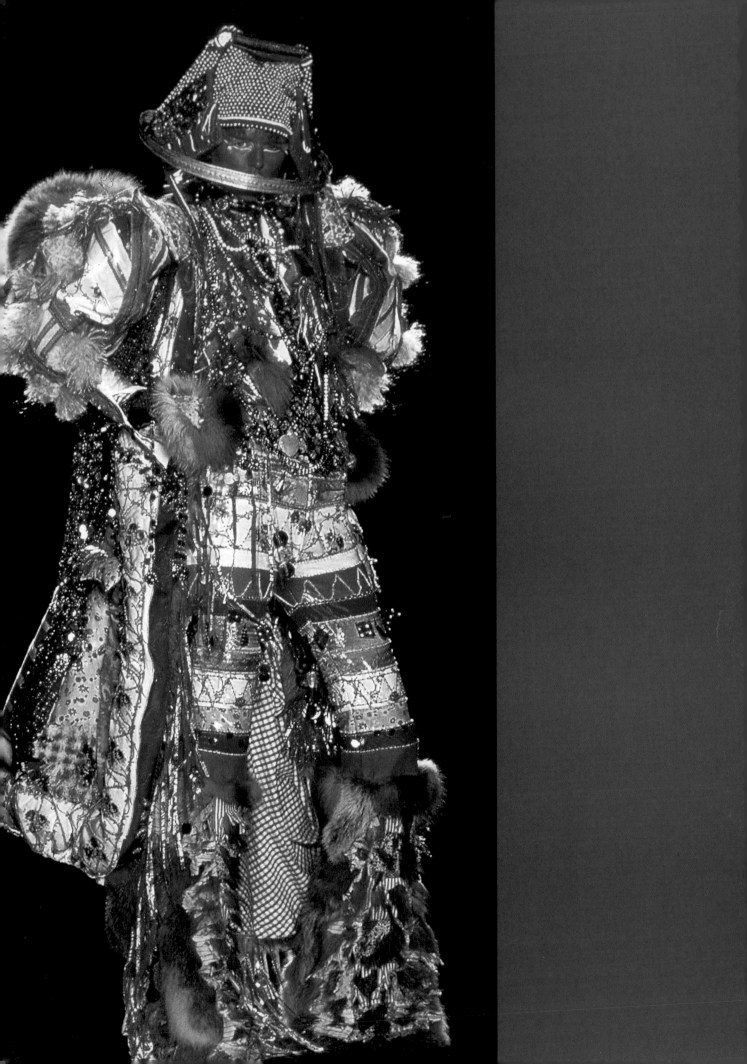

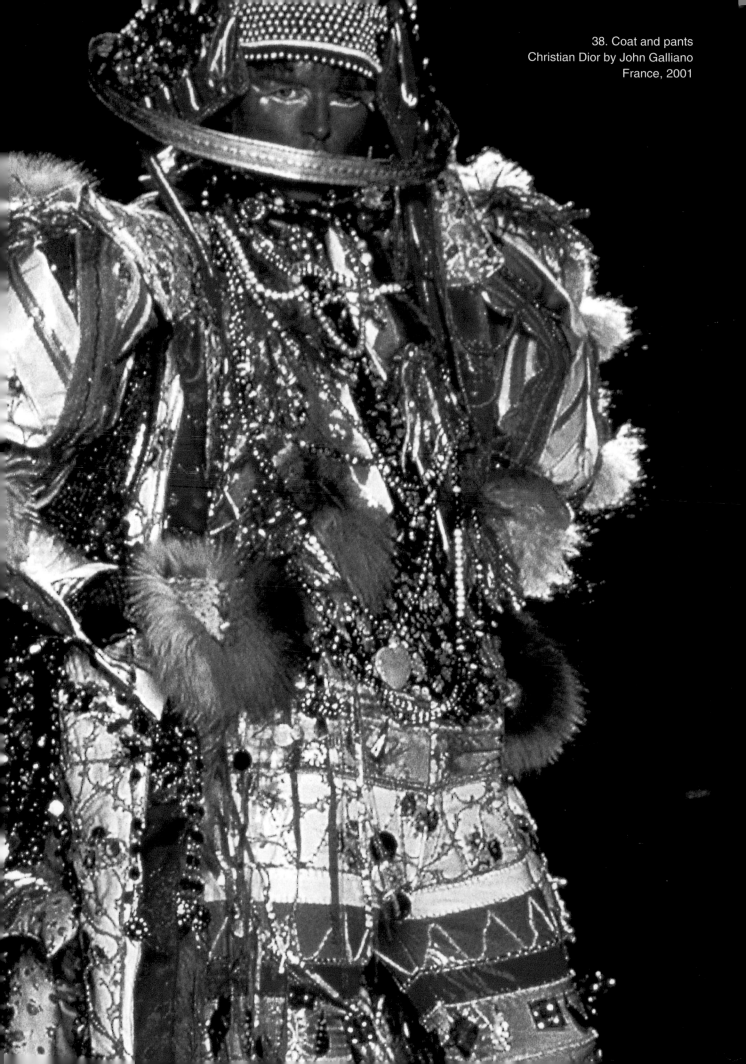

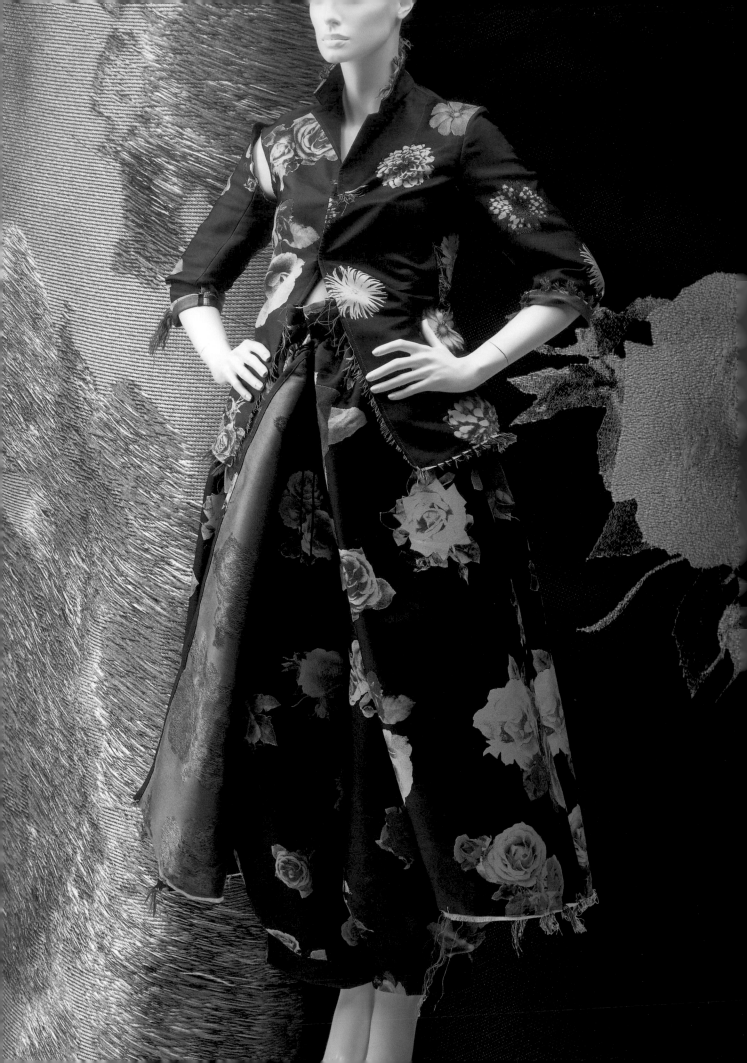

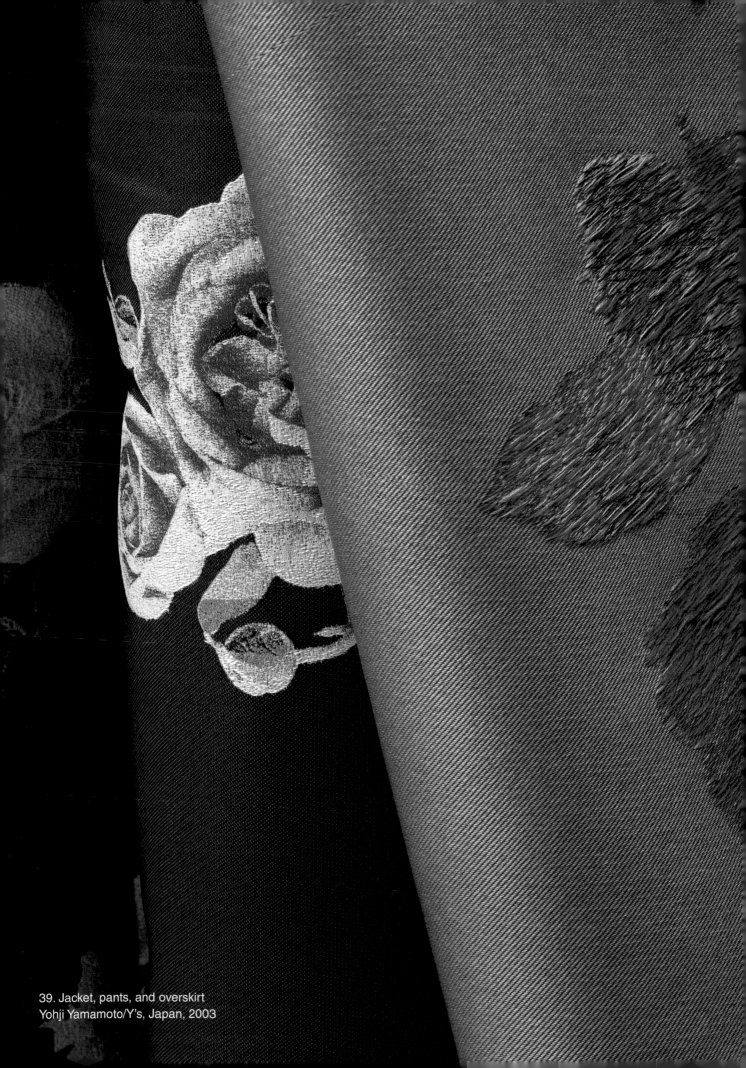

39. Jacket, pants, and overskirt
Yohji Yamamoto/Y's, Japan, 2003

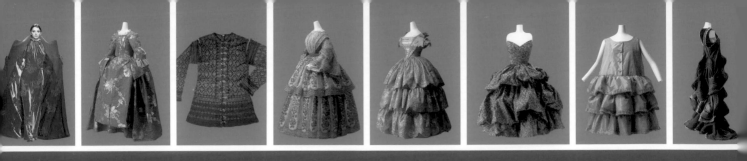

B L

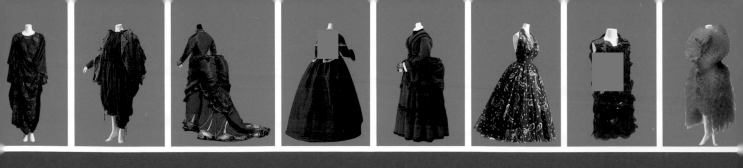

U

E

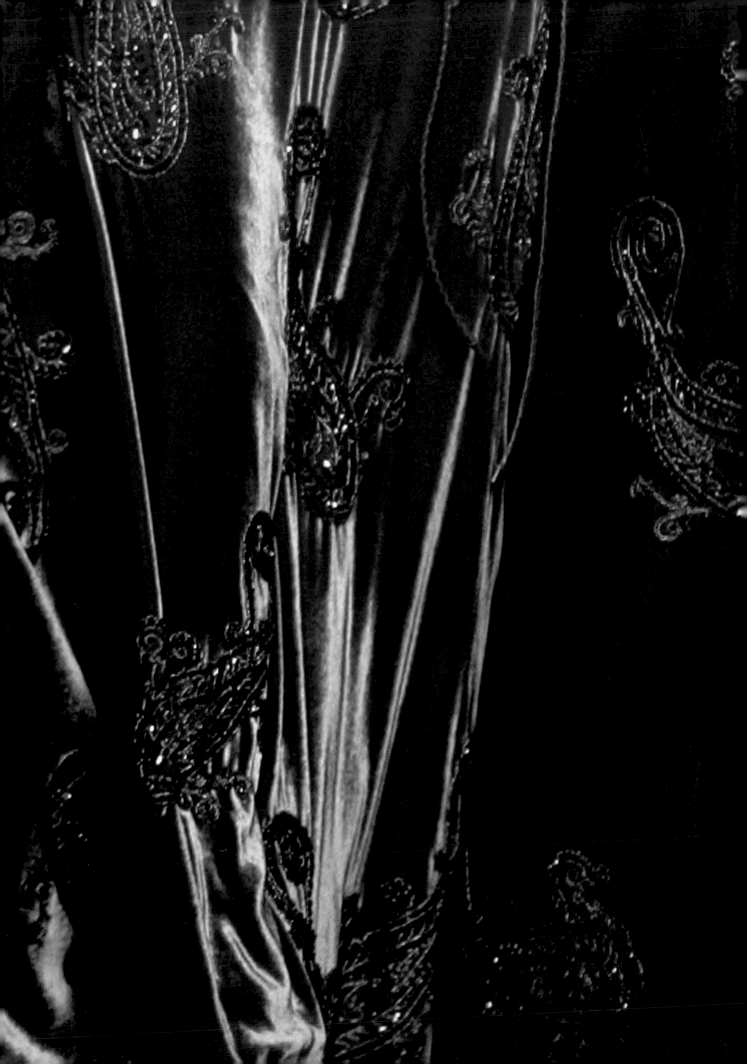

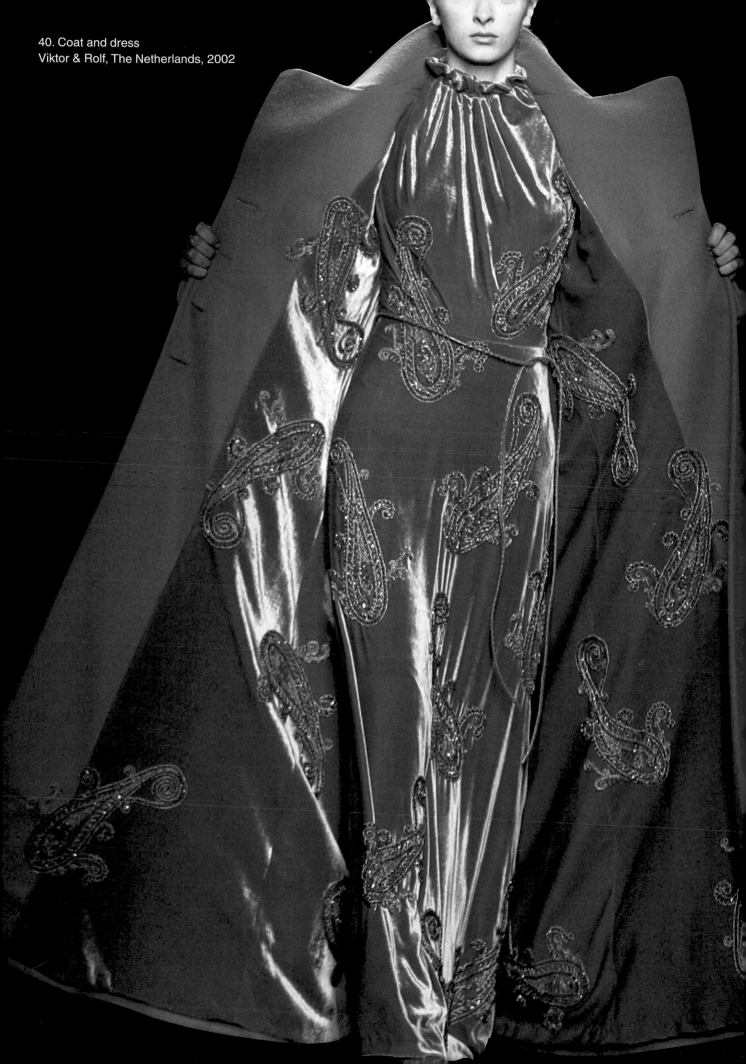

40. Coat and dress
Viktor & Rolf, The Netherlands, 2002

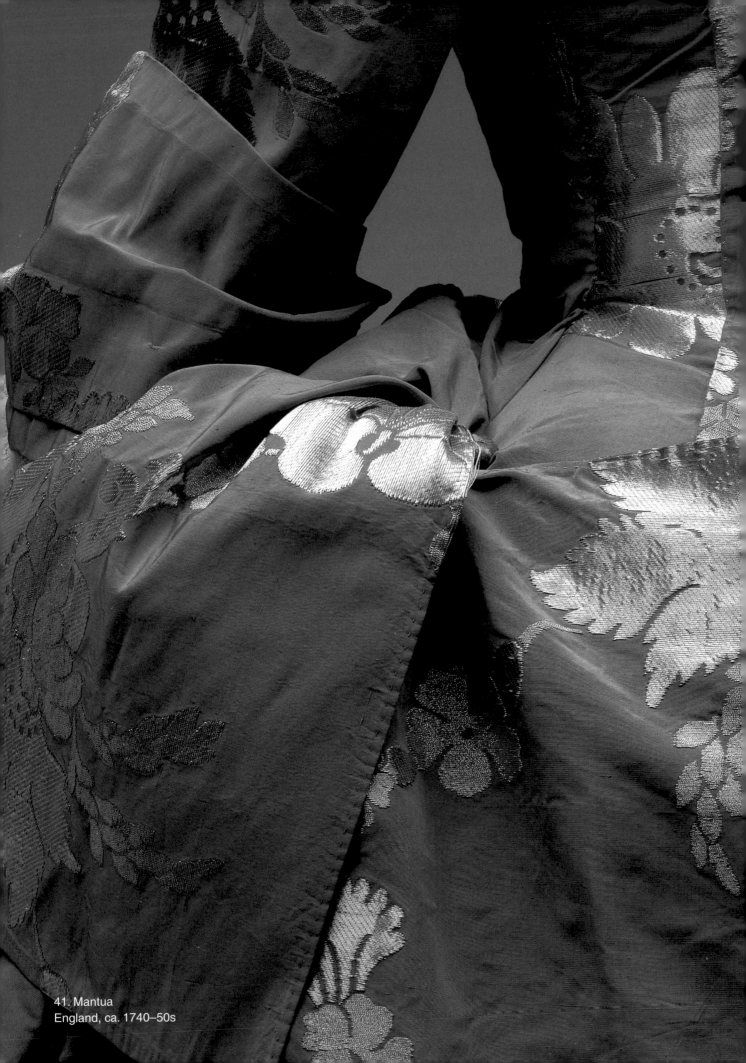

41. Mantua
England, ca. 1740–50s

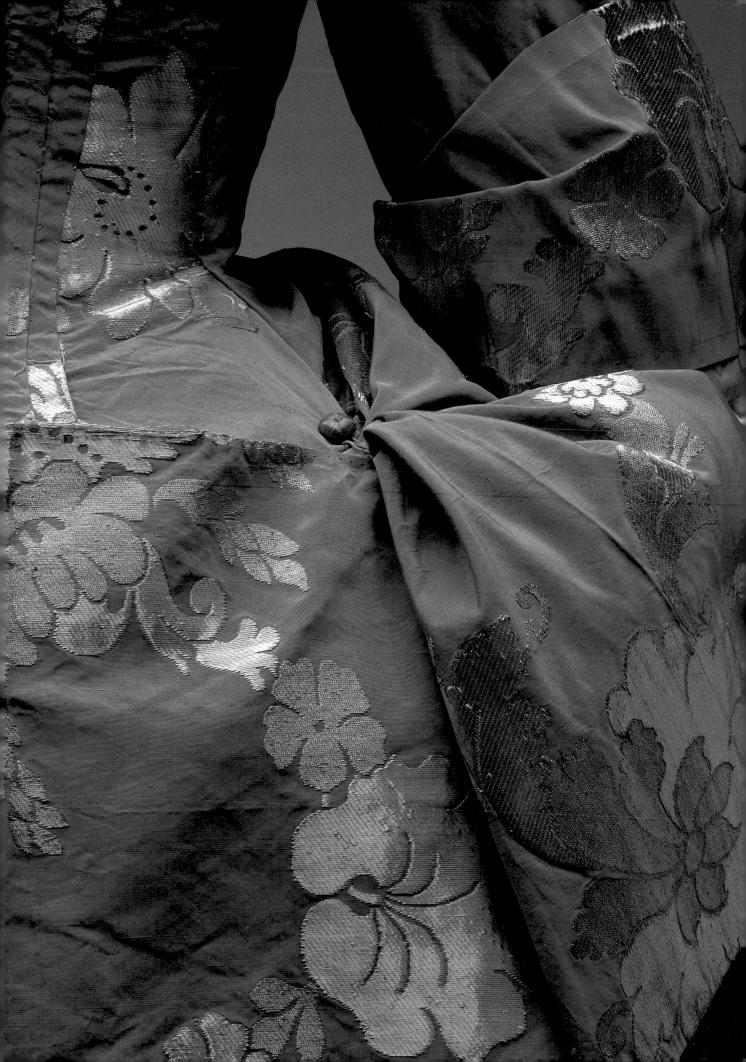

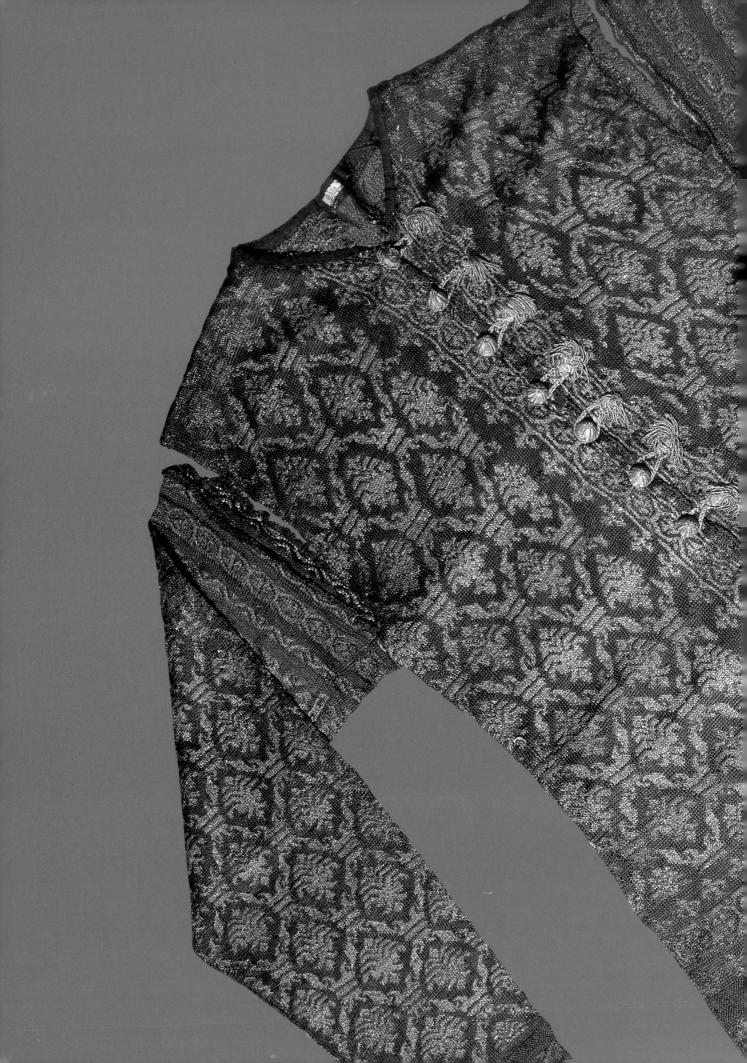

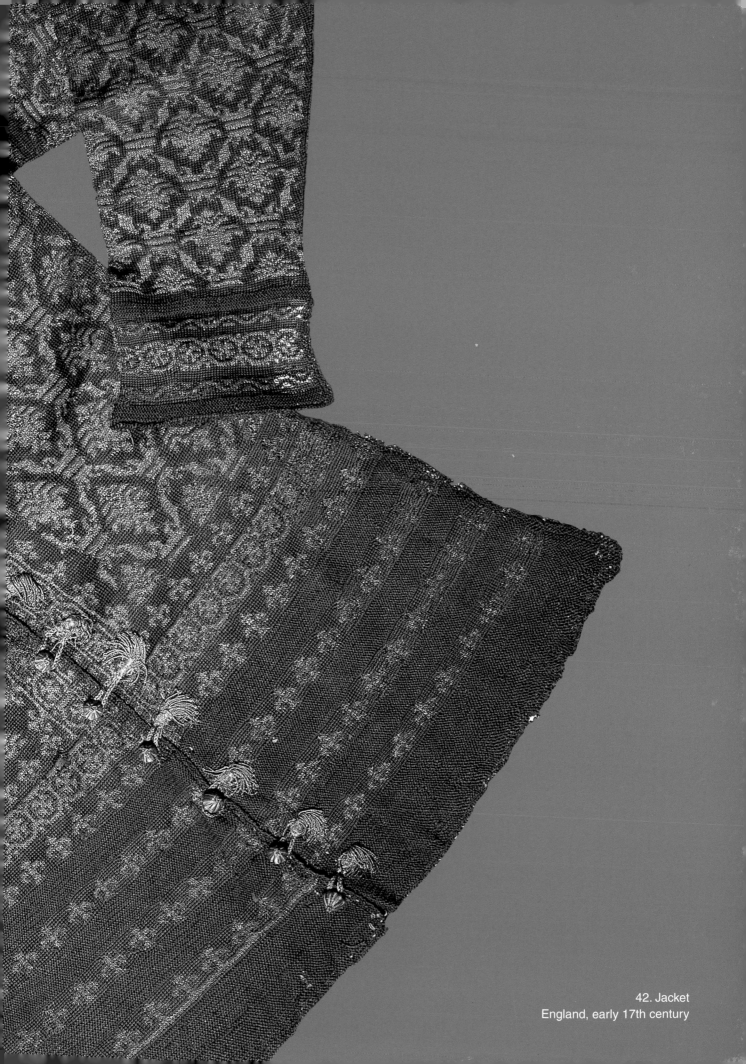

42. Jacket
England, early 17th century

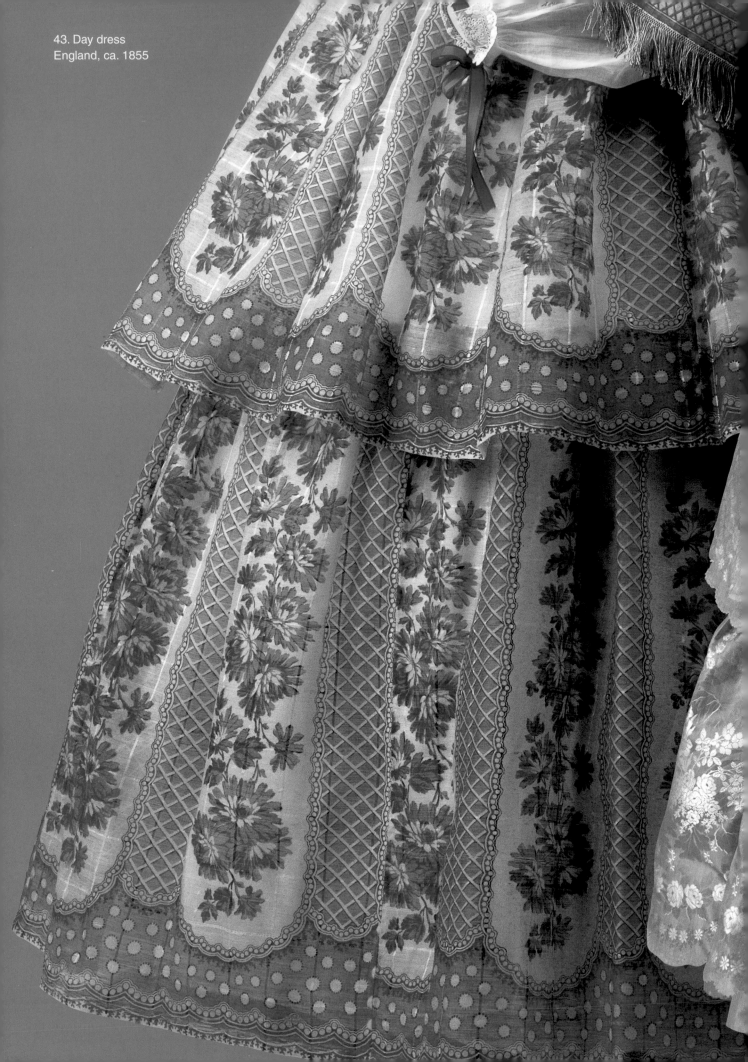

43. Day dress
England, ca. 1855

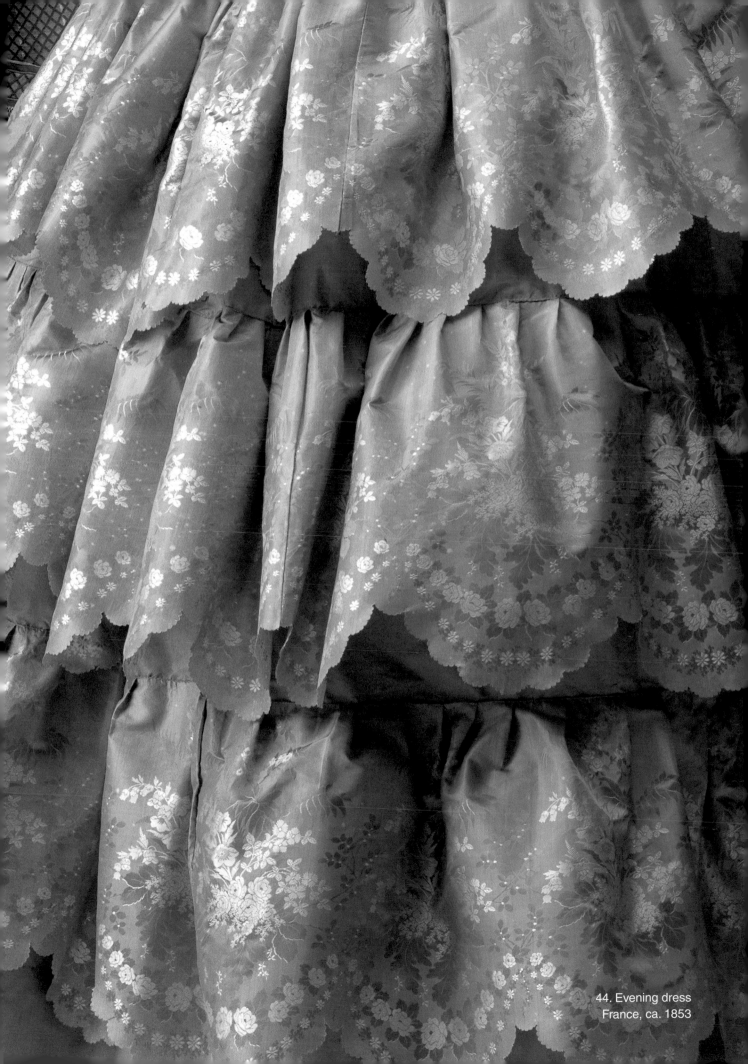

44. Evening dress
France, ca. 1853

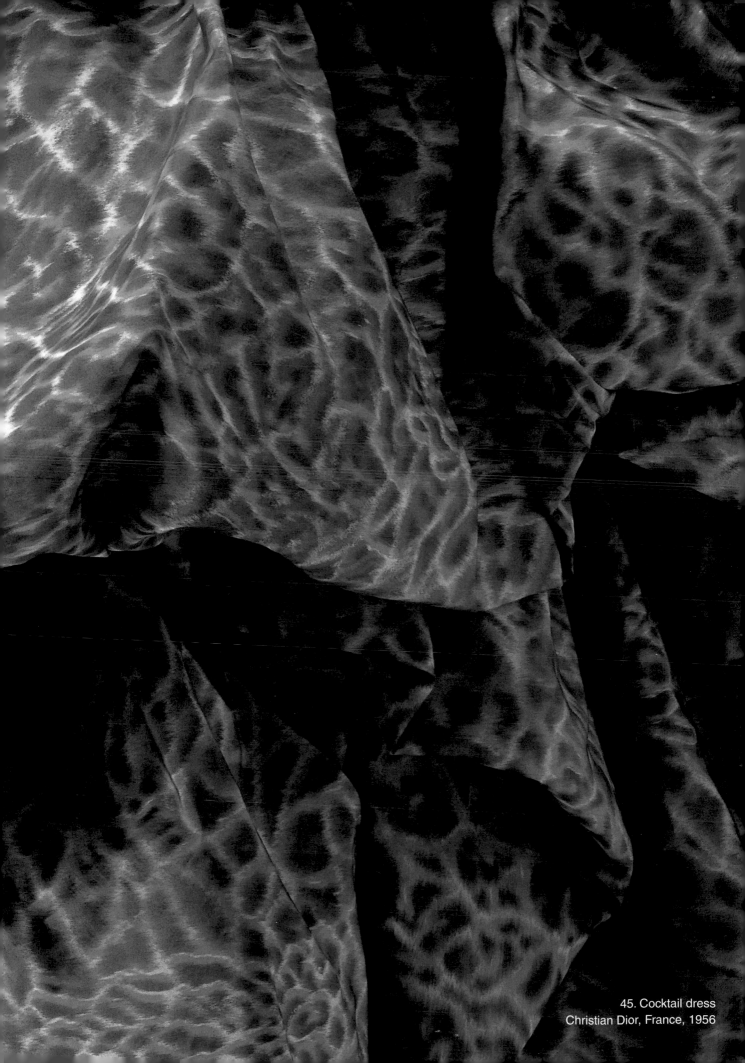

45. Cocktail dress
Christian Dior, France, 1956

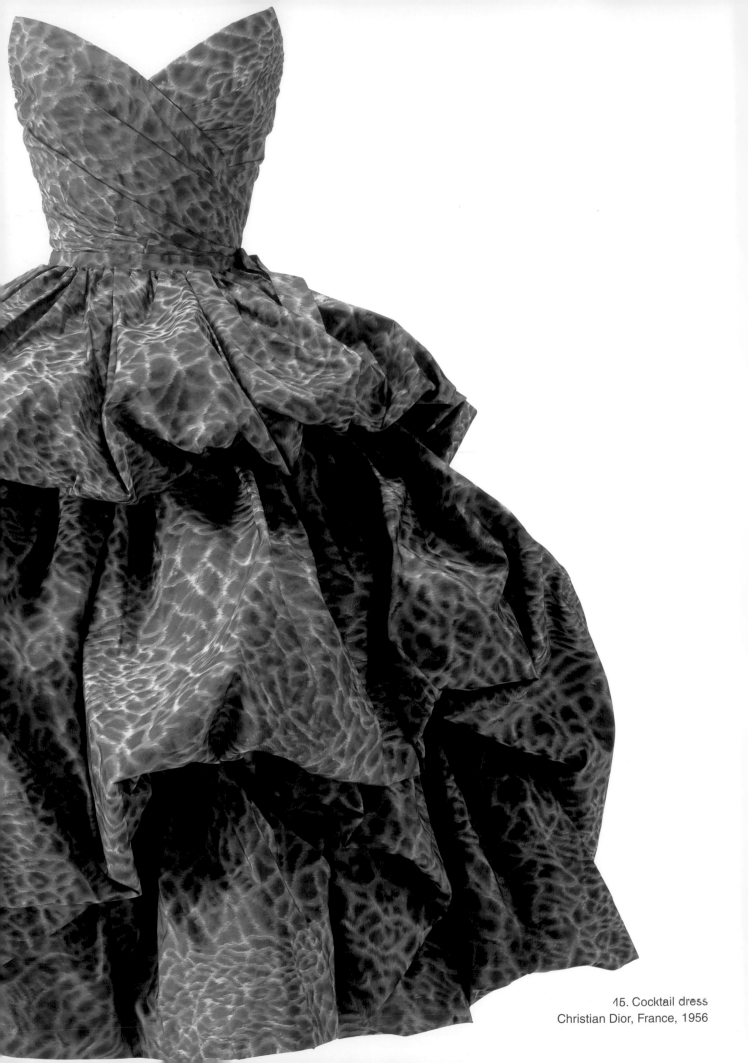

15. Cocktail dress
Christian Dior, France, 1956

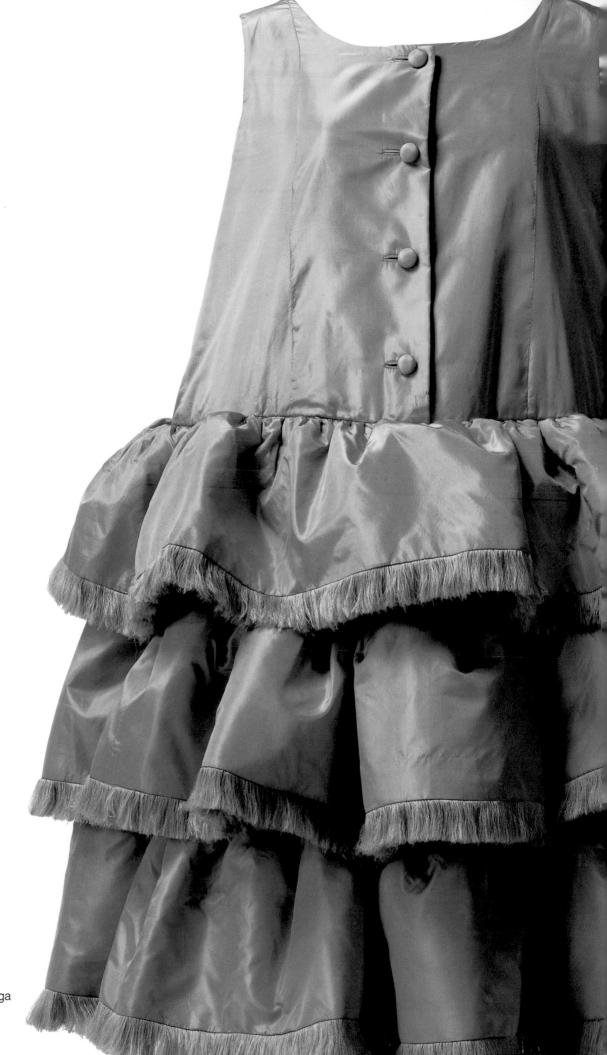

46. Cocktail dress
Cristobal Balenciaga
France, 1959

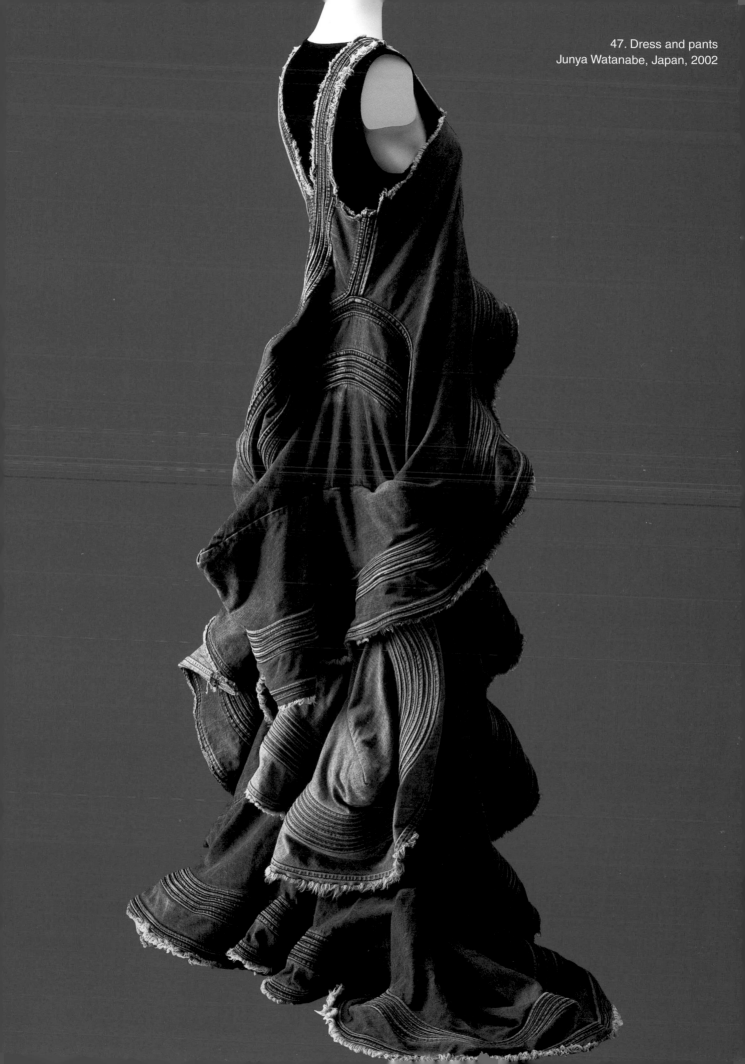

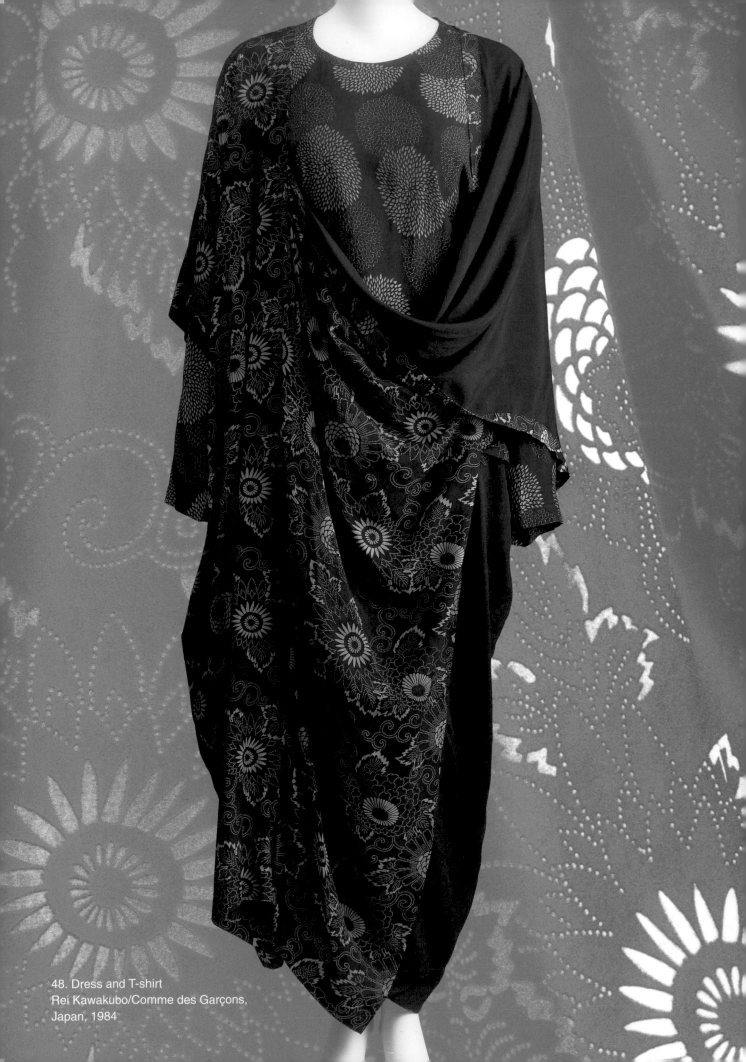

48. Dress and T-shirt
Rei Kawakubo/Comme des Garçons,
Japan, 1984

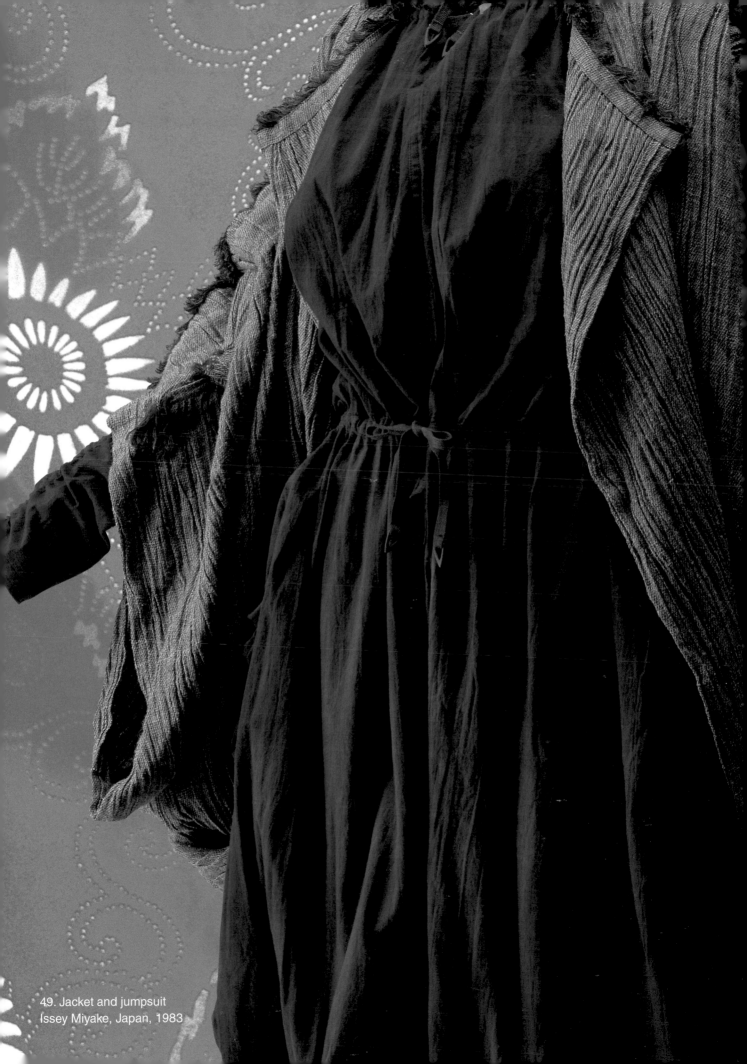

49. Jacket and jumpsuit
Issey Miyake, Japan, 1983

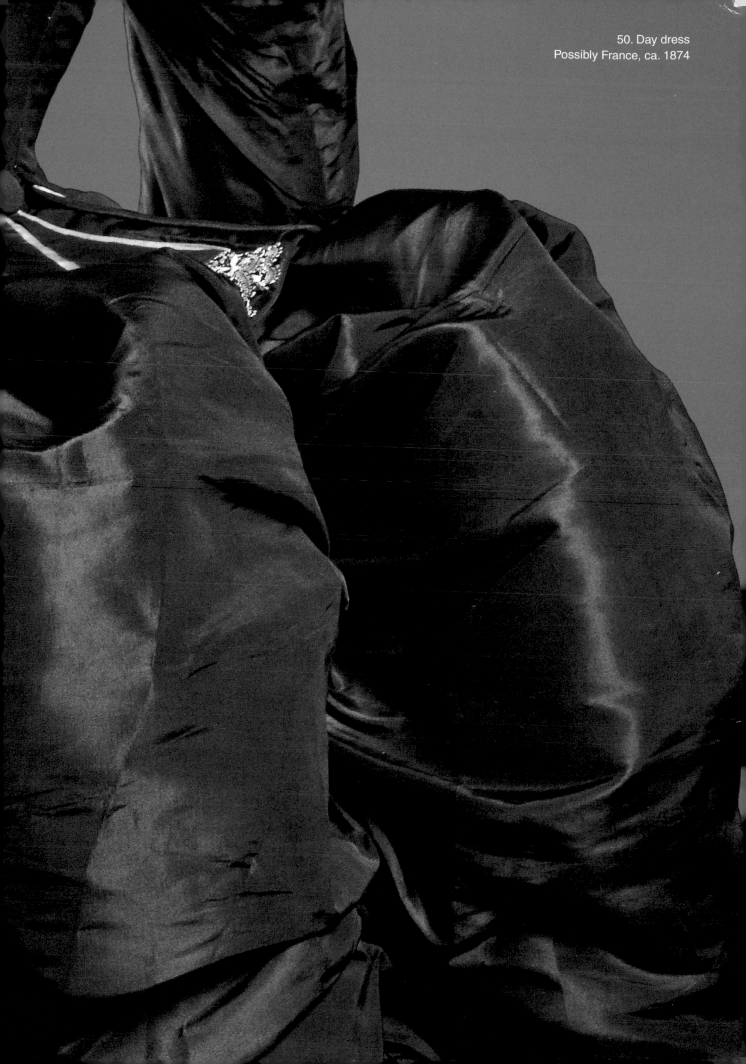

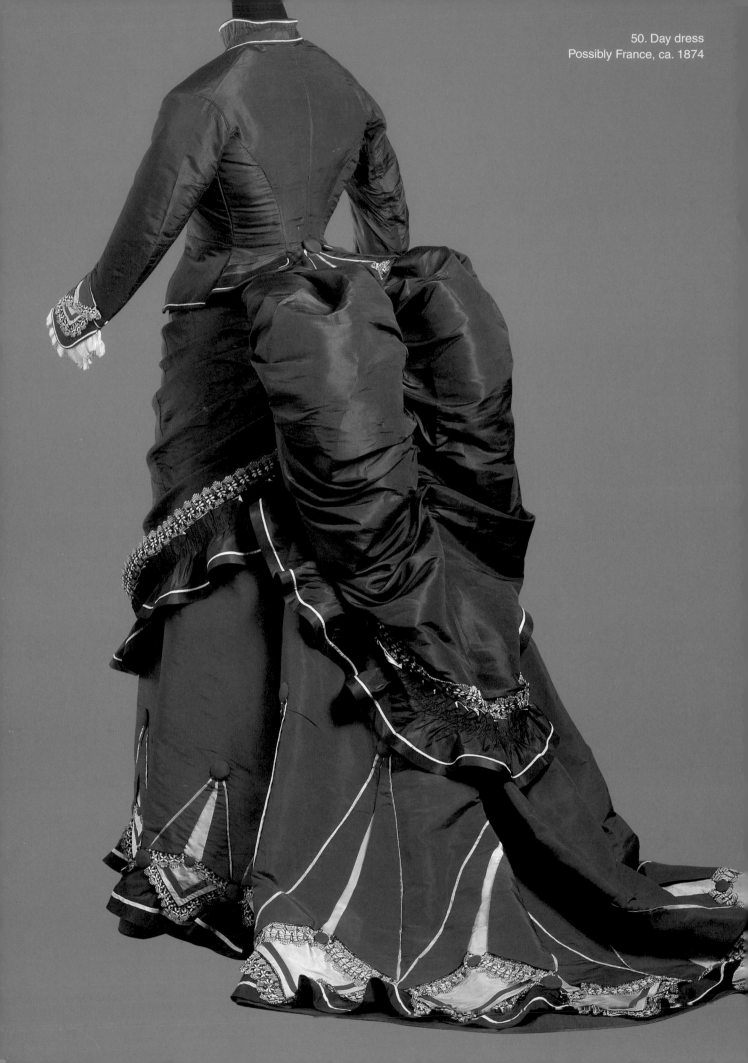

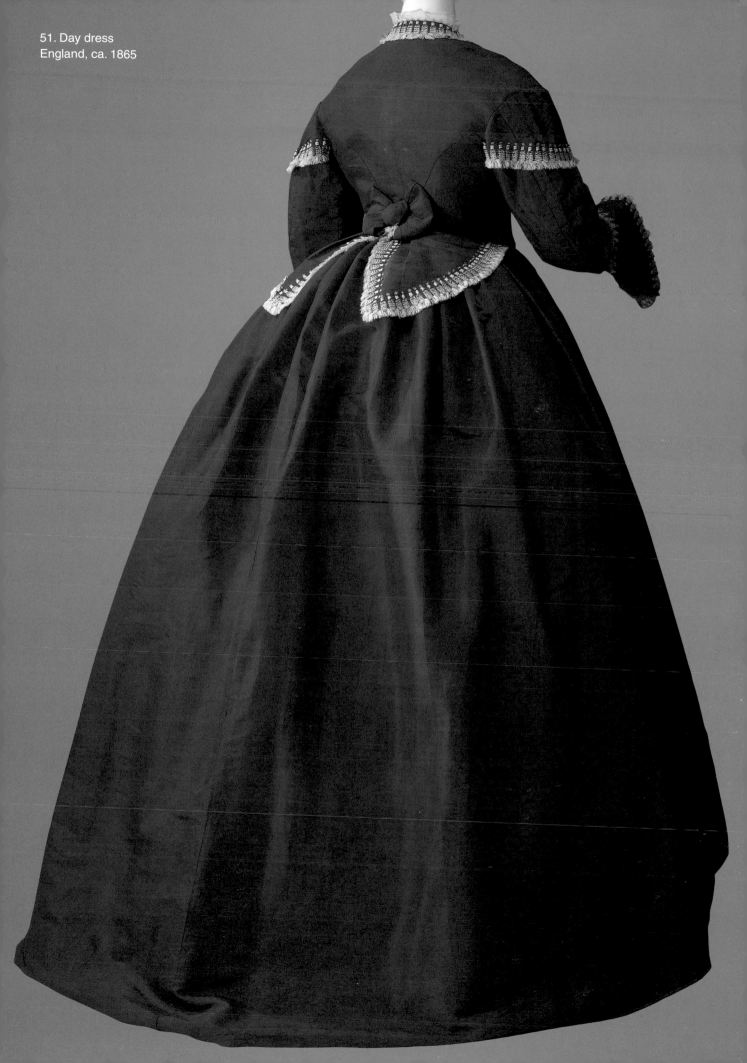

51. Day dress
England, ca. 1865

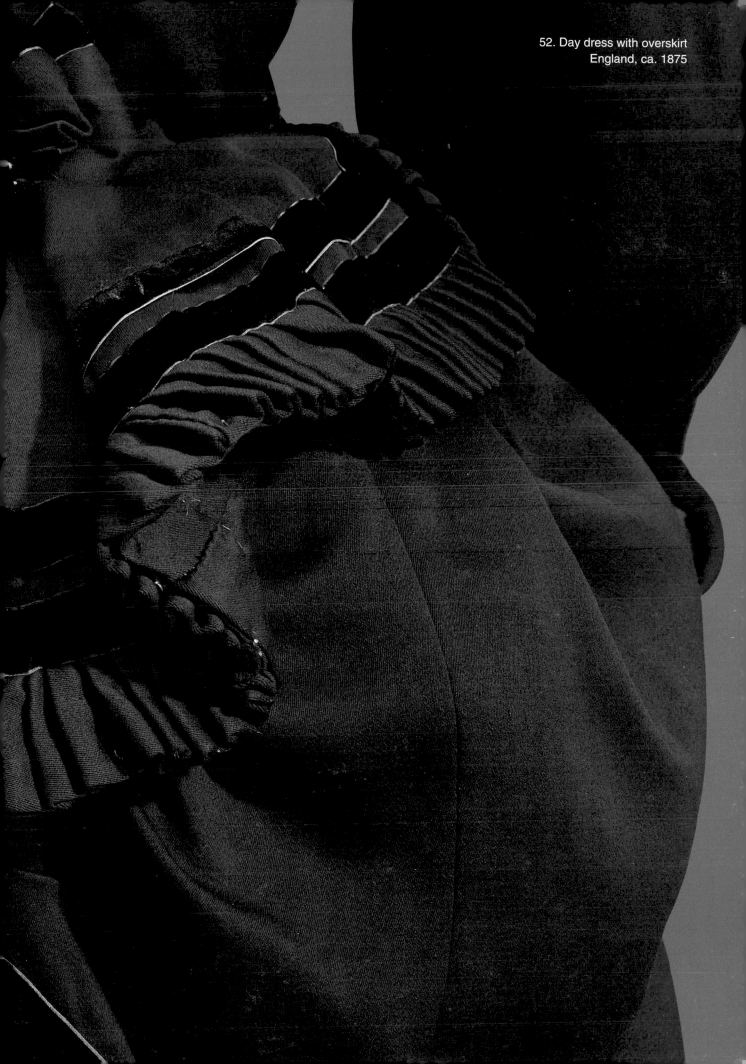

52. Day dress with overskirt
England, ca. 1875

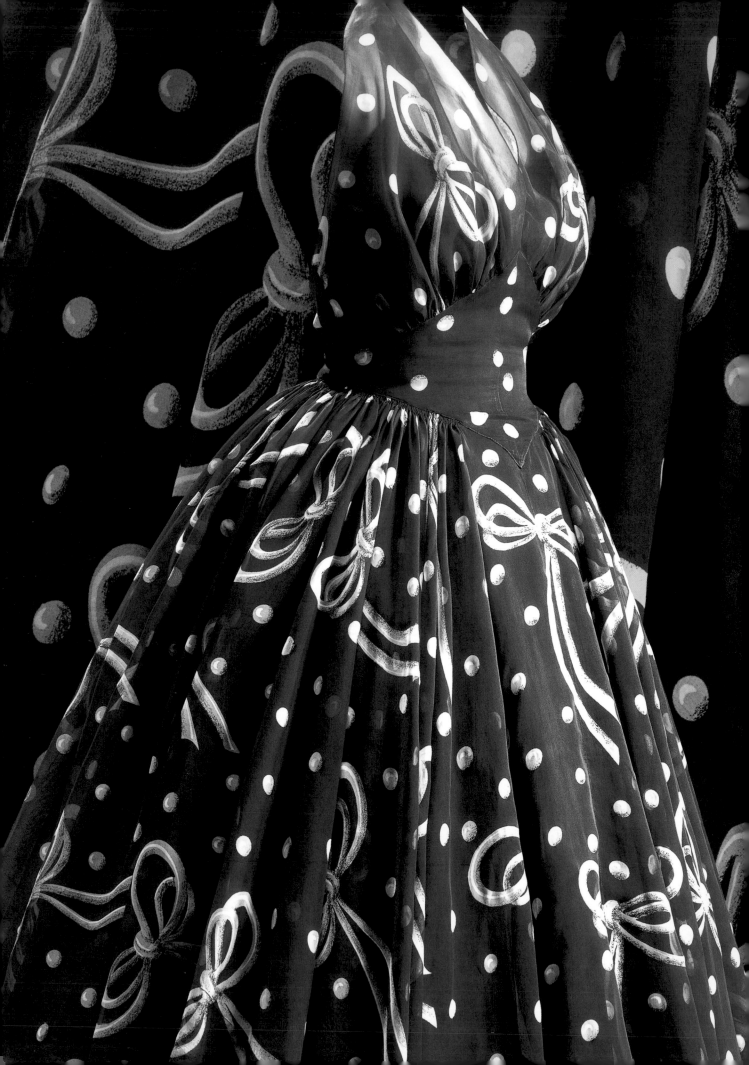

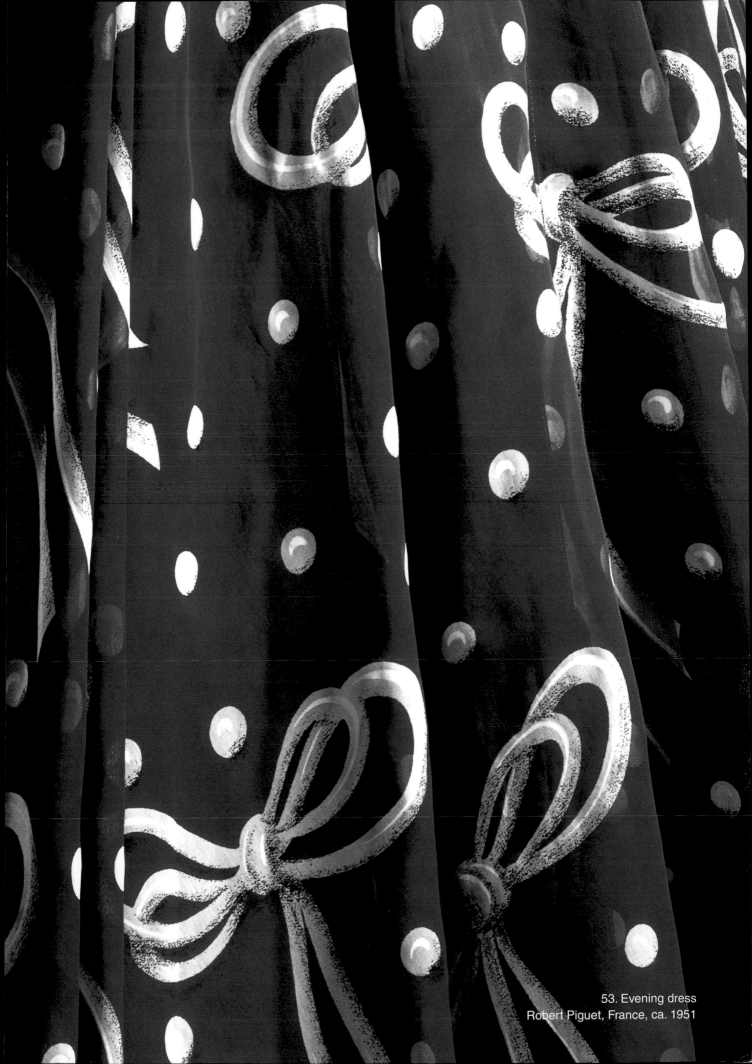

53. Evening dress
Robert Piguet, France, ca. 1951

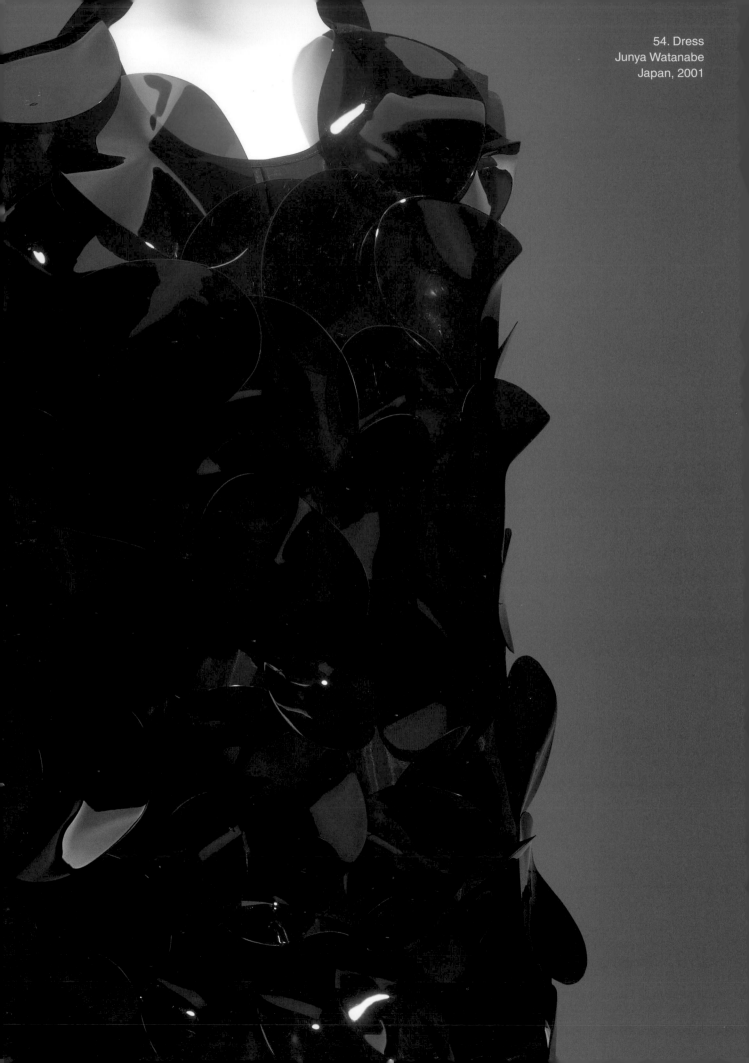

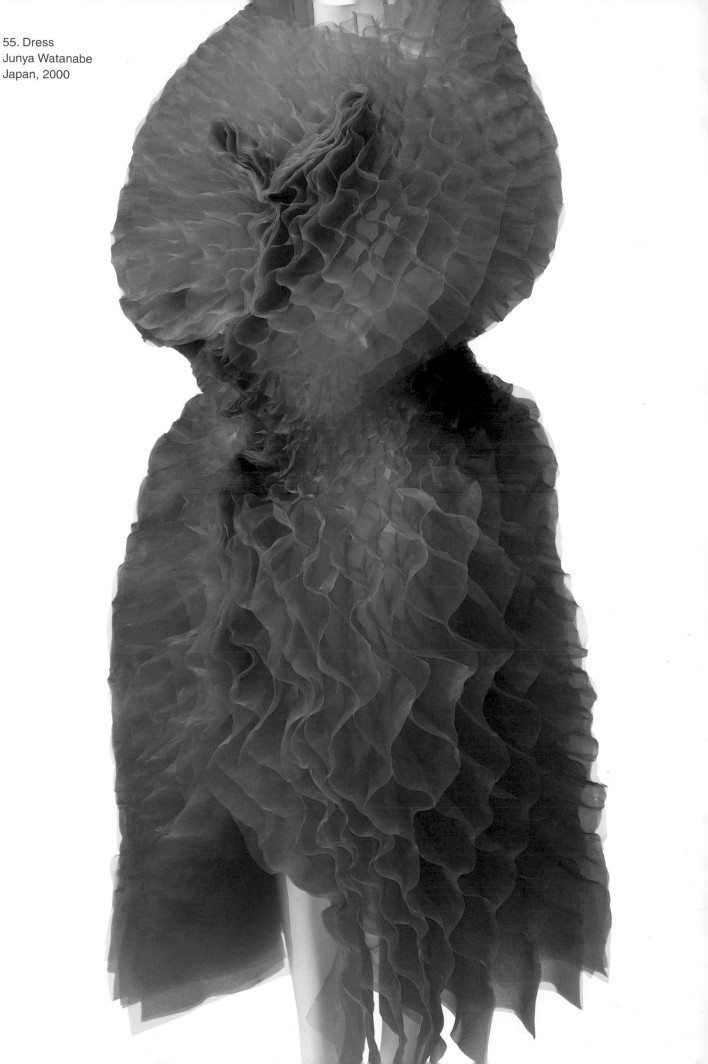

55. Dress
Junya Watanabe, Japan, 2000

R E D &

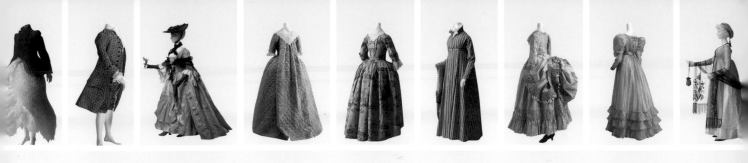

YELLOW

56. Jacket and skirt
Viktor & Rolf
The Netherlands, 1998

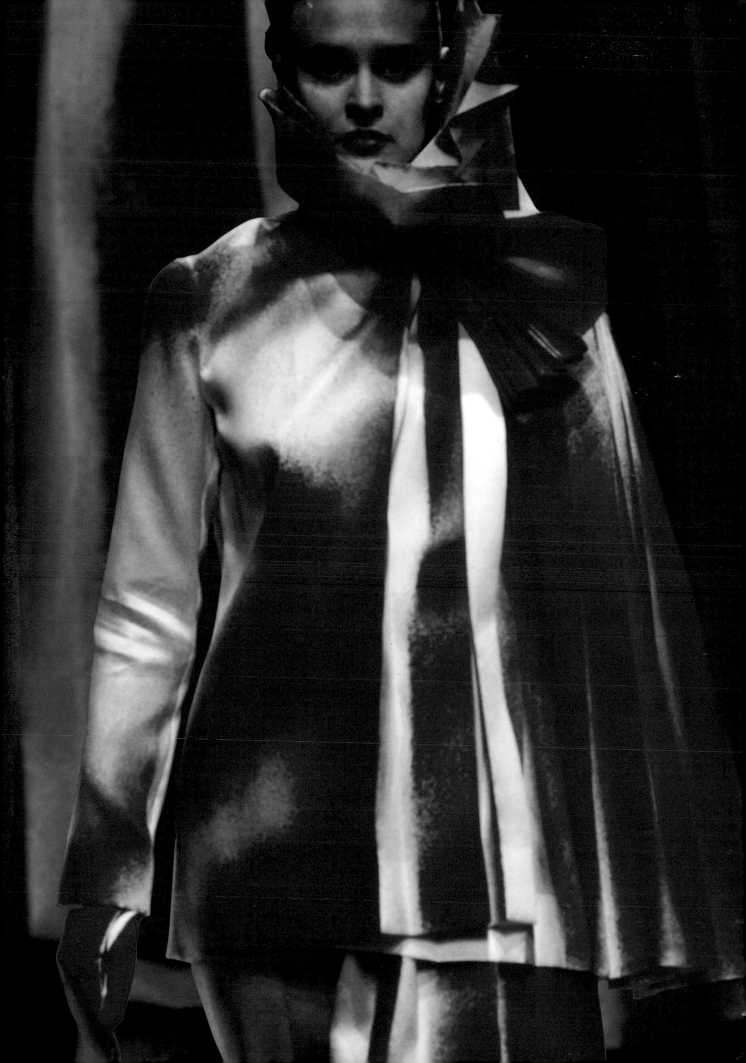

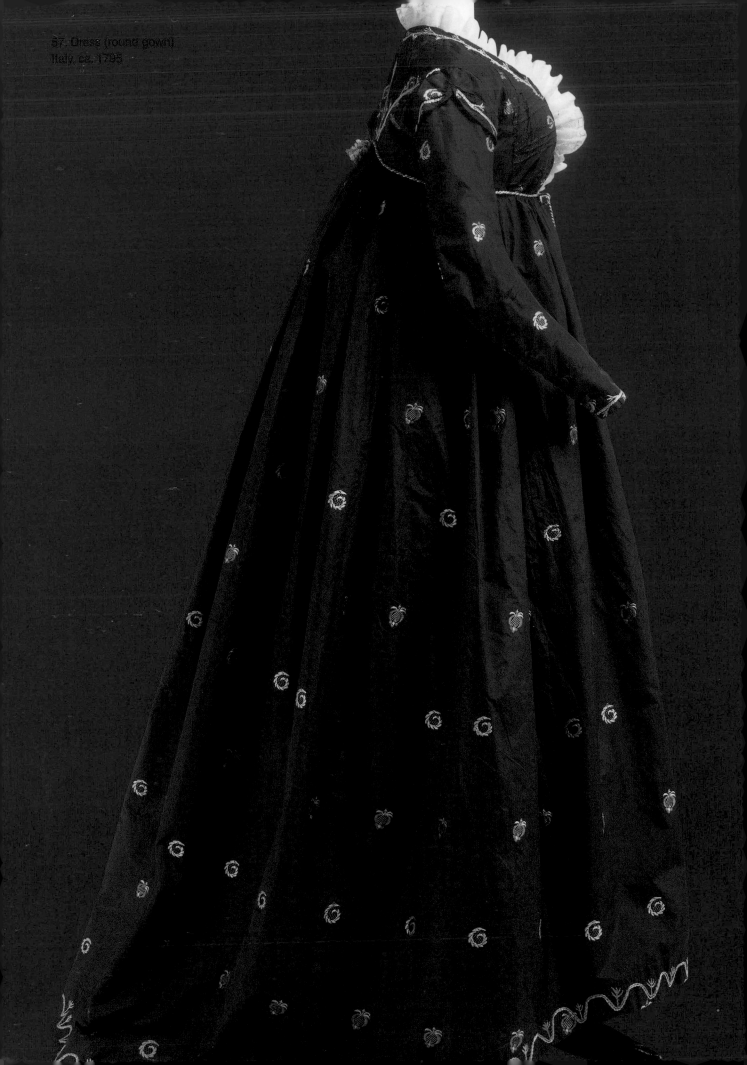

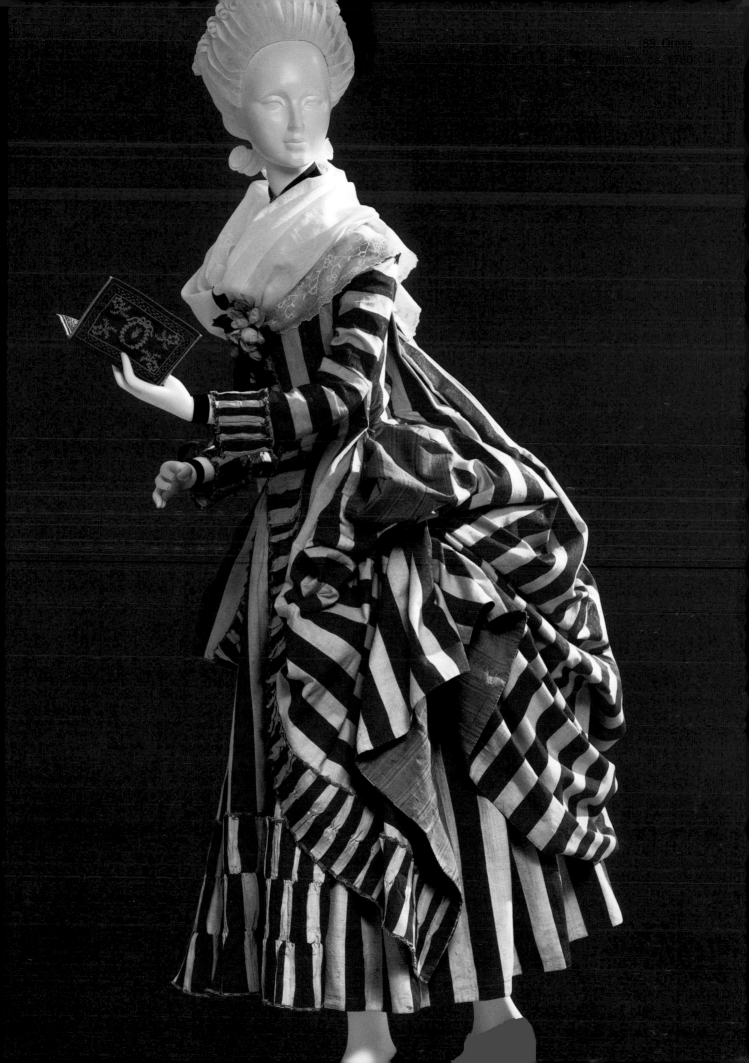

5. Dress, France.

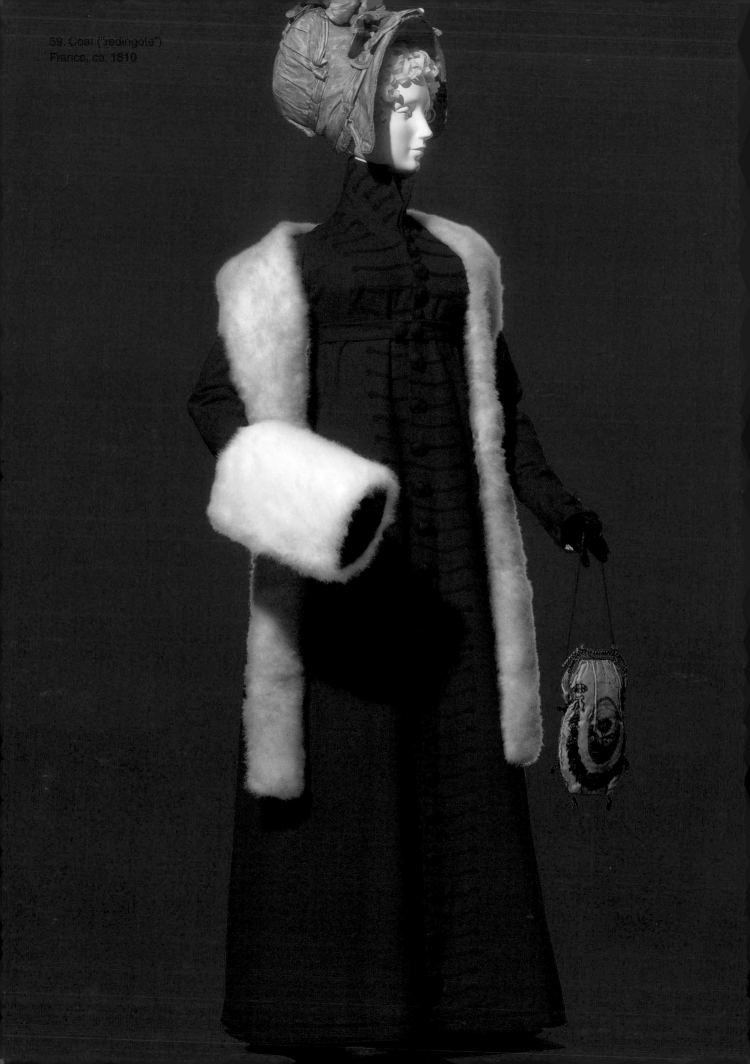

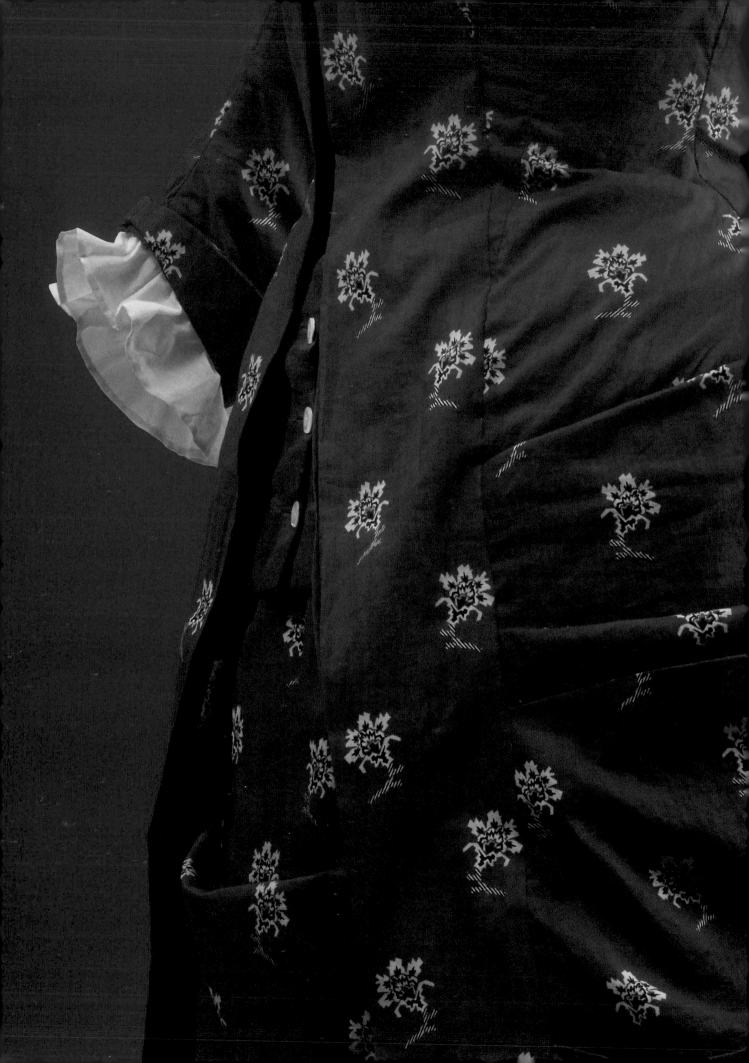

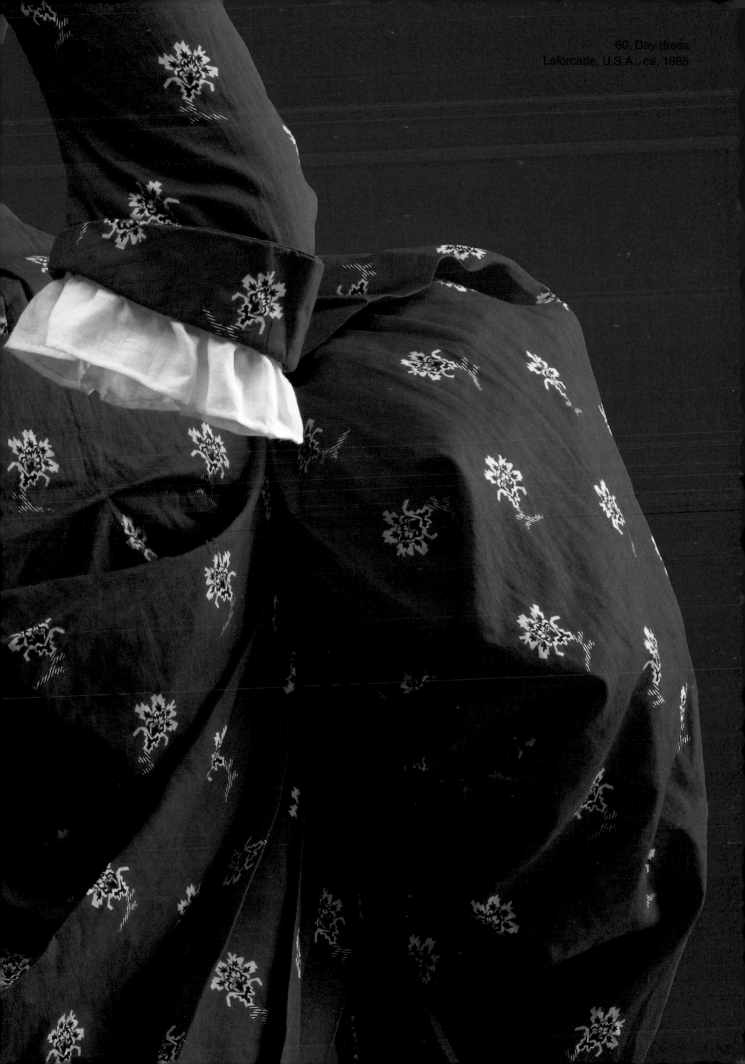

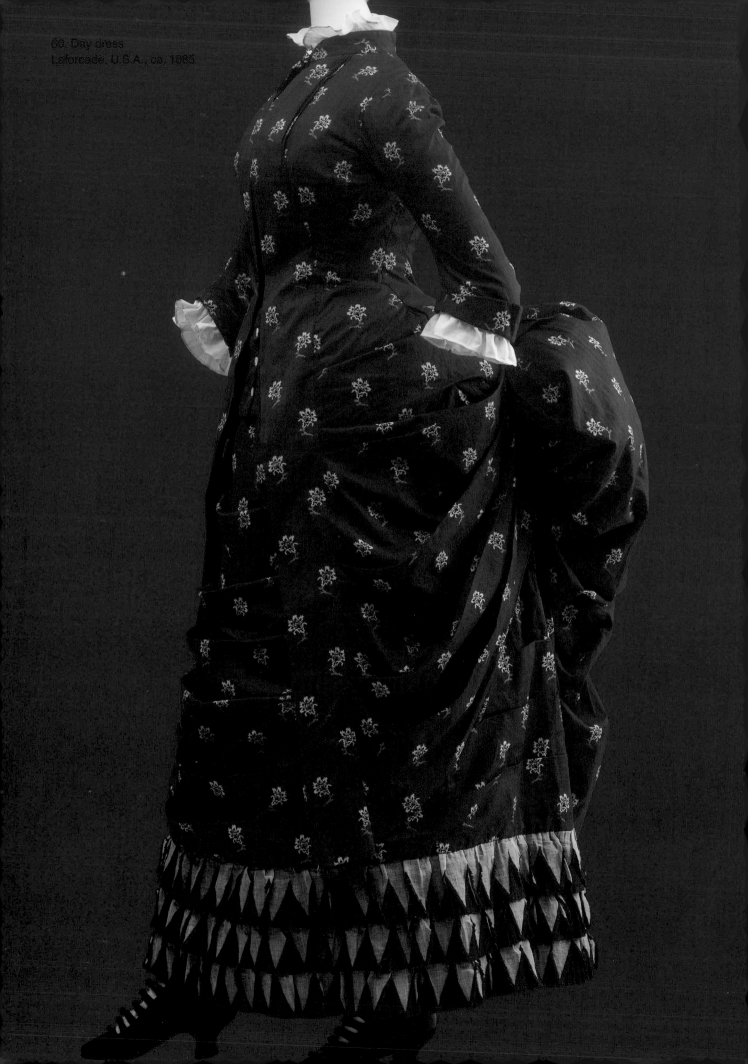

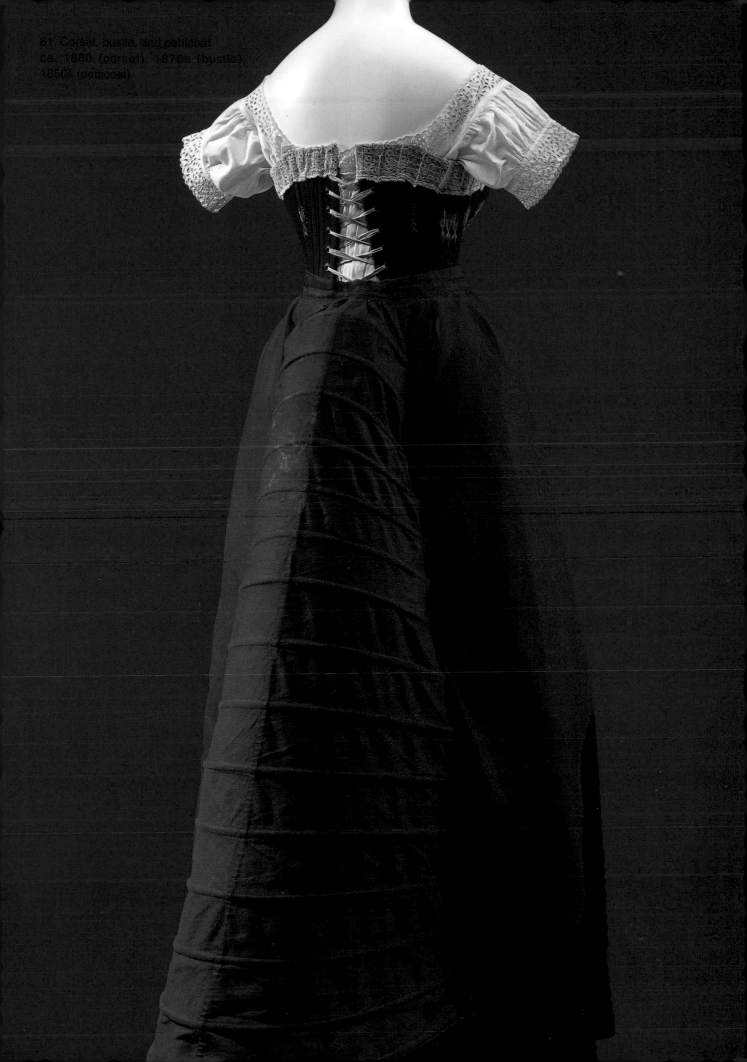

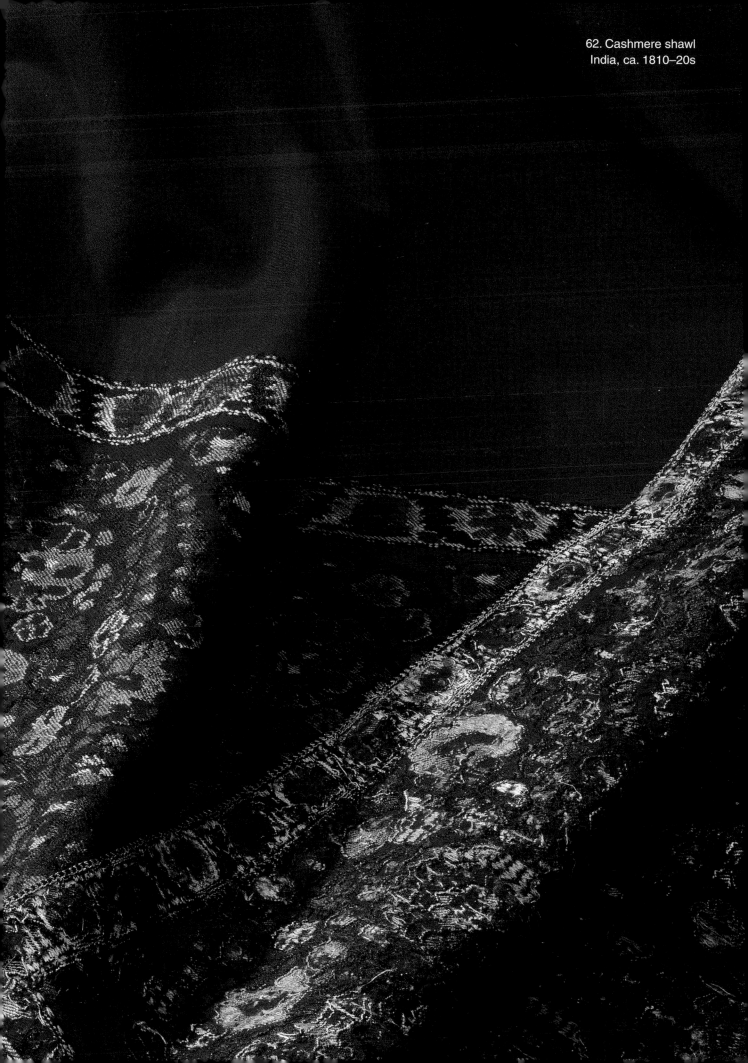

62. Cashmere shawl
India, ca. 1810–20s

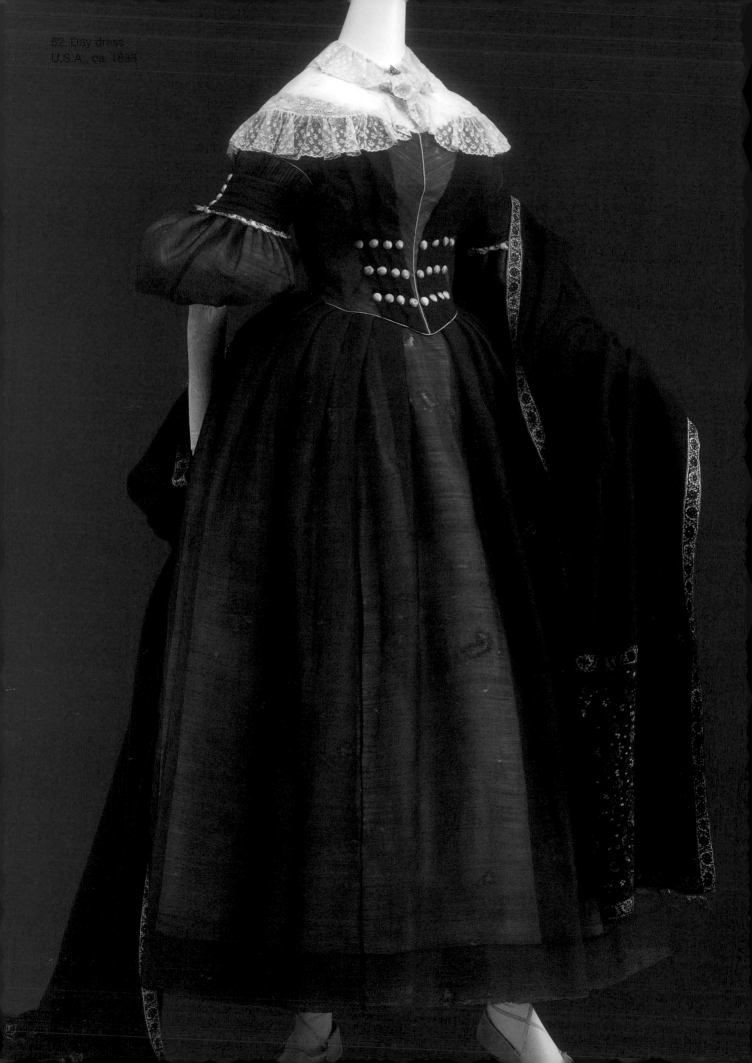

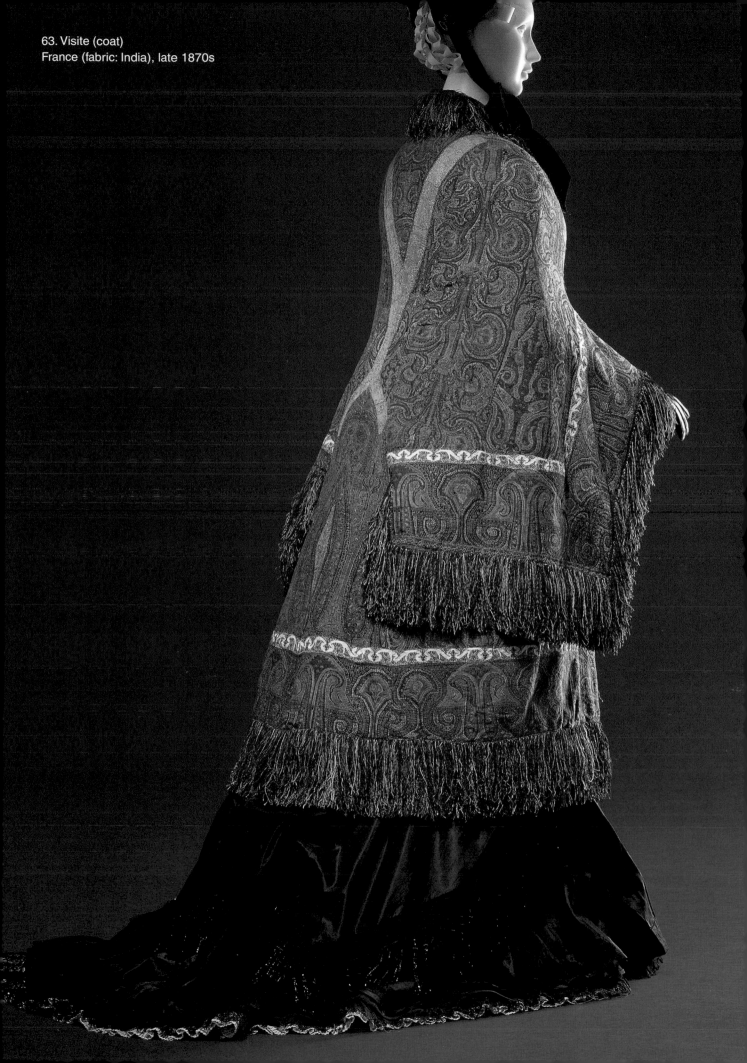

63. Visite (coat)
France (fabric: India), late 1870s

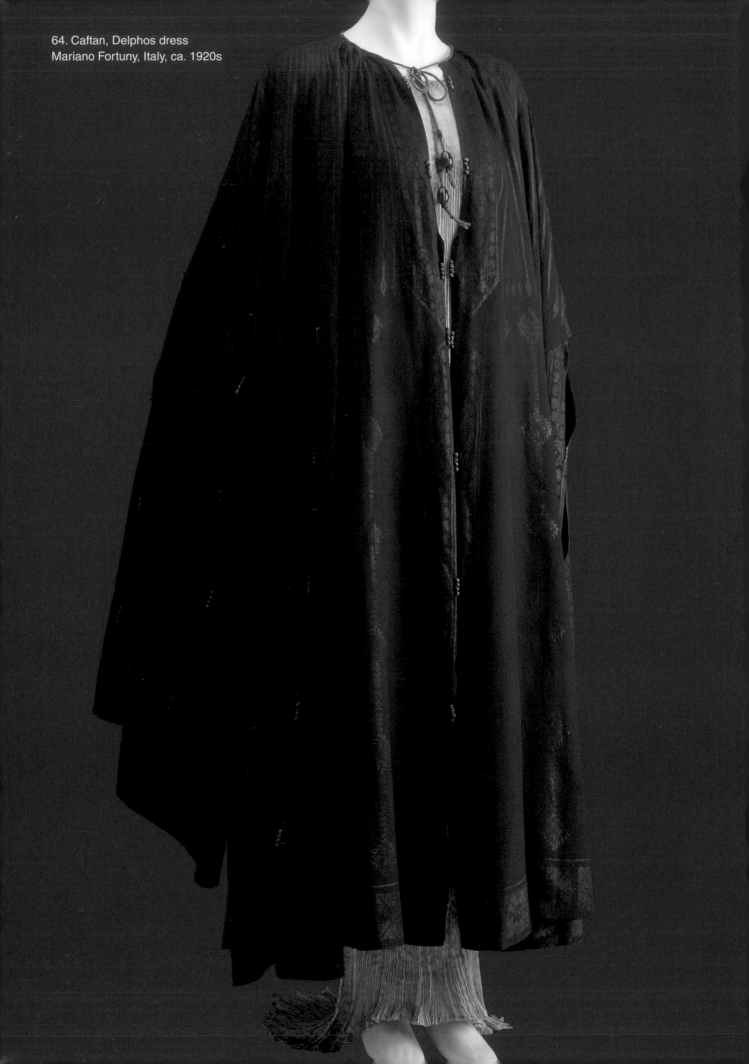

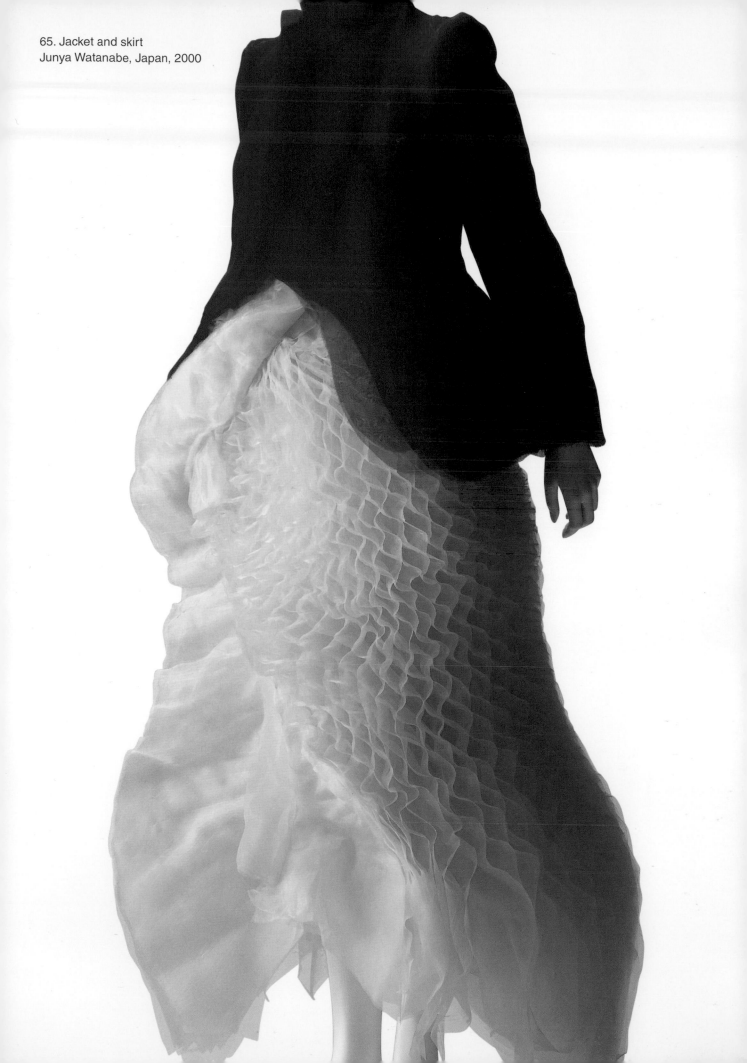

65. Jacket and skirt
Junya Watanabe, Japan, 2000

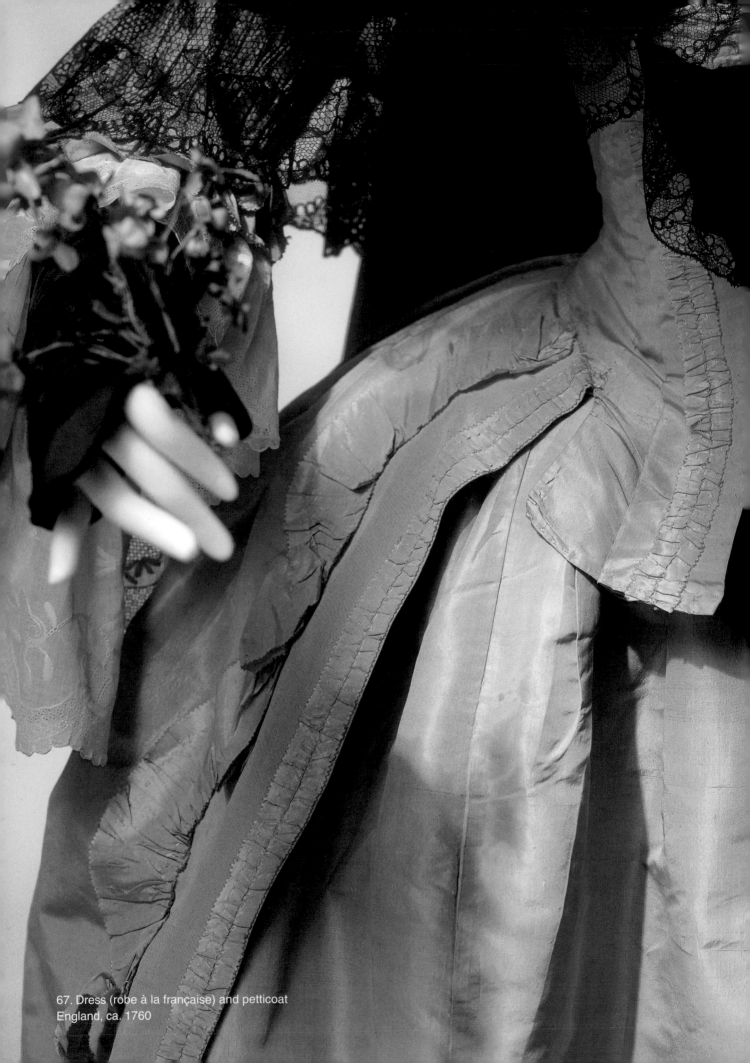

67. Dress (robe à la française) and petticoat
England, ca. 1760

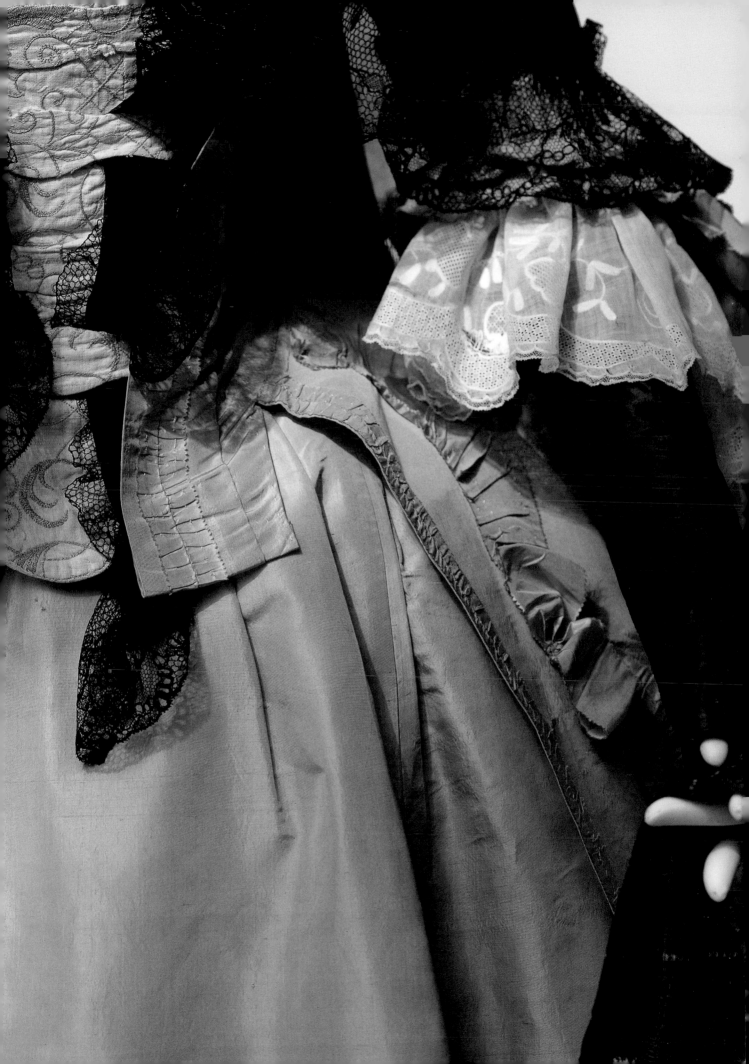

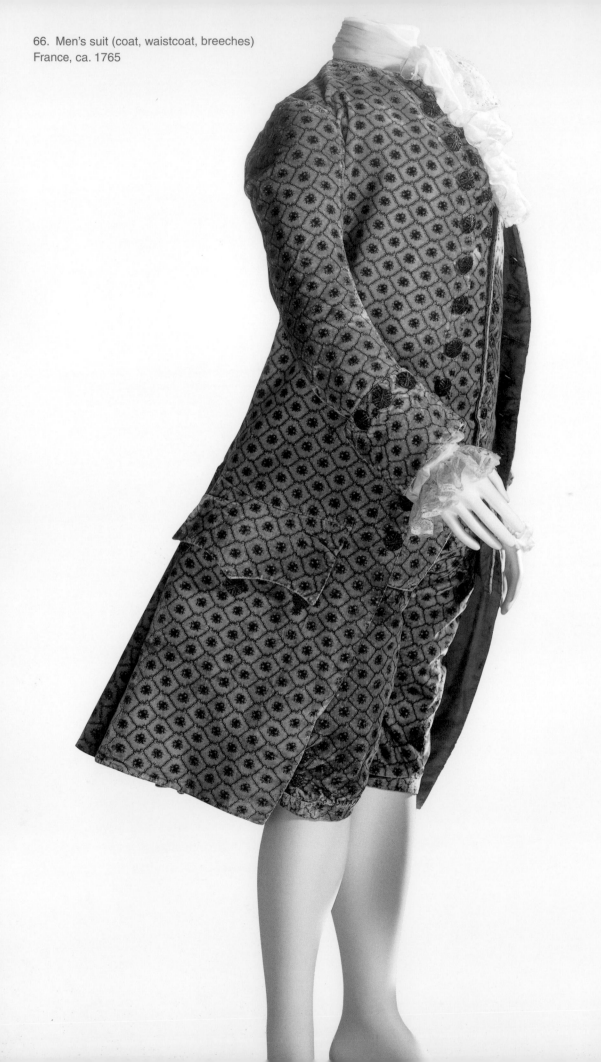

66. Men's suit (coat, waistcoat, breeches)
France, ca. 1765

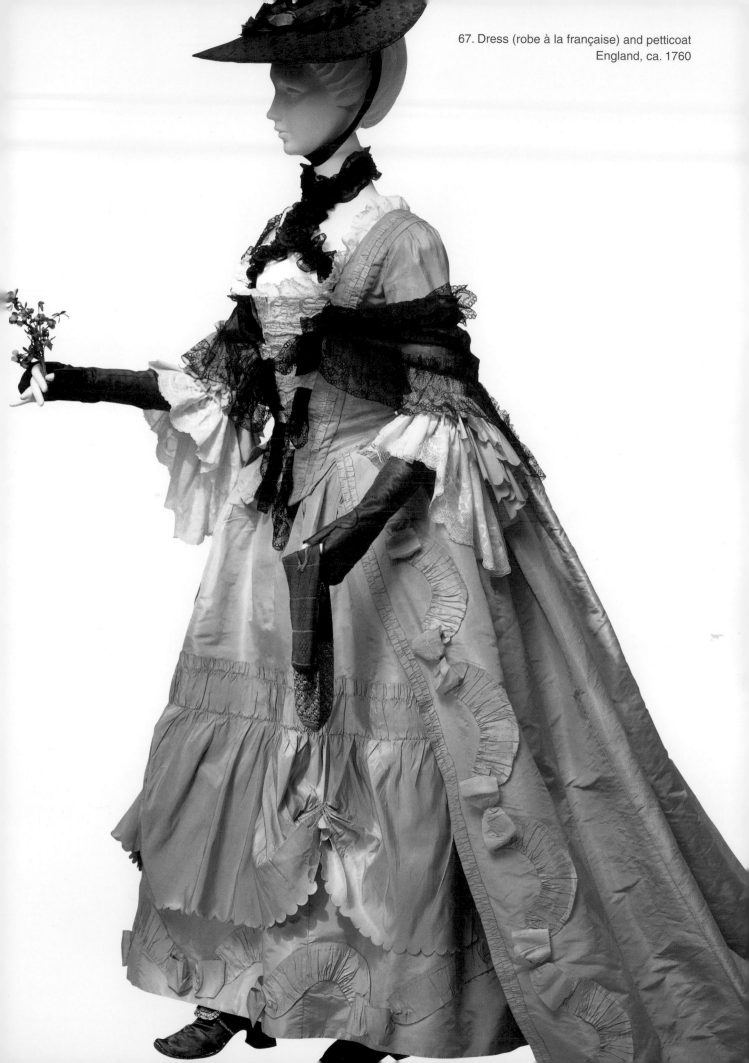

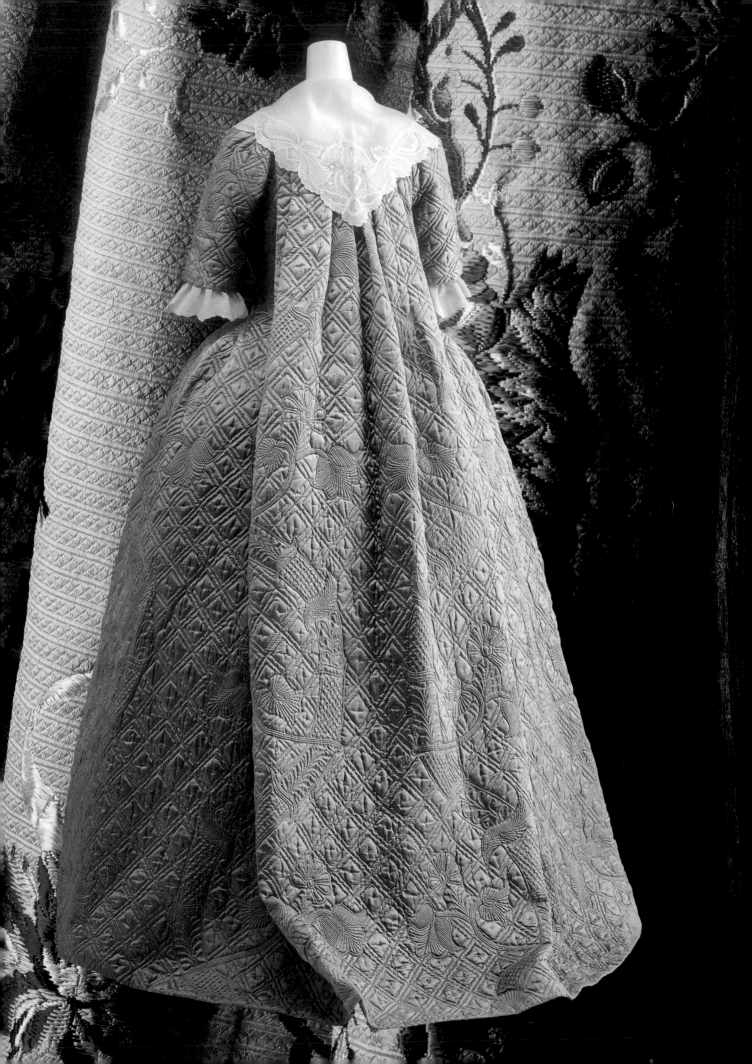

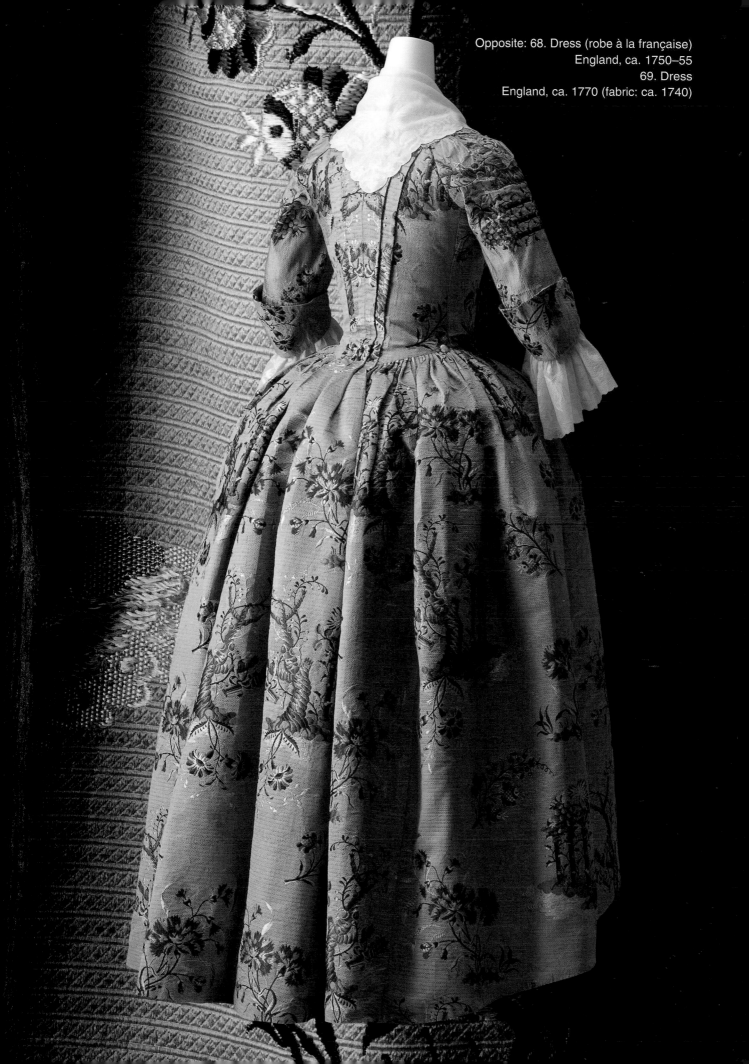

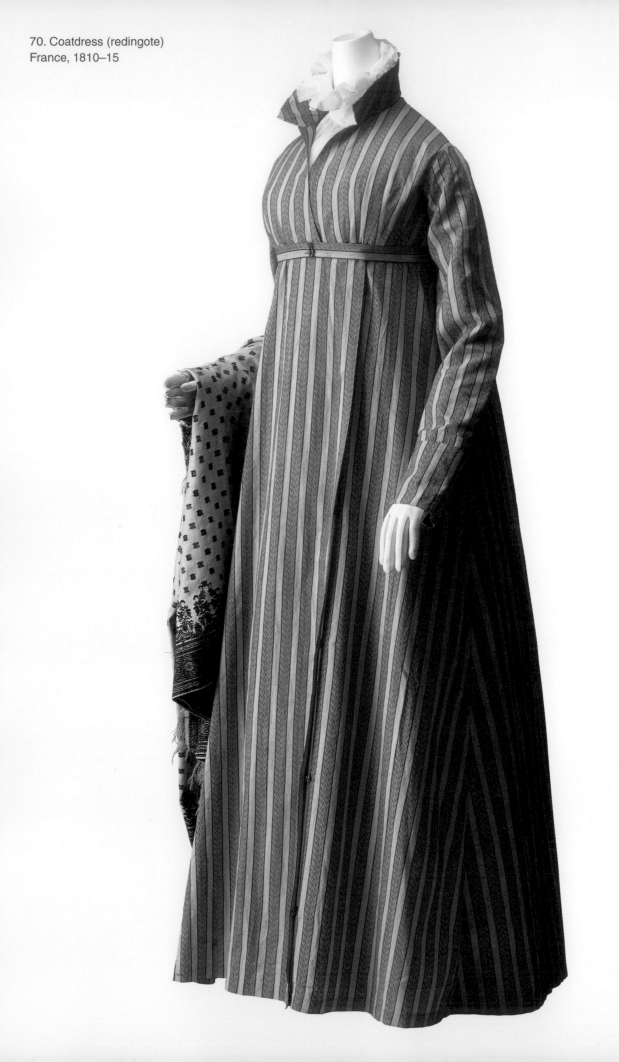

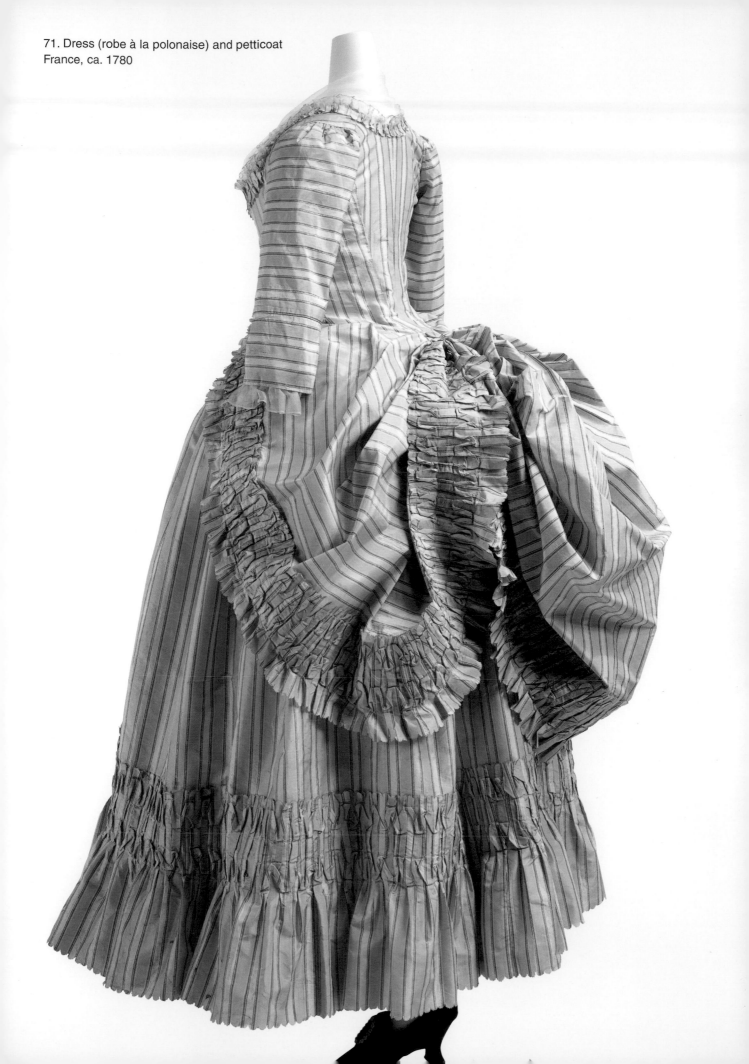

71. Dress (robe à la polonaise) and petticoat
France, ca. 1780

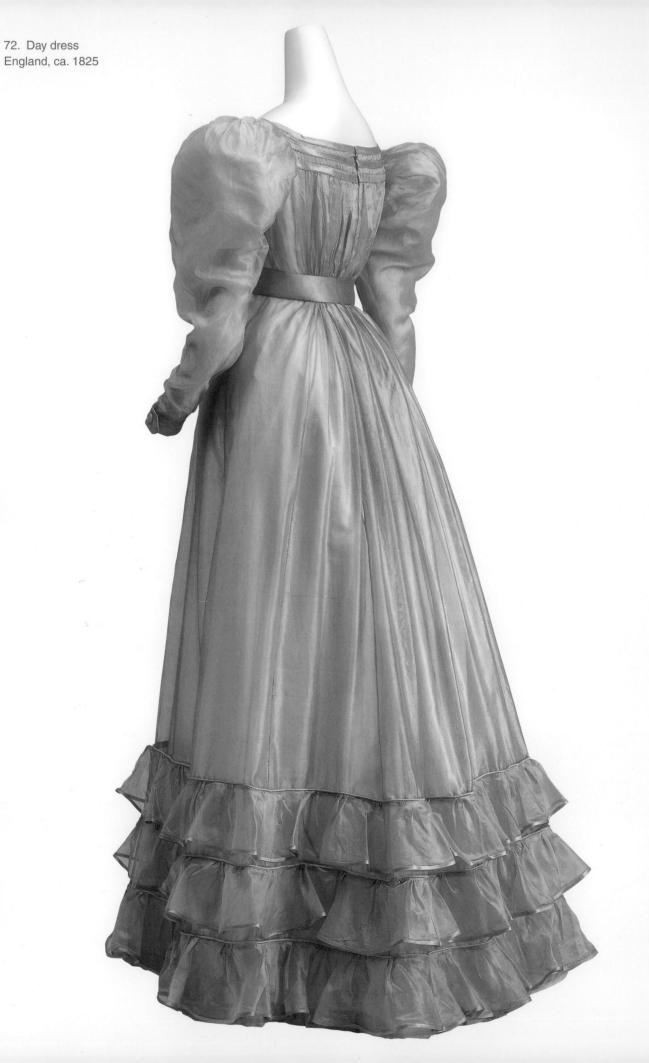

72. Day dress
England, ca. 1825

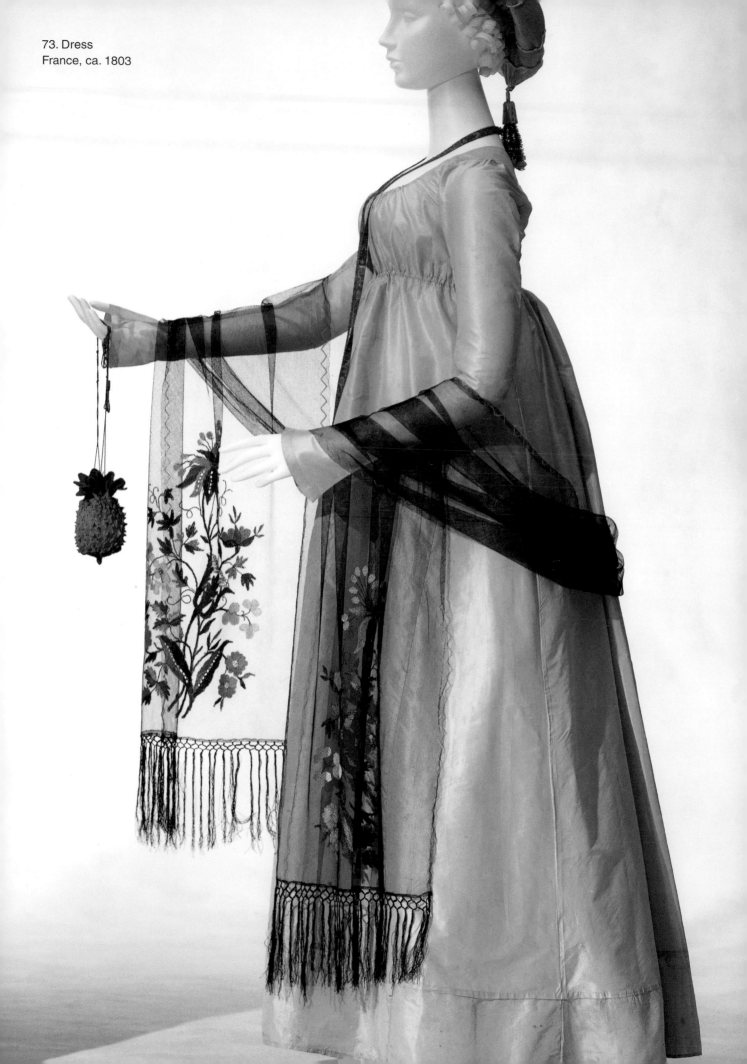

73. Dress
France, ca. 1803

W H

I　　T　　E

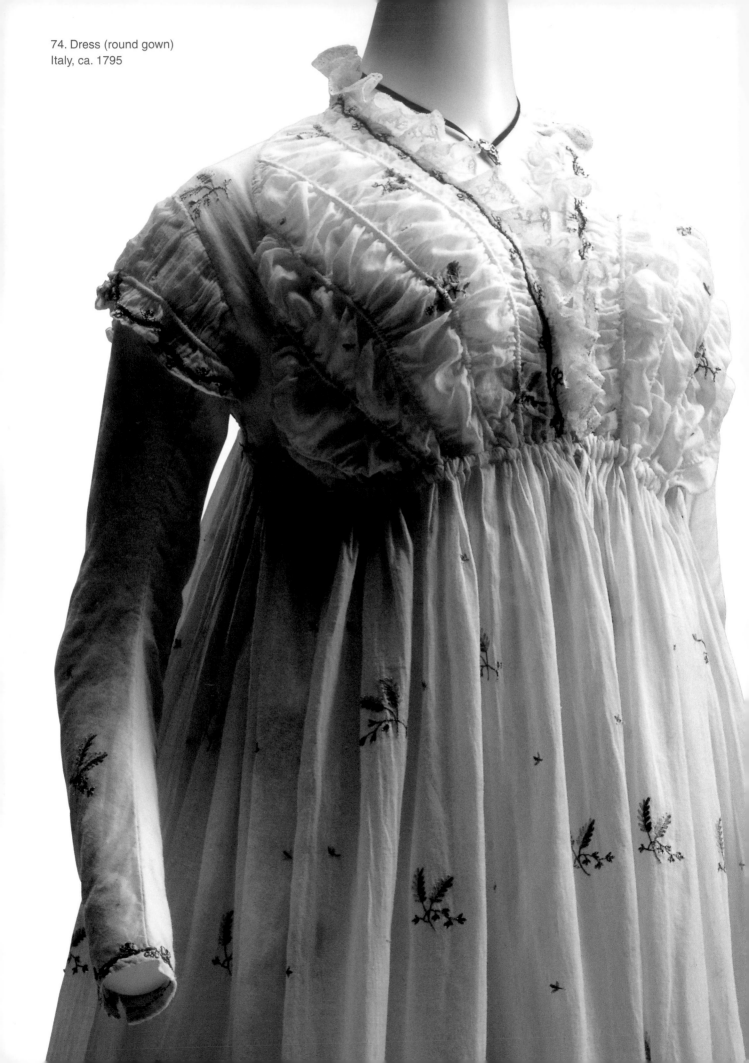

74. Dress (round gown)
Italy, ca. 1795

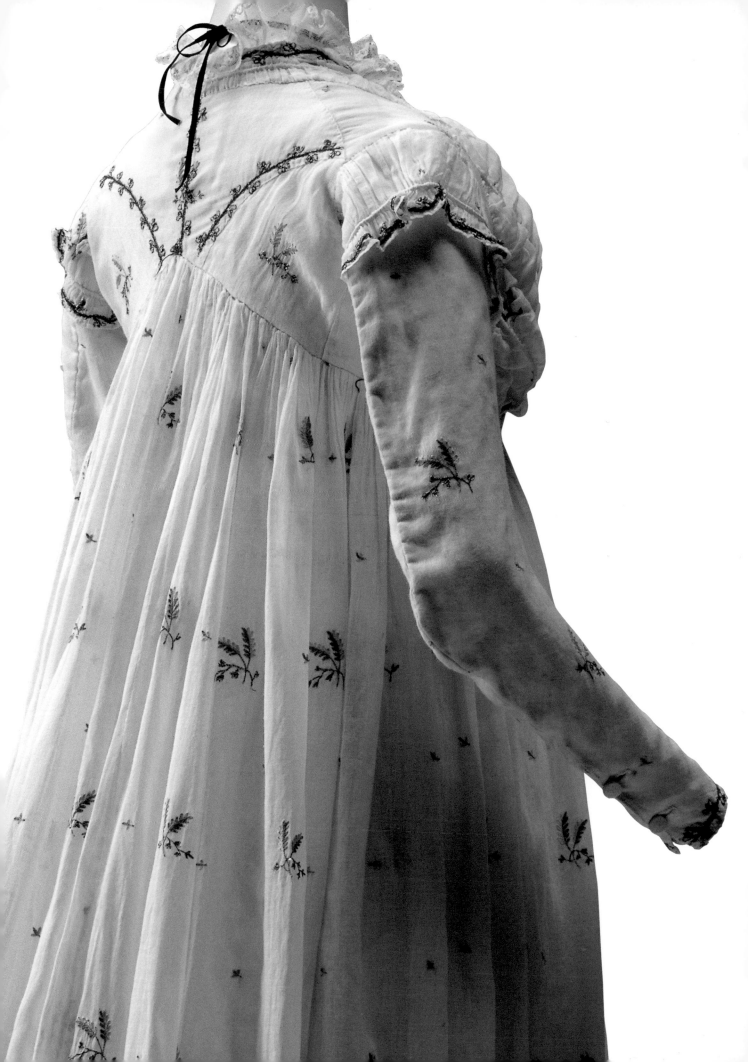

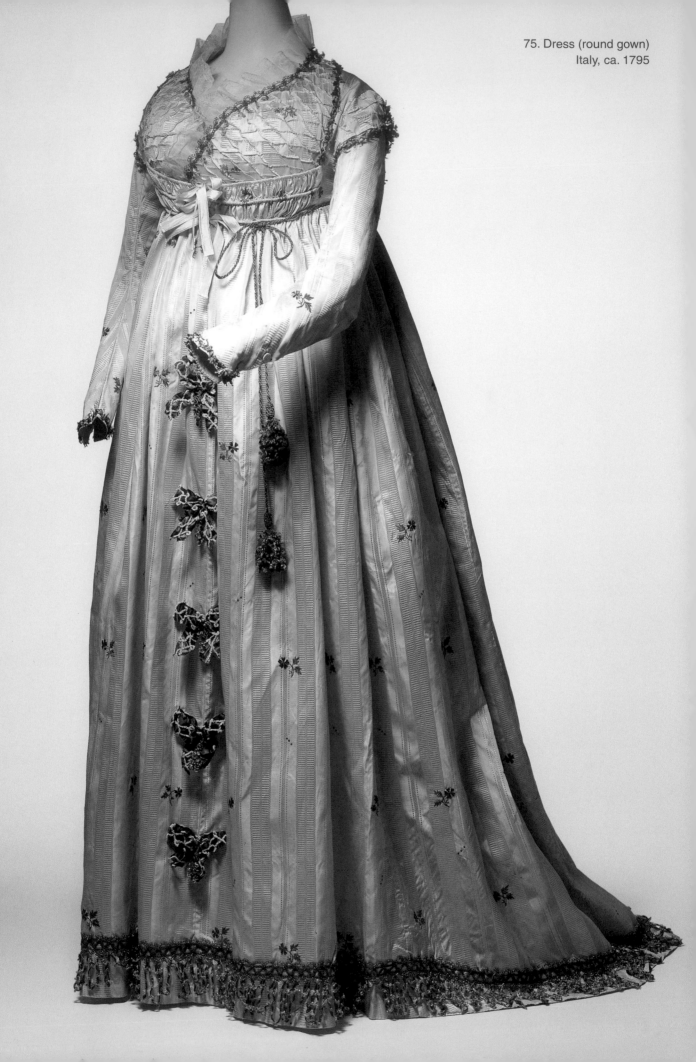

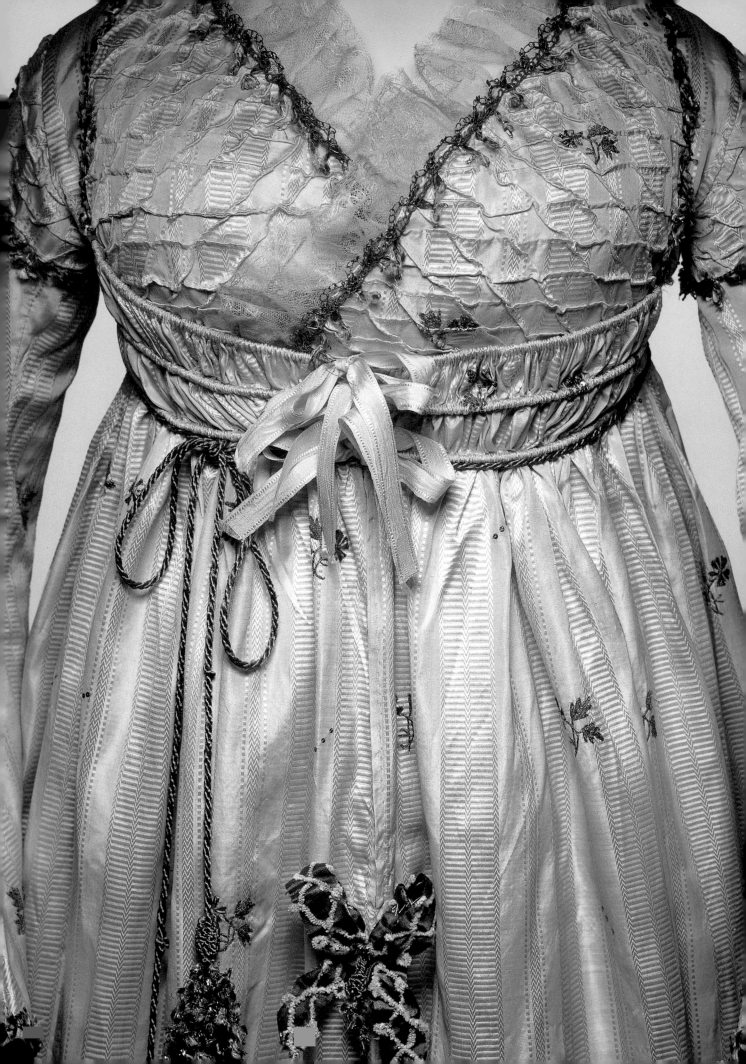

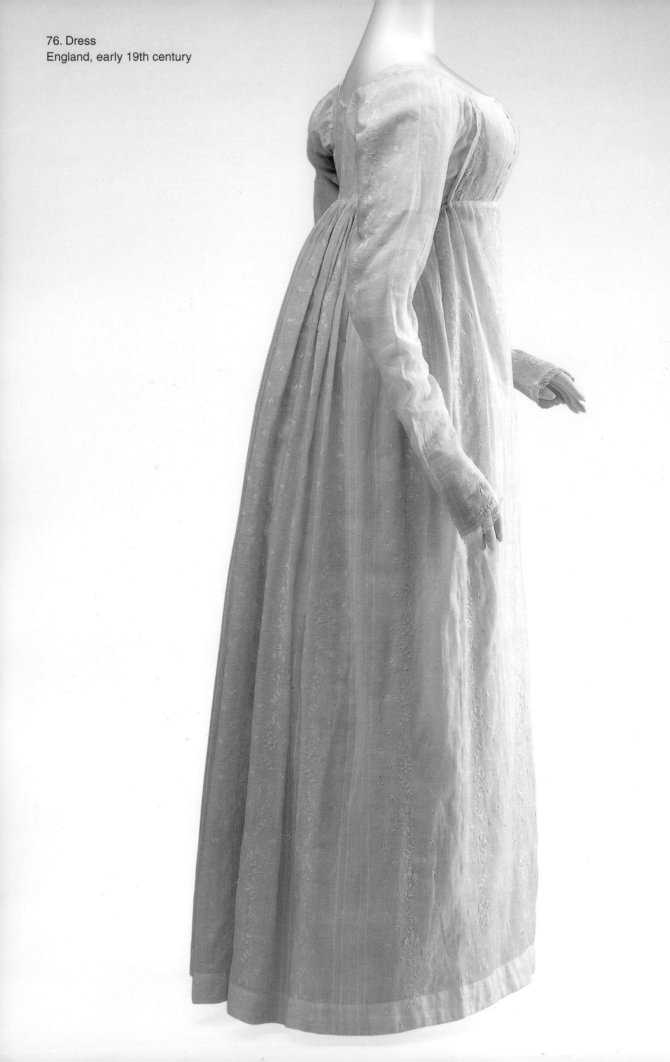

76. Dress
England, early 19th century

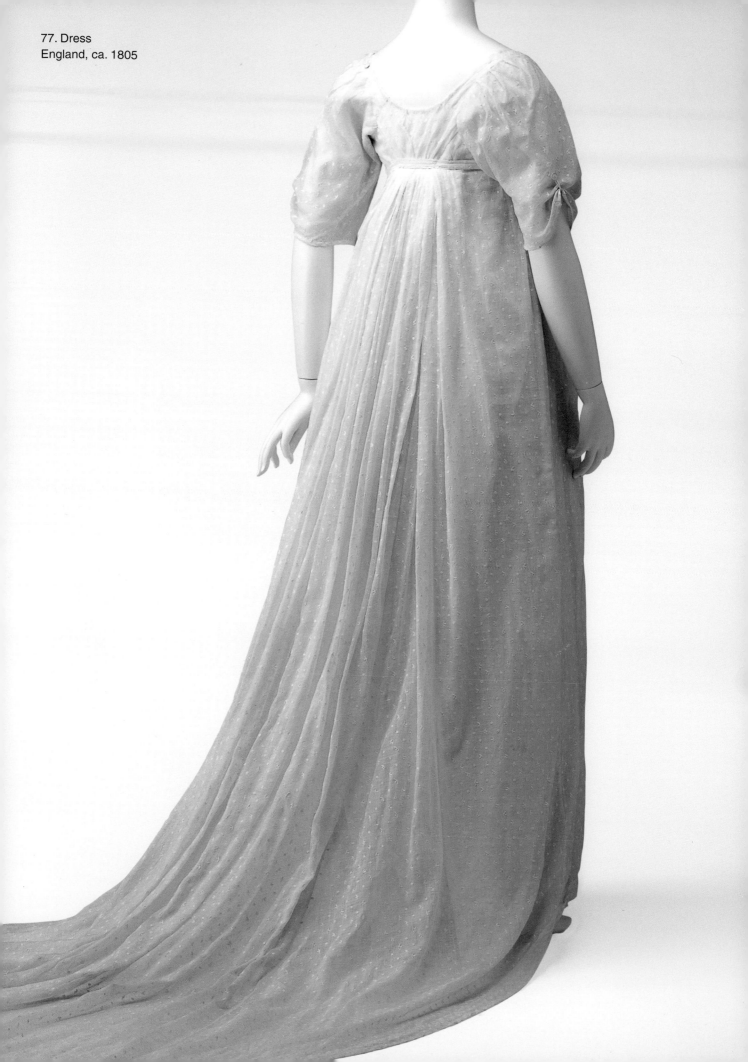

77. Dress
England, ca. 1805

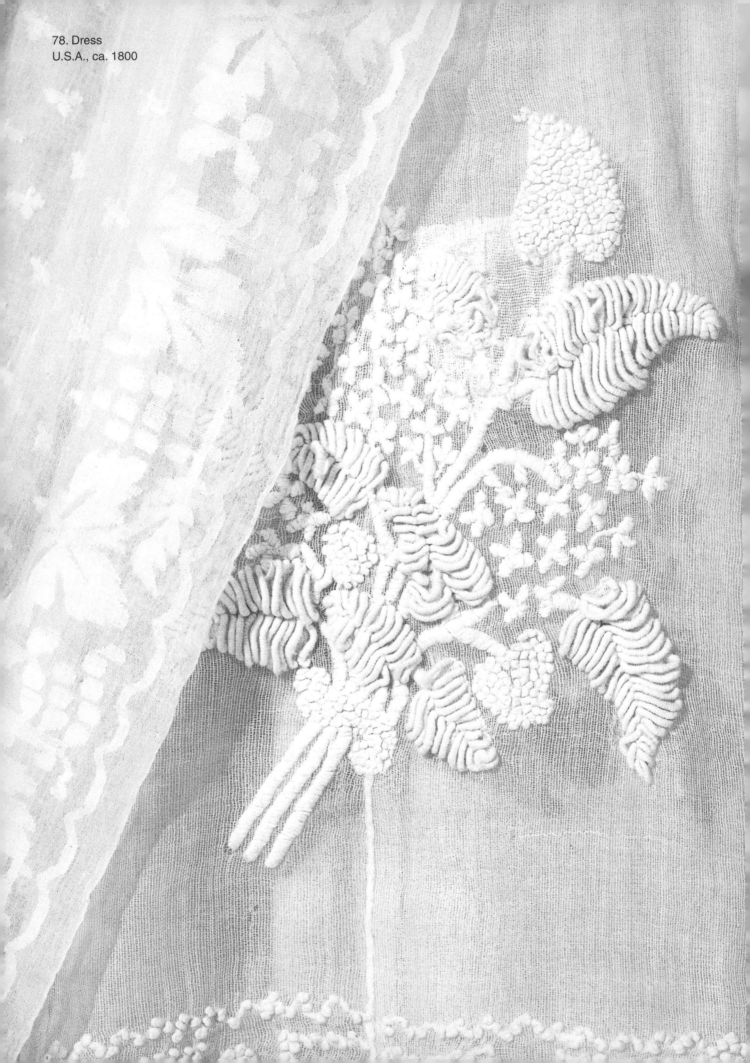

78. Dress
U.S.A., ca. 1800

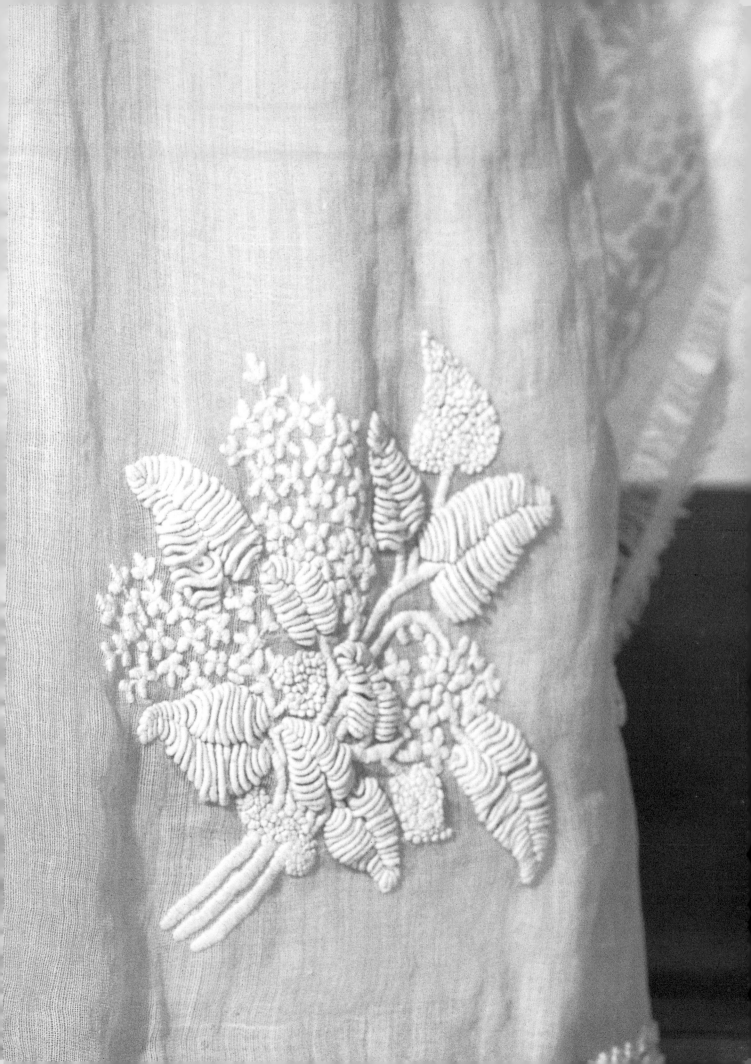

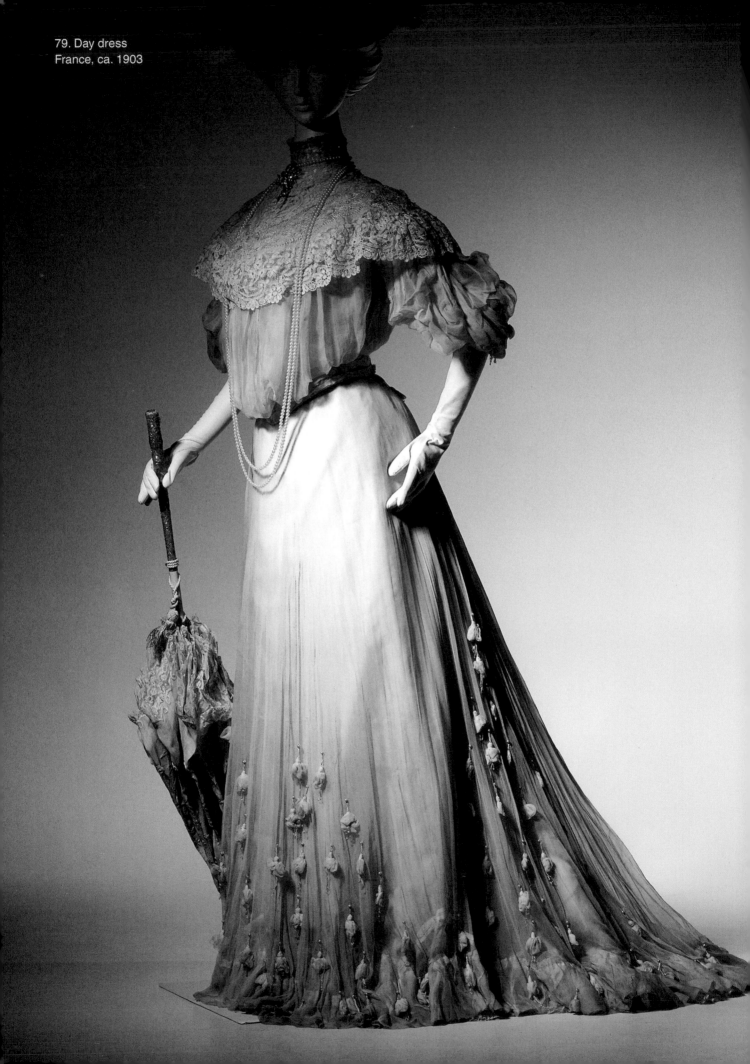

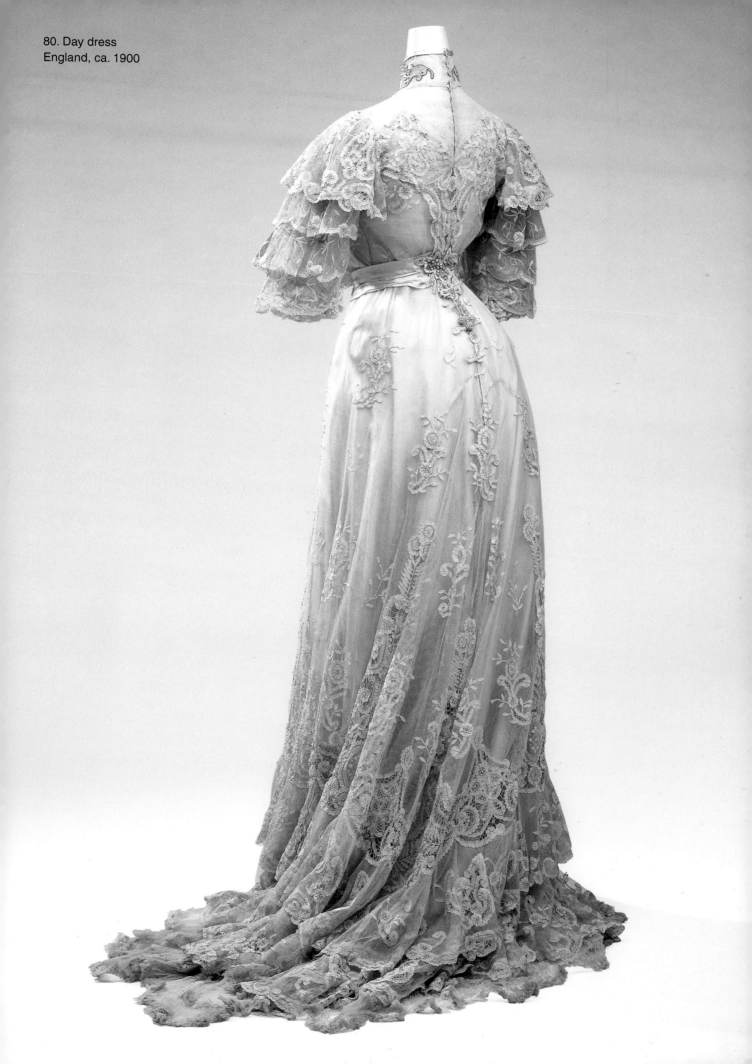

80. Day dress
England, ca. 1900

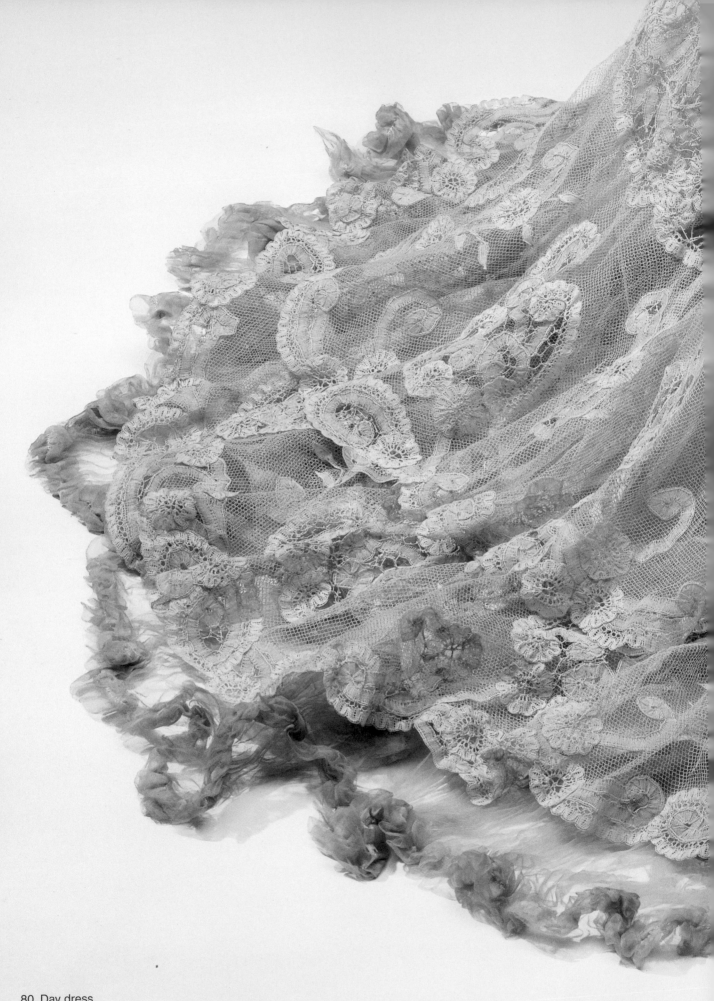

80. Day dress
England, ca. 1900

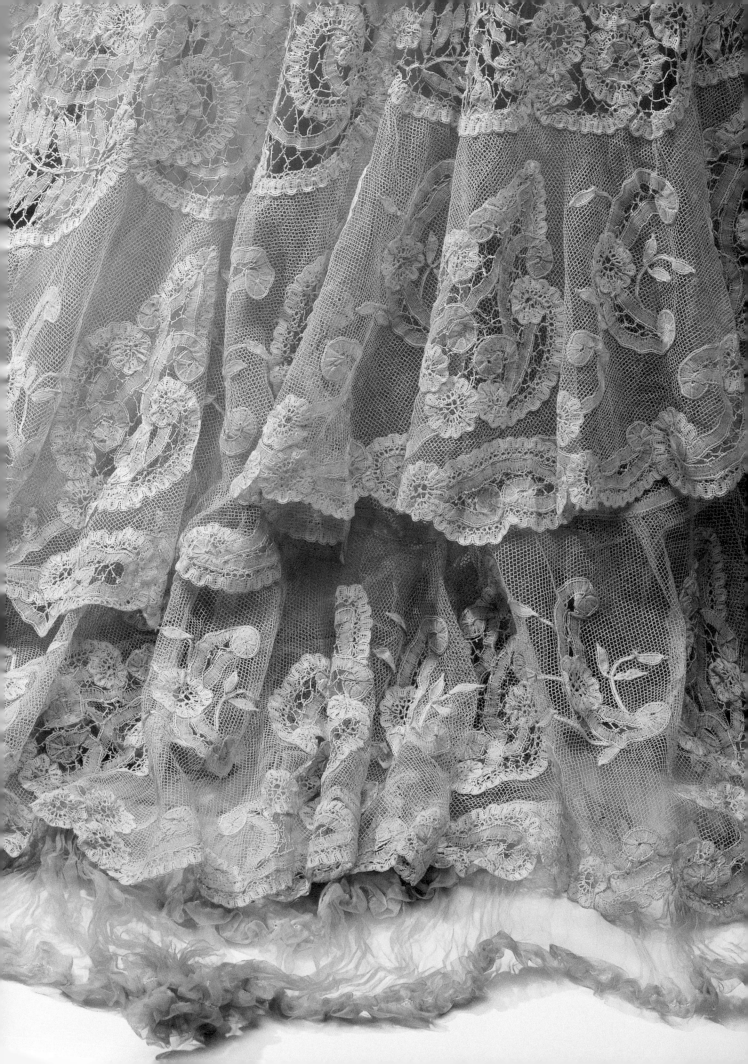

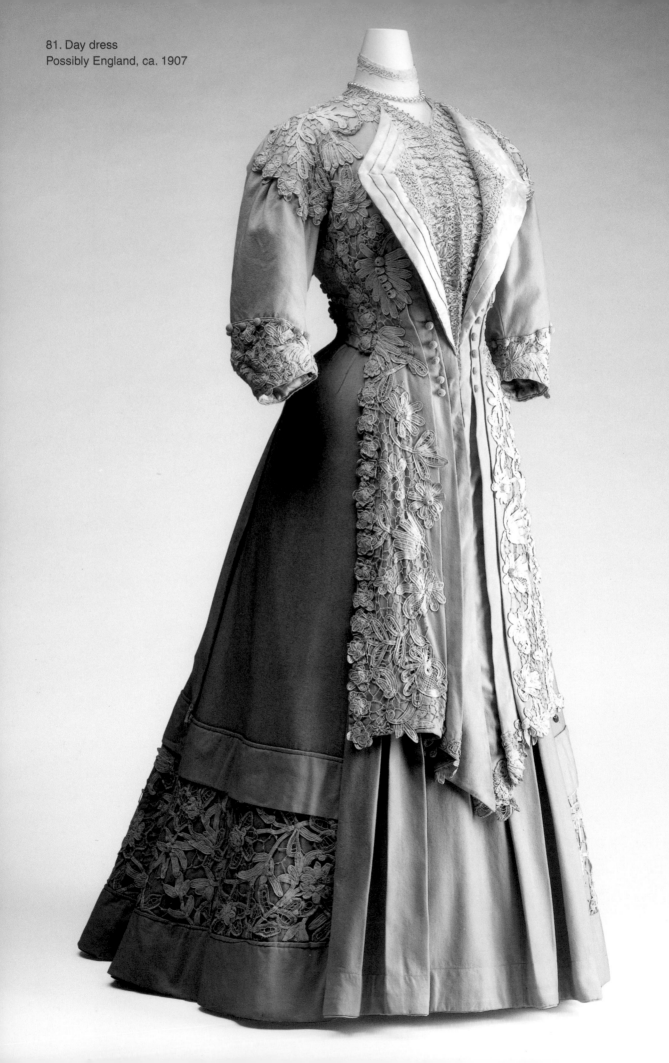

81. Day dress
Possibly England, ca. 1907

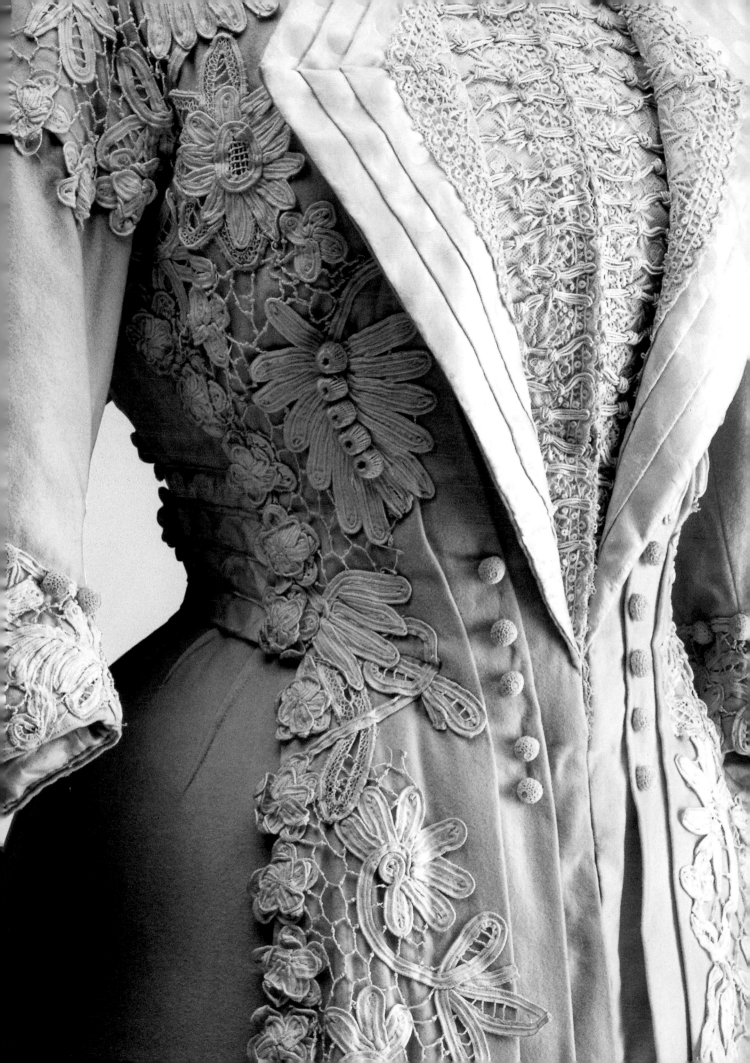

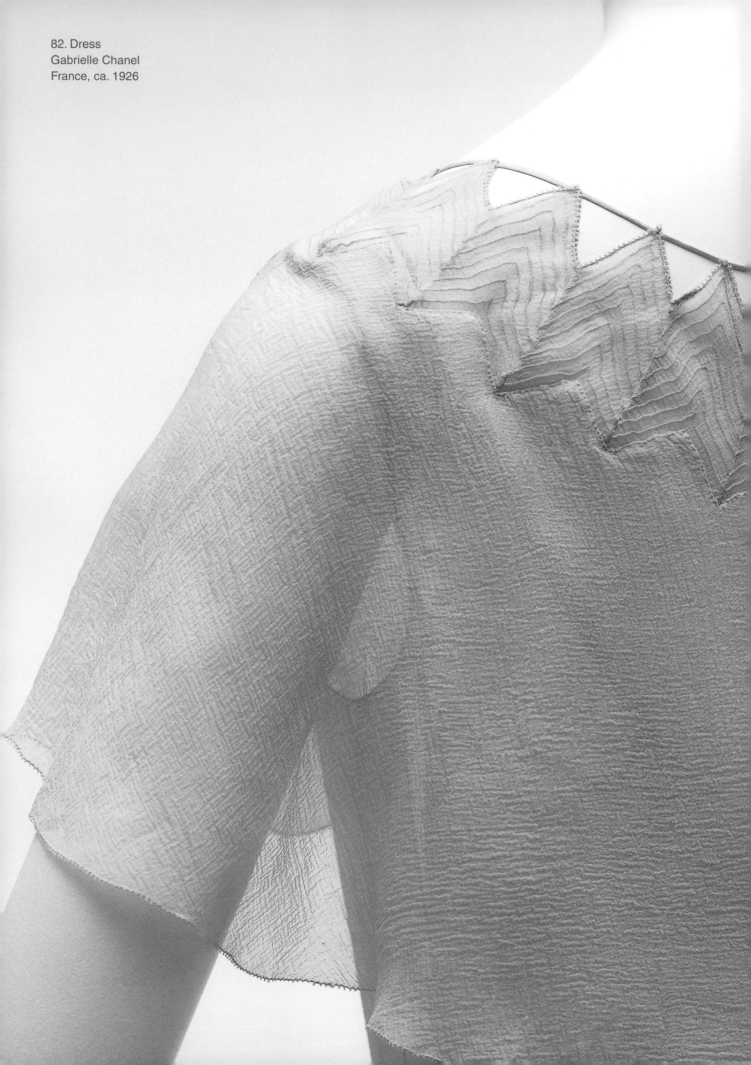

82. Dress
Gabrielle Chanel
France, ca. 1926

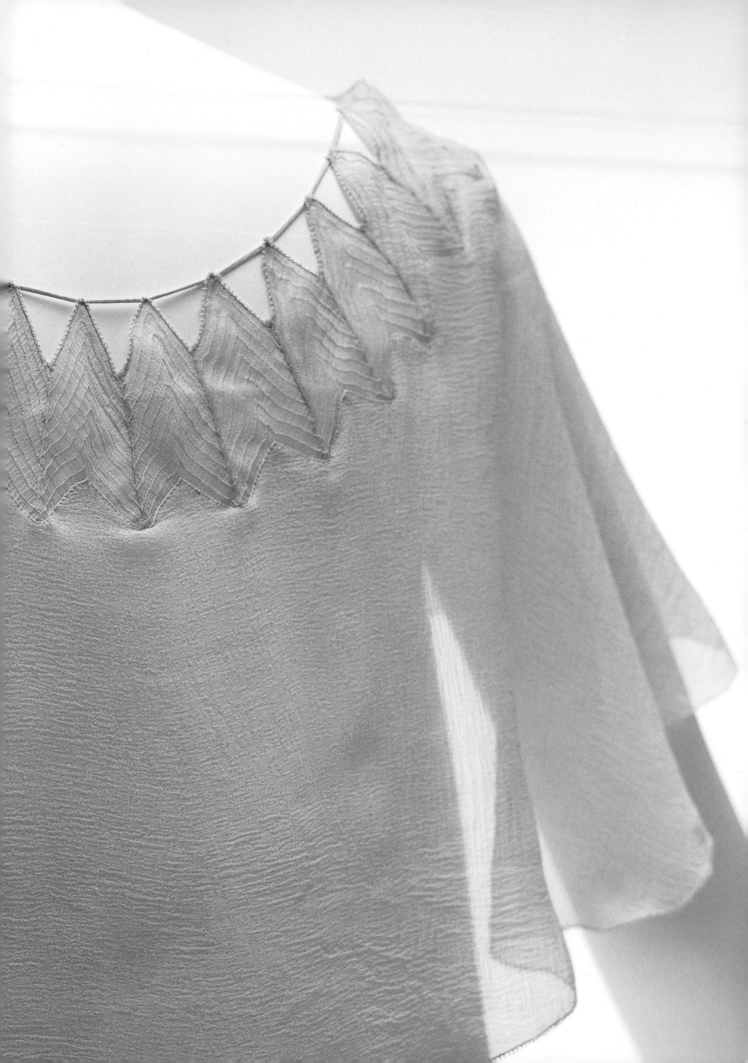

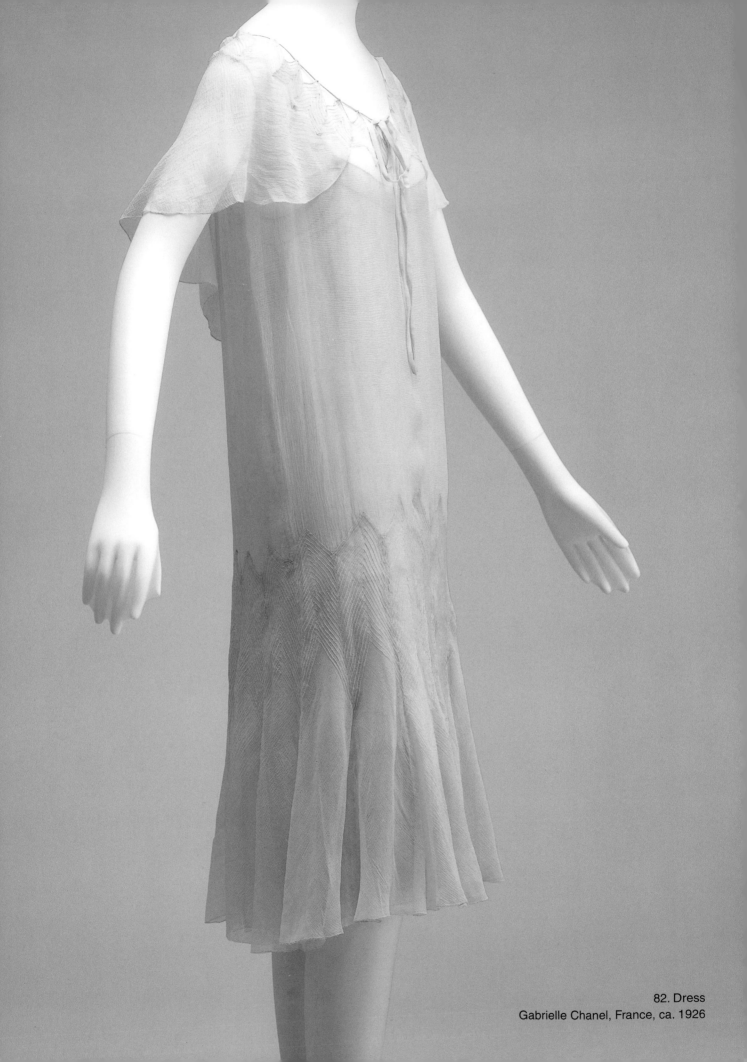

82. Dress
Gabrielle Chanel, France, ca. 1926

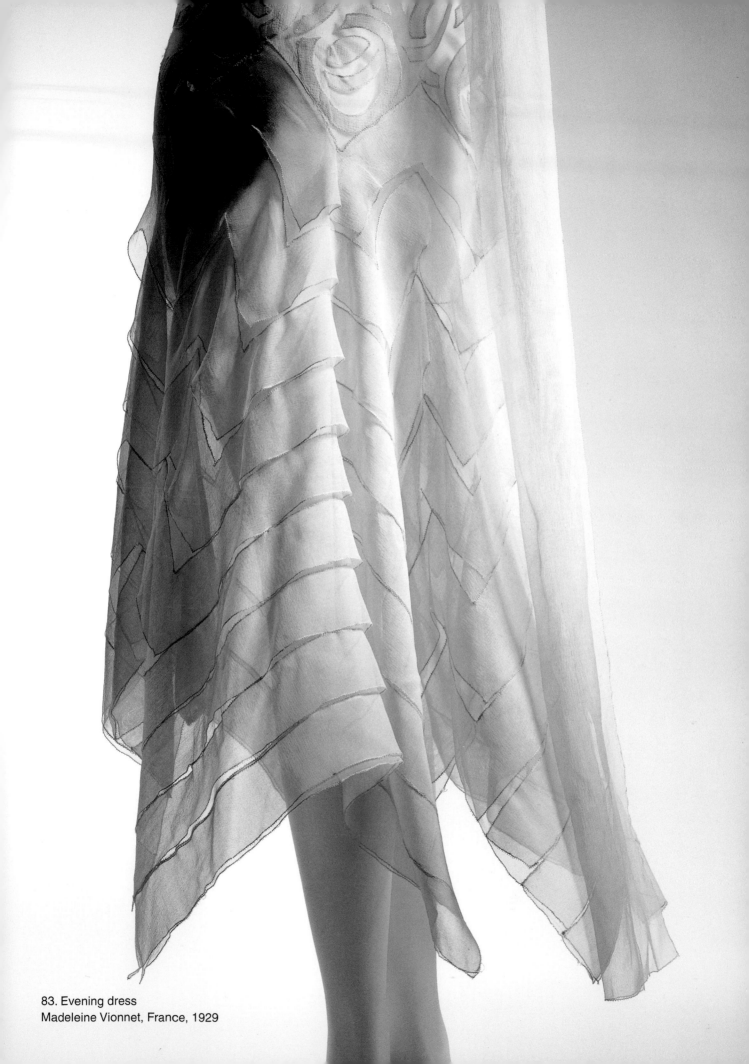

83. Evening dress
Madeleine Vionnet, France, 1929

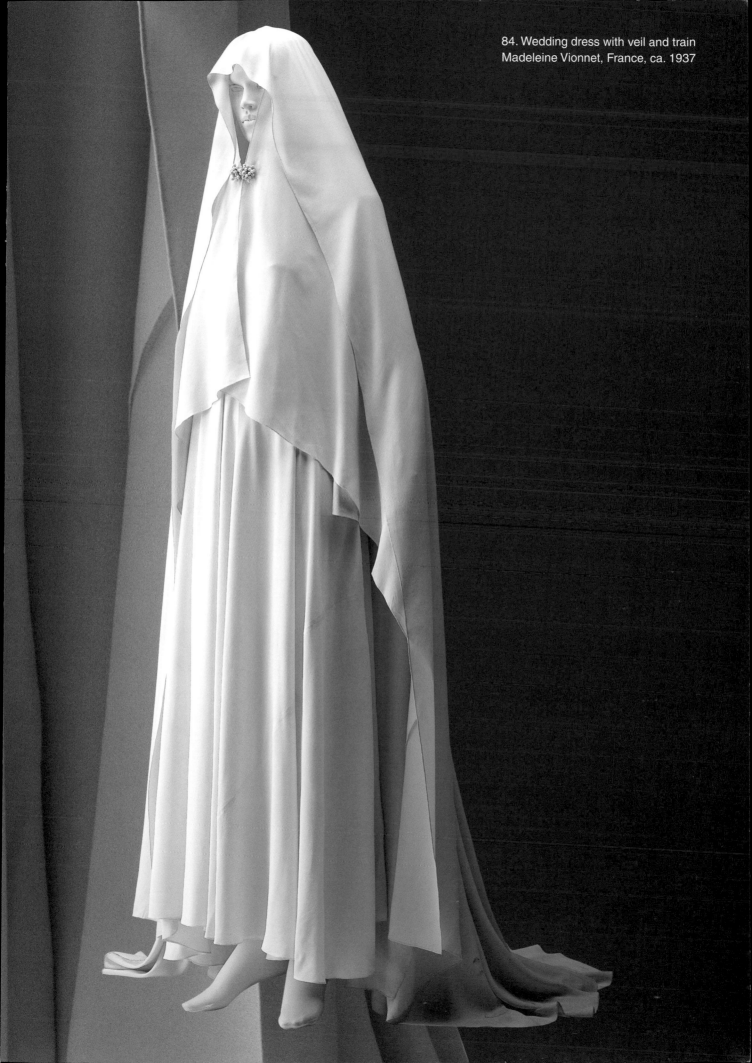

84. Wedding dress with veil and train
Madeleine Vionnet, France, ca. 1937

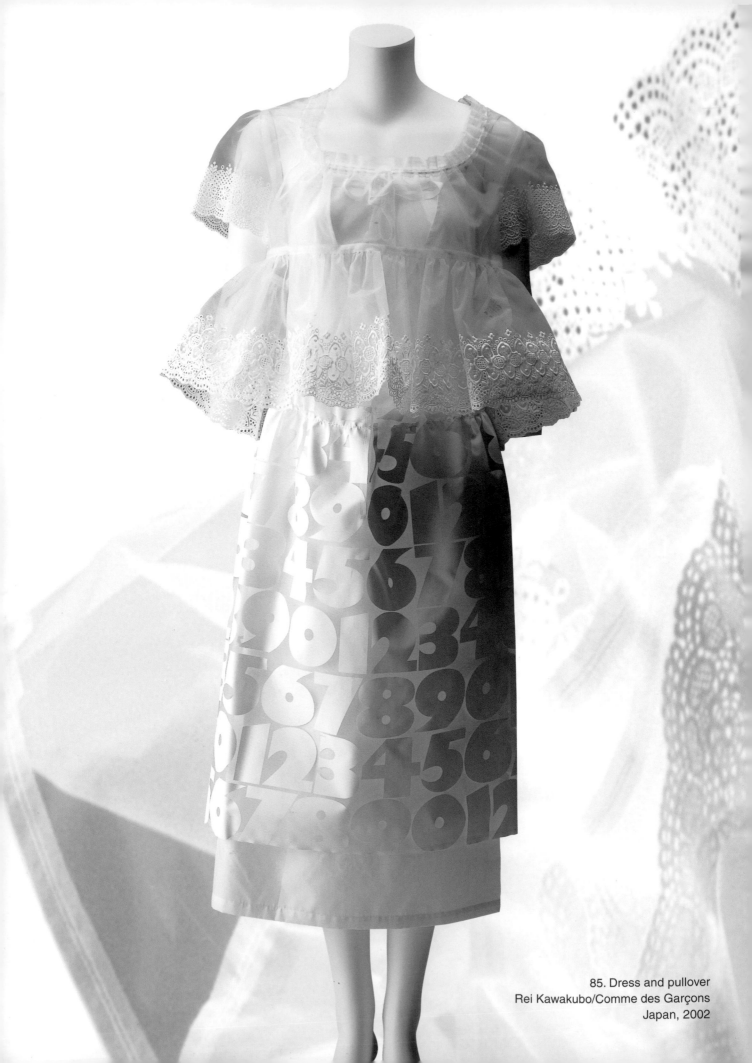

85. Dress and pullover
Rei Kawakubo/Comme des Garçons
Japan, 2002

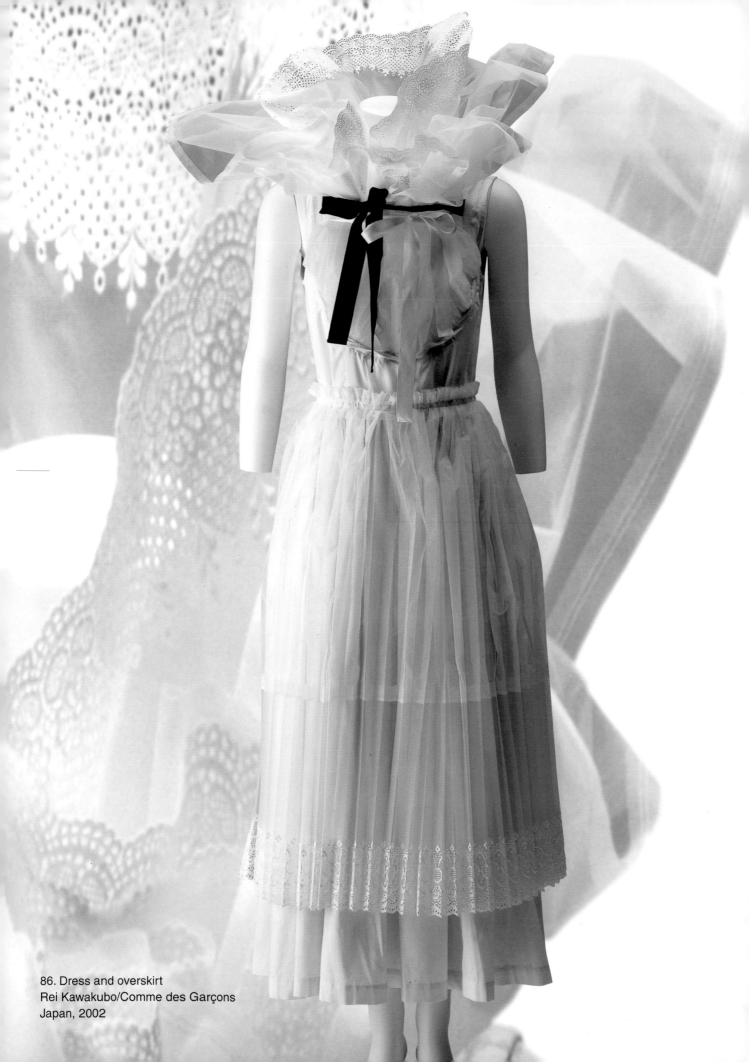

86. Dress and overskirt
Rei Kawakubo/Comme des Garçons
Japan, 2002

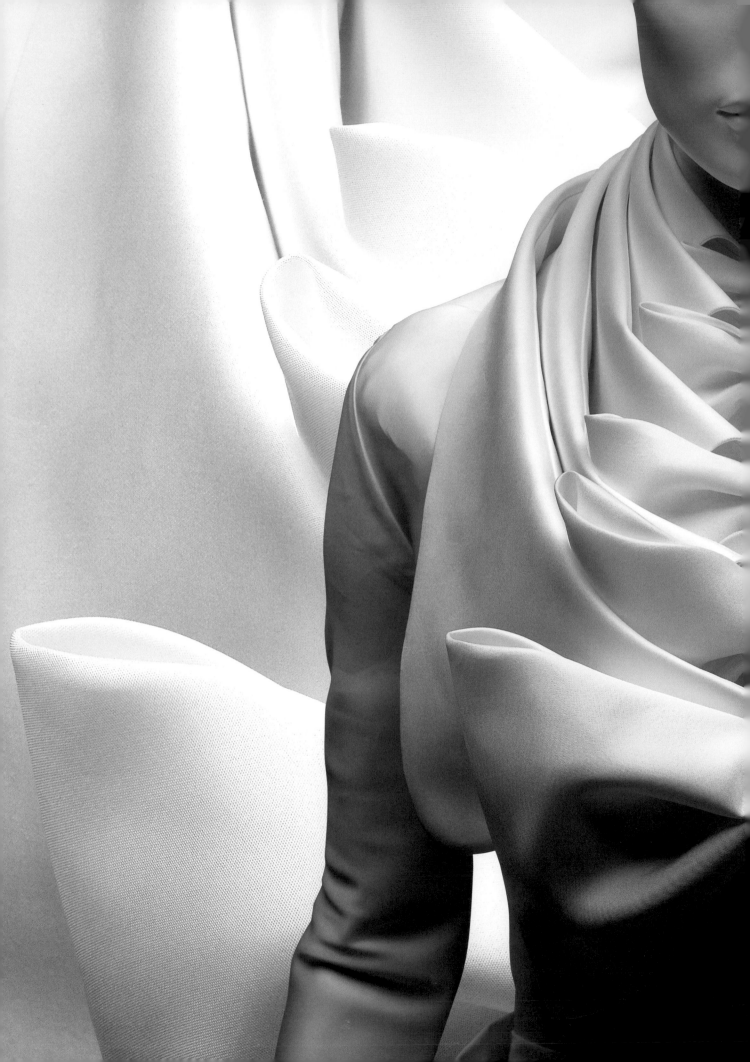

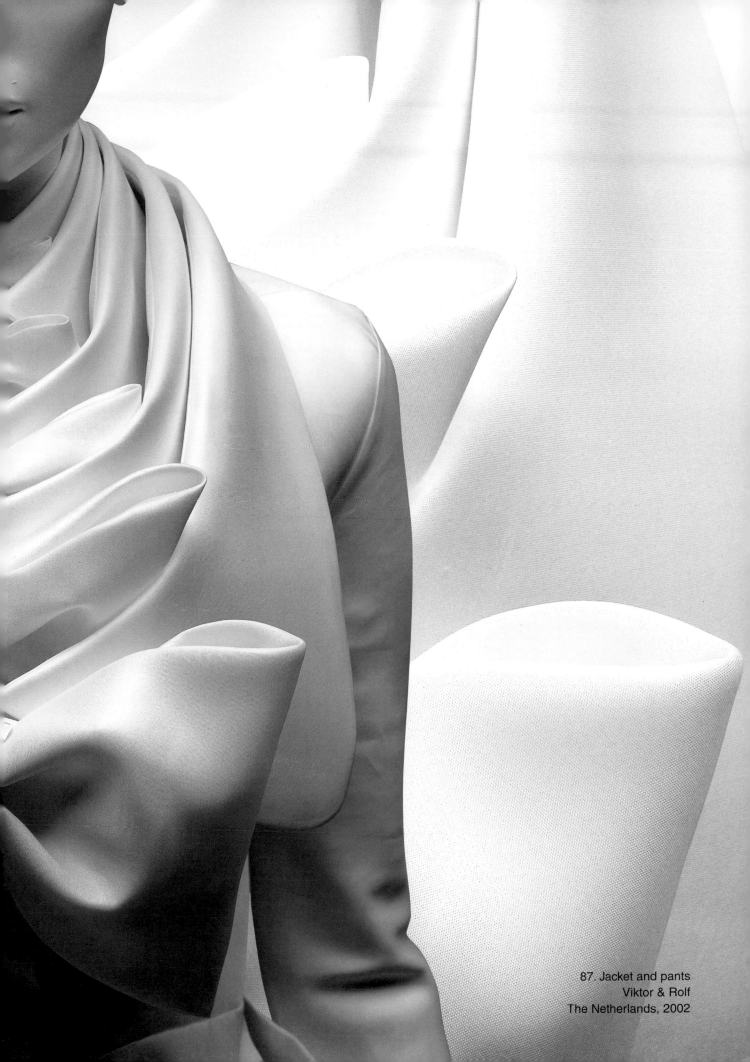

87. Jacket and pants
Viktor & Rolf
The Netherlands, 2002

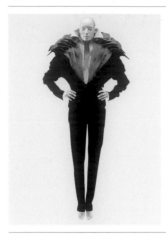

1.
Jacket and pants
Viktor & Rolf
The Netherlands, 2003
Wool, layered with cotton and silk collars
KCI (Inv. AC11077 2004-4AB)

In their fall 2003 collection, Viktor & Rolf transformed basic items of contemporary fashion by using exaggerated volumes and layered details. This color-conscious duo used black, white, and beige—colors basic to today's fashion—to hint at the existence of a repeating color cycle in the fashion market. Viktor & Rolf's work suggests that the continuous change in color trends in fashion is a device of industrial society, a way to create a difference among products. The fact that today's society is full of color is a direct result of the market's need to continually update that difference. It is also interesting to note that the achromatic colors used in menswear in the nineteenth century have now become the basic repertoire of womenswear.

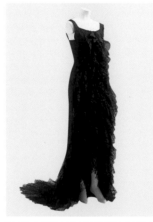

2.

Evening dress
Cristobal Balenciaga
France, 1961
Silk with layers of Chantilly lace
KCI (Inv. AC140 1977-10-4)

Cristobal Balenciaga was a shining star in the fashion industry after World War II. Balenciaga was born in Spain, and opened couture houses in San Sebastian, Barcelona, and Madrid before moving to Paris in 1937. He produced many designs in black, a color associated with Spanish fashion since the Renaissance and reflected in Spanish painting. Balenciaga was also a master of lace; note how the black Chantilly lace flows dynamically and rhythmically on this dress like the tiered ruffles on the traditional costume of a Flamenco dancer.

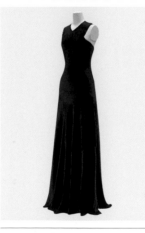

3.

Evening dress
Madeleine Vionnet
France, 1932
Silk satin; two pieces used for bodice and five, in various sizes, for skirt
KCI (Inv. AC3700 1981-3-2)

A slender silhouette emphasizing the curves of the female body was popular in 1930s fashion. Its potential was fully realized with Madeleine Vionnet's bias-cut technique, which allowed her dresses to flow smoothly and comfortably along the natural lines of the body. In this dress, which is cut in two pieces for the bodice and five for the skirt, the use of black highlights those lines effectively and dramatically.

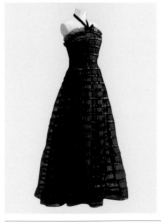

4.
Evening dress
Madeleine Vionnet
France, 1939
Silk tulle and lamé tape; lamé underdress; velvet ribbon for strap
KCI (Inv. AC6424 1989-21-7)

Lengths of gold lamé tape, placed parallel to each other at five-centimeter intervals, shape the silhouette of this dress so that it broadens toward the hem. The gathered tulle has been layered and stitched on top of the tapes to achieve a balanced finish for the dress.

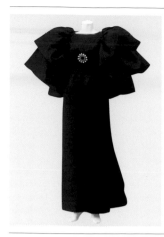

5.
Evening dress
Cristobal Balenciaga
France, 1964
Silk gazar
KCI (Inv. AC7012 1991-19-1AC)

This black evening dress clearly demonstrates Balenciaga's design principles. He created complete harmony between color and form by emphasizing the best characteristics of his material—*gazar,* a crisp silk organza especially created for him by the Swiss textile manufacturer, Abraham—to create the bold double sleeves. Every Balenciaga collection included a dress—often in black—made entirely by the couturier's own hands.

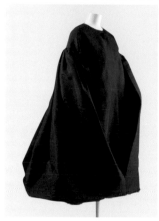

6.
Coat
Christian Dior
France, 1957
Silk faille; wrapped button at neckline
KCI (Inv. AC6977 1991-10)

Christian Dior played an important role in the revival of Paris haute couture after World War II. In each season's collection, he created a dress featuring a particular line, and used black to highlight the formal rigor of the silhouette. Dior said that black is "the most popular and the most convenient and the most elegant of all colors. Black may be sometimes just as striking as a color."
This coat is from his *Ligne Libre* (Free Line) collection. He took advantage of the stiffness of the silk faille, folding the hem up to double the fabric. This coat also shows a hint of Yves Saint Laurent's style—he joined the house of Dior in 1955.

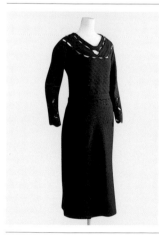

7.
Day dress
Gabrielle Chanel
France, ca. 1930
Cashmere herringbone twill; bias cut; open-work embroidery at chest, back, and cuffs
KCI (Inv. AC4255 1982-15-1)

Gabrielle "Coco" Chanel created a style of dress appropriate for independent women in a modern society. Her clothes were brimming with functional beauty, an expression of the modernist spirit informed by the stylistic inventions of Art Deco. Chanel's trademark *petite robe noire* was particularly original in that it did not attempt to show off the techniques, such as elaborate cut, needed to create it. The bodice and skirt portions of this dress are cut on the bias with the herringbone twill pattern running in opposite directions; they are joined by an asymmetrical seam. Open-work embroidery decorates the neckline and sleeves.

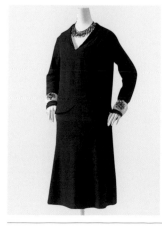

8.
Day dress
Gabrielle Chanel
France, ca. 1927
Silk satin-back crepe
KCI (Inv. AC7605 1992-26-1)

True to Chanel's design philosophy, the intricate pieced construction and delicate topstitching of this dress are not obvious to the casual observer. The open sailor-style collar is one of Chanel's favorite necklines, introduced in the sportswear sold at her Deauville boutique during World War I. This unassuming "little black sailor dress" makes a perfect backdrop for bold and colorful jewelry.

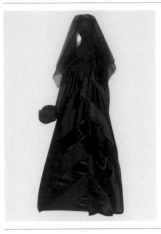

9.
Dress
Viktor & Rolf
The Netherlands, 2001
Silk *duchesse* satin; silk cord detailing at the bust
Collection of The Groninger Museum, The Netherlands

In this dress from their *Black Hole* collection for autumn/winter 2001, Viktor & Rolf created color and pattern using only one fabric. The illusion of different shades of black is due to the play of light on strips of heavy *duchesse* satin arranged in a chevron pattern.

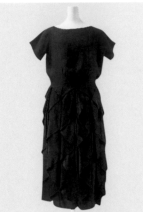

10.
Dress
Madeleine Vionnet
France, 1918–19
Silk satin-back crepe
KCI (Inv. AC6813 1990-24-1)

In this dress inspired by ancient Greek costume, the difference in the two sides of the fabric creates a modern, visually interesting effect. The cascading folds on the skirt are made of twenty bias-cut pieces. Vionnet made similar dresses in ivory, yellow, pink, and red, but the black is the most arrestingly modern.

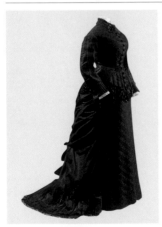

11.
Day dress
England, ca. 1875
Silk taffeta bodice and skirt; fringe of jet beads
KCI (Inv. AC1551 1978-40-2AB)

Black mourning dresses were worn throughout Western Europe in the nineteenth century. Especially in England, widows wore only matte black for the first "year and a day"; the only jewelry they were allowed to wear was jet (fossilized wood), highly valued for its black luster. Black silk taffeta and jet embroidery were typical materials used for the lustrous black dresses worn later in the mourning period.
Several factors informed this change in the public perception of black, including the prolonged mourning of Queen Victoria for her husband since 1861, the invention of aniline black synthetic dye in 1863, and the influence of predominantly black menswear.

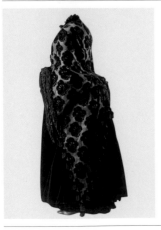

12.
Visite (coat)
U.S.A., ca. 1885
Silk velvet; jet beads and chenille at cuffs, center back, and hem
KCI (Inv. AC5366 1986-17-6)

A *visite* is an overgarment fashionable at the same time as the bustle. A slit was made at the center back to accommodate the protruding volume of the dress, and decoration was concentrated at the back, the focal point of the silhouette. This visite of voided velvet with a foliate motif is decorated with chenille fringe and elaborate embroidery of jet beads.

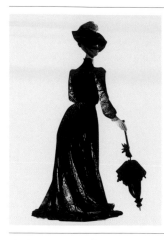

13.
Day dress
France, ca. 1900
Silk velvet embroidered with chenille; lace trimming; silk chiffon; silk satin skirt layered with machine lace; chenille fringe
KCI (Inv. AC3621 1980-29-2)

The silhouette of this dress follows an S-curve, a shape typical of *belle époque* fashion and also found in Art Nouveau design. Although the surface is decorated with chenille and machine-made lace, in this dress, the dynamic S-curve stands out as a result of the black color. In movement, the long chenille fringe would emphasize its dramatic, sinuous lines.

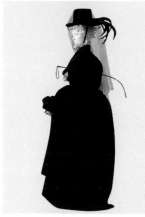

14.
Riding habit
France, ca. 1810
Wool broadcloth; tailored jacket and skirt
KCI (Inv. AC5313 1986-8-2AB)

Since the end of the eighteenth century, the dark suit has dominated and defined menswear. At the same time, more women began taking up horseback riding, one of the only sports available to them. The clothes they wore for this aristocratic pastime were strongly influenced by menswear, and in France, the resulting riding habit became known as an *Amazone*. Tailoring for men and dressmaking for women had previously been two distinct professions. In the late nineteenth century, some tailors who specialized in women's riding habits, like John Redfern and Henry Creed, expanded to become leading international couturiers.

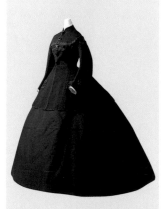

15.
Jacket and skirt
U.S.A., ca. 1865
Wool jacket trimmed with silk, jet beads and jet buttons; silk faille skirt
KCI (Inv. AC5510 1986-52 Gift of Mr. Martin Kamer, AC2929 1979-29-5C)

This costume consists of a menswear-inspired jacket and a skirt supported by a cage crinoline. In the late nineteenth century, the combination of a tailored jacket and coordinating skirt developed as a feminine version of the suit, appropriate for daily wear.

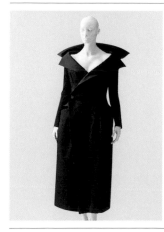

16.
Dress
Yohji Yamamoto
Japan, 2003
Cotton gabardine; double-breasted; unfinished cuffs and hem
KCI (Inv. AC11050 2003-36-7AC Gift of Yohji Yamamoto Inc.)

Yohji Yamamoto first took part in ready-to-wear collections in Paris in 1981, and showed his collections during haute-couture week from the spring/summer 2003 season through the spring/summer 2005 season. The venue for the presentation of this particular dress was the beautiful salon of the Opéra Garnier.
This décolleté dress, shaped at the waist, pays homage to Dior and other Paris couturiers of the 1950s. It also incorporates some traditional elements of menswear, including strict tailoring, a right side overlapping the left side, and most important, black color.

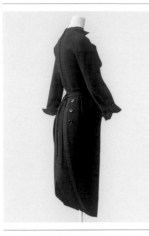

17.
Day dress
Christian Dior
France, ca. 1949
Wool
KCI (Inv. AC8942 1993-31AC)

This elegant yet sporty day dress incorporates the essence of menswear-inspired fashion, with its fitted cut and details such as a high, tight collar and sharp double cuffs. Navy blue was Dior's favorite color; he once said, "Among all the colors, navy blue is the only one which can ever compete with black, it has all the same qualities."

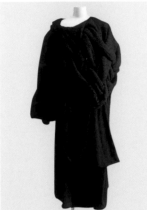

18.
Sweater and skirt
Rei Kawakubo/Comme des Garçons
Japan, 1983
Wool knit sweater; wool/nylon blend knit skirt
KCI (Inv. AC7843 1993-24-51, AC7824 1993-24-32 Gift of Comme des Garçons Co., Ltd.)

In the early 1980s, Rei Kawakubo and Yohji Yamamoto presented baggy, asymmetrical clothes, often with holes, in achromatic colors. Predominantly black, the clothes lodged a quiet yet strong protest against the conventional Western European aesthetic. Kawakubo's black was the first to herald a new era for fashion. From the 1990s onwards, Kawakubo demonstrated her ability to use vivid colors, though black remains the symbol of her pioneering early days.
This black ensemble is from the early part of Kawakubo's career, soon after her Paris debut. The dynamic combination of panels gives this sweater a sculptural effect.

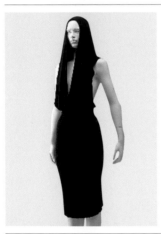

19.
Dress
Azzedine Alaïa
France, 1984
Silk jersey
KCI (Inv. AC11036 2003-31-2)

Alaïa typified the body-conscious fashion of the 1980s, attempting to create functional clothes using advanced stretch materials. He pursued femininity in the body itself, at a time when social changes were favoring women's independent social status. The minimal but voluptuous line of this dress, which leaves the back entirely bare and reveals a body refined by exercise, is brought out by its reddish-black color. Where Vionnet used the bias-cut in the 1930s, Alaïa used stretch materials in the 1980s to achieve a similar body-hugging effect.

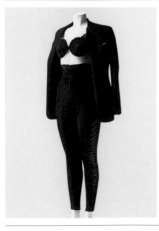

20.
Jacket, brassière, and pants
Jean-Paul Gaultier
France, 1987
Rayon jacket; nylon/lycra/silk blend satin brassière and pants
KCI (Inv. AC5642 1987-24-5AC)

Jean-Paul Gaultier mixes elements from various cultures and periods, appropriating and reinterpreting fashion history in a unique and contemporary way. Since the early 1980s, his designs have turned the underwear of the past—corsets, brassières, and garter belts—into the outerwear of the present. This outfit is a typical example: "indecent" black underwear has been transformed into dynamic urban wear, and the elastic material creates a black luster, gleaming like a second skin.

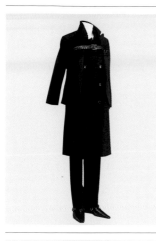

21.
Coat, jacket, and pants
Rei Kawakubo/Comme des Garçons
Japan, 2000
Wool gabardine jacket; wool tweed coat and pants
KCI (Inv. AC10355 2000-31-2AD)

In this ensemble, Kawakubo subverts the vocabulary of menswear by shuffling the established order of garments. Instead of a coat over a jacket, she layers a jacket over a coat; instead of placing the belt at the waist, she places it across the chest. While the tailoring is traditional and the garments are no less functional, the altered proportions and transformed relationships among the garments force us to examine the structure and meaning of the suit.

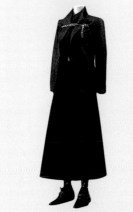

22.
Jacket and skirt
Rei Kawakubo/Comme des Garçons
Japan, 2000
Fake leather jacket over wool pin-striped jacket; wool gabardine skirt
KCI (Inv. AC 10354 2000-31-1AE)

Kawakubo's work is best understood in the context of the history of black in fashion and anti-fashion since World War II. While Dior and Balenciaga showed elegant black dresses in the 1950s, the color also became popular with the Existentialist movement and the anti-establishment youth of the Beat generation. In late-1970s Britain, the punk movement attracted youth eager to voice their dissatisfaction with a long economic depression and stifling social system. Kawakubo's fall 1991 collection was inspired by punk, and consisted mainly of black clothes. As a reaction against the establishment, Kawakubo's work is aptly symbolized in this color of protest.

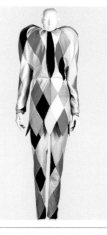

23.
"Harlequin" jacket and pants
Viktor & Rolf
The Netherlands, 1998
Cotton satin; cut in diamond shapes and constructed in harlequin check pattern
The Groninger Museum, The Netherlands

In medieval Europe, clowns, musicians, and entertainers—people with no social status—dressed in multicolored garments. Striped and multicolored clothes such as the *mi-partie* (costumes vertically separated into fields of contrasting colors) were despised because of their association with such people, although it no longer provokes such a reaction in us.
This ensemble is constructed of vintage fabric originally used by Balenciaga in 1967, reworked into a multicolor patchwork pattern. It is from Viktor & Rolf's *Atomic Bomb* collection, in which the designers expressed the festive mood of the millennium celebrations combined with the apocalyptic pessimism of the end of the twentieth century.

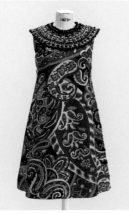

24.
Dress
Yves Saint Laurent
France, 1967
Silk twill with wood and glass-bead embroidery; silk lining
KCI (Inv. AC7078 1992-8-2)

In the late 1960s, Western fashion looked to other cultures for inspiration. This dress from Yves Saint Laurent's *African* collection evokes the brightly patterned fabrics used in traditional tribal garments, and the embellished neckline reinterprets an African necklace as embroidery. Six colors have been used in the fabric's paisley pattern—red, dark red, fuchsia pink, chrome yellow, emerald green, and black. This psychedelic color combination also recalls the effects of the hallucinogenic drug LSD. Popular in the 1960s, it causes visions of intensified colors and distortions of the senses. These effects are permanently identified with the hippie culture, psychedelic art, and fashion of this period.

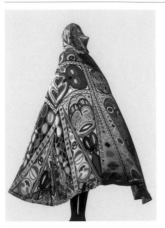

25.
Cape
Emilio Pucci
Italy, 1964
Printed silk
KCI (Inv. AC6821 1990-26-1)

Emilio Pucci's prints often incorporated a variety of ethnic motifs—Mediterranean, African, and Asian—rendered in brightly colored geometric patterns. Silkscreen printing, a technique also used by artists such as Andy Warhol and Peter Max, allowed Pucci to achieve a wide variation of color. Magenta, navy, black, and two shades of pink and purple are used in the fabric for this cape, characterized by a striking print of geometric motifs and African masks.

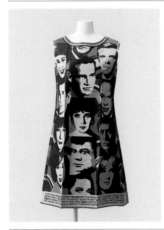

26.
Minidress
U.S.A., 1968
Printed non-woven fiber
KCI (Inv. AC10756 2002-10A)

Pop Art flourished in the early 1960s against the social backdrop of mass consumerism, and brought the phenomenon of everyday popular culture into the world of fine art. The ideas and techniques of Pop Art were almost immediately incorporated into the fields of design, fashion, and advertising. Color had become ubiquitous in popular forms of entertainment like comics, television, and cinema. Mass-production techniques enabled both artists and designers to print stable colors on manmade materials. This dress, made of an inexpensive, non-woven paper, features a printed pattern based on a Warhol silkscreen. It is an excellent example of the infiltration of Pop Art into ready-to-wear fashion.

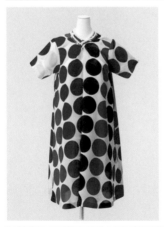

27.
Dress
Junya Watanabe
Japan, 2001
Polyester organdy; printed with colored circles; imitation pearls at neck
KCI (Inv. AC10444 2001-03-12AB)

Junya Watanabe entitled his spring/summer 2001 collection *Pop Couture*. A-line dresses displayed Pop Art references from the 1960s, such as plastic plates, cakes, and geometric circles. Watanabe, however, did not simply look back on those flamboyant times, but reconfigured the tropes of that era with an experimental spirit to rival that of the 1960s. The fabric of this dress is doubled, forming a complicated twisted shape at the joint of the collar, reminiscent of a Möbius strip.

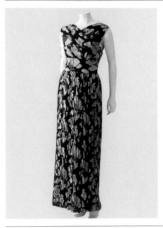

28.
Evening dress with matching belt
Elsa Schiaparelli
France, ca. 1937
Printed silk crêpe
KCI (Inv. AC9470 1997-23-1AB)

The printed motifs on this dress are attributed to Marcel Vertès, a popular illustrator of the period who designed the advertisements for Schiaparelli's perfumes. Schiaparelli often collaborated and derived inspiration for fashion from avant-garde artists, and used such everyday subjects as clouds and balloons as decorative elements in haute-couture clothing. The textile's pattern includes the column in the Place Vendôme, where Schiaparelli's couture house and boutique were located. By printing her name on the column, Schiaparelli transformed the monument—and the body of the wearer—into her brand's advertising "tower."

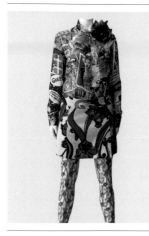

29.
Shirt, skirt, and hose
Dolce & Gabbana
Italy, 2004
Polychrome cartoon-motif printed silk shirt; cotton/linen blend mini-skirt with floral print;
stockings with floral print; polychrome corsage
KCI (AC11076 2004-3AF Gift of Dolce & Gabbana Japan K.K.)

Vivid colors and rich patterns are Dolce & Gabbana's trademarks. This polychromatic
ensemble from their spring 2004 collection, entitled *Fusion,* juxtaposes images inspired
by American comics and Art Nouveau revival motifs—two trends popular in 1960s fash-
ion. The Italian duo once said that Sicily is present in all of their collections. Their work
fuses the multicultural mosaic of Sicilian history with their own contemporary global
viewpoint.

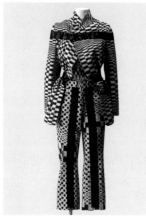

30.
Pantsuit
Rei Kawakubo/Comme des Garçons
Japan, 2001
Printed cotton jacket and pants; printed polyester georgette T-shirt
KCI (Inv. AC10434 2001-3-2AC)

In its spring 2001 collection, Comme des Garçons presented clothes featuring all-over
prints of typical 1960s motifs such as flowers and Op Art (optical art). Op Art used geo-
metric patterns in contrasting hues or gradations to create optically deceptive designs,
in which the pattern could not be distinguished from the background. It was a signifi-
cant experiment in the complete separation of colors from symbolism and material, us-
ing them purely for their visual effects. Camouflage—originally developed to disguise
soldiers during combat—is used as applied trim on this Op Art–inspired suit. Kawaku-
bo's unique combination of two patterns originally intended to be visually deceptive re-
sults in a bold statement in which neither pattern recedes into the background.

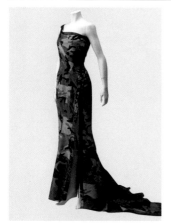

31.
Dress
Christian Dior by John Galliano
France, 2001
Printed silk taffeta trimmed with leather
KCI (Inv. AC10417 2000-50AB)

The design of camouflage patterns includes the study of illusion, sight, and chromatics.
All available knowledge about the sense of sight was applied to the first camouflage
patterns, designed during World War I in an attempt to hide soldiers during combat.
Fashion has often appropriated the power of military uniforms, and here Galliano
expresses that power in a silk dress. This dress reverses the function of camouflage,
using it to draw attention to the wearer rather than concealing her.

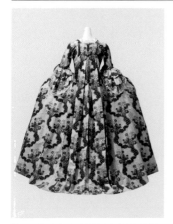

32.
Dress (robe à la française)
France, 1775 (fabric: ca. 1760s)
Brocaded silk
KCI (Inv. AC11075 2004-2AB)

This dress is thought to have been worn by Madame Oberkampf for an audience with Queen
Marie Antoinette in 1775. Silk textiles based on the most advanced dyeing and weaving
methods were extremely expensive. Sophisticated brocading techniques were required to
execute this elaborate floral pattern, enlivened by a ribbon of fur. Many tonal gradations of
green, red, and purple were used to achieve three-dimensional, naturalistic effects. Accord-
ing to the dyeing section of the eighteenth-century French *Grande Encyclopédie,* natural
dyes and agents were used to create various hues, a process which required detailed and
laborious work. At his factory in Jouy-en-Josas near Paris, Madame Oberkampf's husband,
Christophe-Philippe, produced printed cottons called toiles de Jouy that were just as colorful
and more affordable, but they were not formal enough to appear before the Queen.

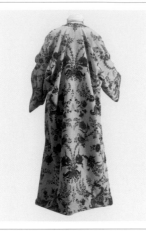

33.
Man's at-home robe (banyan)
England, 18th century
Resist-dyed, printed and painted cotton (chintz); silk lining; wool interlining
KCI (Inv. AC7675 1992-46)

Indian chintz, printed and painted with colorful and colorfast floral patterns, was brought to Europe by the Dutch East India Company by the early seventeenth century. Men's at-home robes, such as this *banyan,* and women's dresses made of exotic Indian chintz became extremely popular. This fashion craze caused a trade deficit and threatened domestic silk industries to such an extent that some European governments eventually prohibited the import and use of Indian cottons, but prohibition was largely unsuccessful. In the eighteenth century, colorfast printing was developed in Europe, and printed cottons emulating Indian chintz were produced domestically.

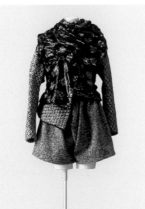

34.
Jacket, vest, and short pants
Rei Kawakubo/Comme des Garçons
Japan, 1999
Wool/rayon/polyester/ lamé blend tweed jacket and short pants; polyester vest embroidered with sequins
KCI (Inv. AC10099 1999-16-5AE)

With this ensemble, Kawakubo challenges long-established notions of Western dress by mixing opposite fabrics, forms, and colors. In this case, tweed, traditionally worn in the country where its muted colors provided a measure of camouflage in the winter landscape, is given the additional texture of metallic lamé and contrasted with a multicolored sequin-embroidered vest more appropriate for an urban nightclub. Kawakubo both tailors and drapes the tweed in defiance of its natural properties, creating a suit so abbreviated that it fails to keep the body warm. By layering a vest over a suit, she also subverts the accepted order of dress.

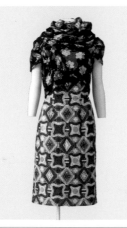

35.
Jacket and dress
Rei Kawakubo/Comme des Garçons
Japan, 1999
Polyester georgette jacket embroidered with sequins; cotton satin dress embroidered with rayon and lamé
KCI (Inv. AC10095 99-16-1AD)

In this ensemble, multicolor meets multi-texture. Kawakubo twists and drapes the fabric of the jacket, fixing the shape with a safety pin to achieve a complex sculptural form accentuated by shimmering color. The lamé-embroidered dress and sequin-embroidered jacket reflect the light diffusely, focusing attention on surface phenomena such as texture and color.

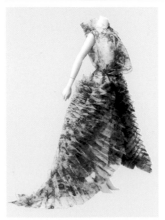

36.
Evening dress
Junya Watanabe/Comme des Garçons
Japan, 2000
Printed polyester organdy
KCI (Inv. AC10360 2000-31-7AC)

In this dress, Watanabe shows his talent for drawing out the specific characteristics of a particular fabric. Here the crisp texture of polyester organdy harmonizes with the elegant silhouette of the dress in a futuristic fusion of texture and form. The softly colored floral print and honeycomb pleating accentuate the diaphanous quality of the fabric. Synthetic fibers such as polyester and nylon have been mass-produced since the 1950s, and their quality has steadily improved. They are no longer just substitutes for natural fabrics and have become established as materials that enable new and unique modes of expression.

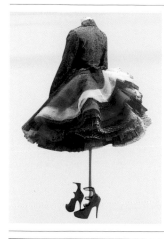

37.
Jacket and skirt
Vivienne Westwood
England, 1993
Nylon lace jacket with floral print; lined with nylon organdy; skirt with layers of poly-chrome nylon tulles
KCI (Inv. AC10961 2003-17-1AB)

In the 1970s, Vivienne Westwood made British punk clothing fashionable. She was most responsible for the spread of the simple design formula "punk fashion = black," but in the 1980s, she used color in order to break her ties with punk. Since her autumn/winter 1981 *Pirates* collection, she has used color along with historical forms to create works with strong and dynamic visual impact. In this example, the lace jacket is lined in blue organdy to achieve a painterly effect, and the multilayered skirt is cut in graduated layers at the back to reveal many different shades of tulle.

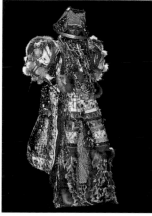

38.
Coat and pants
Christian Dior by John Galliano
France, 2001
Patchwork coat; plastic embroidered jacket; embroidered fur pants; flower print cotton shirt
Collection of Christian Dior Couture, Paris

Here, several garments made of densely patterned patchwork in saturated colors are layered to create an ensemble that overwhelms the senses. This look is strongly influenced by Japanese street fashion, where young people coordinate their costumes to suit their whims, combining many patterns and colors and layering garments in any order.

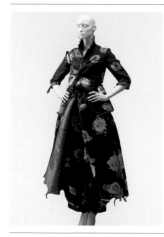

39.
Jacket, pants, and overskirt
Yohji Yamamoto/Y's
Japan, 2003
Gray polyester jacquard patterned with floral motif; unfinished cuffs and hems.
Collection of Yohji Yamamoto Inc., Tokyo

The floral-patterned fabric used in this ensemble was woven using a jacquard process and consists of multiple colors, including red, yellow, purple, white, and black. The dark gray background is made using white yarn for the warp and black yarn for the weft. By exposing unfinished seams and hems, Yamamoto reveals the individual yarns that make up the pattern, like a painter dripping paint from his palette. The painterly effect of the floral pattern is reminiscent of Pointillism—the systematic application of small colored dots used to create images. This technique of juxtaposing colors in textiles, as demonstrated here, has also been used in the RGB systems of television and color printing.

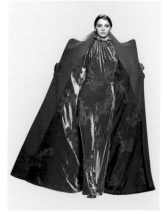

BLUE

40.
Coat and dress
Viktor & Rolf
The Netherlands, 2002
Felted wool coat with beaded velvet crêpe lining; beaded velvet crêpe dress
Collection of Viktor & Rolf, The Netherlands

In their autumn/winter 2002 collection, Viktor & Rolf used blue to suggest the power of fashion to create images beyond their substance. They made full use of a video composing technology called chroma-key. The duo created two interconnected worlds by juxtaposing clothing as tangible material and as digitized immateriality in the same space. This four-dimensional experience invited the viewer to reflect on the relationship between fashion and image-making, and broadened the horizon of what constitutes fashion.

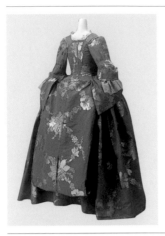

41.
Mantua
England, ca. 1740–50s
Silk taffeta brocaded with plant pattern
KCI (Inv. AC10788 2002-29AB)

The light, elegant, and uninhibited sensibility of Rococo art and design was accentuated by color. In the eighteenth century, the soft and light hues of dresses such as this one were depicted in portraits by painters such as François Boucher and Thomas Gainsborough. The mantua was in fashion as a dress for special occasions from the late seventeenth century to the early eighteenth century in England; it was only worn at the court from the 1730s through the 1750s. The front of the skirt was hitched up to reveal the petticoat, and the train flowed behind or was folded up and fastened over buttons, as seen here. This mantua has a petticoat made of the same fabric, featuring large floral motifs brocaded in silver on a celestial blue ground.

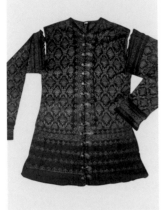

42.
Jacket
England, early 17th century
Silk and metallic knit; silk lining
KCI (Inv. AC3653 1980-32AC)

This extremely rare, early seventeenth-century knit jacket would have been worn under a mantle. The blue yarn contrasts beautifully with gold and silver, and was probably dyed with a mixture of woad or indigo and orcein. Woad was the only blue dye available in Western Europe until the sixteenth century, when it was supplanted by cheap indigo brought from the East.

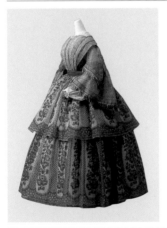

43.
Day dress
England, ca. 1855
Printed silk/wool organdy
KCI (Inv. AC885 1978-24-60AB)

Strong horizontal effects such as stripes and festoons were often used for dresses supported by cage crinolines to accentuate the width of the skirt. The bold stripes of this dress consist of floral and geometric motifs in different shades of blue. Although it is difficult to print on a blend of silk and wool, a wide range of expressions became possible with breakthroughs in printing techniques in the nineteenth century and with the availability of indigo.

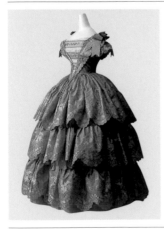

44.
Evening dress
France, ca. 1853
Brocaded silk taffeta, silk satin, silk tulle
KCI (Inv. AC3082 1980-3-5)

In mid-nineteenth-century Western Europe, the elegant style of the eighteenth-century courts appealed to the tastes of the new aristocracy and of the new, rapidly rising bourgeoisie, resulting in a widespread Rococo revival. Empress Eugénie of France and Empress Elisabeth of Austria both admired neo-Rococo fashions, and often dressed in the pale tones associated with the eighteenth century. Their elegant dresses can be seen in portraits by the court painter Franz Xaver Winterhalter. The layered flounces on the skirt of this dress emphasize its dome-like form, which in the early 1850s was supported by layers of petticoats. After the adoption, around 1855, of the cage crinoline, a petticoat of steel wire hoops which could support the voluminous skirts demanded by fashion, skirt flounces gradually became lighter, and eventually disappeared.

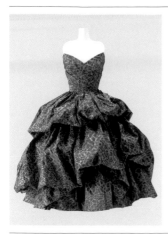

45.
Cocktail dress
Christian Dior
France, 1956
Warp-printed (chiné) silk taffeta; silk tulle petticoat
KCI (Inv. AC5489 1986-47-2AC)

In 1947, Dior launched his "New Look," characterized by a small waist and a full skirt made with an abundance of fabric, setting a benchmark for fashion in the 1950s. His designs are distinguished by their feminine silhouette and subtle color. The different shades of blue in this dress look like ripples on water, and the doubled-over flounces give the impression of gentle waves. Dior adeptly used not only neutral colors such as black, navy, and white, but also light and deep hues. Warp-printed or chiné silks worn by Madame de Pompadour in the eighteenth century were among Dior's favorite fabrics.

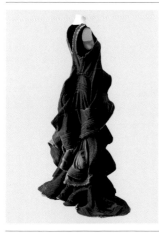

46.
Cocktail dress
Cristobal Balenciaga
France, 1959
Silk taffeta, silk fringe
KCI (Inv. AC4879 1984-22-10)

The pale blue of this dress illustrates the unique shine of silk, and its trapezoidal shape (termed the "baby doll" silhouette) liberates the waist, expanding in an unbroken line from the shoulders to the hem. Balenciaga excelled in designs that abstract the form of the human body, as seen in this dress, a precursor to the A-line dress of the 1960s.

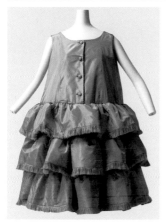

47.
Dress and pants
Junya Watanabe
Japan, 2002
Cotton denim dress with train and pants; unfinished hem
KCI (Inv. AC10732 2002-4-3AB)

The thick cotton twill known as denim originated in Nîmes, France, and was brought to the United States as work wear. Dyed with indigo, denim clothes were convenient, economical, and durable, which led to their popularity during the second half of the nineteenth century. In the twentieth century, denim was transformed from a symbol of youthful protest to a basic item for everyone, and from street style to the latest fashion. Watanabe used sophisticated techniques to transform common denim into this flamboyant dress. The hard denim was washed, softened, and given a vintage effect. Ingenious cut and construction then created an elegant, undulating silhouette.

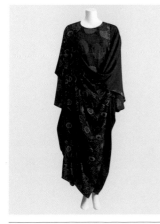

48.
Dress and T-shirt
Rei Kawakubo/Comme des Garçons
Japan, 1984
Rayon dress imitating ai-zome (stencil-resist indigo dyed textiles), stencil-like print; acetate T-shirt imitating ai-zome
KCI (Inv. AC7914 1993-24-122AB, Gift of Comme des Garçons Co., Ltd.)

Ai-zome, or Japanese indigo printed cotton, already established in the general population, became fashionable in Japan during the Edo period (1603–1868). Indigo fixes well to fabric, making it possible to achieve a range of blues using various techniques. Blue was used widely, both for daily wear and for clothes for special occasions. Traditional ai-zome dyeing techniques are still maintained in some regions in Japan. This fabric's pattern resembles ai-zome, but is in fact made by an experimental printing technique, not the traditional stencil printing.

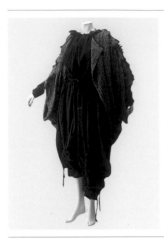

49.
Jacket and jumpsuit
Issey Miyake
Japan, 1983
Linen jacket; cotton jumpsuit
Collection of Miyake Design Studio, Tokyo

Indigotin, the basis of indigo, is one of the oldest vegetable dyes in human history and is found in plants grown in many regions in the world. The Japanese first used Chinese indigo *(Polygonum tinctorium),* then imported Indian indigo in the late Edo period, and finally turned to synthetic indigo near the end of Meiji period (1868–1912).
In this ensemble, Miyake reinterprets traditional Japanese dyeing and weaving methods. He has reproduced the color of Japanese indigo using synthetic dye, updating the concept of traditional Japanese indigo for contemporary international fashion.

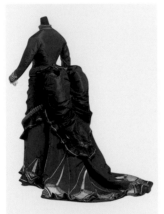

50.
Day dress
Possibly France, ca. 1874
Silk taffeta, silk lace
KCI (Inv. AC4647 1983-25-5A, AC4649 1983-25-5C, AC4650 1983-25-5D)

This dress showcases the color mauve during the period following the discovery of this first synthetic aniline dye by William Henry Perkin in 1856. Aniline dyes were derived from coal tar, and produced vivid purples, reds, blues, greens, pinks, and blacks. In Western culture, shades of purple have been associated with royalty and high status since antiquity. Prior to the discovery of aniline dyes, purple colors were expensive and more likely to be used sparingly. However, with the advent of less expensive artificial dyes, an all-over mauve fabric became accessible to the general public.

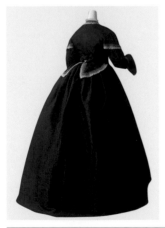

51.
Day dress
England, ca. 1865
Silk taffeta, silk lace and fringe
KCI (Inv. AC2234 1979-10-7AB)

The saturated purple color of this silk dress demonstrates the application of powerful new synthetic dyes to traditional natural fibers, and their dramatic impact on fashion. The extremely wide skirts of the late 1850s and early 1860s, supported by cage crinolines, also provided plenty of space to display the latest fashionable color. This dress shows an intermediate step in the evolution of this silhouette, between the round cage crinoline of the late 1850s and the bustle that would take its place by 1870.

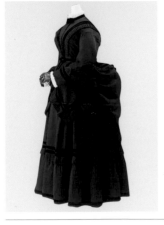

52.
Day dress with overskirt
England, ca. 1875
Wool satin silk velvet ribbon
KCI (Inv. AC4844 1984-18-4AB)

The blue of this dress is a bright color characteristic of synthetic dye. The first artificial indigo was discovered by Bayer in 1880, although synthetic blue dyes such as Lyon blue and alkali blue had been made earlier. The intense manmade colors stimulated the creativity of fashion designers and artists alike in the latter half of the nineteenth century. The House of Worth, the most famous Parisian couture house of the period, created many dresses using synthetically dyed fabrics.

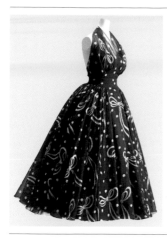

53.
Evening dress
Robert Piguet
France, ca. 1951
Silk gauze; silk faille underdress and silk gauze petticoat
KCI (Inv. AC5358 1986-15AG)

Robert Piguet, who opened his haute-couture house in Paris in 1933, was one of the most fashionable designers of the 1930s. He was renowned for his excellent technique, his sensitivity to color, and the simple beauty of his designs. He was also involved with the visual arts scene of the period, and maintained friendships with artists including Jean Cocteau and Christian Bérard. This "zenith blue" dress with a purple tint was worn by Suzy Parker, the flamboyant red-haired American model and actress. The small waist, full skirt, and halter neckline show how Piguet adapted to the silhouette of the 1950s.

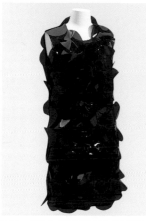

54.
Dress
Junya Watanabe
Japan, 2001
Nylon/polyurethane, trimmed with acrylic circles
KCI (Inv. AC10439 2001-3-7A)

The field of chemistry gave the world both synthetic dyes and manmade fibers; in this dress, Junya Watanabe makes use of both. Nylon fiber was invented by the American chemist Wallace Carothers in 1935, and other synthetic fibers, such as polyester, appeared within a few years. In his designs, Watanabe experiments with the shades and clarity of color that are uniquely possible in synthetics such as polyester, polyurethane, and other plastics.

55.
Dress
Junya Watanabe
Japan, 2000
Polyester organdy
KCI (Inv. AC10363 2000-31-10A)

In Japan, the production of synthetic fibers has for decades provided new possibilities for both color and design. Although Watanabe makes the most of the latest fiber science advances, he does not overemphasize technology in his work, but always retains an element of organic warmth. Nature and artifice are both present in this dress. The texture of the pleated polyester organdy resembles the quilled petals of a dahlia or marigold; however, the intense blue color reminds us that this flower does not exist in nature.

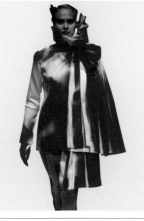

56.
Jacket and skirt
Viktor & Rolf
The Netherlands, 1998
Spray-painted silk satin
The Centraal Museum, The Netherlands

This outfit is from Viktor & Rolf's first haute-couture collection, presented in Paris in 1998, in which the duo asked the question, "What is haute couture?" They caused a sensation with highly original designs which presented abstract and conceptual answers to this question. For a series of outfits dedicated to color as an element of clothing, they chose to focus on the three primary colors—red, blue, and yellow. By spraying red paint over the exterior of precisely pleated garments, leaving the interior white, they highlighted the contrast between the presence and absence of color. In this design, form is consciously subordinated to color, although the two are integrally related.

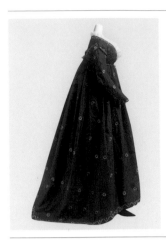

57.
Dress (round gown)
Italy, ca. 1795
Silk satin; silk embroidery at hem; trimmed with silk fly fringe and tassel
KCI (Inv. AC9125 1994-14-3)

The purple-tinted red color of this dress is derived from the kermes beetle, which lives on kermes oaks that grow by the Mediterranean Sea; vast quantities of female beetles are necessary to dye a single piece of cloth. In the late sixteenth century, less expensive cochineal dye, exported to Europe from Central America, eclipsed kermes in popularity. This dress must have cost a small fortune to produce, although it consumed less fabric than earlier eighteenth-century dresses that were open in the front, usually over a matching petticoat. This is a "round gown"—a one-piece dress with bodice and skirt forming a continuous piece gathered by a drawstring, or two separate pieces joined together by a waistline seam.

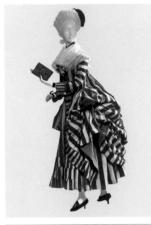

58.
Dress
France, ca. 1780
Striped Pékin silk faille; trimmed with self-fabric and fly fringe
KCI (Inv. AC5316 1986-8-4AB)

In pre-Revolutionary France, while court culture flourished, practical ideas adapted from the lower classes' work and town wear also came into fashion. This dress is one example, in the *retroussée dans les poches* style, in which the back of the dress is pulled through pocket slits on either side, creating a more compact and casual walking dress. The effect of the draped back was emphasized by the strongly contrasting red and white stripes of the *Pékin* silk. *Pékins,* which originated in China, are created using different colors to form stripes of equal width. The fashion for *chinoiserie* in France led to the production of French *Pékins* around 1760.

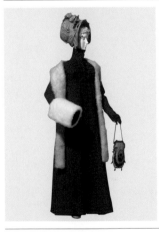

59.
Coat (redingote)
France, ca. 1810
Wool flannel
KCI (Inv. AC5646 1987-27-1)

The colors of Napoleon's army left a profound mark on the public perception of red, and influenced the development of fashion. As in Stendhal's 1830 novel, *The Red and the Black,* in nineteenth-century France, red evoked the military while black denoted the clergy. This *redingote* or coat shows military influence in its red color and in the Brandenburg trimmings on the bodice. The red dye is cochineal, mixed with a very small amount of turmeric.

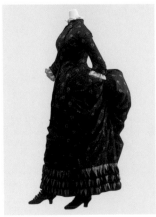

60.
Day dress
Laforcade
U.S.A., ca. 1885
Cotton printed with Indian floral pattern
KCI (Inv. AC903 1978-25-15AB)

This printed cotton dress reflects the greater availability of red dyestuffs in the nineteenth century, as well as the revival of eighteenth-century fashions. During the latter half of the eighteenth century, the fashion for Indian chintz led to the establishment of European cotton printing industries to produce imitations. In the French region of Alsace, the cultivation of madder plants, another traditional source of red dye, began simultaneously, and Alsace became famous for its production of printed cottons with red patterns.

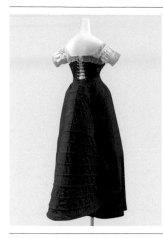

61.
Corset, bustle, and petticoat
ca. 1880 (corset), 1870s (bustle), 1850s (petticoat)
Cotton satin corset; cotton twill and steel wire bustle; printed cotton petticoat
KCI (Inv. AC4475 1983-11-11AB, AC2833 1979-24-27AD, AC1493 1978-39-27)

Before the nineteenth century, undergarments were made of undyed, unbleached linen or cotton. Dyestuffs obtained from animals were thought to contain unhygienic impurities, and expensive dyes were rarely used for underwear. Since few dyes were truly colorfast, there was little point in using them for garments to be frequently washed. From the 1850s onward, however, synthetic dyes brought color even to undergarments, which then began to appear in red, purple, and black. This is an example of the supportive structure necessary to create the fashionable silhouette of the 1870s and 1880s. The bustle could consist of materials such as horsehair, whalebone, bamboo, rattan, or, in this case, steel wire hoops covered with cotton. The extreme artifice of the fashions of this period is well represented by both the bustle silhouette and the use of synthetic colors.

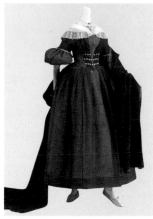

62.
Day dress
U.S.A., ca. 1838
Silk/wool blend gauze with silk satin piping
KCI (Inv. AC2208 1979-9-13, AC2212 1979-9-17)
Cashmere shawl
India, ca. 1810–20s
Red cashmere rectangular-shaped shawl
In India, where it is admired as the color of life, red was produced using natural dyes such as Indian madder, lac, and cochineal. Many of the Indian cashmere shawls first exported to Western Europe at the end of the eighteenth century were made by hand-spinning the soft wool of Kashmir goats from northwest India, and were expensive to produce. Cashmere shawls were worn over the shoulders and, unlike a coat, allowed for the full sweep of mid-nineteenth-century skirts. These shawls were such important accessories that it is difficult to study nineteenth-century women's fashion without considering them. The Indian cashmere shawl seen here would have provided warmth over this dress made of wool and silk gauze.

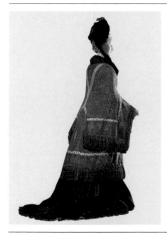

63.
Visite (coat)
France (fabric: India), late 1870s
Tapestry-woven wool; wool fringe
KCI (Inv. AC4843 1984-18-3)

Visites made of richly patterned cashmere, sometimes fashioned from one or more shawls, were popular in the second half of the nineteenth century. They provided a warm outer layer that allowed for the protrusion of a bustled skirt at the center back. The fabric used in this *visite* consists of a combination of different patterns woven with a red warp and a weft of approximately ten different colors, including red, purple, blue, black, green, and white. White patterned borders accent the sleeves and the hem.

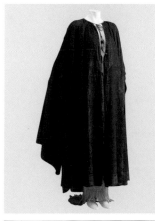

64.
Caftan, *Delphos* dress
Mariano Fortuny
Italy, ca. 1920s
Caftan of crimson plain silk; stenciled with gold Coptic pattern; glass beads; pleated silk dress
KCI (Inv. AC5311 1986-7, AC3189 1980-8-3)

Mariano Fortuny, a designer active in Venice at the beginning of the twentieth century, was inspired by exotic countries and cultures in his production of highly original textiles and clothes. His extensive knowledge of ancient dyeing methods and delicate sense of color allowed him to create subtle, transparent, and rich hues by soaking fabric repeatedly in (mostly) natural dyes.
The red hues in Fortuny's works range from the bluish red in this dress to scarlet or cinnabar red. Oriental motifs, such as the Coptic pattern of this dress, were overprinted in gold and silver or multicolors, using a stencil print technique influenced by Japanese *kata-zome*. The pleated dress worn underneath, in which the silk textile is finely and irregularly pleated, is also typical of Fortuny's work.

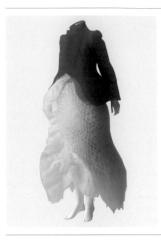

65.
Jacket and skirt
Junya Watanabe
Japan, 2000
Polyester organdy
KCI (Inv. AC10362 2000-31-9AC)

The strong red of the jacket and brilliant yellow of the skirt feature a high color saturation unique to synthetic dye. The skirt is made by layering polyester organdy, an ultra-thin synthetic material, to form a voluminous, three-dimensional, honeycombed shape. The juxtaposition of two primary colors, red and yellow, creates a dynamic counterpoint.

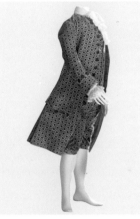

66.
Man's suit (coat, waistcoat, breeches)
France, ca. 1765
Silk velvet, silver
KCI (Inv. AC306 1977-12-21AC)

Before the French Revolution, Western men's fashion could be as colorful as womens-wear. Eighteenth-century men's court suits, which consisted of an *habit* (coat), a *gilet* (waistcoat), and a *culotte* (breeches), were made of luxurious silk fabrics in beautiful hues. This three-piece suit is made of deep yellow velvet with a delicate pattern of small floral motifs surrounded by cartouches.

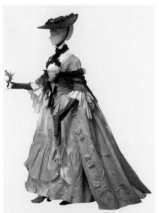

67.
Dress (robe à la française) and petticoat
England, ca. 1760
Silk taffeta
KCI (Inv. AC5761 1988-11AB)

In early Christian culture, yellow was seen as the color of heretics, and held in contempt until medieval times. In China, yellow was the color of the Emperor, a color so noble that common people were forbidden to use it. The eighteenth-century vogue for *chinoiserie* resulted in new interest in yellow in Europe, and it became a fashionable color. The source of the yellow dye used for this textile is weld. The color has a golden shine, resonating with the glossy brilliance of the crisp silk.

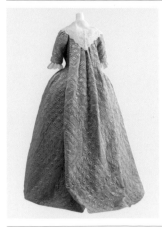

68.
Dress (robe à la française)
England, ca. 1750–55
Quilted silk satin
KCI (Inv. AC6992 1991-12-13)

The yellow dye used for this dress is luteolin pigment, a kind of flavone (a yellow plant pigment) derived from weld. This dress is enlivened by the use of English quilting, a technique in which cotton fibers and cords are inserted in between layers of fabric stitched in geometric and arabesque patterns. Rich yellow hues are reflected by the light striking the uneven surface of the quilted silk. There are many quilted petticoats still extant from the eighteenth century, but dresses like this, in which quilting is applied all over, are very rare. Similar examples are found in the collection of the Museum of London. They are likely to have been worn even on formal occasions because of the beauty and sophistication of the technique.

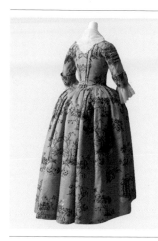

69.
Dress (robe à l'anglaise)
England, ca. 1770 (fabric: ca. 1740)
Spitalfields brocaded silk
KCI (Inv. AC4340 1982-21-3)

This dress exemplifies the main textile design style of eighteenth-century England—influenced by Chinese, Indian, and French motifs—woven on a fashionable yellow ground. The textile was woven in the Spitalfields area of London, which was the center of the English silk industry in the eighteenth century. The background color was called Chinese yellow or King's yellow, a name that came into use in 1761, and the dye is derived from weld. The English-style textile was appropriately used to make a *robe à l'anglaise,* or English-style dress, characterized by its close-fitting back. Like the Spitalfields silks which England exported throughout its empire, the *robe à l'anglaise* became an international fashion.

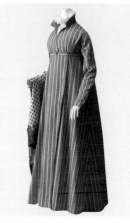

70.
Coatdress (redingote)
France, 1810–15
Printed plain cotton
KCI (Inv. AC10793 2003-02-1)

Stripes were in fashion as an Oriental pattern just after the French Revolution. After the Revolution, under the influence of Napoleon's expedition to Egypt and other events, Egyptian or Turkish stripes were often used for clothes or interior decorations. The fashion for stripes was partly due to their exoticism, but also to the invention of machinery such as spinning machines and Jacquard looms that could produce them more efficiently. The yellow and red striped fabric in this dress looks like a warp print, although in fact it is an ordinary print using madder plants and flavones such as luteolin from plants including weld. This fashionable, slender dress appears even slimmer on account of the vertical stripes.

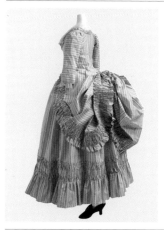

71.
Dress (robe à la polonaise) and petticoat
France, ca. 1780
Striped silk taffeta; ruched trimmings
KCI (Inv. AC7620 1992-34-1AB)

Except for court costume, the trend in the latter half of the eighteenth century was toward simpler clothing, and women's fashion evolved into more relaxed, functional forms. This *robe à la polonaise* from the 1770s is one example of such a casual dress, with the back of the skirt gathered up by cords and divided into three draped parts.

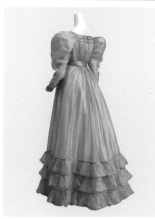

72.
Day dress
England, ca. 1825
Silk gauze, silk satin
KCI (Inv. AC4973 1984-31)

The discovery of the mineral dye chrome yellow in the 1810s brought vivid yellows into fashion. However, the source of the yellow dye of this dress is weld. Thin materials, such as muslin, organdy, and the silk gauze, seen here, came into fashion along with *gigot* sleeves and voluminous skirts during the late 1820s.

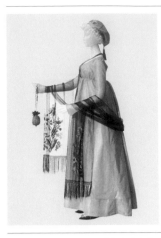

73.
Dress (round gown)
France, ca. 1803
Silk taffeta
KCI (Inv. AC5907 1988-55-26)

After the French Revolution, there was a fashion for high-waisted dresses made of thin white cotton muslin, which were thought to resemble the draped costumes seen in ancient Greek or Roman sculptures. This yellow silk dress is thus particularly striking in the light of the prevailing fashion for white cotton. However, saffron yellow was known to be a popular color in ancient Greece and Rome. The source of the yellow dye used in this dress is weld.

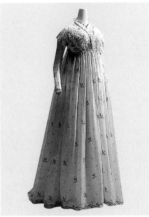

WHITE

74.
Dress (round gown)
Italy, ca. 1795
Cotton muslin embroidered with silver and trimmed with lace
KCI (Inv. AC9123 1994-14-1)

The overwhelming preference for white dresses around the time of the French Revolution (1789–99) was partly due to revolutionary politics. Colorful, expensive silks were associated with aristocratic privilege, whereas plain white cotton signified egalitarian virtue. It was as though the white dress symbolized the beginning of sweeping social changes—democracy, liberation, and progress. It marked the beginning of a new era. This Italian example of the new fashion bears discreet yet unmistakable signs of luxury in the form of silver embroidery and lace trim.

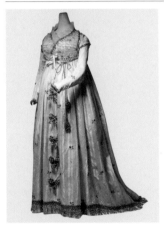

75.
Dress (round gown)
Italy, ca. 1795
Silk embroidered in green silk, gold thread, and sequins, trimmed with fly fringe and tassel
KCI (Inv. AC9124 1994-14-2)

This cream-colored round gown belonged to the same woman as did No. 74, and is very similar in design, cut, and construction. However, this dress is made of silk with a woven striped pattern, further embellished with green and gold metallic embroidery. Soon after his *coup d'état* in 1799, Napoleon worked to revive silk-weaving, lace-making, and other luxury industries in France, and French fashion leadership was reestablished in Europe in the wake of his victorious armies. These high-waisted one-piece dresses were precursors to the silhouette labeled "Empire."

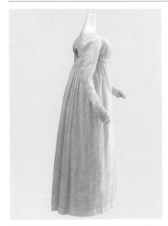

76.
Dress
England, early 19th century
Cotton muslin one-piece dress; cotton floral embroidery; trimmed with linen lace at cuffs
KCI (Inv. AC692 1978-20-17)

This dress reflects England's dominance of the cotton industry and the sweeping changes brought by the Industrial Revolution. A trade agreement signed between England and France in 1786 resulted in the export of huge quantities of English cottons to France. By the early nineteenth century, the mechanization of harvesting, spinning, and weaving had placed the mills of Manchester at the center of a vast global trade. The white cotton dress became a kind of daily uniform for women, as the dark suit was for men.

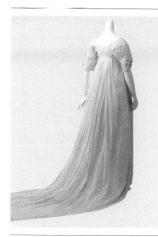

77.
Dress
England, ca. 1805
Cotton muslin, white-work embroidery
KCI (Inv. AC293 1977-12-10)

Neoclassicism in women's fashion was strongly influenced by the excavation of ancient Greek and Roman ruins at Herculaneum, a town that had been buried by an eruption of Mount Vesuvius in 79 AD. Inspired by ancient art, neoclassical fashion freed women's bodies from corset and pannier and aspired to return to the purity of ancient drapery. Here, neoclassical allusions include the high waistline, long train, and pseudo-drapery at the edge of the sleeves. The dress is made of thin, almost transparent cotton and requires an opaque cotton chemise undergarment. By wearing a pink, blue, or yellow under-layer, the wearer could transform the color of her dress.

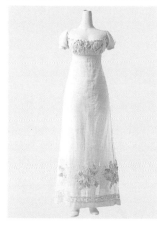

78.
Dress
U.S.A., ca. 1800
Cotton gauze
KCI (Inv. AC5464 1986-42-2)

The heavy white-work embroidery on this American dress echoes the revival of ornament in French fashion under the Empire. Napoleon, who crowned himself Emperor of the French in 1804, created a new imperial court costume to stimulate the production of French luxury goods. The square neckline, puffed sleeves, and lavish embroidery of French court costume is here adapted in American cotton. This dress reminds us that the majority of raw cotton fiber used by the global textile industry was supplied by the United States. The freshness and purity of white cotton were accentuated by cashmere shawls and coats in contrasting colors such as red and yellow.

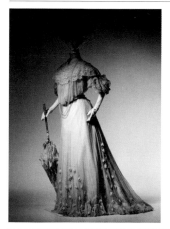

79.
Day dress
France, ca. 1903
Silk chiffon; bobbin lace trim
KCI (Inv. AC3638 1980-29-19AC)

The *belle époque* period at the end of the nineteenth century was characterized by Art Nouveau, its defining style, which incorporated organic motifs in flowing, curving lines. Art Nouveau design influenced all aspects of fashionable life in Europe, from architecture and the industrial arts to apparel. The S-bend corset introduced in the late 1890s ensured that even women's bodies conformed to the curvilinear Art Nouveau ideal. In this dress, sheer white textiles such as silk chiffon and lace enhance the wearer's resemblance to a fragile flower.

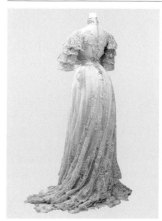

80.
Day dress
England, ca. 1900
Cotton tulle; lace appliqué and insertion; silk satin trimming, pearls, beads, and silver thread embroideries on collar and waist
KCI (Inv. AC3025 1980-2-49)

Light and shadow falling on different levels of transparent tulle and lace create texture in this dress made all in white. Its extreme fragility identified the wearer as a member of the leisured class.

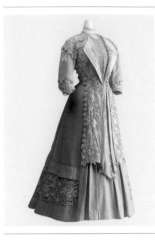

81.
Day dress
Possibly England, ca. 1907
Wool flannel, silk, guipure lace
KCI (Inv. AC1844 1979-1-5AB)

This transitional dress is tailored like a suit, yet encrusted with lace. The *guipure* lace, a heavy, large-patterned decorative lace, contrasts with the strict tailoring of the garment. Women's fashions incorporating elements of menswear grew in popularity in the second half of the nineteenth century, a trend encouraged by English tailors active in Paris.

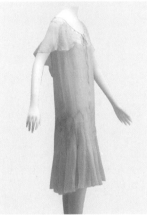

82.
Dress
Gabrielle Chanel
France, ca. 1926
Silk chiffon; underdress of silk charmeuse
KCI (Inv. AC6427 1989-21-10AB)

The nineteenth century's corsetry and emphasis on surface embellishment began to fade away during World War I, a period of sweeping change for women's fashion. After the war, fashion was led by a new generation of couturiers, many of them women, for whom simplicity was the guiding design principle. Gabrielle "Coco" Chanel helped establish a new aesthetic of modern elegance based on subtraction to essential elements. She eschewed unnecessary trimming, and worked primarily in black, white, beige, and other muted colors.

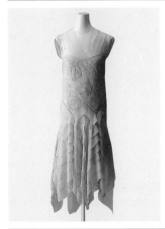

83.
Evening dress
Madeleine Vionnet
France, 1929
Silk chiffon
KCI (Inv. AC6420 1989-21-3AC)

Madeleine Vionnet responded to the preference for simple, modern clothing, which allowed the body greater comfort and freedom of movement, with original cutting techniques and such body-conscious colors as *chair* (skin). This sensual dress in pale features the skillful bias-cut technique, cowl neckline, and handkerchief hemline characteristic of her work. For Vionnet, bringing out the beauty of a garment meant thoroughly researching the properties of a chosen material as it draped on the three-dimensional human body.

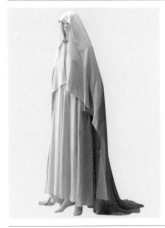

84.
Wedding dress with veil and train
Madeleine Vionnet
France, ca. 1937
Silk crepe
KCI (Inv. AC5514 1986-55AD)

It was not until the mid-nineteenth century that white became associated with wedding dresses, a preference which has since become ubiquitous. Vionnet's wedding dress of heavy, bias-cut silk crêpe flows along the lines of the body, producing dramatic folds. The peaceful, breathtaking beauty of the dress and the purity of the ivory color nobly represent the bride's chastity.

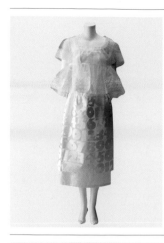

85.
Dress and overblouse
Rei Kawakubo/Comme des Garçons
Japan, 2002
Nylon gauze, cotton/polyester broadcloth
KCI (Inv. AC10737 2002-4-8AB)

White made an impressive appearance in the spring/summer 2002 collections in Paris, perhaps representing a fresh start to the new century as seen in fashions at the turn of the nineteenth and twentieth centuries. Rei Kawakubo's designs for that season featured pure white frills and lace, symbolizing purity and tenderness, and alluded to earlier periods when white was in fashion. This ensemble recalls the high waistlines and drawstring necklines of 1800.

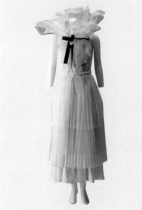

86.
Dress, collar, and overskirt
Rei Kawakubo/Comme des Garçons
Japan, 2002
Cotton, nylon gauze collar and overskirt
KCI (Inv. AC10740 2002-4-11A, AC10735 2002-4-6B)

Rei Kawakubo layers white garments and historical references to suggest that we live in a time of transition. A neckline that recalls the white cotton *fichus* of pre-Revolutionary France is paired with the proportions of World War I, a time when the waistline was displaced and undefined and hemlines were in flux. The childlike innocence of a schoolgirl's black and white bows, reminiscent of Chanel, offers optimism and hope for the future.

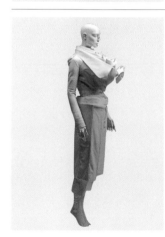

87.
Jacket and pants
Viktor & Rolf
The Netherlands, 2002
Silk twill jacket; acetate georgette pants
KCI (Inv. AC11062 2003-38AC)

Like Rei Kawakubo, Viktor & Rolf presented an all-white collection in spring 2002, which they called *Holy Communion*. In contrast to the aggressive *Black Hole* show of autumn/winter 2001, *Holy Communion* used white as a vehicle for exploring themes of love and purity. Here Viktor & Rolf's remarkable tailoring techniques and formal experimentation take the shape of multiple layers of white bows, representing formality and the respect paid to social ritual.

By Claude Imbert, Ecole Normale Supérieure
Manet, Impressions of Black

"Manet is stronger than we. He can create light from darkness." When he quoted Camille Pissaro, Henri Matisse undoubtedly wanted to lend a prestigious genealogy to his own post-Fauvist paintings, *Les Marocains* or *Les Courges.* Yet he knew that his contemporaries would immediately recognize Edouard Manet's trademark: the particularity of his blacks. Neither the public nor the critics had noticed it, being far too busy decrying the acid green and sour colors that "stuck in the eye like a knife." Tolerated as a descriptive outline on clothes or as emphasis in a painting like the *Après-midi aux Tuileries,* black was deemed to be a bizarre craze for dressing up like a Spaniard. *Olympia* (1863) had reneged on a colorism only recently learned from Delacroix. It was attacked. An astonished critic poured out his resentment on a black cat's "smutty paw prints" and the repulsive "dirtiness" of a nude, wiped completely clean of Titian's gilded carnations, which Manet himself had copied so assiduously some years before. And if the eye could not help itself from following the tone-setting black, from the face of an African to the fur of a cat and then to the thin velvet ribbon which stressed the fleshiness of the nude, it could well be supposed that this was a strategy with obscene intentions.

Manet's friends, starting with Charles Baudelaire, Emile Zola, and then Stéphane Mallarmé, well knew that this black carried the stamp of the modern; it was an amendment to the contract with modernity, and with the colorism which Charles Baudelaire had so eloquently preached. In a brief homage to one of Manet's Spanish canvases, the poet perfectly grasped the polarity which bound her pink satin slippers to her ebony hair and overpowered the colorful profusion of dancer's skirts and petticoats.

> "We see shimmering in Lola de Valence
> The unexpected charm of a pink and black jewel."[1]

The couplet was used as evidence against him during the obscenity trial of *Les fleurs du mal.* A few years later, Emile Zola defended *Olympia,* but still held to a pure and enigmatic coloristic convention:

> "You needed a naked woman, and you picked Olympia, you needed light areas and you placed a bouquet there, you needed some dark and you put a negress and a cat in the corner. What is it supposed to mean? You don't know any better than I do, but I do know that you have created a work of a painter, a great painter."[2]

Mallarmé, the companion of Manet's later years, could live without *Olympia,* the "faded, wilting courtesan." In *Le Bal masqué à l'Opéra,* darkness forces the parsimonious use of color, which would otherwise cheer up the "certain monotony of a background of black clothing," but it does correspond perfectly to the exigencies of modern dress and the allure of a contemporary crowd.

> "I do not believe that it is possible to be otherwise than surprised by the delicious range provided by the blacks: evening dress and dominos, hats and masks, velvet, brocade, satin, and silks."[3]

His farewell to Manet precisely captures both charm and mystery:

> "Haunted by a certain black, the modern French masterpiece."[4]

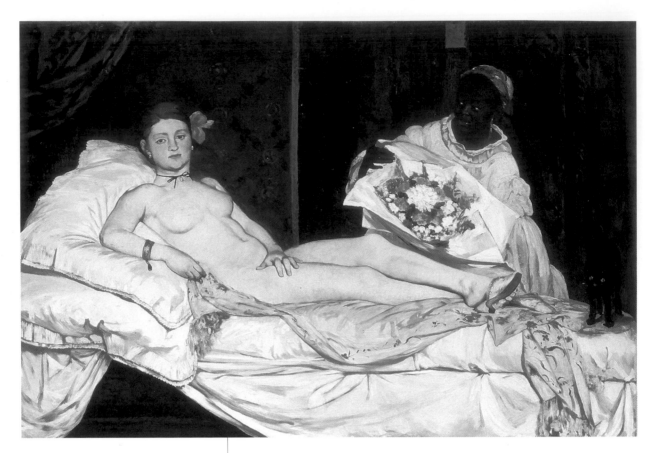

Almost without exception, Manet's first blacks were surfaces. The experiments were performed on clothing imported from a Spain he had not yet visited—costumes taken from the theater or the bullfight, in stark contrast to the frock coats, gloves, top hats, and polished footwear of the Parisian paintings. The black of the fabric or leather absorbs the light and redistributes it arbitrarily, depending how its own surface refracts artificial light. And all this was tackled directly, necessarily combined with the cold light of the studio. Manet found in photography the power not to reflect a form, but to capture a fleck of light as does the surface of fabric. The canvas had ceased to imitate a mirror or a hypothetical Albertine window. The wools, velvets, taffetas, and satins, but also homespun rags, established a new relationship between a texture and its own visibility. Painting regained its proper powers, which were lost to the convention of an illusionistic surface playing the role of an optical instrument. As clothing does, it adds texture to the diversity of the pigments which absorb or diffract the light. The black, punctuated by white highlights, reminds us that all the colors arise from a pictorial fabric, whence they emerge matte or glossy, flat or creased, strong or faded, textured by brushstrokes. Pure, luminous, profane, they are captured by modern screens and dyes and reproduced with intensity.

The main point for Manet was to furnish the canvas with its strained luminescence found between the black, which continually swallows light, and the white, which is not the opposite, but simply an extreme variant of the same principle. Leaving here the naturalistic play of dark and light or theatrical chiaroscuro, Manet introduced a parameter which grabs the pictorial visibility and from which the eye of the viewer cannot escape. *La Chanteuse des rues* (1862) varies all the grays—from black to white, shiny and dull, punctuated by small patches of red. The

cherries, which the female figure holds in a paper cone in one hand while she carries them to her mouth with the other, adds to it a garnet color—like a jewel worn carelessly. Manet had sought and found his model. He exulted: "I've got Victorine." Victorine Muret's milky complexion would be the substance of his nudes to come.

Le vieux musicien (1862) is, in sheer size and complexity, the most ambitious work the painter attempted. Seven figures are spread out in a line and viewed head-on or at three-quarter perspective, like the fashion plates Baudelaire evoked in the early pages of *The Painter of Modern Life,* or the Japanese prints which several world's fairs had spread far and wide.

Manet took his figures from Le Nain, Velázquez, Goya, Jean-Antoine Watteau, from antique statuary, and even from his own paintings, with examples of drapery, poses, clothing, and textures. They are organized according to two criteria. Le vieux musicien, copied from a statue of Chrysippus seen in the Louvre, but adorned with a romantic hairstyle and equipped with a violin, is balanced on his left by the silky white glare of a young boy, obviously inspired by Watteau's *Gilles.* The characters are, as it were, disguised, or rather dressed up, in a variety of always impure blacks—brownish, bluish, or in the dusty black of a threadbare cape, all referring back to Gilles's tunic. Nothing is taking place between the group of figures other than, essentially, a friendly, tacit complicity, which criss-crosses the whole history of art. It is authenticated by the embrace which a young boy with a Spanish haircut (used hundreds of times by Manet) gives to this new Gilles, rescued here from the unfathomable despair of Watteau's clown and suffering a hangover after the decline of the Ancien Régime. These ragged children proudly wear the new uniform of modern intensity, black on white. It occupies an area of painting resolutely emptied of natural or historical scenes, from which Manet had nevertheless recruited, and perverted, his characters.

The following year, Manet wanted to answer the critics who expected of him another nude. He had attempted such a work one year earlier with a *Nymphe surprise* painted in the style of Rubens, cut out of a much larger original painting on a biblical theme, for which his wife Suzanne Leenhof had posed. Accepting the challenge, Manet painted two nudes, *Olympia* and *Le déjeuner sur l'herbe.* Only the second was submitted to the Salon. It was refused, as were two "Spanish" paintings, *Victorine en costume d'espada* and *Jeune homme en costume de Majo.* For the latter, the models pose in near astonishment as they try, through their attitudes and manners, to transcend their costumes. The black of the *majo* is accented by a large white belt, and that of the espada by a bright pink *muleta*—no sign here of a real bullfighter's red cape (similarly the *torero mort* has a pale gray *muleta* in his left hand). These Goya-esque elements obviously had been staged in the artist's studio. It is as if they had apprenticed themselves to another, more urgent realism.

It is necessary to see *Le déjeuner sur l'herbe* (originally called *Le bain*) in the same way. The naked flesh of the woman, like the tunic of Gilles, seems made of the same stuff as the frock coats, trousers, and waistcoats of the men. They are all, in a clear allusion to the *Concert Champêtre* of Giorgione, installed in the center of the canvas in a cluster of intensely luminous blacks, whites, and grays. The trio, entirely out of place in their environment, as if on a photographic plane, is inserted, or rather opened up, between the colorist still life of the lunch

ABOVE: Edouard Manet, *Street Singer (La chanteuse des rues),* about 1862. Museum of Fine Arts, Boston, Bequest of Sarah Choate Sears in memory of her husband, Joshua Montgomery Sears 66. 304.

OPPOSITE: Edouard Manet, *Olympia,* 1863. Musée d'Orsay.

in the foreground and the Impressionist background, with the discrete colored patch of the chaffinch. In this painted manifesto, Manet, by varying the dimensions of the blacks and whites, isolated and emphasized these characters, who seem to invent the comportment of a new bourgeoisie which has everything left to learn—its manners, its pleasures, and its feelings. The modern, including what now follows in the way of other bathers (by Manet himself, by Paul Cézanne, and by Pablo Picasso) is essentially unceremonious and smart.

Olympia is cut from the same cloth. But what the previous painting lays out in three planes is more subtly composed here. The gaze of the viewer, initially struck by the gesture of a *Venus pudica,* is drawn by the calculated seduction of the bouquet of flowers, then follows the pull of the black colors—the African servant's face, the cat's fur, the velvet choker around Olympia's neck which constricts the pale flesh of her body. The eye is made prisoner by this new frame, by this nude lightly outlined in black, her paleness accented by the brightness of the sheet on which Olympia, half sitting, strikes a variation on the pose from *Nymphe surprise,* already evoked in *Le déjeuner sur l'herbe.* Black ribbon against white skin, this strict and sober inversion of the costume of the *majo,* plays a similar role, producing a "Victorine en costume d'Olympia." Her body lacks the flesh tones one would normally expect of a courtesan, and it also lacks the biblical or mythological references which had conventionally framed the history of the female nude, and which Manet himself had initially used. Here we also find that the obverse side, that chain of erotic associations which was tolerated, and even required, is also broken. It was necessary to relearn how to look at a nude, from the simple succession of being dressed to undressed, here presented to the gaze in a double halo of adjacent colors and with a stunning intensity of black on white. *Olympia* reinforces *Le bain*, but instead of inserting a moment of intensity in an afternoon pastoral through dissonance, the circular movement of the painting could not fail to convert any recalcitrant colorist's eye.

Olympia's face repeats the photographic effect. Her indifferent and faraway gaze, turned towards an object unknown to the observer, wipes out indiscretion and places us firmly in the modern arena of gestures,

attitudes, circumstances, processes, and customs of everyday life, and even includes posing in the studio of an artist. Her crown of hair, set off by an extravagant flower behind her right ear, adds to the ironic appearance of what almost looks like a respectable town hat—a favorite ornament of Manet's last watercolors and portraits.

Years earlier, Eugène Delacroix had explored the contradictions of black, a color which was pictorially necessary, but guilty by association. *The Massacres de Scio* demanded "this happy squalor," but he knew full well what questionable moroseness was to be found in satisfying it: "an old leaven, a totally black background" (journal, May 7, 1824). Painting, as inherited by Delacroix, was conceived as theater, which used both the confessional and the psychological apparatus of realist representation. Ten years later—after the ordeal of the dark satanic lithographs with which he illustrated Goethe's *Faust* and the ensuing voyage to Morocco, which delivered him from it—the only traces of black remaining were the lines of kohl accentuating the arched eyes of the *Femmes d'Alger,* echoed in arabesques on the body of an African servant.

In fact, black was accepted as the medium of all kinds of reproduction, be it engravings, prints, etchings, or photographs. This new role mitigated without completely eliminating the contradictions in a color only recently relieved of its connotations of disaster, shadowy spirituality, of either sanctity or profanity, and transformed it for everyday use. Baudelaire gave this explanation for the paradox of wearing a frock coat for everyday use: "We are all attending one funeral or another." This would have been grating had the black been just another color added to the palette in order to serve a representational hell. But in taking a detour by way of ink, photographic reproduction, and illustrations, it had made us accustomed to the effects produced by a meeting of light and texture, the visibility of which declines exactly in proportion to its intensity. Manet played on this relationship, taking note of Leonardo da Vinci's advice to a disciple to closely observe how faces changed at dusk or in the light of a storm. The texture of clothing inherits the functions of skin. It appropriates the photographic surface, and teaches the painter a lesson.

The reversible polarity of black and white is reasserted in the lithographs Mallarmé requested to accompany his translation of Edgar Allen Poe's poems. Light flows over the ground of the large white sheets among pools of black ink. But it is chiefly in the paintings that Manet completed his study of darkness. Zola's portrait in black shows, as if placed on shelves above his writing desk, a reproduction of *Olympia* and a Japanese print, juxtaposing their blacks, saturated after drinking in all the light, and their whites, opaque from having kept none. We know many sketches and variants of the portrait of Berthe Morisot in mourning called *Au bouquet de violettes,* painted after the siege of Paris, the Commune, and the Bloody Week. Berthe standing, Berthe sitting, now against the light, now protected by a fan or again hidden by a veil, or her face ravaged by pain and grief and cruelly slashed by black strokes. By combining the slow, perfect intensity of black and white with the ordeal of mourning, individuated and, little by little, assumed by a familiar face, Manet rejoins Baudelaire to resolve the rictus of contradictions which led the poet to be suspected of Satanism. *A une passante* captures emotion in a gesture, a brutal foreground, and an instantaneous photographic effect that seems beyond time.

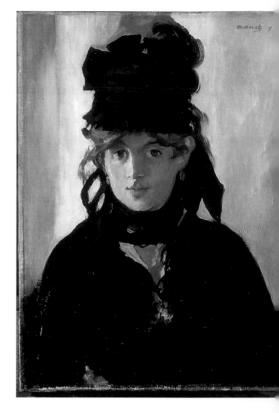

OPPOSITE: Edouard Manet, *Le déjeuner sur l'herbe,* 1863. Musée d'Orsay.

ABOVE: Edouard Manet, *Berthe Morisot au bouquet de violettes,* 1872. Musée d'Orsay.

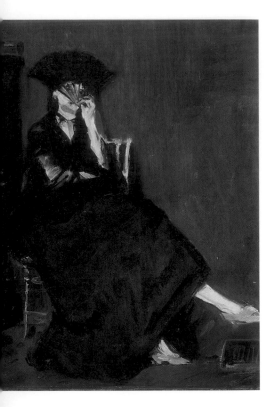

ABOVE: Edouard Manet, *Berthe Morisot à l'éventail*, 1872. Musée d' Orsay.

OPPOSITE: Edouard Manet, *A Bar at the Folies-Bergère (Un Bar aux Folies-Bergère)*, 1882. Courtauld Institute Gallery.

"Tall, slim, dressed in mourning, majestic pain,
A lady passes, with one fastidious hand raising swaying scallop and hem
Agile and noble...
A bolt of lightning, then the night—fugitive beauty...[5]

When grief acquires individual characteristics, takes on the quality of a face or clothing, and appeals to decorum, it both takes form and transforms. The glance of Berthe Morisot, painter, rehabilitates the act of seeing.

The last outdoor open-air pictures, such as *Le bateau goudronné,* where black sailing boats are superimposed on the horizon, hinge on black. Manet invented the gray seascape, where the high seas lose themselves in the shore in a nearly monochrome expanse, cut by perpendiculars, whites, blacks, the gray of hats, scarves, and elegant, mantled, brocaded silhouettes, of which we can see little else.

His last major painting, *Un Bar aux Folies-Bergères,* sums up his use of blacks, whites, and dazzling intensity by stopping time because, once again, it is not a question of linear narrative. Manet continues here the audacity of the *Bal masqué,* blurring the scene, placing his moments in another frame. The fundamental range of stark blacks and whites is emphasized by two lamps of the purest white in the middle of the painting. The barmaid's black waistcoat is split by a gray dress. The gray is taken up by the trapezoidal décolletage, bordered with lace and crossed by a thin black velvet choker. This foreground, cut out like a silhouette by Seurat, lends structure and foundation to the composition. It brings forward the black, casts it onto the surface and projects the barmaid to the foreground as if on a balcony. She echoes her surroundings. From this unique single "impression" some figures can be deciphered, as from a collage in the pages of an album. They are transformed, stretched, answered, and more or less clearly reflected or diffracted by the imperfect mirrors that are unavoidably found in music halls. On the right, the central image develops an initial echo. The body of the barmaid, completely black, seen this time from behind, faces a frock coat, a top hat, and a masculine face as illegible as a faded photograph. On the left, a similar effect is produced on a different scale. We perceive, as if from afar, equally jumbled, a seething mass of top hats, dark dresses, and frock coats without interruption, apart from a light dress. The angles of the woodwork frame them with a pink already seen in the Spanish paintings. In this way, Manet juxtaposes different viewpoints as if taken from the memories of a passerby, recapitulating contradictory aspects in a virtual space. Constructed out of black and white, pushed to incandescence by artificial theatrical light, this picture radiates an emotion of pure presence from every stroke. Manet has eliminated photographic melancholy by giving it a graduated, textured intensity which makes the colors vibrate and transforms the canvas into what Merleau-Ponty called "the world made flesh."

In 1848, the young Manet, a midshipman in a training ship on a voyage to Brazil, describes in several enthusiastic letters the bay of Rio de Janeiro, his excursions in the forest, baskets of fruit and provisions, the black skin of the slaves seen bare-breasted at the market, the hummingbirds passing through a clearing during a picnic, just like the chaffinch in *Le déjeuner sur l'herbe.* A not-to-be-missed masked ball "just like at home" gripped the colonial town on some evenings and unbent

its otherwise restrained manners. Would he describe modern life with a Brazilian accent? Instead of forcing these "childhood memories" (in the Freudian sense) into the act of representation, the equivalent of a statement, he would ceaselessly disseminate this burst of intensity which alone could carry the weighty intersection of past, present, and imagined future. Manet had for a long time both researched and borrowed in assembling his repertoire of effects. The dark clothes and mantillas of the Portuguese in Rio, or those of the Spaniards in the Plaza de Toros, mixed with the bustle of everyday modern life were not just austere miscasting, but a liberation of darkness from the panic-stricken ceremonies of fear.

"I just did what I saw," said Manet simply. We ought to see, rather than the sheer exoticism of modernity, the rich, fertile ground of a life which finished by giving a face to that which Baudelaire called fashion. But this, as Mallarmé noted in his anonymous chronicles in *La dernière mode,* all took place at the Salon.

1. "On voit scintiller en *Lola de Valence* le charme inattendu d'un bijou rose et noir."

2. "Il vous fallait une femme nue, et vous avez choisi Olympia, il vous fallait des taches claires et lumineuses et vous avez mis un bouquet, il vous fallait des taches noires et vous avez placé dans un coin une négresse et un chat. Qu'est-ce que cela veut dire? Vous ne le savez guère et moi non plus. Mais je sais moi que vous avez fait une œuvre de peintre et de grand peintre..."

3. "je ne crois pas qu'il y ait lieu de faire autre chose que de s'étonner de la gamme délicieuse trouvée dans les noirs : fracs et dominos, chapeaux et loups, velours, drap, satin et soie"

4. "hanté de certain noir, le chef d'œuvre nouveau et français."

5. Longue, mince, en grand deuil, douleur majestueuse,

Une femme passa, d'une main fastueuse soulevant, balançant le feston et l'ourlet

Agile et noble...

Un éclair, puis la nuit - fugitive beauté...

Yasuo Kabayashi, Professor, University of Tokyo

Blue: Poetry of Space and the Body

The dominant theme of Viktor & Rolf's fall 2002 collection was "blue," but this does not mean that they merely created blue clothes. Their work represented a dramatic entry in the long exploration by artists of the essence of "blue." The title of the show was *Long Live the Immaterial!,* and the color blue was their gateway to that immateriality. The mystique of "blue" lies not in its presence in specific material, but in the color of space that expands in an immaterial way. It is only now, as a result of chemosynthesis, that many different blue pigments and coloring materials exist, to the extent that our everyday lives and products are now inundated with the color. Blue pigments are extremely rare in nature, and before the development of synthetic colors, people went to incredible lengths in search of it. Ultramarine blue—derived from lapis lazuli, which is only produced in one region in Afghanistan— was highly prized in the Western world, and was at one point almost as valuable as gold. The color was often used to depict the Virgin Mary's robes, representing her infinite compassion.

The blue of the sky, a symbol of vastness and immateriality, seems clear and obvious to us, and yet, when we fly up into it, we never arrive at that blue, which is merely an optical illusion. The blue of the ocean exists only in aggregate; a single cup of it is as clear as glass. Blue simply escapes into the beyond. The more we pursue it, the farther away it seems, glittering in the distance.

In this sense, blue represents an infinite motion, an expansion centered deep in the beyond. Rudolf Steiner, a twentieth-century German philosopher who developed Goethe's color theory into a unique form of mysticism, wrote that, in contrast to yellow, which is a light that becomes diffused from the center outwards, blue is a light that becomes diffused as it moves from the periphery toward the center and, at the same time, toward the depths beyond. This is why, when faced with blue, we are filled with the urge to leap into it, as if jumping into a well: we are filled with the desire to dive into the blue sky.

No one in the history of art personifies this desire better than the French artist Yves Klein. Klein did not just patent a monochromatic pigment entitled International Klein Blue (IKB), but actually leapt into space in a 1960 performance piece entitled *Le saut dans le vide.* A photograph of the event shows Yves Klein horizontal, body straightened, poised in mid-air descent. Although blue did not feature in this performance—carried out on a pavement of gray stone in Paris—the work is stamped with the strong desire of this artist to dive into the emptiness of space—the realm of blue.

Yves Klein's passion for the blue sky was such that he resented birds, because they create holes in the perfect expanse of blue sky. In his art, he created perfectly flat, monochromatic blue surfaces with the conspicuous absence of any distinguishing marks. In its spirituality, blue emphasizes that our existence on this earth takes the material form of our bodies, revealed against the background of blue space.

Klein produced a series of works titled *Anthropometry,* in which IKB was applied to a woman's body. Her body was then "printed" onto paper to leave a blue mark, the same technique as a "fish print." In this instance, the blue was reversed to represent the mark of the body. For Klein, who also produced the IKB-saturated *Blue Sponge* series during the same period, the paint-covered body absorbed, like a sponge, the spiritual blue that fills the sky. The result is a blue body in the emptiness of space, or the shadow of a body, like a white hole in the blue space.

The construct of the prototypical problem underlying the possibility of

225

ABOVE: Paul Cézanne, *Bathers (Les Grandes Baigneuses)* 1900-06. The National Gallery.

OPPOSITE: Yves Klein, *Leap into the Void (Saut dans le vide),* 1960.

reversing, through blue, the material body and the immaterial and spiritual spatiality of the color was clearly apparent in Viktor & Rolf's chroma-key show. Indeed, Viktor & Rolf clearly acknowledge Yves Klein's influence on their work.

The representation of the nude human body in space represents one of the primary conundrums of Western painting. In 1899, the young Henri Matisse purchased a small oil painting by Paul Cézanne depicting a bathing scene (*Three Bathers,* 1879–82). Matisse kept this work close at hand for most of his life. This anecdote can be interpreted as Cézanne, the master, handing over his baton—a painting—to another master, Matisse, from the nineteenth century to the twentieth. In other words, it represents a transferal of this fundamental representational dilemma.

If Cézanne was attempting to depict space by "layering touches of fine color" (a technique that he inherited from Impressionism), Matisse invented the ability to evoke the emotion of space within the "global" surface of a single color—a decisive step and a stroke of genius. In extreme terms, the history of twentieth-century painting can arguably be described as the elaboration of a process begun with this one step.

The *Dance* paintings each depict a group of nudes dancing in a ring against a bright blue background—*Dance* was produced in 1909, three years after Cézanne's death, and *Dance II* in 1910. Matisse inherited, and then incorporated, the issues surrounding *Bathers* with which Cézanne wrestled, translating it into his own unique language of painting. Here, space was not captured on a sensory or perceptive level, but emotionally, even musically—Matisse declared that painting is the "music" of color, hence the title *Dance.* In fact, the title of a related work painted by Matisse during the same period is *Music.*

It should not be forgotten that Matisse never approached true abstraction, which was to come later. Although Matisse described the use of color as "weaving" music, he did not construct an abstract language of painting in which form was lost. To Matisse, painting represented a medium in which people, with distinct physical forms, exist in an ever-present, closed space. The essence of Matisse's work lies in this personal place—the "indoors," a space which is transformed into music through the magic of color.

In Matisse's paintings, bright colors are always rising up to fill the canvas. The culmination of his work, next to the Chapel of the Rosary in Venice, is the *Blue Nude* series (1952), pieces that were nothing more than several pieces of blue paper cut-outs against a white background. The series represents the barest elemental properties of the "nude in space," the aesthetic conundrum Matisse inherited from Cézanne. Here, the nude has absorbed the entire blue space, spreading its limbs as though it represented the heavens. This is the stage, in the relationship between the human figure and "blue," before the realization of Yves Klein's *Anthropometry* performance. This represents a secret handing over of the baton from Matisse to Yves Klein through the color blue and the nude. If so, the relay must have been located in the blue of southern France and the Mediterranean—Yves Klein was originally from Nice, and its beaches inspired him to become an "apostle of blue." Nice is also where Matisse spent the latter half of his life. The Mediterranean sky and the smell of the ocean emanate from *Blue Nude.*

From Cézanne to Matisse to Klein, one feature is revealed to us as we follow the art-historical relay of blue and the body: the absence of the face. In Cézanne's *Bathers,* the faces of the nude women are roughly

depicted, without any particular individuality, as are those of the figures in Matisse's *Dance* series. The figure in *Blue Nude* has a head but no face. In Yves Klein's *Anthropometry*, the only visible traces of the body are the torso and limbs, presumably not entirely due to the technical impossibility of covering the model's face in paint.

Why is the personality effaced when the figure encounters blue? The faceless human body depicted by these artists seems to represent the universality of human existence in its purely material, essential form. The British filmmaker Derek Jarman redefined IKB as "universal blue" in his film *Blue* (1993), in which blue entirely fills the screen. The body present in blue has already discarded the "face," the signpost of its individuality, to appear as nothing more than a symbol of the basic materiality of being. The resulting image becomes a dynamic juxtaposition of the material (the body) and the immaterial (blue). The silhouette of the figure, like skin, is the boundary of those realms.

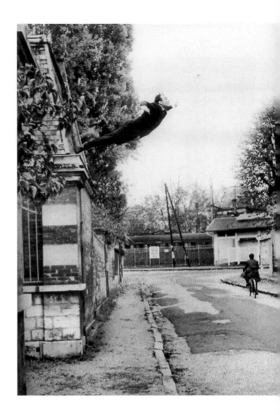

The work of contemporary artist Aki Kuroda—born in Kyoto but based in Paris—often features the silhouette of a figure, which he calls a "caryatid" (in Greek architecture, a detailed sculpture of a female figure used as a structural element, often a column). In Kuroda's version, the caryatid is reduced to her essential forms, devoid of any ornament or detail, and faceless. Her very body is nothing more than an outline, an empty, hollow space, a cast-off skin. In Kuroda's work, even the final figure of a human being has disappeared. The silhouette is so glyphic, or symbolic, that it is almost mythic, the mold from which all human bodies are cast. In this sense, even the space that surrounds the form is not of this earth, but rather spiritual and immaterial. Kuroda's blue is similar to Klein's IKB, but deeper, a blue that contains darkness, and gushes forth like magma to fill the space.

Kuroda's departure point was the *Yami (Darkness)* series, which featured only black lines. In his paintings, "blue" was born out of this "darkness," and the prototype of the glyphic body developed from this "blue." As Gaston Bachelard wrote in *Air and Dreams: An Essay on the Imagination of Movement*, "At first there is nothing, and this is followed by a deep nothingness, and then a deep blue." Kuroda's work can arguably be described as following a similar process—first there is nothing, followed by a deep darkness, and then the depth of a blue cosmos, the body of the "caryatid" piercing the garden of that cosmic blue to create a vacuum.

Man first flew into space in 1961. Since Yuri Gagarin's statement on his return from this journey that "Earth was blue," the color has taken on a newly cosmic meaning. Hearing the news, Yves Klein—always the artist—commented that Gagarin had attended the opening of Klein's exhibition held in space. As we have seen, blue has strong associations with the immaterial, but as Gagarin points out, it is also the defining color of our planet, the material foundation of our existence.

Viktor & Rolf also recognized in blue an ambiguous combination of the material and immaterial, and investigated this phenomenon with dramatic success in their chroma-key show. Emptiness and substance, the body and the spirit—the eternal adventure of blue unfolds where these contradictory elements of our world come together.

Dominique Cardon, Research Director, Centre National de la Recherche Scientifique

Fashion in Colors and Natural Dyes: History under Tension

Even before the invention of the first artificial and synthetic dyes, which signaled the start of a new type of intellectual and technological adventure, all civilizations in the world had managed to live in colors—they dyed human and animal skins, hair, teeth, bones, and all sorts of vegetable fibers and woods, in the whole range of colors of the rainbow. This implied a constant quest of the human mind and energy to simultaneously discover the amazingly rich coloring resources contained in living organisms—mostly plants and a few invertebrate animals—and to find appropriate ways to use them to obtain the desired color and make it last on each selected substrate. It is under this constant tension between the generosity of nature and the strictness of her laws that ancient dyers developed their art.

The *Fashion in Colors* exhibition and book offer a magnificent illustration of this ancient art, since all the colors we admire on any costume dated earlier than the second half of the nineteenth century were produced using natural dyes. Even in some of the more recent textiles on display, dye analyses might reveal their colors to also be of vegetable or animal origin, since natural dyes continued to be used well into the twentieth century by prestigious textile designers such as Mariano Fortuny. In fact, only a few color effects in this exhibition, even in the Multicolor section, are impossible to produce with vegetable and animal dyes.

This induces, therefore, reflections upon the complex relationship between natural and synthetic dyes; the historical reasons for the temporary decline of the former and triumph of the latter; the differences in their systems of production and in their compositions; and the implications of these differences from aesthetic and socioeconomic points of view. This may best be done by reconsidering some of the key periods defined in *Fashion in Colors* in the light of the history of natural dyes.

Mauve: The Modern Fulfillment of an Ancient "Purplemania"

If the invention of mauve by William Henry Perkin in 1856 represents the beginning of a new era—the age of synthetic dyes—it is largely due to the prestige associated with the color purple since remote antiquity. In the ancient Mediterranean world, the most beautiful, durable, and luxurious purple, violet, and mauve colors were obtained by fishing, scarifying, and vat-processing millions of marine seashells belonging to four different mollusk species of the *Muricidae* family: *Bolinus brandaris, Hexaplex trunculus, Stramonita haemastoma,* and *Ocenebra erinaceus*. Since each animal contains less than one milligram of the colorless product that will eventually produce the purple dye, the dye baths were used until completely exhausted, producing colors ranging from the dark purple called *blatta* (coagulated blood) to pale mauves, or the conchylian colors.

Given the precious nature of these true purple dyes, it is no wonder that a huge industry gradually developed in the ancient world to imitate their different shades using different (and more readily available) ingredients and processes. The best of these imitation purples was described in ancient Babylonian and Egyptian texts. Fast purple shades were obtained by dyeing wool in two baths, first in blue with woad *(Isatis tinctoria)* or indigo *(Indigofera tinctoria),* and then, after mordanting with alum, in a red dye bath composed of either madder (*Rubia*) or dye-insects (*Kermes* or *Porphyrophora*). Not only are such combinations of

dyes most commonly identified with the purple color of Coptic textiles, but they survived among European dyers for more than a thousand years after the production of true mollusk purples disappeared. Many samples of such purple dyes on woolcloth—combining woad/indigo and cochineal or madder—figure in dyers' recipe books of the eighteenth and nineteenth centuries, preserved in French archives.

According to the Egyptian alchemical sources, other plants were also used to imitate purple, including alkanet *(Alkanna tinctoria),* the root of which contains a purple dye identical to that of the traditional Japanese dye *murasaki (Lithospermum erythrorhizon).* As late as the first half of the nineteenth century, when the printed cotton industry had taken on such economic importance in Europe, a fashion for textile designs of small flowers on purple alkanet ground triumphed in France for some years.

Since antiquity, the other common way to imitate purple was the use of orchil, already a semi-synthetic dye, produced by macerating Mediterranean sea-coast lichens *(Roccella)* in the ammonia of putrid urine with the addition of oxygen, introduced by frequent stirring of the fermenting mass. The rich purples of orchil, a direct, easy-to-apply dye, were still very popular in Europe in the nineteenth century, when various species of lichens, collected in mountainous regions of Europe as well as on various coasts worldwide (the Canary islands, Africa, India, and even Baja California), arrived by the thousands of tons each year to the orchil factories of France, in Clermont-Ferrand, Lyon, and Paris, and the United Kingdom, mostly near Edinburgh, Scotland.

In 1856, the year in which mauve was invented, a group of French chemists managed to overcome the main technical drawback of orchil, its poor light-fastness, by patenting an improved fabrication process for an orchil dye that they—significantly—named purple. "Pourpre française"... too late! The times were ripe for the dawn of artificial dyes, and the "democratization" not only of purple but of all colors.

Blue: From Local to Global, and from Regal to Democratic

For European civilizations, from prehistoric to medieval times, a fast blue dye could only be obtained by using woad, the only locally available indigo-plant. Brunette, a perfect, colorfast black, and one of the most prestigious medieval colors, was also based on a blue ground, but darker than that used for purple, followed by a mordant bath of alum and a red dye (most commonly madder but sometimes kermes). Even darker than the ground of brunette, the blackish blue known as "pers," so costly due to the expensive dyestuff and skilled labor needed to produce it, was only available to the powerful and wealthy elite. Each of the degrees of this woad-blue scale, followed by a yellow dye, gave a corresponding standardized shade of green, from "gay green" and "grass green" to "emerald green." As the vat was used until exhaustion, without further addition of woad, the strong clear blues of the new vats gradually got paler and grayish. Only then were the inexpensive clothes of the lower-class people dipped into it.

All this technical organization rested upon a complex production chain, which encouraged the development in medieval Europe of what can be called an industrial form of agriculture, involving whole regions. Woad was cultivated on hundreds of hectares. The leaves had to be picked, brought to mills, crushed into a pulp, shaped into balls,

and put to dry in huge sheds. A second fermentation of the crushed balls, performed either locally or in one of the major textile centers, was required to further concentrate the indigo in the granulous dyestuff *(pastel agranat),* about 150 kilograms of which was put into every new vat. Thousands of workers were employed in this production at a massive scale, and huge fortunes were built by a few businessmen able to develop closely knit international connections.

This highly developed economic system paved the way for a further degree of globalization as soon as new routes across the oceans—first to Asia, then to America—were opened, and colonial methods of exploitation allowed massive imports of cheaper foreign indigo. Although already imported into medieval Europe, indigo extracted from the indigo shrubs *(Indigofera)* had thus far only been used to dye vegetable fibers and silk. It was eventually added in ever-increasing proportions to the huge woad vats of the wool-cloth industry. Thousands of tons were also used in cotton-printing centers scattered all over Europe until, at the very end of the nineteenth century, the discovery of an economically viable synthesis of indigo abruptly ruined the worldwide agricultural production of indigo plants. This double revolution—the triumph of exotic, then of synthetic, indigo—brought about a democratization of saturated blue and green colors in fashion, at least in industrialized countries, that would have been inconceivable in the era of the medieval woad vat.

Red and Yellow: From Small- to Large-scale Production

As outstanding as mollusk purple, in terms of economic value and symbolic power, were the scarlet and crimson dyes produced by a few tiny European and Asian insects, parasites of trees or herbs—kermes *(Kermes vermilio),* lac-dye *(Kerria lacca),* and several species of *Porphyrophora,* including Polish and Armenian cochineals. As with purple, the prestige of red dyes derived largely from the difficulty and expense of their production. An astronomical number of animals was needed to produce them: One gram of kermes dye represented sixty to eighty dry females, while ancient recipes recommended using at least an equal weight of dyestuff and textile to be dyed. Dyers' madder *(Rubia tinctorum),* largely cultivated in several regions of Europe, was therefore the most popular source of red tones, and also served to obtain pinks, oranges, purples, grays, browns, and the most precious black, brunette.

Yellow dyes, naturally present in many herbs, were abundant all over Europe. Some were cultivated, like weld *(Reseda luteola),* while others were massively collected in wild expanses of land, like dyers' broom *(Genista tinctoria),* saw-wort *(Serratula tinctoria),* and trentanel *(Daphne gnidium).* Gathering, drying, and carrying such light but bulky dyestuffs represented a branch of economic activity that has been largely overlooked by historians until recently.

The age of exploration brought dramatic changes in the range of red and yellow dyes available to European dyers. Within less than a century, all the insect dyes formerly used were replaced by a cochineal *(Dactylopius coccus)* dye which the ancient civilizations of Central and South America had succeeded in domesticating in a cactus species. The new dye, made abundant through careful breeding techniques, was also much richer in red colorants (containing at least ten times

more than kermes) than the European alternative, and substantially less expensive as a result of Spain's colonial exploitation of America.

The most dramatic change of scale in natural-dye production came with the adoption of exotic dye-woods, which arrived in boats loaded with trunks and logs full of red or yellow coloring matter. From Asia came sappan-wood *(Caesalpinia sappan)*, sandalwood *(Pterocarpus santalinus)*, and narrawood *(Pterocarpus indicus)*; from Africa, camwood *(Baphia nitida)* and barwood *(Pterocarpus soyauxii)*; and from America, the red brazilwood *(Caesalpinia echinata)* and brasiletto *(Haematoxylum brasiletto)*, and the yellow fustic *(Maclura tinctoria)* and quercitron, or black oak *(Quercus velutina)*. With each of these new dye sources, new shades of reds and yellows as well as new recipes for and combinations of dyestuffs became available. Some recipes for maroon, beige, gray, and black dyes, used for woolcloth and printed cotton, called for three to four different dye-woods.

For centuries, these imported dyestuffs continued to increase both choices for consumers and creative possibilities for dyers. By the mid-nineteenth century, however, as the big European dye industries remained completely dependent on natural dyestuffs, dye crops like indigo and madder, as well as dye-wood forests—already occupying millions of hectares all over the world—were overexploited, and began to disappear quickly. Industrial society faced a crucial problem which may rise again in the future: the need to constantly diversify and increase its supply of raw materials to answer an ever-growing demand.

How Will Fashion Be Colored in a Future Era of Renewable Resources?

Whether and how the colors used in fashion were, are, and will be related to the aforementioned problems of supply—of both natural and synthetic products—is certainly one of the most important questions raised by this exhibition and book.

The advent of synthetic dyes corresponded with the enthusiastic industrial exploration of the technological possibilities opened by fossil resource exploitation, first of coal, then petrol. The most emblematic of the resulting dyes, man-made out of black tar from black coal or black petrol, was aniline black. After its development, one dye bath could produce a color that, previously, had always required complex combinations of dyestuffs and mordants. Cheap and easy to apply, synthetic dyes and pigments produced a major cultural revolution that has irreversibly changed the world. They have accustomed people to take colors for granted, to be surrounded by them in most circumstances of their lives, without necessarily giving them conscious attention. As fossil resources become more scarce, it will be one of the challenges of the twenty-first century to keep colors available as an aesthetic choice, affordable for the masses of the future, and not have to rely on white, or undyed, textiles for sheer scarcity of dyestuffs.

Dyes and paints of the future will probably be produced from a combination of all the different types of resources of our globe, including recycled ones. They will most likely include some natural dyestuffs, already known or still to be discovered, necessarily produced and processed using improved technology. Research into natural dyes, therefore, has not only a promising future but will certainly inspire many designers and fashions to come.

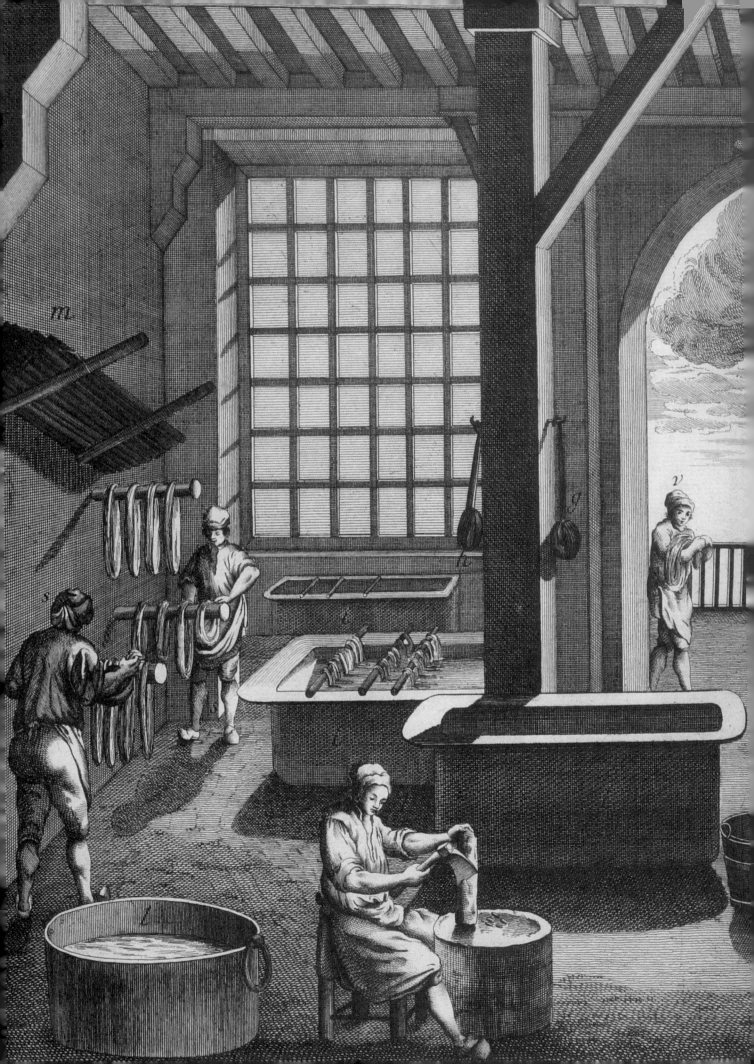

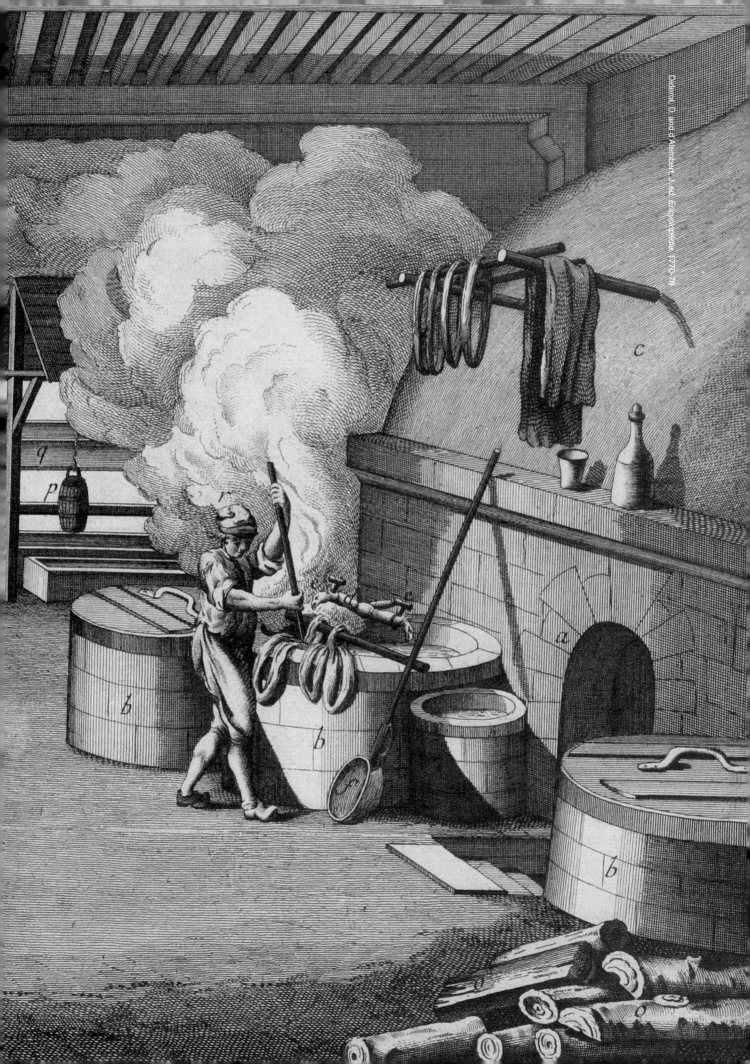

Dyeing is the process of fixing color into fibers or other material. A material is colored when the coloring agent, generally a dye, penetrates between the fiber molecules, adhering through chemical reactions or other combinative processes. The dyeing effect is usually improved by heating the dye bath or adding a mordant—a mineral salt that combines with dyestuffs to form an insoluble compound. Dyes and pigments are the two main types of coloring agents. Dyes, natural or synthetic, are either dissolved or dispersed in water, and are absorbed by and then combined with a material to create a color. This glossary explains some key terms associated with dyes and dyeing as used in Western clothing.

Alizarin

A red dye obtained from the root of the madder plant *(Rubia Tinctorum)*. Alizarin was discovered in 1826, and first synthesized by German chemists Carl von Graebe and Carl Liebermann in 1868. Used with different mordants, madder can be used to produce varied shades of red, orange, pink, violet, or brown.

Aniline Black

A black synthetic dye which works by oxidizing aniline, a coal tar derivative, to produce a precipitate that is trapped by the fibers. Friedrich Runge first discovered in 1834 that oxidization of aniline produces green and black colors, and John Lightfoot perfected the process in 1863. Aniline black was used to dye cotton a colorfast black at a low cost.

Aniline Dye

A generic term for various synthetic dyes made from aniline. In the nineteenth century, all synthetic dyes were made from aniline, including mauve, magenta, aniline black, and Bismarck brown; thus synthetic dyes were generically referred to as aniline dyes or coal-tar dyes.

Bath Dyeing

A technique in which cloth is soaked in a dye vat, maximizing the penetration of the coloring agent.

Bleaching

The process of whitening a material by removing its natural coloring agents. In the past, vegetable fibers such as linen and cotton were bleached by exposure to the sun for several months, but in the second half of the eighteenth century, chemical bleaching using chlorine became popular as the cotton industry developed in England. In 1786, the French chemist Claude-Louis Bertholet discovered that a bleaching liquid made from chlorine and alkali could be effective, followed by Charles Tennant in Scotland, who developed the first controllable bleaching process for fabrics.

Cochineal

A red dye made from dried female cochineal beetles *(Dactylopius),* which live on cactuses in Central and South America, and were used in those areas as early as 1000 BC. The main coloring agent of cochineal dye is carminic acid. It will dye purplish red if aluminum is used as mordant, and red if tin is used; tin mordant must be used to obtain a strong red. Beginning in the 1500s, due to well-organized, large-scale

breeding controlled by the Spanish, cochineal dye became available at low prices in Europe. This dye is colorfast and creates a deep red, so cochineal eventually came to replace kermes dyeing on the Mediterranean Sea and lac dyeing in India.

Discharge printing

A technique, developed in Glasgow, Scotland, around 1810, after the discovery of bleaching chemicals, in which a pre-dyed fabric is printed with a paste that contains bleach or another color-removing chemical, creating a pattern. Other chemicals can be used to create a new color in the discharged area.

Indigo

A variety of plants of the Indigofera species containing the coloring agent indigotin. Indigotin-bearing plants, including European woad and Chinese indigo used in Japan, have been used as dyestuffs since ancient times—as early as 2500 BC in Egypt, China, and Central Asia. Indigo, important because it is compatible with both plant and animal fibers, was brought to Europe during the age of exploration, and eventually replaced woad because it contained more indigotin. The word "indigo" signifies the blue color indigotin, or can be used as a generic term for all indigotin-bearing plants. Leaves and stems of indigo contain colorless and water-insoluble indican (glycoside of indoxyl) instead of blue indigotin. Indican is transformed into glucose and indoxyl by fermentation—on exposure to the air, indoxyl is easily oxidized to become blue indigotin. In the early 1880s, the German researcher Adolf Bayer successfully synthesized indigotin, and synthetic indigo was put on the market in 1897. Denim died with synthetic indigo was originally used for laborers' clothes, but became established as casual daily wear among the younger generation in the 1960s. Denim jeans discolor easily with friction, as the dye is not colorfast. The resulting worn-out effect was once viewed as a disadvantage of the dye, but today is regarded as attractive and part of indigo's value.

Kermes

A red dye derived from parasite beetles (*Kermococcus vermilis* or *Kermes ilicis*) found in kermes (meaning "red" in Arabic) oak trees, which grow around the Mediterranean Sea. The coloring agent is kermesic acid. After the discovery of the New World, kermes was supplanted by cheap cochineal dye exported to Europe from Central America.

Lac

A red insect dye produced in India from at least the fourth century AD. The insect *(Tachardia lacca)* lives primarily on ficus trees; the fertilized female insects secrete a hard, red coating over the trees' branches. The resin compound is used in the preparation of shellac, after the dyestuff has been extracted.

Madder

A perennial plant of the *Rubiceae* family, madder is found in many regions worldwide, including Europe, India, Japan, and China. The roots are a source of red coloring agents such as alizarin and purprin, and they have been used as a dye since 1500 BC in Egypt; earlier in China and India; and at least 900 BC in Peru. Madder plants were the most popular source of red dye in ancient Europe, and were grown in the

Middle Ages on a large scale for the dyeing of wool. In the late medieval period, the complicated "Turkey Red" (*Andrinople*) dyeing process—which combined madder with an aluminum mordant—was invented in the Near East. Although this dyeing process had reached Europe by the latter half of the eighteenth century, articles dyed Turkey Red continued to be exported to Europe until the nineteenth century.

Mauve
The first synthetic dye, discovered by the English chemist William Henry Perkin in 1856. Perkin accidentally compounded the coloring during an experiment to synthesize quinine, a treatment for malaria. Named mauvein, and largely ignored in England, the color was re-named mauve in France and put into practical use.

Mordant
Usually a metallic salt which serves to fix a dye in or on a fiber by combining with the dye to form an insoluble compound. Different mordants used with the same dye will produce different colors; mastery of these chemicals is critical to producing a broad palette. Mordant technology has been practiced in India since at least the second millennium BC.

Natural Dye
Natural dyes can be broadly categorized into vegetable, animal, and mineral dyes. A color derived from natural dye changes according to the mordant used, and repeated dyeing also creates different effects in the density, deepness, and maturity of the color.

Printing
A technique of creating patterns on fabric with color pastes, or by printing with resist media and then dyeing, or with mordants in the dye, either by machine or hand. Common types of printing include woodblock, copperplate, roller, and silkscreen. Printed textiles were made in the Caucasus in 2000 BC; blocks were said to be used in India from 3000 BC. The earliest existing fragments date from the fourth century AD.

Resist dyeing
A technique of creating a pattern by applying a physical or chemical barrier to a fabric before dyeing in order to prevent color from penetrating the blocked areas. Resist techniques are used all over the world, including tied or stitched resist, such as *shibori* in Japan, or *plangi* in Southeast Asia and Africa; warp-resist ikat, in which a pattern is created in the threads before weaving; and wax or rice-paste resist techniques, like batik.

Saffron
A yellow produced from dyers' saffron *(Carthamus tinctorus)* and saffron yellow *(Crocus sativas)*. Dyers' saffron seeds have been found in tombs in Egypt which date from 2000 BC, and were used to dye mummy wrappings. Saffron's two main pigments are water-soluble saffron yellow (yellow) and water-insoluble carthamin (red).

Silkscreen printing
A technique of printing using a screen stencil, composed of a frame on which a mesh is stretched. The ink does not penetrate the screen in

those areas where an emulsion has been applied. Silkscreening began in the United States, reportedly inspired by Japanese stencil printing, and came into widespread use in the late 1920s. Silkscreen printing was valued because of the ability to produce much larger patterns. Most textiles today are printed using a rotary silkscreen process.

Substantive dyes

Dyestuffs that have an affinity for textile fibers, and do not require the addition of a mordant.

Synthetic dye

A dye utilizing manmade coloring agents. (See mauve) After the appearance of William Henry Perkin's first synthetic dye, more were developed in quick succession, and it became possible to dye large quantities of cloth inexpensively. The first large group of synthetic dyes, including fuschine and magenta, were all derived from coal-tar. They were bright, clear colors, and easy to use, but at first were not very colorfast.

Tyrian purple

A red-purple dye obtained from the glandular secretions of murex mollusks *(Murex trunculus)*. Huge quantities of such animals were necessary to dye one piece of clothing this color, making it so expensive that, prior to the nineteenth century, it was available only to royalty, aristocrats, and high-ranking priests. The color was consequently referred to as "Imperial Purple," and served as a symbol of wealth and power in the Mediterranean region. The name comes from Tyre, the Phoenician city where the dyeing method was established. A less expensive imitation of this color, using a red dye on top of woad or indigo, was widely used. Tyrian purple dyeing in the Mediterranean region disappeared around the fall of Constantinople in 1453.

Weld

An annual or perennial plant of the *Resedaceae* (mignonette) family, weld was known by the Romans and mentioned by Virgil and Pliny; and was a primary source of yellow dye in Europe from antiquity. The pigment is luteolin, and the yellow color is obtained by using alum as a mordant.

Woad

A perennial plant of the *Cruciferae* (mustard) family that bears yellow flowers. The dye is extracted from the leaves, and the dyeing agent is indican, as with indigo. As it was the only source of a colorfast blue dye in Europe, woad was cultivated throughout Europe from prehistory until the seventeenth century when it was supplanted by indigo—cheaper and containing more dye matter—imported in large quantities from Indonesia and the Americas.

Amazone (cat. 14, 15): Women's riding wear, fashionable during the nineteenth century. Named after the Amazons, the female warriors of Greek mythology.

Banyan (cat. 33): Men's indoor garment originating in India. Worn in the seventeenth and eighteenth centuries in England, and known as an *Indienne* in France, its wear was strongly influenced by the import of the *Japonische Rock,* the Japanese kimono imported by the East India Company to Western Europe.

Bustle (cat. 12, 50, 60, 61): Pad or framework worn under a skirt to create a protruding rear, popular in various forms in the latter half of the nineteenth century. Bustles were made from various materials, including steel and rattan, and in various shapes, from simple pads to complete cages that supported the weight of the skirt in back.

Camouflage (cat. 30, 31): From the French word *camoufler,* meaning to disguise or hide, camouflage is an irregular, mottled multicolor pattern, initially developed by the French army during World War I to disguise soldiers during field combat. It was adopted and popularized by urban fashion in the 1970s.

Cashmere shawl (cat. 62, 63): A patterned, tapestry-woven covering for the head or shoulders woven from the wool of Kashmir goats found in northwest India and surrounding countries, and used in India for centuries by both men and women. Cashmere shawls were exported to Europe at the end of the eighteenth century and remained popular as an item of women's fashion throughout the nineteenth century. They were also produced in Western Europe—from the 1840s, Lyon, France, gained a reputation for high-quality cashmere, while Paisley, Scotland, was known for its inexpensive jacquard-woven shawls.

Chemise dress (cat. 76, 77, 78): A white cotton dress styled with a high waistline, worn with or without a corset or pannier, and cut in straight widths and gathered at the neck like a chemise (undergarment). Fashionable in the late eighteenth and early nineteenth centuries.

Crinoline (cat. 43, 44, 51): A mid-nineteenth-century petticoat designed to give skirts extraordinary volume. Crinoline was originally the term for a petticoat woven from horsehair (crin) and linen (lin), but also referred to petticoats featuring steel hoops, which became popular in the 1850s.

Gigot sleeve (cat. 62, 72): A sleeve fashionable in the 1830s, full and rounded from the shoulder to the elbow and then tapered to the wrist, its title being the French word for leg of mutton. When the shape came into fashion again in the 1890s, it was dubbed an elephant sleeve.

Indienne (cat. 33): A French term referring to fabric imported from India, and especially men's at-home robes made from such material. The term is also used in French to mean chintz (an English word derived from the Sanskrit word for colorful).

Jet (cat. 11): Fossilized driftwood with the color of coal. Fashionable in nineteenth-century jewelry, jet was polished to a brilliant sheen, then cut and beveled.

Mantua (cat. 41): A loose, front-opening dress produced during the late seventeenth and early eighteenth centuries, and worn in the English royal court until the 1750s. The front skirt was open to reveal the petticoat, and the train flowed behind or was tucked up.

Mi-partie (cat. 23): A costume vertically bifurcated in the center by different colors or textures. A popular fashion in the fourteenth century among aristocratic boys, it eventually became established as a costume of clowns, musicians, and entertainers.

Paper dress (cat. 26): A disposable dress made of a soft, non-woven fabric, briefly in fashion in the late 1960s. The paper dress represented many of the key characteristics of Pop Art of the period: cheap, expendable, and reproducible.

Pékin stripes (cat. 58): Striped textiles, originally produced in China, in which different colors or different weaving methods form contrasting narrow and wide stripes. The spread of *chinoiserie* led to the production of Pékin-striped garments in France around 1760.

Petite robe noire (cat. 7, 8): The archetypal "little black dress," developed in the 1920s by designers such as Gabrielle "Coco" Chanel and Edward Molyneux.

Redingote (cat. 59, 70): A men's coat in the eighteenth and nineteenth century, or a women's dress or coat derived from that style and fashionable in the early nineteenth century. The riding coat, originally worn in England, was used by the French army for hunting wear and military uniforms, and came to be called a *redingote* in French at around the end of the eighteenth century.

Retroussée dans les poches (cat. 58): A tailoring technique popular in France throughout the eighteenth century, in which the skirt was pulled out from the pocket slits on either side of a dress, creating full drapes at the back.

Robe à la Française (cat. 32, 67, 68, 69): A typical women's dress in the eighteenth century, characterized by deep pleats across the back of the shoulder falling to the hem, as opposed to *à l'anglaise,* which is fitted close to the small of the back.

Robe à la Polonaise (cat. 60, 71): A style of women's dress in which the back of the skirt is held up by cords and divided into three draped parts. Produced in the late eighteenth century, the name is said to refer to the partition of Poland in 1772.

Visite (cat. 12, 63): Woman's cape-like outdoor garment, popular in the latter half of the nineteenth century and characterized by a cut appropriate for wearing with a bustle.

SELECTED REFERENCES

General Costume History and Theory

BARTHES, R. *Système de la Mode*. Paris: Editions du Seuil, 1967.
BATTERBERRY, M. and BATTERBERRY, A. *Fashion: The Mirror of History*. New York: Greenwich House, 1977.
BEAULIEU, M. *Le Costume Moderne et Contemporain*, collection *Que sais-je ?* No. 505, 4th ed. Paris: Presses Universitaires de France, 1968.
BENAÏ M, L. *Le Pantalon*. Paris: Les Editions de l'Amateur, 1999.
BLACK, J. A. and Garland, M. *A History of Fashion*. London: Orbis Publishing, 1975.
Boucher, F. *Histoire du Costume en Occident*. 2nd ed. Paris: Flammarion, 1983.
FUKAI, A., ed. *Sekai Fukushoku-shi*. Tokyo: Bijutsushuppan-sha, 1998.
GAUDLAULT, R. *La Gravure de Mode Féminine en France*. Paris: Les Editions de l'Amateur, 1983.
ISHIYAMA A., ed. *Seiyou Fukushoku Hanga*. Tokyo: Bunka Shuppan-kyoku, 1974.
KITAYAMA S. and SAKAI T. *Gendai Môdo Ron*. Tokyo: Hôsôdaigaku-kyôiku-shinkô-kai, 2000.
KOIKE, M. and TOKUI, Y. *Ifukuron Fukushoku No Rekishi To Gendai*. Tokyo: Hôsô-daigaku-kyôiku-shinkô-kai, 1990.
LAVER, J. *Costume and Fashion: A Concise History*. Rev. ed. London: Thames & Hudson, 1995.
PISETZKY, R. L. *Il Costume e la Moda Nella Società Italiana*. Turin: Giulio Einaudi,1978.
RIBEIRO, A. and CUMMING, V. *The Visual History of Costume*. London: B. T. Batsford, 1989.
RUDOFSKY, B. *The Unfashionable Human Body*. New York: Doubleday & Company, 1971.
RUPPERT, J., and others. *Le Costume Français*. Paris: Flammarion, 1996.
SAINT LAURENT, C. *L'Histoire Imprévue des Dessous Féminins*. Paris: Sola Editeur, 1966.
SUGINO, T. and KOIKE, M. *Fukushokubunkaron*. Tokyo: Hôsôdaigaku-kyôiku-shinkô-kai, 1994.
TANIDA, E. and TOKUI, Y. *Ifukuron Fukushoku No Biishiki*. Tokyo: Hôsôdaigaku-kyôiku-shinkô-kai, 1986.
VICTORIA & ALBERT MUSEUM. *Four Hundred Years of Fashion*. London: William Collins Sons & Co., 1984.
WASHIDA, K. *Môdo No Meikyû*. Tokyo: Chûou Kouton-sha, 1989.

Eighteenth Century

BIEHN, M. *En Jupon Piqué et Rode d'Indienne*. Marseille: Jeanne Laffitte, 1987.
BLUM, A. *Les Modes au XVIIe et au XVIIIe Siècle*. Paris: Librairie Hachette, 1928.
BUCK, A. *Dress in Eighteenth Century England*. London: B. T. Batsford, 1979.
DE MARLY, D. *Costume & Civilization: Louis XIV & Versailles*. London: B.T. Batsford, 1987.
DELPIERRE, M. *Dress in France in the Eighteenth Century*. Trans. Beamish, C. New Haven: Yale University Press, 1997.
HART, A. and NORTH, S. *Fashion in Detail from the 17th and 18th Centuries*. New York: Rizzoli, 1998.
LANGLADE, E. *Rose Bertin, the Creator of Fashion at the Court of Marie Antoinette*. New York: Charles Scribner's Sons, 1913.
LEGROS DE RUMIGNY, *L'Art de la Coëffure des Dames Françoises*. Paris: Aux Quinze-Vingts, 1767.
MOREAU, J. M. *Monument du Costume Physique et Moral de la Fin du Dix-huitième Siècle*. Neuwied on the Rhine: Société Typographique, 1789.
RIBEIRO, A. *Dress in Eighteenth Century Europe, 1715-1789*. London: B. T. Batsford, 1984.
RIBEIRO, A. *Fashion in the French Revolution*. London: B.T. Batsford, 1988.

Nineteenth Century

BOEHN, M, VON and FISCHEL, O. *Modes and Manners of the Nineteenth Century*. Trans. Edwardes, M. London: J. M. Dent & Sons, 1927.
CUNNINGTON, C. W. *English Women's Clothing in the Nineteenth Century*. London: Faber and Faber, 1937, 1956.

DE MARLY, D. *The History of Haute Couture, 1850-1950.* New York: Holmes & Meier, 1980.

FAVRICHON, A. *Toilettes et Silhouettes Féminines chez Marcel Proust.* Lyon: Presses Universitaires, 1987.

FUKAI, A. *Japonism in Fashion: Umi Wo Wattata Kimono.* Tokyo: Heibon-sha, 1994.

FUKAI, A. "J. L. David as Costume Designer." *Dresstudy,* vol. 12 (Fall 1987): 16-23.

FUKAI, A. "Modernité and Fashion." *Dresstudy,* vol. 29 (Spring 1996): 16-21.

KITIYAMA, S. *Oshare No Shakai-shi.* Tokyo: Asahishuppan-sha, 1991.

MINAMI, S. *Pari Môdo No 200 Nen: 18 Seiki Kôhan Kara Dainijitaisen Made.* Tokyo: Bunkashuppan-kyoku, 1990.

PERROT, P. *Les Dessus et les Dessous de la Bourgeoise.* Paris: Librairie Arthème Fayard, 1981.

SEGUY, P. *Histoire des Modes sous l'Empire.* Paris: Tallandier, 1988.

STEELE, V. *Paris Fashion: A Cultural History.* New York: Oxford University Press, 1988.

Twentieth Century

BAILEY, A. *The Passion for Fashion.* London: Dragon's World, 1988.

BADOUT, F. *Mode de Siècle.* Paris: Editions Assouline, 1999.

BEATON, C. *The Glass of Fashion.* New York: Doubleday & Co., 1954.

BUXBAUM, G., Ed. *Icons of Fashion: The 20th Century.* Munich: Prestel Verlag, 1999.

CUNNINGTON, C. W. *English Women's Clothing in the Present Century.* London: Faber and Faber 1952.

DERYCLE, L and VIERE, S. V. DE. *Belgian Fashion Design.* Amsterdam: Ludion Ghent, 1999.

DESLANDRES, Y. and MÜLLER, F. *Histoire de la Mode au XXe Siècle.* Paris: Somogy, 1986.

DORNER, J. *Fashion in the Forties & Fifties.* London: Ian Allan, 1975.

DU ROSELLE, B. *La Mode.* Paris: Imprimerie Nationale, 1980.

FUKAI, A. *Pari Korekushon: Môdo No Seisei Môdo No Hishô.* Tokyo: Kodan-sha, 1993.

FUKAI, A. *20 Seiki Môdo No Kiseki.* Tokyo: Bunkashuppan-kyoku, 1994.

HOWELL, G., Ed. *In Vogue: Six Decades of Fashion.* London: Allen Lane, 1975.

HUSAN, H. *Key Moments in Fashion: The Evolution of Style.* London: Hamlyn, 1998.

IZUISHI, S. *Kanpon Burû Jînzu.* Tokyo: Shincho-sha, 1999.

LEPAPE, C. and DEFFERT, T. *Georges Lepape: Ou L'Eléhance Illustrée.* Paris: Herscher, 1983.

LOBENTHAL, J. *Radical Rags: Fashions of the Sixties.* New York: Abbeville Press, 1990.

MARTIN, R. *Fashion and Surrealism.* New York: Rizzoli, 1987.

MARTIN, R. and KODA H. *Flair.* New York: Rizzoli, 1992.

POLHEMUS, T. *Street Style.* London: Thames and Hudson, 1994.

STEELE, V. *Women of Fashion: Twentieth Century Designers.* New York: Rizzoli, 1991.

VEILLON, D. *La Mode sous L'Occupation.* Paris: Payot, 1990.

WATSON, L. *Vogue: Twentieth-century Fashion.* London: Carlton Books, 1999.

Designers

BENAÏM, L. *Yves Saint Laurent.* Paris: Grasset, 1993.

CHAPSAL, M. *Sonia Rykiel.* Paris: Herscher, 1985.

CHARLES-ROUX, E. *Chanel and Her World.* Trans. Wheeler, D. New York: The Vendome Press, 1981.

COLEMAN, E. A. *Opulent Era: Fashions of Worth, Doucet and Pingat.* New York and London: The Brooklyn Museum and Thames & Hudson, 1989.

DE RETHY, E. and PERREAU, J. L. *Monsieur Dior et Nous 1947-1957.* Arcueil: Anthese, 1999.

DEMORNEX, J. *Madeleine Vionnet.* Paris: Editions du Regard, 1990.

DESLANDRES, Y. *Poiret: Paul Poiret 1879-1944.* Paris: Editions du Regard, 1986.

DIOR, C. *Dior by Dior: The Autobiography of Christian Dior,* trans. Frazer, A. London: Weidenfeld and Nicolson, 1957.

GUILLAUME, V. *Jacques Faith.* Paris: Editions Paris-Musées and Société Nouvelle Adam Biro, 1993.

JOUVE, M. A. and DEMORNEX, J. *Balenciaga.* Paris: Editions du Regard, 1988.

KAMITSIS, L. *Paco Rabanne.* Paris: Michel Lafon, 1996.

KAWAKUBO, R. *Comme des Garçons.* Tokyo: Chikuma Shobo Co., 1986.

KIRKE, B. *Vionnet.* ed. Tokai, H. Tokyo: Kyuryudo Art Publishing Co.,1991.

LEYMARIE, J. *Chanel*. Geneva: Editions d'Art Skira, 1987.
Martin Margiella. Special issue, Street (Tokyo) no. 82 (December 1995).
Martin Margiella 2. Special issue, Street (Tokyo) no. 127 (April 1999).
MCDERMOTT, C. *Vivienne Westwood*. London: Carlton Books, 1999.
MCDOWELL, C. *Jean-Paul Gaultier*. London: Cassel & Co., 2000.
MIYAKE DESIGN STUDIO ed. I*ssey Tachi: Issey Miyaki & Miyake Design Studio 1970-1985*. Tokyo Obunsha Co., 2000.
MIYAKE, I. *Issey Miyake Bodyworks*. Tokyo: Shogakukan, 1983.
MOFFITT, P. and CLAXTON, W. *The Rudi Gernreich Book*. New York: Rizzoli, 1991, and Taschen, 1999.
POIRET, P. *En Habillant l'Epoque*. Paris: Bernard Grasset, 1930.
RAWSTHORN, A. *Yves Saint Laurent: A Biography*. London: HarperCollins, 1996.
RICHARDS, M. *Chanel Key Collections*. London: Hamlyn, 2000.
SIROP, D. *Paquin*. Paris: Editions Adam Biro, 1989.
TAKADA, K. *Takada Kenzo Sakuhinshû*. Tokyo: Bunkashuppan-kyoku, 1985.
WHITE, P. *Elsa Schiaparelli*. London: Aurum Press, 1986.
WORTH, J. P. *A Century of Fashion*. Boston: Little Vrown and Company, 1928.
YOHANNAN, K. and NOLF, N. *Claire McCardell: Redefining Modernism*. New York: Harry N. Abrams, 1998.

Textiles

BREDIF J. *Toiles de Jouy*. Paris: Editions Adam Biro, 1989.
DAMASE, J. *Sonia Delaunay: Fashion and Fabrics*. London: Thames & Hudson, 1991.
HANDLEY, S. *Nylon: The Story of a Fashion Revolution*. Maryland: The Johns Hopkins University Press, 1999.
IRWIN, J. and BRETT, K. B. *Origins of Chinz*. London: Her Majesty's Stationery, 1970.
JACQUÉ, J. T. *Chefs-d'Œuvre du Musée de l'Impression sur Etoffes, Mulhouse,* vol. 1. Tokyo: Gakushûkenkyû-sha, 1978.
KING, D. *British Textile Design in the Victoria & Albert Museum, vol. I, The Middle Ages to Rococo*. W.S. Maney & Son, 1983.
KRAATZ, A. *Dentelles*. Paris: Editions Adam Biro, 1988.
LEVEY, S.M. *Lace: A History*. London: Victoria & Albert Museum, W. S. Maney & Son, 1983.
LEVI-STRAUSS, M. *Cachemire*. Milan: Arnoldo Mondadori Editore, 1986.
PALLISER, B. *History of Lace,* 4th ed. London: Sampton Low and Marston & Co., 1902.
PEREZ-TIBI, D. *Dufy*. Paris: Flammarion, 1989.
TUCHSCHERER, J.-M. *Etoffes Merveilleuses du Musée Historique des Tissus, Lyon, vol. 1, 2*. Tokyo: Gakken, 1976.
VÖLKER, A. *Die Stoffe der Wiener Werkstätte 1910-1932*. Wien: Verlag Christian Brandstatter, 1990.

Exhibition Catalogues

The Age of Napoleon: Costume from Revolution to Empire 1789-1815. New York: The Metropolitan Museum of Art, 1989.
Emilio Pucci. Florence: Biennale di Firenze and Skira Editore, 1996.
Europe 1910-1939. Paris: Musée de la Mode et du Costume, 1997.
Giorgio Armani. New York: Guggenheim Museum, 2000.
Givenchy: 40 ans de Création. Paris: Musée de la Mode et du Costume, 1991.
Histoires du Jeans. Paris: Musée de la Mode et du Costume, 1994.
Hommage à Christian Dior 1947-1957. Paris: Musée des Arts de la Mode, 1986.
Japonisme & Mode. Paris: Musée de la Mode et du Costume, 1996.
The Kyoto Costume Institute. *Charles-Frederick Worth*. Kyoto: The Kyoto Costume Institute, 2000.
The Kyoto Costume Institute. *Evolution of Fashion 1835-1895*. Kyoto: The National Museum of Modern Art, 1980.
The Kyoto Costume Institute. *Japonism in Fashion*. Kyoto: The National Museum of Modern Art, Kyoto, 1994.
The Kyoto Costume Institute. *Japonism in Fashion*. Tokyo: TFT Hall, 1996.
The Kyoto Costume Institute. *Mariano Fortuny 1871-1949*. Tokyo: Spiral Hall, 1985.
The Kyoto Costume Institute. *Revolution in Fashion 1715-1815*. (Ancien Régime at Fashion Institute of Technology, New York) New York: Abbeville Press, 1989.
The Kyoto Costume Institute. *Visions of the The Body: Fashion or Invisible Corset*. Kyoto: The National Museum of Modern Art, Kyoto, 1999.
Madeleine Vionnet, l'Arte de la Couture. Marseille: Musée de Marseille, 1991.

Madeleine Vionnet. Lyon: Musée des Tissus, 1994.

Madeleine Vionnet: Les Années d'Innovation 1919-1939. Lyon: Musée Historique des Tissus, 1994.

Mariano Fortuny Venise. Lyon: Musée Historique des Tissus, 1981.

Mode 1958-1990: Yves Saint Laurent. Tokyo: Sezon Museum of Art, 1990.

Modes & Révolutions. Paris: Musée de la Mode et du Costume, 1989.

La Mode: Le Miroir du Monde du XVIe au XXe siècle. Tochigi, Japan: Tochigi Prefectural Museum of Fine Arts, 1995.

Pierre Cardin: Past, Present, Future. London: Victoria & Albert Museum, 1990.

Robert/Sonia Delauney. Tokyo: The National Museum of Modern Art, Tokyo, 1979.

Robes du Soir 1850-1990. Paris: Musée de la Mode et du Costume, 1990.

Fashion Dictionaries and Indexes

CALASIBETTA, C. *Fairchild's Dictionary of Fashion, 2nd ed.* New York: Fairchild Publications, 1988 (1975).

CUNNINGTON, C. W., Cunnington, P. and Beard, C. *A Dictionary of English Costume 900-1900.* London: Adam & Charles Black, 1960.

FUKAI, A., OGIMURA, A. and ÔNUMA, J., ed. *Fasshon Jiton.* Tokyo: Bunkashuppan-kyoku, 1990.

LELOIR, M. *Dictionnaire du Costume.* Paris: Librairie Gründ, 1951.

MARTIN, R. *The St. James Fashion Encyclopedia.* Detroit: Visible Ink Press, 1997.

MERKEL, R. S. and TORTORA, P. G. *Fairchild's Dictionary of Textiles,* 7th ed. New York: Fairchild Publishing, 2000 (1986).

MILBANK, C. R. *Couture.* London: Thames and Hudson, 1985.

O'HARA, G. *Dictionary of Fashion and Fashion Designers*, rev. ed. London: Thames and Hudson, 1998 (1986).

PICKEN, M. B. *The Fashion Dictionary.* New York: Funk & Wagnalls, 1957.

REMAURY, B. *Dictionnaire de la Mode au XXe Siècle.* Paris: Editions du Regard, 1994.

Acknowledgments: The Kyoto Costume Institute

As with any exhibition of this scale and scope, many people, institutions, and galleries
have been extraordinarily helpful in providing information and facilitating introductions.
We would like to thank, collectively and individually, the following:

Bus Stop Co., Ltd.
Bram Craassen / VIKTOR & ROLF
Domenico Dolce and Mr. Stefano Gabbana / Dolce & Gabbana
Dolce & Gabbana Japan K.K.
Akira Endoh / Ritsumeikan University
Kenzo Fujii / Textile Technology Center, Kyoto Municipal Industrial Research Institute
Pamela Golbin / Musée de la Mode et du Textile, Paris
France Grand, Paris
Shigemi Inaga / International Research Center for Japanese Studies
Tsutomu Iyori / Kyoto University
Kenichi Kamigaito / Tezukayama Gakuin University
Jun Kanai / Issey Miyake U.S.
Rei Kawakubo / Comme des Garçons Co., Ltd.
Mitsuo Kimura / Kobe Women's University
Ikuko Kumagai / Yohji Yamamoto Inc.
Caspar Martens /The Groninger Museum, Groninger
Issey Miyake / Miyake Design Studio
Witolf Nowik / Laboratoire de Recherche des Monuments Historiques (LRMH),
Champs-sur-Marne
Masako Ohmori / Miyake Design Studio
Soizic Pfaff/ Christian Dior Couture
Yoshio Sakurai / Kyoto University
Béatrice Salmon / Union Centrale des Arts Décoratifs
Kazunari Shingu / Kyoto University
Sachiko Shoji, Tokyo
Laura Spanbroek / VIKTOR & ROLF
Chigako Takeda / Comme des Garçons Co., Ltd.
José Teunissen / The Centraal Museum, Utrecht
TORCH Gallery, Amsterdam
Miguet Vivienne / Archives Départementales de l' Hérault
Toshio Yokoyama / Kyoto University
Yohji Yamamoto / Yohji Yamamoto Inc.
Kenji Yoshida / National Museum of Ethnology, Osaka

List of Lenders

We would like to express our heartfelt gratitude to the following museums, institutions, and collectors for entrusting us with the loans of their precious works.

Archives Départementales de l' Hérault / Montpellier
Dominique Cardon / Lyon
The Centraal Museum / Utrecht
Christian Dior Couture / Paris
The Groninger Museum / Groninger
Miyake Design Studio / Tokyo
Yohji Yamamoto Inc. / Tokyo
VIKTOR & ROLF / Amsterdam